THE THYSSEN-BORNEMISZA COLLECTION

Twentieth-century American painting

THE THYSSEN-BORNEMISZA COLLECTION

Twentieth-century American painting

Gail Levin

GENERAL EDITOR SIMON DE PURY
Sotheby's Publications

© The Thyssen-Bornemisza Collection 1987
First published 1987 for Sotheby's Publications by
Philip Wilson Publishers Ltd
26 Litchfield Street, London WC2H 9NJ

ISBN 0 85667 332 3
LC 87–061728

Designed by Gillian Greenwood
Typeset in Photina by Jolly & Barber Ltd, Rugby, Warwickshire
Printed and bound by Snoeck, Ducaju & Zoon, NV, Ghent, Belgium

Contents

Acknowledgements

I am especially grateful to Susan Edwards, graduate student at the City University of New York, for her enthusiastic and intelligent participation in this project as research assistant and as compiler of the artists' biographies. I also wish to thank Emily Goldstein for her help in preparing the bibliography. I am also grateful to the many scholars, particularly Carol Clark, Rowland Elvea and Jim Jordan, who shared their research with me directly as well as those whose publications contributed importantly to my effort. A special thanks also goes to Carl Lobell. Finally, Joan A. Speers deserves credit for her careful editing and translation of my American into English.

Gail Levin

Foreword

European private and public collections that include American art have generally focused their attention on post Second World War paintings. From Abstract Expressionism onwards, most important trends of American painting are well represented in museums and collections around Europe. In contrast, Baron Thyssen-Bornemisza's interest in American art started with paintings from the beginning of the twentieth century. His first acquisitions in that field were made in 1973 at the New York sale of the Edith Gregor Halpert Collection. The works of Edward Hopper and Georgia O'Keeffe particularly appealed to him. He was then gradually attracted to paintings of the nineteenth century. The result of that interest is catalogued in Barbara Novak's *Nineteenth-century American painting* (1986), the third volume in our series.

The Baron's American art collection is now spread over a wide geographical area, including a number of American museums, the residences of several American and Swiss ambassadors and even the Federal Reserve Board in Washington, DC. It has therefore never been possible to see this collection as a whole, with the exception of the *American Masters* exhibition held at the Vatican in 1983, in Lugano in 1984 and in various American museums in 1984–86. The present catalogue written by Gail Levin gives the first overall view of a collection that has grown quite rapidly. Baron Thyssen-Bornemisza's main concern now is to prune it and gradually improve the quality.

Simon de Pury

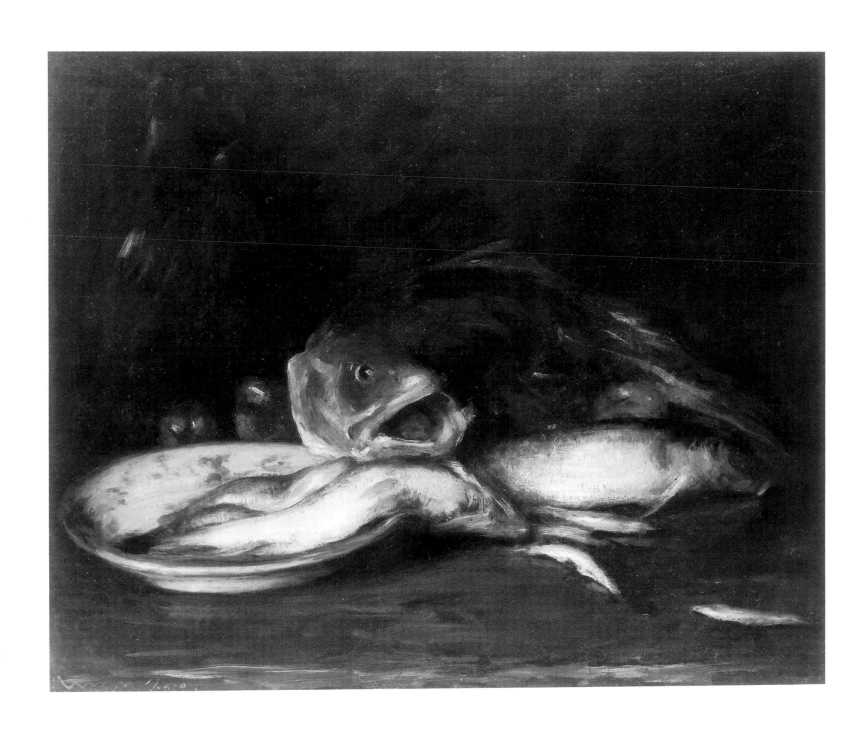

1 William Merritt Chase, *Still Life with Fish and Plate*, 1905–15,
Thyssen-Bornemisza Collection, Lugano

INTRODUCTION

The search for a native style

Nowhere can the struggle of the birth of modern painting in America be more clearly seen than at the New York School of Art, located at Fifty-seventh Street and Sixth Avenue in New York City. Founded by William Merritt Chase as the Chase School of Art in 1896, Chase gave up the school's administration two years later, but remained the dominant personality on the staff. An elegant showman, Chase stressed to his students his own Europeanised refinement and bravura style.

The New York School of Art also offered classes in illustration. During these years, illustrators were often celebrated and their work commanded enormous popularity in America. Many of the leading illustrators also painted. For example, Maxfield Parrish [1, 2]* worked as a muralist and N.C. Wyeth [3] painted landscapes. Artists better known as painters also illustrated: John Sloan [10], who taught briefly at this school, Edward Hopper [60–67], who studied both illustration and painting at the school, William Glackens, George Luks, Everett Shinn, George Bellows [11], Stuart Davis [17–19] and Arthur G. Dove [25–27].

When he invited Robert Henri [4] to join the teaching staff beginning with the 1902–1903 term, Chase (fig. 1) was not prepared for the younger artist's radically different philosophy and style of teaching. Although he began teaching only night classes, Henri's magnetic personality attracted many students. Rather than technique, Henri stressed content – 'art for life's sake', rejecting Chase's more traditional commitment – 'art for art's sake'. During the years Henri had spent as a student and teacher in Philadelphia, he had become close friends with John Sloan, William Glackens, George Luks and Everett Shinn, all of whom were then employed as illustrators – or more precisely, artist-reporters – for city newspapers. This coterie undoubtedly influenced him to relate art to the events and appearance of the world around him, no matter how ordinary or distressing.

By autumn 1903, Henri's teaching schedule had grown to four popular classes: morning men's life, evening men's life, afternoon portrait class and composition class. His appeal rested in his emphasis on 'emotional values' and 'freedom of self-expression', as Rockwell Kent [12], one of his students, later recalled.[1] Henri stressed his philosophy of art more than any one style. He would insist: 'The great artist has not reproduced nature, but has expressed by his extract the most choice sensation it has produced upon him.'[2] An inspiring teacher, Henri taught many others who later made a name for themselves, including: Edward Hopper, George Bellows, Patrick Henry Bruce [15], Glenn Coleman, Stuart Davis and Morgan Russell.

Not all of Henri's teaching was at the New York School of Art, however. The rivalry between Chase and Henri grew intense. In 1907, as a result of Henri's growing influence, Chase bitterly withdrew from the school he had founded and returned to the nearby Art Students League. Maintaining, 'art is draftsmanship', he objected to the 'vulgarity' of the work of Henri and his students. This battle epitomises the shift in American art from nineteenth-century elegance to

*Catalogue entries are referred to in square brackets

twentieth-century realism as it was mirrored in the staff and students of the New York School of Art. The school survived until Henri, dismayed by its financial mismanagement, left in 1908 to establish his own school.

Although Henri was elected an associate member of the conservative National Academy of Design in 1905 and was made a full academician a year later, he could do little to influence the jury's choices for the 1907 spring annual. He failed to convince his fellow jurors to include work by his good friends Glackens, Sloan, Luks or Shinn, or by his former students Rockwell Kent and Carl Sprinchorn. Disillusioned, Henri withdrew his own two submissions.

When Arthur B. Davies was denied membership in the Academy a month later, he arranged an exhibition at the Macbeth Gallery for himself, Henri and six other friends, including Sloan, Luks, Glackens, Shinn, Ernest Lawson [5] and Maurice Prendergast [6–9]. The artists in this exhibition, which took place in February 1908, became known as The Eight. Theirs was the first of several exhibitions which challenged and eventually broke the authority of the National Academy, making it much easier for artists to exhibit their work before the interested public.

Inspired by the example of the artists who had exhibited as The Eight, a group of Henri's former students, including Arnold Friedman, Guy Pène du Bois [58, 59], George Bellows, Rockwell Kent and Edward Hopper, among others, organised the 'Exhibition of Paintings and Drawings by Contemporary American Artists', which took place on 9–31 March 1908 on Forty-second Street in New York. The reviewer from the *New York American* praised the exhibition, claiming that it drew 'one step nearer to a national art'.[3] Increasingly, critics began to call not only for an original American style of art, but also for an American subject matter.

The birth of an avant-garde

Concurrent with the Realists in the Henri coterie, an avant-garde movement emerged led by photographer Alfred Stieglitz. From 1905 to 1917, Stieglitz showed modern European and American art at his Little Galleries of the Photo-Secession, popularly known as '291', after its address on Fifth Avenue. Among the American artists shown by Stieglitz were Arthur G. Dove [25–27], Marsden Hartley [28], John Marin [32–36], Max Weber [47, 48] and Georgia O'Keeffe [37–41], whom he married in 1924. His gallery became a meeting place for young artists who also read *Camera Work*, the magazine espousing modernism that he published and edited. It was at '291' that many American artists first encountered the work of Cézanne, Picasso and Matisse.

With the notable exception of Georgia O'Keeffe, most of the artists in the Stieglitz circle travelled abroad early in their careers. Most visited Paris where they came to know the expatriate art patrons, Gertrude and Leo Stein. The Stein home served as a salon where many American vanguard artists had the chance to meet significant European artists including Picasso and Matisse and to study the advanced work the Steins collected. In 1908, Sarah Stein, the wife of the third Stein sibling, Michael, was instrumental in the founding of the Académie Matisse where several American artists studied, among them, Max Weber, Patrick Henry Bruce and Morgan Russell. Yet Matisse's influence on young American artists in this period was much greater than the number who actually studied with him.

The Armory Show and its repercussions

The American audience for modern art was extremely limited until the tumultuous New York Armory Show of 1913. Organised by artists such as Walt Kuhn [29–31], Arthur B. Davies and Walter Pach, the Armory Show introduced European avant-garde art to a wide American public and definitively terminated the control of the conservative National Academy of Design. In the face of so notorious an event which attracted the attention of vast crowds, including such notables as Theodore Roosevelt and Enrico Caruso, the public could no longer remain complacent. Works such as Marcel Duchamp's *Nude Descending a Staircase* (see [18] fig. 3) and Wassily Kandinsky's *Improvisation No. 27* (see [78] fig. 2) challenged popular taste and provoked much public attention. When the exhibition travelled to Chicago, an investigator for the Senatorial Vice Commission took a close look at the show and concluded that the modernist art was immoral, citing that the women in Matisse's painting, *Le Luxe II*, had only four toes.[4]

2 Franz Marc, *Der Traum*, 1912, Thyssen-Bornemisza Collection, Lugano

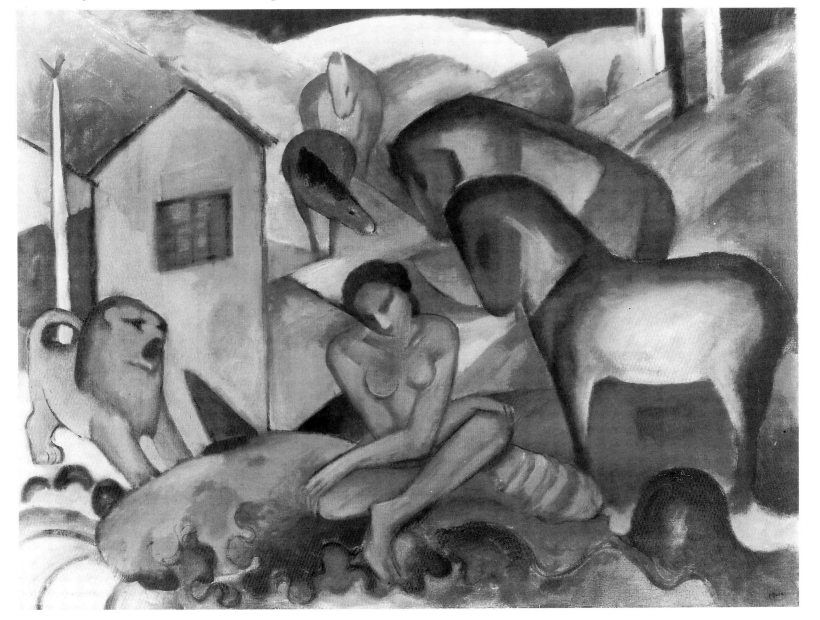

Despite all the controversy, or perhaps because of it, a number of important patrons of avant-garde art emerged: New York lawyer John Quinn, Chicago lawyer Arthur Jerome Eddy, Lillie Bliss, later a founder of New York's Museum of Modern Art, and Walter Conrad Arensberg, poet and the eventual supporter of Dada artists. Some of America's younger artists were jolted by the experience of the Armory Show, most significantly Man Ray and Stuart Davis. Years later, Davis commented on the impact of this exhibition: 'Henceforth the American artist realised his right to free expression and exercised that right.'[5]

The European nexus: expatriates and imports

Some American artists became rather established in European art circles. After a stay in Paris, Marsden Hartley [28] settled in Germany, where he met Kandinsky, Franz Marc (fig. 2) and Gabriele Münter. Living in Berlin, Hartley managed to show with these Blaue Reiter artists in the 'Erster deutscher Herbstsalon' in 1913. While developing his own original abstract style, he shared the Europeans' interests from mysticism to primitivism.[6] At about the same time, another American modernist, the German-born Oscar Bluemner [13, 14], also travelled in Germany and Paris, absorbing vanguard styles.

In Munich, in June 1913, and in Paris, the following October, two expatriate Americans, Morgan Russell (fig. 3) and Stanton Macdonald-Wright exhibited abstract colour paintings in a

3 Morgan Russell, *Synchromy in Orange: To Form*, 1913–14, Albright-Knox Art Gallery, Buffalo, NY

4 Francis Picabia, *Embarras*, 1914, Thyssen-Bornemisza Collection, Lugano

3

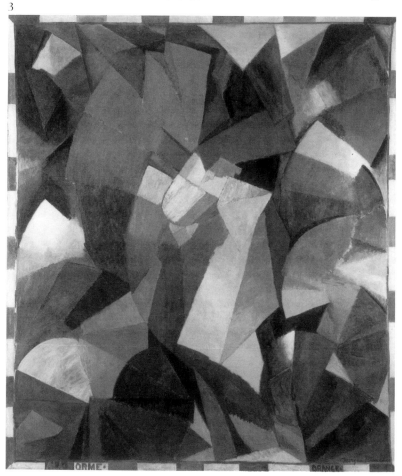

4

style they called Synchromism.[7] Emphasising rhythmic coloured shapes, Synchromist paintings were often based on interpreting the planes of sculpture through colour principles. In boastful manifestoes published in their exhibition catalogues, the two young Synchromists claimed to have pursued the use of colour beyond that in Impressionism, Cubism or Futurism, and they boldly attacked the rival abstractionists known as Orphists of whom Robert Delaunay was a member. After they showed in New York in 1914, the Synchromists briefly attracted a following (including young artists such as Thomas Hart Benton [50–52] and Andrew Dasburg) which culminated in the Forum Exhibition of Modern American Painters held in New York in 1916.

Modernist trends among American artists were greatly affected by the outbreak of war which soon caused most to return home from Europe. Marcel Duchamp's arrival in New York in 1915 encouraged the development of the Dada movement in America. Among the other leading artists involved with this development were Francis Picabia (fig. 4), Man Ray [42], Katherine Dreier and Morton Schamberg.

Responding to the senselessness of war, Dada artists rejected traditional forms and created a new iconoclastic imagery. Dada art was nurtured by a number of small periodicals: *Blind Man*, *Rongwrong*, *New York Dada* and *291*, the latter published by Stieglitz from 1915 at the suggestion of Marius De Zayas, Paul Haviland and Agnes Ernst Meyer. Dada artists emphasised wit, mechanical forms and typographical experimentation. Artists who were briefly allied with Dada included Joseph Stella, Arthur G. Dove and John Covert, all of whom produced collages in the Dada spirit.

In 1917, the Society of Independents held its first annual exhibition, allowing any artist to exhibit simply by paying a small registration fee. The idea of a non-juried exhibition was a further rejection of the former power of the National Academy of Design. Duchamp managed, however, to create a work which would be rejected; he submitted his now-famous fountain signed by his alias, 'R.Mutt'. Actually a mass-produced urinal, Duchamp's entry insulted the seemingly liberal organising committee.

The twenties and thirties: nationalism and tradition

During the prosperity of the 1920s, a number of American artists developed an interest in urban and industrial subject matter. Their fascination with the architecture and machinery of modern technology parallels that of their contemporaries in Europe such as the French Purists and the Russian Constructivists. Yet these were individuals who lacked an organised group with which to exhibit or issue manifestoes. Nonetheless, by the late twenties, critics identified these artists as 'Immaculates'. It was only decades later that the term 'Precisionism' was used by art historians to describe this work.[8]

Some artists were only briefly interested in the subject matter or the aesthetic of Precisionism: Elsie Driggs and Helen Torr, for example. Georgia O'Keeffe [37–41], influenced in part by Stieglitz's photography, momentarily departed from her more famous nature studies to explore the architecture and the mood of New York. Painter and photographer, Charles Sheeler [43–46], was much more deeply involved in the pursuit of Precisionist aesthetic and industrial subjects. He turned to mechanical themes only after the depiction of machines by his close friend, Morton Schamberg, who had been associated with the Dada movement.

The industrial landscape also became the theme of paintings by Joseph Stella and Charles Demuth [20–24], two modernists who had been exposed to the lessons of Cubism and Futurism during their travels abroad. Beginning in the 1930s, Ralston Crawford [16] continued to investigate such industrial and urban subject matter. The city also figured importantly in the sophisticated abstractions of Stuart Davis [17–19] who had absorbed the lessons of Cubism firsthand in Paris in 1928.

During this period of growth of modernist styles, influenced in a large part by contemporary European art, some American artists preferred a more traditional realist style with an emphasis on subject matter, often native American themes then celebrated by critics. These artists were the heirs to Robert Henri's philosophy that the artist should depict the life around him. Some of these artists had just ignored the avant-garde. For example, Edward Hopper [60–67], in contrast to Patrick Henry Bruce, his former classmate at the New York School of Art, later remarked on such a lack of interest when, as a young man, he had lived in Paris just after finishing art school in 1906: 'I had heard of Gertrude Stein, but I don't remember having heard of Picasso at all.'[9] Others among Hopper's contemporaries portrayed their own vision of the American scene. With a narrative flourish, Reginald Marsh [68–70] depicted the energy of the crowds in New York. Guy Pène du Bois [58, 59] painted elegant figures, often in strange encounters. Charles Burchfield [53–57] celebrated nature with rather lyrical and sometimes fantastic observations of the world around him.

Even among the modernist artists who had returned to America after the outbreak of the war, abstraction had begun to give way to more conservative figuration and greater degrees of verisimilitude. Marsden Hartley [28] turned primarily to painting still-lifes and landscapes; Andrew Dasburg painted Cézannesque landscapes, still-lifes and figures; fellow Synchromists Morgan Russell (who continued to live in France) and Stanton Macdonald-Wright began to paint clearly recognisable figures. Walt Kuhn [29–31] abandoned his Post-Impressionist experimentation to paint melancholy figures in a more traditional manner.

With the noisy propaganda of xenophobic critics such as Thomas Craven, Regionalism came to be identified with three major mid-western painters during the 1930s: Thomas Hart Benton [50–52], Grant Wood and John Steuart Curry.[10] Combining nostalgia for a simpler past with observations of rural life, the Regionalists celebrated America with a nationalistic fervour, depicting mostly farmers and other workers, historical events, and religious ritual. Grant Wood's *American Gothic* with its staged scene of a farmer and his wife standing stoically before a white clapboard farmhouse with a gothic-style window, epitomises the folksy Regionalist attitude.

Thirties alternatives: protest and experimentation

Not long after the emergence of the Realists, a number of artists appeared who concerned themselves with another aspect of American life. Sympathetic with the working classes and the urban poor, the Social Realists communicated a leftist-oriented humanitarian concern. Responding to the Depression, Moses Soyer painted the unemployed; his brother, Raphael Soyer [76, 77], painted melancholy figures in works like *Transients*. Ben Shahn [71–75] painted political rallies and commemorated the execution of Sacco and Vanzetti. The Social

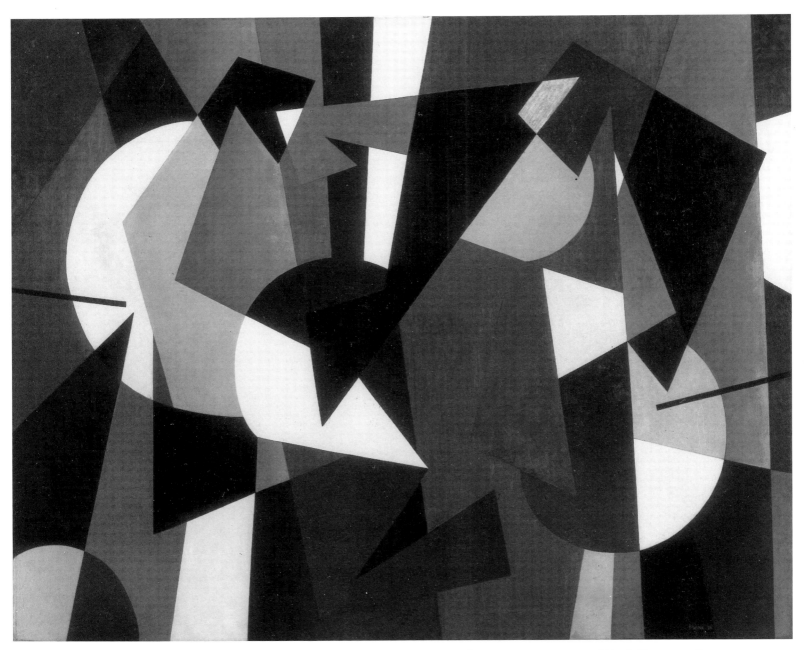

5 George L. K. Morris,
Concretion, 1936,
High Museum of Art,
Atlanta, GA

Realists felt the influence of the Mexican muralists, Diego Rivera and José Clemente Orozco
who produced famous American mural commissions.

Contemporary with the Surrealists in Europe, American artists also produced their own
diverse versions of fantastic art. Some of this painting became known as Magic Realism after
an exhibition at the Museum of Modern Art in 1943 called American Realists and Magic
Realists.[11] Artists like Jared French, Ivan Albright [49], Peter Blume, O. Louis Guglielmi, Helen
Lundeberg and Lorser Feitelson created original and strange images that are too individualistic
to be considered derivative of the European Surrealists.

At the same time that these variations of realism were thriving, an interest in abstraction
based on European work was again developing. In 1937, a group of artists in New York
founded American Abstract Artists in order to promote their ideas and to hold exhibitions for
its members. Leading figures in this group included George L. K. Morris (fig. 5), Ilya Bolotowsky,
Albert Swinden, Burgoyne Diller and Alice Trumbull Mason. The membership was especially

interested in the work of Fernand Léger and Piet Mondrian, both of whom were to come to live in New York as a result of the Second World War.

Among the many European emigrés that came to live in exile in New York during the Second World War, the Surrealists played the most crucial role. They influenced the young artists responsible for the formation of a new and original American style – Abstract Expressionism. The Surrealists living in New York included Andre Breton, Max Ernst, Salvador Dali, Roberto Matta Echaurren (fig. 6), André Masson, Gordon Onslow Ford, Kurt Seligmann and Yves Tanguy (fig. 7). The Surrealists had shown at New York galleries during the 1930s, but their largest impact came at the time of the exhibition called First Papers of Surrealism which was held at the Whitelaw Reid Mansion on Madison Avenue from 14 October to 7 November 1942.[12] Organised by Breton, Duchamp, Sidney Janis and Robert Allerton Parker, this exhibition also included work by several Americans, for example, William Baziotes, David Hare, Robert Motherwell and Kay Sage. Matta knew Baziotes, Motherwell and Gorky [78, 79] and had a definite impact on their work at the time. Pollock and Rothko seem to have responded to

6 [Roberto] Matta [Echaurren], *Composition*, 1939, Thyssen-Bornemisza Collection, Lugano

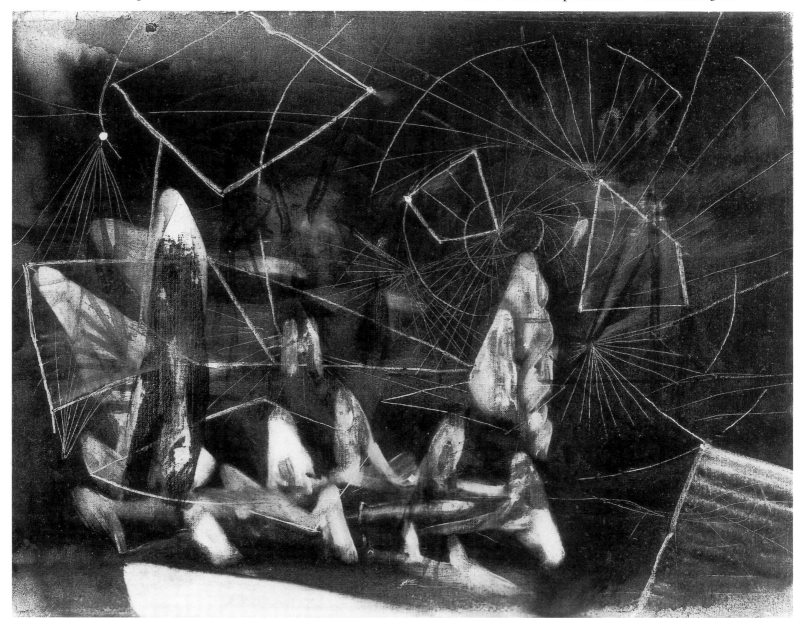

7 Yves Tanguy, *Encore et Toujours*, 1942, Thyssen-Bornemisza Collection, Lugano

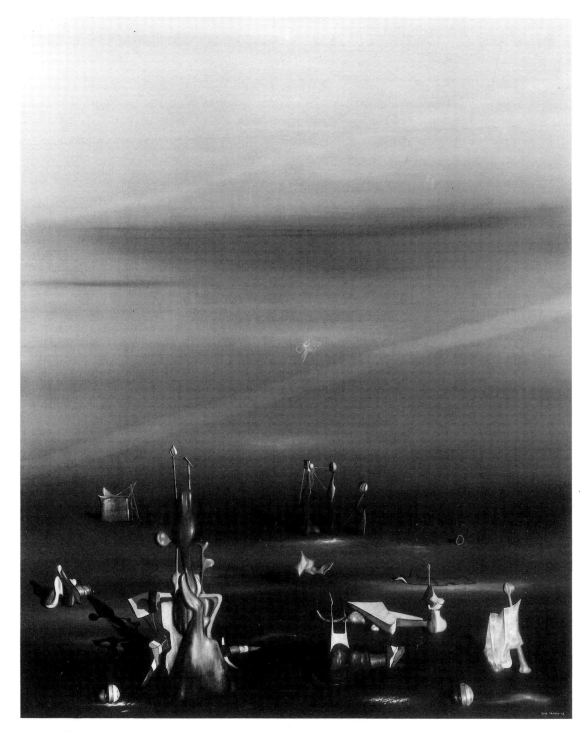

Masson's nature-related abstraction. The Surrealists served as one of the most significant catalysts in the development of Abstract Expressionism.

Another important factor in the development of Abstract Expressionism were the Works Progress Administration's Federal Arts Projects, known as the WPA/FAP, which began in 1935 and continued until 1943. Lee Krasner [85], Jackson Pollock [87–90], James Brooks, Ad Reinhardt and Arshile Gorky were among the participants in the Federal Art Project who later became known as the Abstract Expressionists. The opportunity to paint murals in public buildings encouraged many of these artists to work in large scale, which would later be identified as a salient characteristic of Abstract Expressionism.

Abstract Expressionism

From the late thirties to the forties, a number of New York artists experimented with abstract painting stressing biomorphic shapes, gestural expressionist brushstrokes, and subject matter including myth, ritual and primitive influences. Their work was personal, subjective, and often emotionally charged. By the late forties, several artists had eliminated all representational elements. Jackson Pollock, once a student of Regionalist Thomas Hart Benton, had absorbed lessons from the art of Picasso, Kandinsky, Miró and Masson.[13] Pushing the Surrealists' interest in automatism beyond the confines of easel painting, Pollock had begun to pour skeins of paint onto an unstretched canvas rolled out on the floor.

Other artists in Pollock's milieu, including Lee Krasner, Willem de Kooning [83, 84] and Hans Hofmann [80–82] also experimented with gestural abstraction and the exploitation of accident. This radical style of painting was aptly described by critic Harold Rosenberg as 'Action Painting'.[14] In the 1950s, Franz Kline pursued this gestural style, experimenting for a time with bold canvases painted in a palette limited to black and white. The gestural painting taken up by Pollock, Krasner, Bradley Walker Tomlin and others also resulted in the all-over painting surface. In the Pacific Northwest, Mark Tobey, who studied Japanese calligraphy and followed the mystical Baha'i faith, also developed an all-over painting style referred to as 'white writing'. His work was more delicate and generally smaller in scale than that of his abstract contemporaries in New York.

Many younger artists also began to experiment with this style while searching for a more personal mode of painting. Before developing a figurative painting style, both Richard Diebenkorn and Elmer Bischoff briefly painted Abstract Expressionist canvases on the West Coast. In New York, for example, both Alfred Leslie and Al Held [118] painted Abstract Expressionist canvases before the former switched to realism and the latter to hard-edged abstraction.

The New York School, as these Abstract Expressionist painters came to be called, also included some artists, such as Mark Rothko [92] and Barnett Newman, who preferred to express their abstraction as expressive colour relationships. They created chromatic abstractions which became increasingly reductive and environmental in scale. Intense colour in Rothko, Clyfford Still [93] or Newman might be described as approaching the sublime. Other artists, such as Baziotes, Theodore Stamos and Gorky, utilised biomorphic shapes with poetic references to their own experience or literary sources throughout their mature work. Most of these artists produced pictures which went beyond the limitations of Cubist space, emphasising a flat or ambiguous space.

Representational alternatives during the forties and fifties

Although Abstract Expressionism dominated the media during the 1940s and 1950s, many artists continued to paint in representational styles, developing original and significant work in a more traditional vein. Influenced by Matisse, Milton Avery [95, 96] painted figures in a new simplified manner, emphasising colour, contour and other decorative qualities. Younger contemporaries like Rothko and Gottlieb admired his work, particularly for his sense of colour.

Another mode of figurative painting emerged in Boston at this time with Jack Levine [97–99]

and Hyman Bloom, two young artists who studied together with Denman Ross at Harvard. While Bloom was drawn to mysticism, in part through his Eastern European background, Levine created richly coloured, imaginative and exaggerated images based on reality, somewhat in the tradition of earlier social protest artists.

Narrative art continued earlier figurative painting and illustration traditions. Since the 1940s, Andrew Wyeth [102–104], the son of the well-known illustrator, N.C.Wyeth, has been paint-

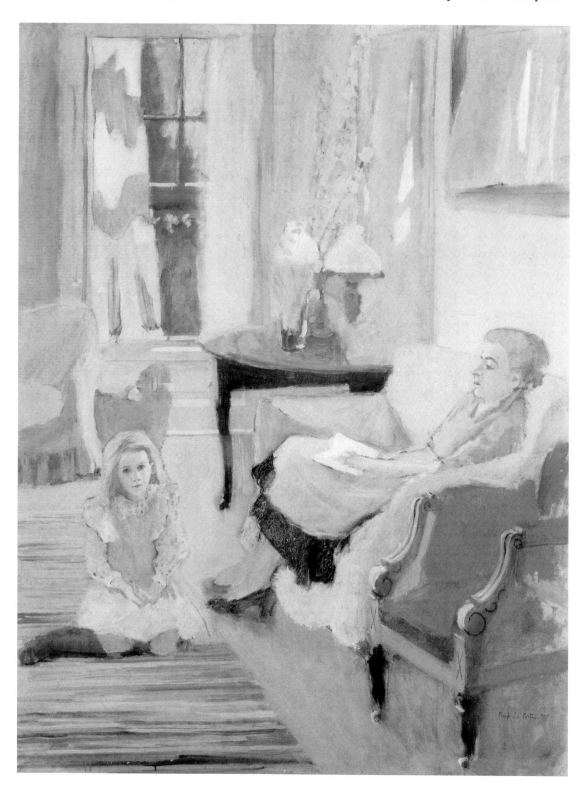

8 Fairfield Porter, *Katie and Anne*, 1955, Hirshhorn Museum and Sculpture Garden, Smithsonian Institution, Gift of Joseph H.Hirshhorn, 1966, Washington, DC

ing landscapes, figures and still-lifes with a subdued, limited palette and much detail. Like Hopper, Wyeth tries to paint his personal vision of the world around him, but his images demand a more specific, less universal reading. Wyeth's vision is based on the rural world of Maine where he spends summers and Chadds Ford, Pennsylvania, where he lives in winter.

Strong figurative work was also pursued during the fifties by artists like Larry Rivers [101], once a follower of de Kooning. Rivers took on the vernacular images of American culture and questioned everything. Nothing was too sacred for him to recast through his own vision. His blurred images and references to advertising and famous works of art anticipated the subsequent revival of figuration and the development of Pop Art.

Fairfield Porter (fig. 8), a painter and an art critic, also continued an important representational style during the heyday of Abstract Expressionism. Less narrative than Wyeth, Porter usually painted his family and friends and the beautiful calm worlds of summertime Maine and rural Long Island. Like Hopper, his surroundings became an excuse for painting light and he worked in a realist style influenced by French Impressionism and Vuillard.

During this same period, a number of significant artists developed very individual, even eccentric styles, sometimes influenced by the traditions of Dada and Surrealism. Joseph Cornell [105, 106] produced collages and constructed boxes inspired by Surrealist precedents and his own obsessive imagination. Walter Murch [100] painted evocative still-lifes, often of isolated mechanical objects. Anne Ryan [107, 108] made intricate abstract collages inspired by those of the German Dadaist, Kurt Schwitters.

Pop Art

By the 1960s, younger artists were reacting against the once dominant Abstract Expressionist painting style. Rather than looking inward, the next generation began to look at the superficial artifacts in the world around them. They borrowed from advertising, commercial illustration and comic strips rather than from high art. They were humorous and lighthearted and even poked fun at the seriousness of Abstract Expressionism.

Two precursors of Pop Art, Robert Rauschenberg [110] and Jasper Johns, created work which took a new direction as early as the 1950s. Under the influence of the vanguard composer, John Cage whose aesthetics combined ideas derived from Dada and Zen Buddhism, they pursued audacious concepts and used unusual materials. It was while studying with Josef Albers [117, 118] at Black Mountain College in North Carolina that Rauschenberg had met Cage. After producing series of all white and all black paintings, Rauschenberg made constructions utilising discarded objects. Johns explored banality with series of paintings which resembled targets, flags, maps or other ordinary objects.

Pop artists, working independently, chose to emphasise mass media and commercial imagery. Claes Oldenburg, making oversized ordinary items, and George Segal [112], placing anonymous sculpted figures in mundane contexts, created the sculptural equivalents of Pop paintings. Roy Lichtenstein [109], James Rosenquist [111], Jim Dine and Tom Wesselmann [113–116] managed to suggest erotic content even in the most banal subjects. The seeming detachment of Pop artists from the images they represented suggest that the style emerged in reaction to the emotionality of Abstract Expressionism.

Minimal and Reductivist Art

By the 1960s and throughout the 1970s, many other kinds of nonobjective painting appeared following the waning of Abstract Expressionism as the dominant style. Colour-field abstraction, which was called 'post-painterly abstraction' by art critic, Clement Greenberg, was based on developing certain formal characteristics from Pollock's drip paintings. For example, in the early 1950s, Helen Frankenthaler began to pour paint onto unprimed canvas, emphasising the lyrical nature of her colours and shapes on a flat surface. Two artists in Washington, DC, Morris Louis [120] and Kenneth Noland, saw her work and also began to stain raw canvas for its sensuous optical effects.

Post-painterly abstraction was pursued by many artists in the 1960s and 1970s. While artists like Jules Olitski and Larry Poons painted or sprayed lush colours in lyrical arrangements, others like Al Held [119], Jack Youngerman and Ellsworth Kelly painted crisp, hard-edged abstract images, sometimes utilising eccentrically shaped canvases. One might also view Richard Diebenkorn's abstract Ocean Park series, dating from the late sixties, in this same context.

Concurrent with colour-field painting, optical relationships and modes of perception held the attention of a number of American artists during the sixties. Josef Albers [117, 118] was the most significant artist who can be associated with this trend, although his own work developed from his years at the Bauhaus in his native Germany. Albers' Homage to the Square series and his teaching have influenced many artists, among them his former student, Richard Anuszkiewicz, who became known as an 'Op' artist.

Frank Stella [121], another artist who created unusually shaped canvases, stands out for having had the most singular development, creating a body of work which encompasses constant change and stylistic innovation. By 1970, Stella had painted series of pictures in stripes, black pinstripes, monochrome metallic paints, coloured mazes, irregular polygon shapes and rainbow-coloured protractors. Since the 1970s, Stella has produced very colourful baroque paintings on elaborate constructed metal supports which have become increasingly three-dimensional, making them closer to sculpture than to traditional painting.

Stella is also associated with Minimal Art and Systemic Painting, both referring to an alternative to Abstract Expressionism. The term 'Systemic Painting' which was used by Lawrence Alloway to title an exhibition of contemporary painting at the Guggenheim Museum in New York in 1966, refers to a highly organised, planned and controlled type of painting. Minimal artists, who attempted to eliminate any personal meaning or allusion to representation in their work, were concerned with pure form.

Agnes Martin's reductivist abstractions (fig. 9), with their simple systems of grids and light, dematerialised presence, epitomise the Minimal style. The white paintings of Robert Ryman, the often sombre monochrome rectangles of Brice Marden, the brighter monochrome shaped canvases of Robert Mangold, and the intricate shapes of Dorothea Rockburne's folded drawings might be described as continuing this austere direction which is most clearly seen in the Minimal sculpture of Don Judd and Carl André.

The subject matter and personal content excluded from Minimal Art was simultaneously the very substance of an opposing style – Conceptual Art. These artists emphasised pure idea to the exclusion of formal considerations. Rejecting the idea of the art object as a commodity, Mel Bochner painted abstract images directly on the wall in temporary installations. His pieces

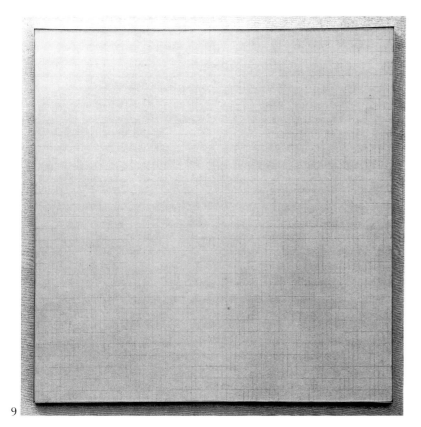

were meant to visualise concepts related to theory and problem solving. Still other Conceptual artists such as John Baldesarri, Sol LeWitt (fig. 10), and Robert Morris, used language, photographs, audio effects and other means in their attempts to present their ideas.

9 Agnes Martin, *Grass*, 1967, Stedelijk Museum, Amsterdam

10 Sol LeWitt, *Walldrawing no. 8*: Lines of random length from the four corners and the mid-points of the four sides towards the centre point of the wall, 1973, installation, Lisson Gallery, London

Recent figuration

Concurrent with Pop Art and subsequently, various styles of representational art have developed independently. Responding to his own obsessive vision, Richard Lindner [126, 127] painted erotically charged images of figures with hard-edged and exaggerated body parts. During the sixties, Romare Bearden [122] began depicting the Black experience in America through the medium of collage. His style, with its strange juxtapositions and abstract patterns, is informed by modernist art. Alex Katz began painting his stylised figures of people he knows in the late fifties. His work has evolved to feature large-scaled images of elegantly portrayed figures in interior and rural settings.[15] Katz has also continued to produce his cut-outs, a kind of figure-shaped painting.

Photo-Realism, also known as Super Realism, began in the mid-sixties and became very popular during the early 1970s. It can be seen as a reaction against the austere aesthetics of Minimalism. Rather than the advertising or comic images of Pop Art, Photo-Realists utilised photographs which they usually produced themselves. Some of these artists use slide projectors to transfer the image while others copy the photograph directly. Various aspects of cityscapes appear frequently in Photo-Realists like Richard Estes [123–125], Robert Bechtle and Ralph Goings, while Chuck Close concentrated on colossal portraits with the subjects chosen from his friends or family. Audrey Flack and Idelle Weber have most often painted still-lifes.

11 Jack Beal, *Nude with Patterned Panel*, 1966, John and Mable Ringling Museum of Art, Sarasota, FL

Many other realists who do not work from photographs have produced important work. Philip Pearlstein paints anonymous models posing, often with abrupt cropping, concentrating more on the forms themselves than any personal expression of emotion. Jack Beal (fig. 11) also paints the figure, but has a much greater interest in narrative and symbolism. Jane Freilicher, Neil Welliver and Rackstraw Downes all depict painterly renditions of their particular vision of the landscape.

Recent developments

In addition to the harsh ideological purism of Minimalism, the conservative illusionism of Photo-Realism also prompted reactions. One new direction was the emergence, in the mid-seventies, of the Pattern and Decoration or Pattern Painting trend. This style encompasses the work of artists like Joyce Kozloff, Miriam Schapiro, Kim MacConnel, Robert Zakanitch and Robert Kushner. Schapiro and Kozloff came to Pattern Painting in part through their feminist orientations, combining a feminist and decorative sensibility. Schapiro has made paintings in the shapes of houses, fans or kimonos, while Kozloff has created tiled environments as well as patterned paintings.

Perhaps it is too soon to hope to have any real perspective in summing up the first half of the eighties. Yet, in the media at least, one issue has dominated most others – appropriation. Beginning with Neo-Expressionism, artists have been borrowing from earlier styles in their search for something new. This period has been hailed as Post-Modernist, suggesting that new art will once again wholeheartedly embrace modernist taboos such as narration and mimesis.

Neo-expressionist, Julien Schnabel, glued broken plates onto his paintings and painted on velvet evoking cheap dimestore paintings. David Salle borrowed and recombined images from earlier artists and the media. Kenny Scharf has taken his garish cartoon images from television. Mike Bidlo emulated Pollock's drip paintings and copied other famous modern artists exactly. Sherry Levine, who generated attention by merely photographing reproductions of modern masters, has recently handpainted copies of some of the more simply constructed works by Malevich and Leger.

Artists today are clearly searching for new directions and some of them are evidently quite lost in their search. In the mid-eighties, as in the seventies, it seems that there is not one dominant style. Eric Fischl has produced a kind of erotic narrative painting based on the most traditional images and style. Only the content is somewhat new and that appears to derive from the cinema, to the extent that it does not come from earlier artists like Balthus. Abstraction is vital in the hands of painters like Elizabeth Murray (fig. 12), Katherine Porter and Gregory Amenoff. Jennifer Bartlett moves between abstraction and representation with a conceptual cleverness. Graffiti art continues both on the subway trains and in art galleries. And in the proliferation of small, often artist-operated galleries, a definite Lower East Side kitch has emerged. Collages by Bonnie Lucas and assemblages by Rodney Alan Greenblat or Rhonda Zwillinger exude the spirit of the East Village. Most recently, a number of artists have attempted to revive hard-edged geometric abstraction under the banner of Neo-Geo. Fascination with technology is evident in both theme and computer-generated imagery. Much of the most interesting work being done is still languishing in the studios awaiting recognition. The diversity available offers a wealth of interesting, provocative work.

12 Elizabeth Murray, *Writer*,
1979, St Louis Art Museum,
St Louis, MO

Notes

1 Rockwell Kent, *It's Me O Lord. The Autobiography of Rockwell Kent* (New York: Dodd, Mead & Company, 1955), p. 83

2 Robert Henri, 'A Practical Talk to Those Who Study Art', *The Philadelphia Press* (12 May 1901), reprinted in Robert Henri, *The Art Spirit*, ed. Margery Ryerson (Philadelphia, PA: J.B.Lippincott, Co., 1923), pp. 73–82, as 'An Address to the Students of the School of Design for Women, Philadelphia'

3 [Guy Pène du Bois], 'One Step Nearer to a National Art', *New York American* (10 March 1908)

4 Milton W.Brown, *The Story of the Armory Show* (New York: Joseph H.Hirshhorn Foundation, 1963), p. 175

5 Stuart Davis, 'Abstract Painting in America', in Diane Kelder, ed., *Stuart Davis* (New York: Praeger Publishers, Inc., 1971), p. 112

6 See Gail Levin, 'American Art', in William Rubin, ed., *Primitivism in 20th Century Art: Affinity of the Tribal and the Modern* (New York: Museum of Modern Art, 1984), pp. 452–73 and Gail Levin, 'Marsden Hartley and Mysticism', *Arts Magazine* (November 1985), pp. 16–21

7 See Gail Levin, *Synchromism and American Color Abstraction, 1910–1925* (New York: George Braziller, 1978)

8 For a discussion of the critical history of these terms, see Karen Tsujimoto, *Images of America: Precisionist Painting and Modern Photography* (Seattle, WA: University of Washington Press, 1982), pp. 21–25

9 Quoted in Gail Levin, *Edward Hopper: The Art and the Artist* (New York: W.W.Norton & Co., 1980), p. 24

10 See, for example, Thomas Craven, *Modern Art: The Men The Movements The Meaning* (New York: Simon and Schuster, 1934)

11 For a discussion of this style, see Jeffrey Wechsler, *Surrealism and American Art, 1931–1947* (New Brunswick, NJ: Rutgers University Art Gallery, 1977), pp. 35–39

12 See Gail Levin, 'Surrealisten in New York und Ihr Einfluss auf Die Amerikanische Kunst', in *Europe/America: The History of an artistic fascination since 1940* (Cologne, West Germany: Museum Ludwig, 1986)

13 For a discussion of these influences, see the author's essays in Robert Carleton Hobbs and Gail Levin, *Abstract Expressionism: The Formative Years* (Ithaca, NY: Cornell University Press, 1979)

14 Harold Rosenberg, 'The American Action Painters', *Art News* 51 (December 1952), pp. 22–23, 48–50

15 For a discussion of this artist's development and sources, see Gail Levin, *Alex Katz: Process and Development* (Hamilton, NY: Picker Art Gallery, Colgate University, 1984)

CATALOGUE

Where a painting has alternative titles, both are given, divided by an oblique.

Wherever possible, dates are given for provenance.

Exhibitions are listed by city, title, institution, date and catalogue number (where known).

In order to avoid too much repetition, a number of touring exhibitions and their respective catalogues have been abbreviated in the text as follows:

Australian tour, 1979–80
America & Europe: A Century of Modern Masters from the Thyssen-Bornemisza Collection
Perth, Art Gallery of Western Australia
Adelaide, Art Gallery of South Australia
Brisbane, Queensland Art Gallery
Melbourne, National Gallery of Victoria
Sydney, Art Gallery of New South Wales

Zafran Eric M.Zafran, *America & Europe: A Century of Modern Masters from the Thyssen-Bornemisza Collection* (Perth: exhib. cat., Art Gallery of Western Australia, 1979)

USA tour, 1982–83
20th Century Masters: The Thyssen-Bornemisza Collection
Washington, DC, National Gallery of Art
Hartford, CT, Wadsworth Atheneum
Toledo, OH, Toledo Museum of Art
Seattle, WA, Seattle Art Museum
San Francisco, CA, San Francisco Museum of Art
New York, NY, Metropolitan Museum of Art

Lieberman William S.Lieberman, *20th Century Masters: The Thyssen-Bornemisza Collection* (Washington, DC: exhib. cat., International Exhibitions Foundation, 1982)

Vatican, 1983; Lugano, 1984
Maestri americani della Collezione Thyssen-Bornemisza
Rome, Musei Vaticani
Lugano, Villa Malpensata
USA tour, 1984–86
American Masters: The Thyssen-Bornemisza Collection
Baltimore, MD, Baltimore Museum of Art
Detroit, MI, Detroit Institute of Arts
Denver, CO, Denver Art Museum
San Antonio, TX, Marion Koogler McNay Art Institute
New York, NY, IBM Gallery of Arts and Sciences
San Diego, CA, San Diego Museum of Art
Palm Beach, FL, Society of the Four Arts

Baur John I.H.Baur, *American Masters: The Thyssen-Bornemisza Collection* (Washington, DC: exhib. cat., International Exhibitions Foundation, 1984)

For touring exhibitions which feature only occasionally, the title and overall dates are listed first, followed by the city and institution. In those cases where a catalogue only pertains to a particular location, the catalogue number is listed after that location and not after the encompassing dates of the tour.

In the captions to the comparative illustrations, medium and dimensions are given only where relevant.

Catalogue entries are referred to in square brackets.

List of paintings

Early 20th-century illustration

Maxfield Parrish 1870–1966

1 Villa d'Este

1903, oil on board, 71 × 46 cm (28 × 18 in)
Signed lower right: 'M.P.'; signed, titled and inscribed on verso: 'The Oaks, Windsor Vermont, December of 1903'

Provenance
Private collection
Andrew Crispo Gallery, New York
Thyssen-Bornemisza Collection, 1979

Reproduced
Edith Wharton, 'Italian Villas and their Gardens', part IV, 'Villas near Rome', *The Century Magazine* (1904), p. 865
Edith Wharton, *Italian Villas and Their Gardens* (New York: The Century Company, 1910), p. 126
A Collection of Colour Prints by Jules Guerin and Maxfield Parrish (Cleveland, OH: J.H. Janson, 1917)

Exhibition
Boston, MA, *Maxfield Parrish*, Williams and Everett Company, Winter 1904–Spring 1905

Maxfield Parrish painted *Villa d'Este* in 1903 as one of a series commissioned to illustrate Edith Wharton's book, *Italian Villas and Their Gardens*.[1] Parrish executed *Villa d'Este* in December 1903, while in residence at his home, The Oaks, in Cornish, New Hampshire, located near Windsor, Vermont. After both Parrish and Wharton had travelled to Italy, they met in Lenox, Massachusetts to finalise the format and content of their collaborative book. Parrish was reportedly very pleased to be able to pursue landscape painting at this time.[2]

Wharton called the Villa d'Este the most famous of the 'three great villas built by Cardinals beyond the immediate outskirts of Rome.'[3] She described the villa as:

> an unfinished barrack-like building, [which] stands on a piazza at one end of the town of Tivoli, above gardens which descend the steep hillside to the gorge of the Anio. . . . From this upper terrace, with its dense wall of box and laurel, one looks down on the towering cypresses and ilexes of the lower gardens. The grounds are not large, but the impression produced is full of a tragic grandeur.[4]

This, in fact, describes rather well what we can see in the painting that Parrish made for his illustration.

Elsewhere in the same book, Parrish illustrated *The Pool of the Villa d'Este* at the same locale and the Villas Campi, Gori, Bello, Medici, and Chigi, among other places. Parrish referred to his paintings as 'colored drawings', a logical appellation for one identified as an illustrator. Having experimented with different techniques, after 1900, he preferred to work in coloured glazes of oil. Typically, he used a support of composition board covered with glued papers to create a ground of white.

Notes
1 Edith Wharton, *Italian Villas and Their Gardens* (New York: The Century Company, 1910), p. 126
2 Coy Ludwig, *Maxfield Parrish* (New York: Watson-Guptill Publications, 1973), p. 32
3 Wharton, *op. cit.*, p. 139
4 *Ibid.*, pp. 140–44

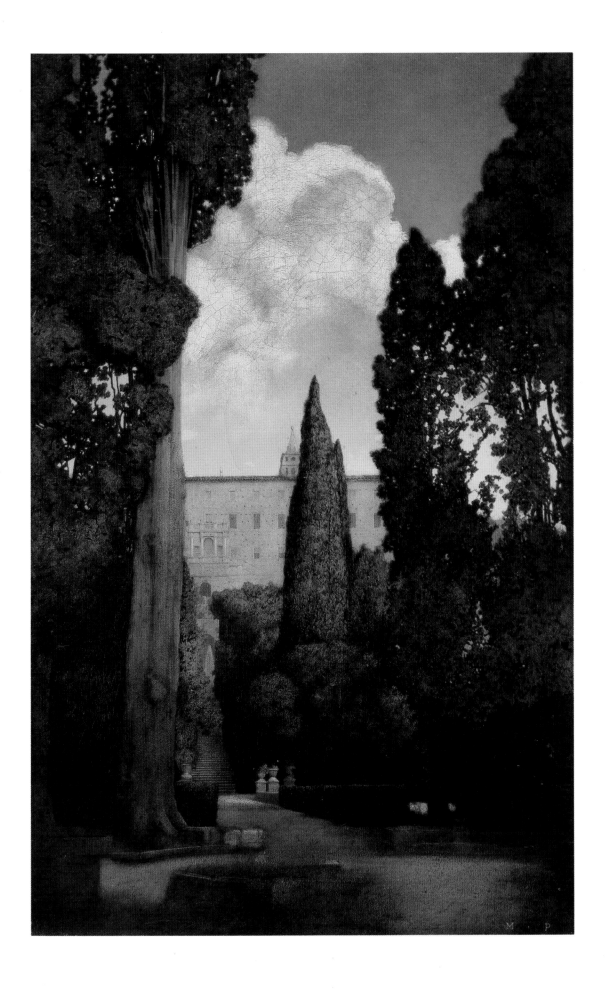

Maxfield Parrish 1870–1966

2 Illustration for 'The Knave of Hearts'

1924, oil on fibreboard, 50.8 × 41.3 cm (20 × 16¼ in)
Signed lower right: 'MP'; signed, titled and inscribed on verso

Provenance
Scott & Fowles, New York
Private collection
Sale, Sotheby Parke Bernet, New York, American 19th and 20th Century Paintings, Drawings, Watercolors and
 Sculpture, 21 April 1978, lot 90
Thyssen-Bornemisza Collection, 1978

Literature
Paul W. Skeeters, *Maxfield Parrish, The Early Years 1893–1930* (Los Angeles, CA: Nash Publishing, 1973),
 p. 271, illus.
Coy Ludwig, *Maxfield Parrish* (New York: Watson-Guptill Publications, 1973), pp. 48–53, 206, cat. no. 707
Zafran, p. 150, no. 49

Exhibitions
New York, *Maxfield Parrish*, Scott & Fowles, November–December 1925
Australian tour, 1979–80, no. 49

This illustration is inscribed on the verso: 'The Knave of Hearts. The King and The Chancellor are impatient to enter the Kitchen. Maxfield Parrish. Windsor, Vermont, 1924.' It is an illustration for Louise Saunders' book, a children's play entitled *The Knave of Hearts*, published in 1925.[1] In 1920, Parrish wrote to J. H. Chapin at Scribner's, his publisher: 'The reason I wanted to illustrate *The Knave of Hearts* was on account of the bully opportunity it gives for a very good time making the pictures. Imagination could run riot, bound down by no period, just good fun, and all sorts of things.'[2] The author of this play, Louise Saunders, was the wife of the renowned Scribner's editor, Maxwell Perkins.

Parrish completed the twenty-six paintings for *The Knave of Hearts* in just three years. The book was published first in a large format (14 × 11½ in) in the autumn of 1925 and a more compact edition shortly thereafter. The more expensive original edition did not sell well, priced at ten dollars.[3] Parrish had, however, much greater success with sales of the paintings he had made as illustrations.

This scene represents the Chancellor of the Kingdom of Pompdebile informing Violetta through the kithen door that the King is waiting to sample her tarts. Parrish depicted these characters in exaggerated postures, with memorable expressions, and colourful costumes as they would actually look in a production of this play. The background scenery resembles a backdrop for a stage set.

Notes
1 Louise Saunders, *The Knave of Hearts* (New York: Charles Scribner's Sons, 1925), p. 31, soft-cover spiral edition (Racine, WI: Artists and Writers Guild, 1925)
2 Coy Ludwig, *Maxfield Parrish* (New York: Watson-Guptill Publications, 1973), p. 48
3 *Ibid.*, p. 53

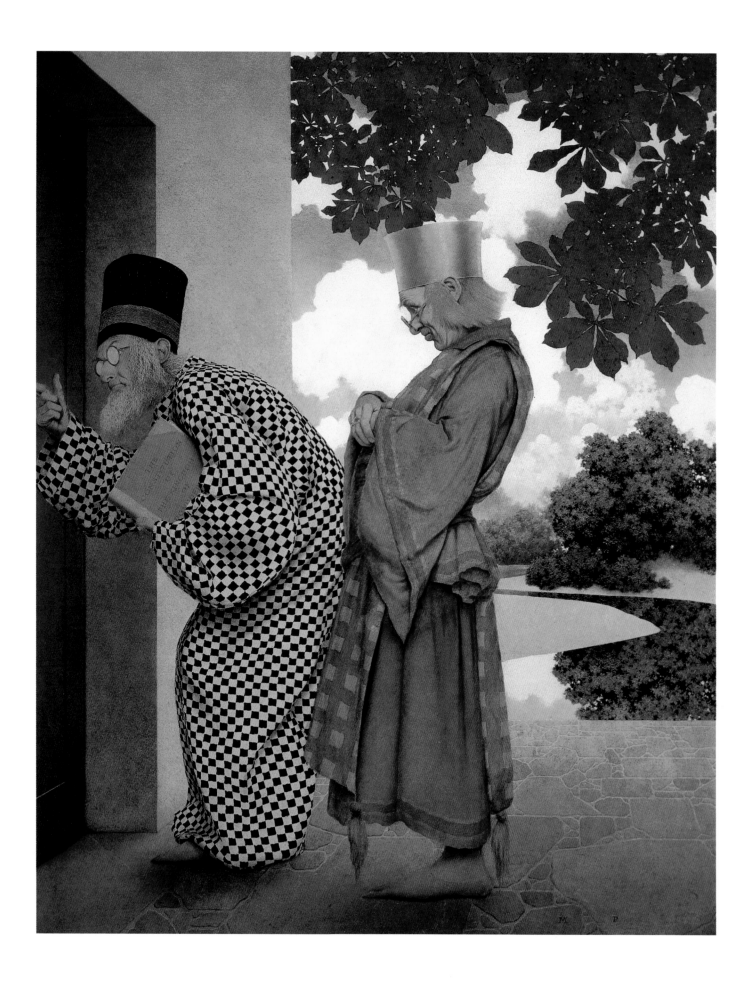

N. C. Wyeth 1882–1945

3 Farm

c. 1916, oil on canvas, 152.4 × 182.9 cm (60 × 72 in)

Provenance
Carolyn Wyeth (the artist's daughter)
Andrew Crispo Gallery, New York
Thyssen-Bornemisza Collection, 1978

Exhibitions
New York, *20th Century American Painting and Sculpture*, Andrew Crispo Gallery, August 1979
Vatican, 1983, no. 103; Lugano, 1984, no. 101
USA tour, 1984–86, no. 103

Although previously exhibited under the title *Kuerner's Farm*, this painting could not possibly depict the farm when Karl Kuerner owned it. He had fought in the German army during the First World War, arrived in Chadds Ford immediately after the war and then took up farming. N. C. Wyeth's son, Andrew, would later devote much time to painting Kuerner's farm which he first knew as a boy during the 1920s. While this farm is probably in the same area, the buildings depicted are not identical with those represented by Andrew Wyeth, nor are the pine trees he recalled and painted visible in this canvas.[1]

N. C. Wyeth, more famous as an illustrator than as a painter, had, from the beginning of his career, expressed his desire to become a landscape painter. In this painting, he depicted a farm in early spring, as is clear from the daffodils and narcissuses blooming prominently in the foreground. The effect of the bright sunlight breaking through the clouds and illuminating this pastoral landscape is one of cheerfulness and calm. The trees are just opening their new green leaves and we see nature's new beginning. This optimistic vision painted in a soft, pastel palette is quite different from the darker, more somber mood and tonality of his son Andrew's later paintings (see [102] to [104]).

From the time he moved there in the spring of 1908, N. C. Wyeth adored the Brandywine River valley in rural Pennsylvania with its rolling hills and gentle streams. He explained this enthusiasm: 'I am finding deeper pleasure, deeper meanings in the simple things in the country life here. Being older and more mature, I am realizing that one must go beneath the surface to paint and so it is that my real loves, my real affections are reviving.'[2]

Notes
1 See the 'Two Worlds of Andrew Wyeth: Kuerners and Olsons', Metropolitan Museum of Art *Bulletin* XXXIV (Autumn 1976), p. 40
2 Quoted in Douglas Allen and Douglas Allen, Jr., *N. C. Wyeth: The Collected Paintings* (New York: Crown Publishers, Inc., 1972), pp. 63–65

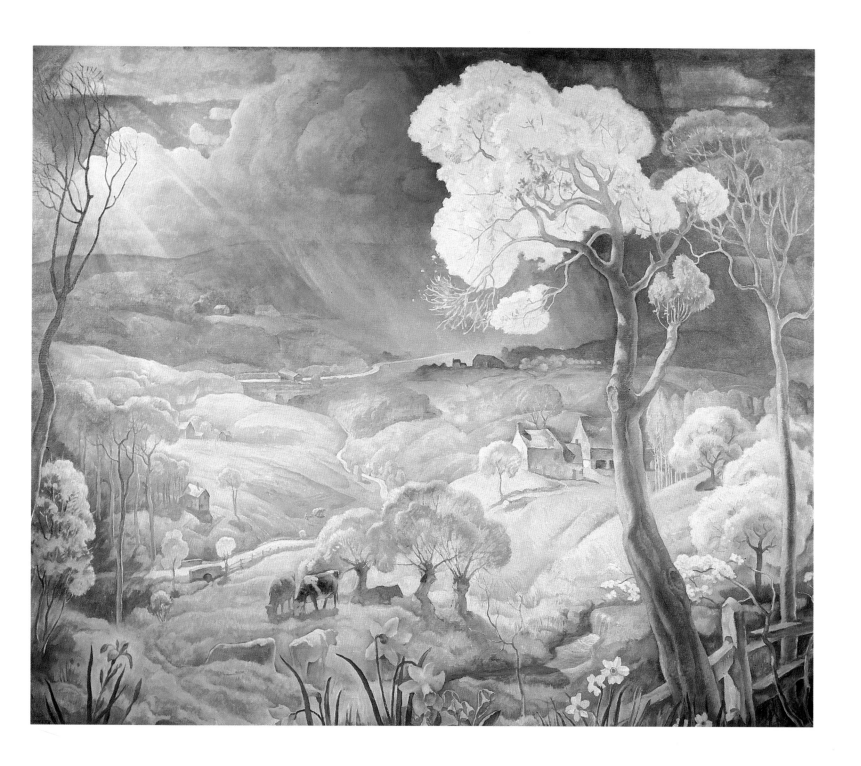

The Eight and their followers

Robert Henri 1865–1929

4 Marjorie Reclining

1918, oil on canvas, 66 × 81.3 cm (26 × 32 in)

Provenance
Estate of the artist
Chapellier Gallery
Dr and Mrs Harold Rifkin
Andrew Crispo Gallery, New York
Thyssen-Bornemisza Collection, 1981

Literature
Baur, pp. 20, 89, illus., no. 63

Exhibitions
New York, *Robert Henri: Painter, Teacher, Prophet*, New York Cultural Center, October–December 1969
Vatican, 1983, no. 63; Lugano, 1984, no. 61
USA tour, 1984–86, no. 63

Robert Henri's *Marjorie Reclining* of 1918 is a portrait of his wife, the former Marjorie Organ, whom he married in 1908. Henri met Marjorie who was a newspaper cartoonist for two New York papers, the *Journal* and the *World*, through her colleague, cartoonist Rudolph Dirks. Just two days later, Henri began painting his first portrait of this beautiful vivacious young woman and within a few months they were married. In 1911, three years after their marriage, Marjorie posed for Henri's painting entitled *The Ancient Dress (The Masquerade Dress)* (fig. 1).

Marjorie's position here is quite different from the more formal standing poses Henri had employed in earlier paintings (fig. 2). Looking out at the painter and the spectator directly, she reclines, leaning against a stack of pillows, but turning her body in the direction of the painter. This position and direct gaze convey intimacy between the artist and his model. The pose also recalls that of *Olympia*, 1863, by Edouard Manet, the French Impressionist much admired by Henri.

Henri's style is painterly in the extreme with broken heavy brushstrokes, reminiscent of the work of the Dutch painter Frans Hals whose work he admired and praised to his students. This impasto creates a more sensual, textured tactile effect. His colours are warm, although Marjorie seems rather idealised in her white dress. Reds, blues and yellows surround her and the green background has a golden cast. Henri, at the time, was experimenting with the colour system devised by Hardesty Gillmore Maratta.[1]

This painting has an unfinished quality about it, but this also adds to the seeming spontaneity of the work. The loose broken brushstrokes enliven the composition. Details, however, like the fingers on Marjorie's hands, are not defined. Instead, Henri makes the viewer focus on her face and dramatic red hair. He probably ceased painting this portrait of his wife to work on some commissioned portrait, for as he had commented in the winter of 1916–17: 'I have three unfinished things and I have no doubt that the unfinished ladies are thinking angrily about my procrastination. . . .'[2] Painting Marjorie, after all, was more a labour of love, than the way he earned his living.

Notes
1 See William Innes Homer, *Robert Henri and His Circle* (Ithaca, NY: Cornell University Press, 1969), pp. 184–89
2 Quoted in Bennard B. Perlman, *Robert Henri Painter* (Wilmington, DE: Delaware Art Museum, 1984), p. 139

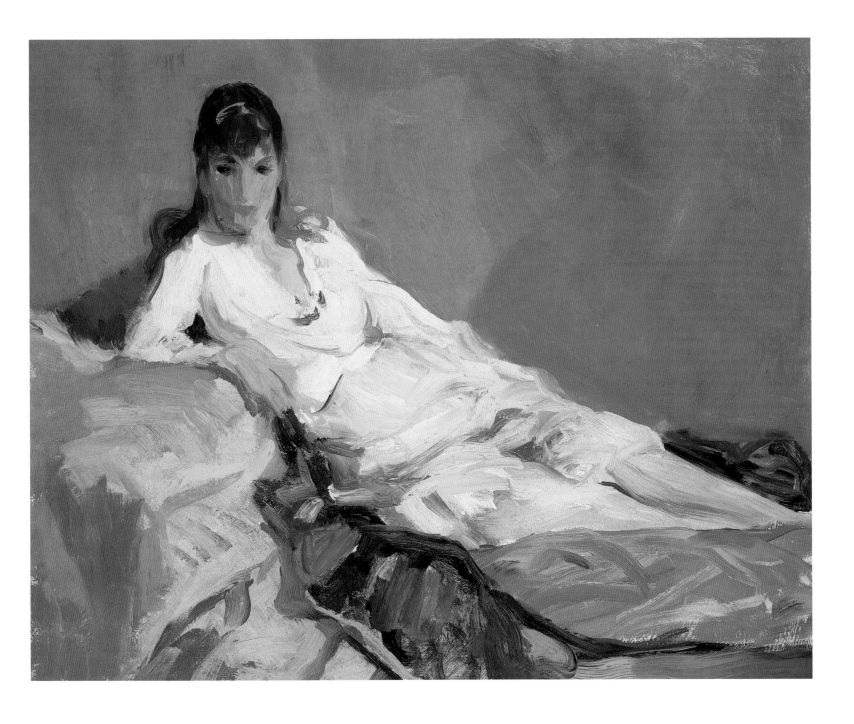

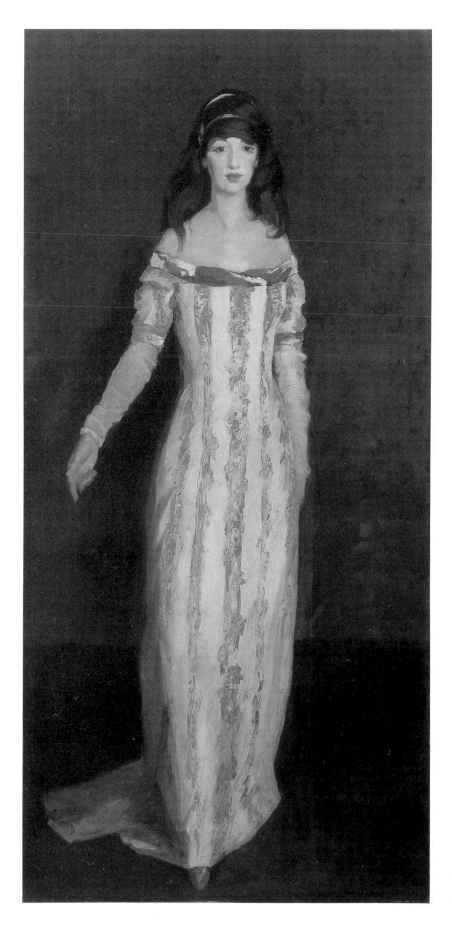

1 Robert Henri, *The Ancient Dress (The Masquerade Dress)* 1911, Metropolitan Museum of Art, New York

2 Robert Henri, *Portrait of Marjorie Henri*, 1910, M.H. de Young Memorial Museum

Ernest Lawson

<div align="right">1873–1939</div>

5 Stream by the Farm

c. 1902, oil on canvas, 50.8 × 61 cm (20 × 24 in)
Signed lower left: 'E. Lawson'

Provenance
Private collection
Andrew Crispo Gallery, New York
Thyssen-Bornemisza Collection, 1979

Although a member of the Realist group called The Eight, Lawson's landscapes and cityscapes were done in a painterly style that can be characterised as Impressionist. His views of the city, however, were typically of scenes such as the Harlem River at High Bridge, giving a pastoral look to the edge of the metropolis. He was clearly attracted to the landscape in terms of the effect of seasons and weather.

Stream by the Farm, though a winter scene, is anything but dreary. Sunlight breaks through the clouds and is reflected by the icy stream. The snowy banks of the stream also reflect the light, so that this canvas has a glistening quality. The water sparkles and the colours of the farm buildings are soft greens and earth tones. This soft tonality adds a touch of gentle beauty to snowscapes such as this one. The bare branches of the trees remind the viewer of the harshness of winter, but the overall effect is one of celebration, not melancholy.

The painter and the art critic, Guy Pène du Bois, wrote about Lawson's appreciation of the landscape:

1 Ernest Lawson, *Winter*, 1914
Metropolitan Museum of Art, New York

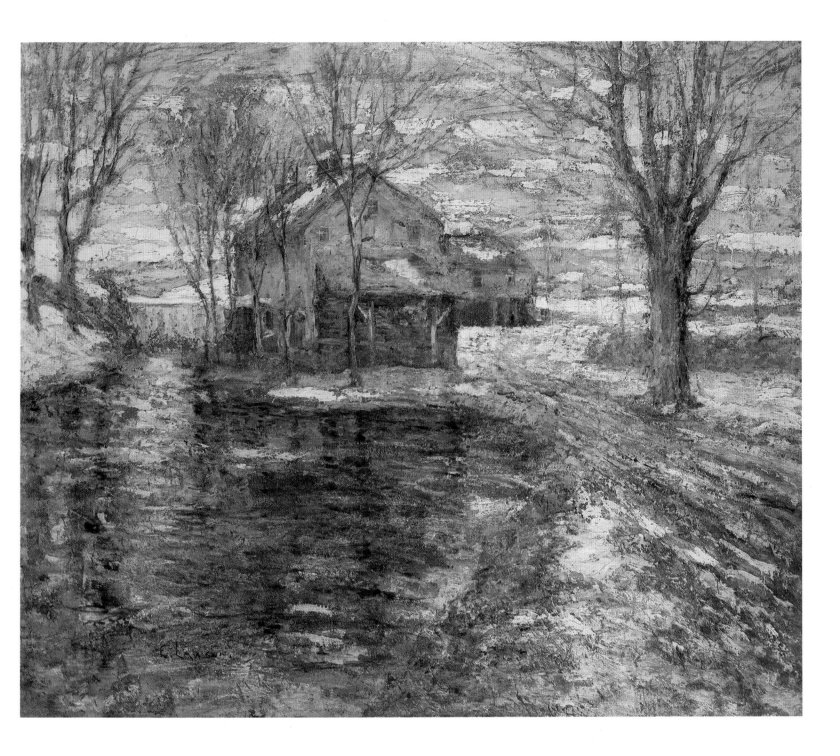

Note

1 From an obituary of Ernest Lawson by Guy Pène du Bois in the *New York Herald Tribune* (30 December 1939, repr. in *Ernest Lawson* (New York: ACA Heritage Gallery, Inc., 25 April–20 May 1967), n.p.)

His love of nature was real. He never attempted to popularize the tunes he wrote about it nor to give them those pseudo-nationalistic twists. . . . But when he sat in unconscious humility before an American or any other landscape he could and did, in those happy moments that came so often to him, go beyond its outer to its inner significance.[1]

Perhaps it was his youth in Halifax, Nova Scotia, that made Lawson partial to painting winter landscapes. *Stream by the Farm* can be compared to the artist's many other views of winter scenes. He painted, for example, *The Harlem River in Winter*, *Huts in Winter*, *Melting Snow*, *Spring Thaw*, *Harlem Winter*, *Snowbound*, *Upper Harlem River* and *Winter* (fig. 1), a view of another farm by a stream. Lawson was not only attracted to snow scenes but to more rural views as well, also perhaps reflecting his background in rugged Nova Scotia.

Maurice Prendergast 1859–1924

6 The Race Track (Piazza Siena, Borghese Gardens, Rome)

1898, watercolour on paper, 35.6 × 46 cm (14 × 18 in)
Signed lower left: 'Prendergast'

Provenance
Charles Prendergast, Westport, CT
Dr Faucett, Darien, CT
Mrs Faucett, Darien, CT
Andrew Crispo Gallery, New York
Thyssen-Bornemisza Collection, 1982

Exhibitions
Vatican, 1983, no. 61; Lugano, 1984, no. 59
USA tour, 1984–86, no. 61

Maurice Prendergast painted *The Race Track (Piazza Siena, Borghese Gardens, Rome)* in 1898 during an extended stay of eighteen months in France and Italy. He produced many watercolours on this trip, kept sketchbooks recording the art that he studied, and annotated his guidebook, all revealing his enthusiastic response to what he saw. Some of the other watercolours executed in Italy on this trip include *Campo Vittorio Emanuele, Siena, Pincian Hill* (fig. 1), and *A Procession on the Piazza (St Marks)* (fig. 2).

Prendergast painted in what can be described as an American Post-Impressionist style. He reduced detail to spots of colour, conveying the essence of the scene without retaining every observable fact. He chose a palette of rather cool tones when he painted *The Race Track (Piazza Siena, Borghese Gardens, Rome)* and emphasised subtle greens, blues and lavender. Several of the women wear long garments which blend in with the colours of the trees in the background.

There is an oil painting called *The Race Track* (fig. 3) which is dated c. 1900 which may also record the same sight in Rome. The fence is of a similar construction, but the choice of the area depicted is so different that it is difficult to determine if the two represent the same location. Prendergast's palette also emphasises a green tone in this oil, but it is quite different than the cooler green of the watercolour.

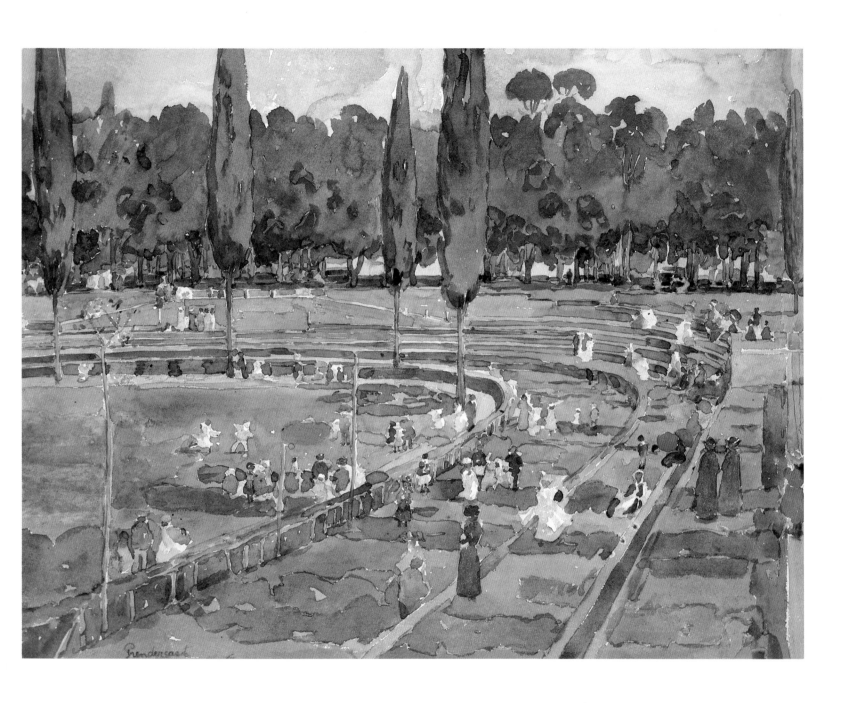

1 Maurice Prendergast
Pincian Hill, 1898–99,
Phillips Collection, Washington, DC

2 Maurice Prendergast
*A Procession on the Piazza
(St Marks)*, 1898–99
High Museum of Art, Atlanta, GA

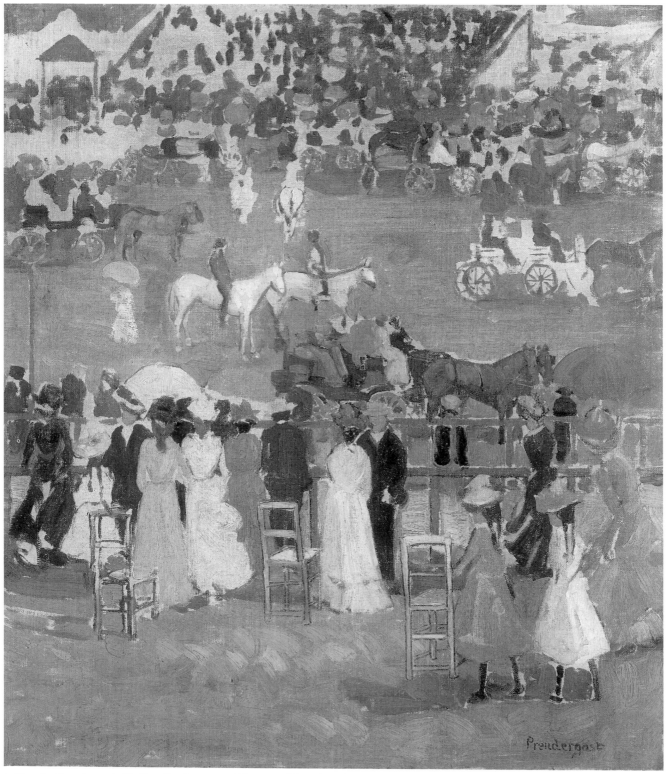

3 Maurice Prendergast, *The Race Track*, c. 1900, Museum of Fine Arts, Boston, MA

Maurice Prendergast \qquad 1859–1924

7 Beach at St Malo

1909, oil on canvas, 44.5 × 36.8 cm (17½ × 14½ in)
Signed lower right: 'Prendergast'

Provenance
Mrs Charles Prendergast, Westport, CT
Thyssen-Bornemisza Collection, 1982

Prendergast is believed to have painted *Beach at St Malo* in the summer of 1909, during his second stay in the French resort, having returned after spending July and August of 1907 there. His enthusiastic response to this cheerful place is apparent in his energetic, vibrant paintings, but he also described St Malo to Mrs Oliver Williams, his friend and fellow artist, shortly after his first stay there: 'During July and August the season was very brilliant, during September it did not interest me so well, so I bid goodbye to St. Malo with its high tides and its ramparts and fled to Paris.'[1]

What appealed to Prendergast in July and August in St Malo is obvious in his painting of the seashore: the vista of sea and brilliant bright skies, the colourful beach with its crowds of festive people thrilled to be on vacation at the seaside, and the clear light of summer. In both his watercolour, *St Malo, No. 2* (fig. 1) and this oil, Prendergast focuses on the brilliantly coloured sea and sky with a promontory of land visible in the distance on the right side.

Note
1 Maurice Prendergast to Mrs Williams, letter of October 1907, quoted in Eleanor Green, *Maurice Prendergast: Art of Impulse and Color* (College Park, MD: University of Maryland, 1976), p. 23

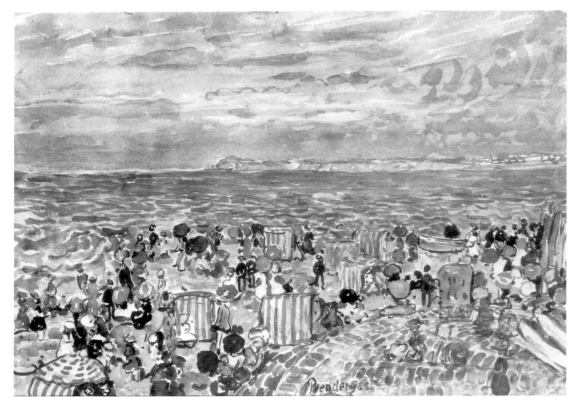

1 Maurice Prendergast, *St Malo No. 2*, c. 1907, Columbus Museum of Art, Columbus, OH

The watercolour and oil painting represent the same site, both include the holiday crowds at the shore, and the striped portable beach cabanas. The heavier handling of paint makes the oil much less delicate than the watercolour of the same sight. Although dated c. 1907, it seems likely that both works were painted during the same period, probably in 1909, during the second summer. This date for the oil has come down through the artist's sister-in-law and the two brothers worked closely together with Charles often making frames for Maurice.

Maurice Prendergast 1859–1924

8 Autumn

1910/12, oil on canvas, 49 × 62 cm (19 × 24 in)
Signed lower right: 'M.B. Prendergast'

Provenance
Kraushaar Gallery, New York
Sale, Sotheby Parke Bernet, New York, American 20th Century Paintings, 13–14 December 1973, lot 61
Andrew Crispo Gallery, New York
Thyssen-Bornemisza Collection, 1974

Literature
Zafran, p. 142, no. 27
Lieberman, p. 18, illus., no. 9
John I.H. Baur, 'Vatican. Le Nouveau Gout Thyssen', *Connaissance des Arts* 379 (September 1983)

Exhibitions
New York, *20th Century American Painting*, Andrew Crispo Gallery, 1974, no. 22
Bremen, *Moderne Kunst Aus der Sammlung Thyssen-Bornemisza*, Kunsthalle, 1975, no. 69, illus.
Australian tour, 1979–80, no. 27
USA tour, 1982–83, no. 9

1 Maurice Prendergast
The Promenade, c. 1912, Columbus
Museum of Art, Columbus, OH

There are problems in dating Prendergast's oil paintings, however, it appears that *Autumn* was painted about 1912. The compressed foreground, sea view in the distance, and visual inter- twining of human figures with trees link this work to others like *Crespuscule* (c. 1912) or *The Promenade* (undated but collected by Fernand Howald as early as 1916) (fig. 1).

One of the interesting aspects of *Autumn* is that there are no adult men present. Are they busy working as these women and children celebrate the harvest season and their leisure? Prendergast suggests mythical pastoral paintings of past epochs where such leisure scenes were depicted.

The artist has chosen a bright, rich palette with warm tones evoking the autumn season. There are colourful leaves on the trees and the figures wear vividly coloured garments, especially three women in the centre who sport red dresses. The bright sunlight reflected on the water causes it to appear almost white in tone. There is a stillness about the figures' postures which indicate their acceptance of what is to come – winter.

Maurice Prendergast 1859–1924

9 Still Life with Apples

c.1913–15, oil on canvas, 38 × 45.7 cm (15 × 18 in)
Signed lower left: 'Prendergast'

Provenance
William F.Laporte
Mr and Mrs Ralph L.Wilson, Canton, OH
Private collection
Kennedy Galleries, Inc., New York
Thyssen-Bornemisza Collection, 1982

Literature
Hedley Howell Rhys, *Maurice Prendergast 1859–1924* (Cambridge, MA: Harvard University Press, 1960), p.72,
 illus.
Patterson Sims, *Maurice B.Prendergast: A Concentration of Works from the Permanent Collection* (New York:
 Whitney Museum of American Art, 1980), p.24, illus.

Reproduced
Advertisement for Kennedy Galleries, Inc., New York, *Apollo* CXVI (July 1982), p.40
Advertisement for Kennedy Galleries, Inc., New York, *Connoisseur* 211 (August 1982), p.4

Exhibitions
Philadelphia, PA, *Still Life*, Philadelphia Museum of Art, 29 September–29 October 1934
Chicago, IL, *Exhibition of Paintings by Maurice Prendergast with Watercolors by Charles Demuth and Carl Kahler*,
 The Renaissance Society, University of Chicago, 29 January–28 February 1946, no.1
Maurice Prendergast 1859–1924, 1960
 Boston, MA, Museum of Fine Arts
 Hartford, CT, Wadsworth Atheneum, 6 October–4 December 1960
 New York, Whitney Museum of American Art
 San Francisco, LA, California Palace of the Legion of Honor
 Cleveland, OH, Cleveland Museum of Art
Vatican, 1983, no.62; Lugano, 1984, no.60
USA tour, 1984–86, no.62

Prendergast's *Still Life with Apples* of c.1913–15 is one of the artist's relatively rare still-lifes, as he preferred painting figures set in the landscape. This painting is still in its original frame designed by the artist's brother Charles. Here we see Maurice Prendergast as the consummate Post-Impressionist. The paint is applied in a spontaneous fashion with broad broken brush-strokes, the palette is bright and bold, and the disposition of objects refers to still-lifes by Cézanne.

This work is closely related to at least three other still-lifes with fruit painted about the same time. The closest work to this one is *Cinerarias and Fruit* of 1915, which also contains a potted plant, but the other two works, *Still Life* (1915) and *Still Life with Bottle*, are not far apart in theme, composition or style.

Prendergast's inclusion of so much blue and white porcelain suggests his awareness of the work of the American expatriate artist James McNeill Whistler who collected and included such china in his paintings. The broad, loose brushstrokes here reveal his knowledge of French painters from Cézanne to Raoul Dufy and Albert Marquet whose work he saw and some of whom he met during his travels in France.[1]

Note
1 Maurice Prendergast to Mrs Williams, letter of October 1907, quoted in Eleanor Green, *Maurice Prendergast: Art of Impulse and Color* (College Park, MD: University of Maryland, 1976), p.24, indicates that Prendergast met Dufy and documents that with an inscribed book of 1915. Whether he met Marquet or others is merely speculative at this time and bears further investigation

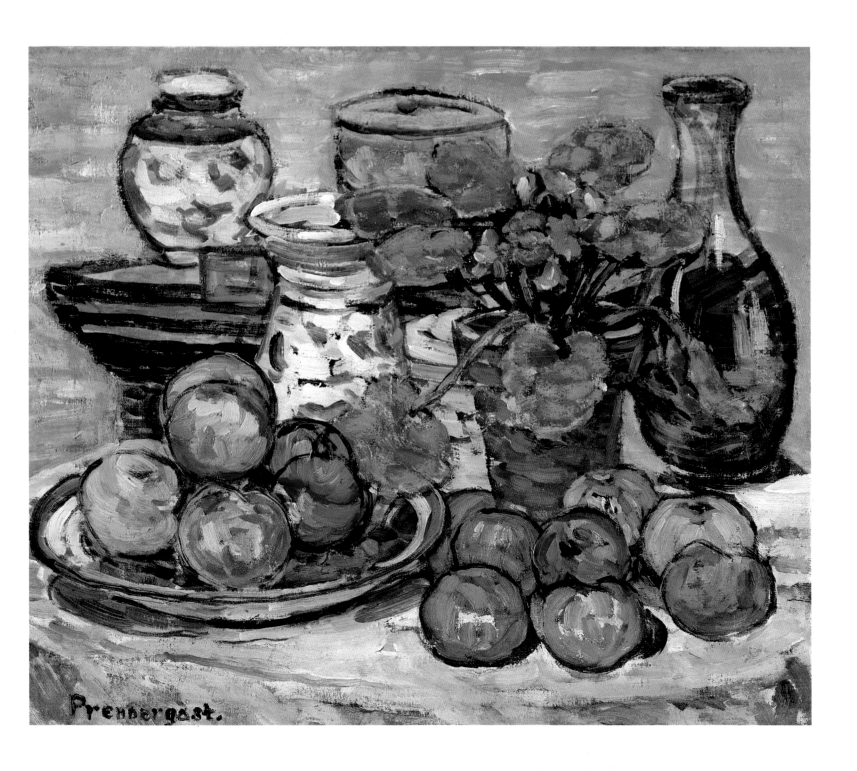

John Sloan 1871–1951

10 Throbbing Fountain, Madison Square

1907, oil on canvas, 66 × 81 cm (26 × 32 in)
Signed lower left: 'John Sloan'

Provenance
Kraushaar Gallery, New York
Cowie Galleries, Los Angeles, CA
Mr Thomas Gomez, Los Angeles, CA
Mr Eugene Inglesias and Mr Howard L. Burdge, Hollywood, CA
Coe Kerr Gallery, Inc. and Ira Spanierman, Inc., New York
Thyssen-Bornemisza Collection, 1979

Literature
The Index, XVII, 31 April and 31 August 1907
John Sloan, *Gist of Art* (New York: American Artists Group, Inc., 1939), p. 214
John Sloan (New York: American Artists Group, Inc., 1943), n.p., illus.
Van Wyck Brooks, *John Sloan: A Painter's Life* (New York: E.P. Dutton & Co., Inc., 1955), p. 67
Bruce St John, ed., *John Sloan's New York Scene: from the diaries, notes and correspondence, 1906–1913* (New York: Harper & Row, Publishers, 1965), pp. 35, 64, 116, 118, 119, illus., 125, 126, 209, 218, 524
David Scott, *John Sloan* (New York: Watson-Guptill Publications, 1975), p. 95, illus.
Grant Holcomb, III, *A Catalogue Raisonné of the Paintings of John Sloan, 1900–1913* (Wilmington, DE: University of Delaware, 1972), no. 53
Zafran, p. 139, no. 21
Baur, pp. 20, 91, illus., no. 65

Reproduced
Advertisement for Coe Kerr Gallery, Inc., New York, *Antiques* 115 (March 1979), p. 425

Exhibitions
Washington, DC, *Exhibition of Oil Paintings by Contemporary American Artists*, Corcoran Gallery of Art, 1909
Pittsburgh, PA, Carnegie Art Institute, 1909
New York, *John Sloan*, Kraushaar Gallery, 1927
New York, *John Sloan*, Montross Gallery, 2–13 January 1934
Santa Fe, NM, *Paintings by John Sloan of Santa Fe and New York*, La Quinta Gallery, 1942, no. 26
Dayton, OH, Dayton Art Institute, 1948
Los Angeles, CA, *Two Hundred Years of American Painting*, Cowie Galleries, 1961, no. 54
Los Angeles, CA, Los Angeles County Museum of Art, 1976–77
Australian tour, 1979–80, no. 21
Vatican, 1983, no. 65; Lugano, 1984, no. 63
USA tour, 1984–86, no. 65

John Sloan painted *Throbbing Fountain* in March and April of 1907 in New York's Madison Square. In his diary entry for 29 April 1907, Sloan noted: 'Put in a good day's work on a picture of the Throbbing Fountain in Madison Square and have a thing which I like. Used gold size as a medium and think that I'm going to like it. It dries very quickly and keeps my color from getting muddy, I think.'[1]

Painted in a thick, dark impasto, *Throbbing Fountain* reflects Sloan's joy in observing city life, all ages and classes of its residents. Earlier, in 1906, he had observed: 'Madison Square Throbbing Fountain with men and women and children watching it and in many case feeling its sensuous charm. It seems to have a hypnotic charm.'[2] Several months later, he noted: 'My usual walk around to Broadway for the Sunday papers, followed by an hour or so seated on a bench in Madison Square. Watching the summer die, watching the fountain pulsing and jetting

Notes
1 Quoted in Bruce St John, ed., *John Sloan's New York Scene: from the diaries, notes and correspondence, 1906–1913* (New York: Harper & Row, Publishers, 1965), p. 125
2 *Ibid.*, p. 35, diary entry of 12 May 1906

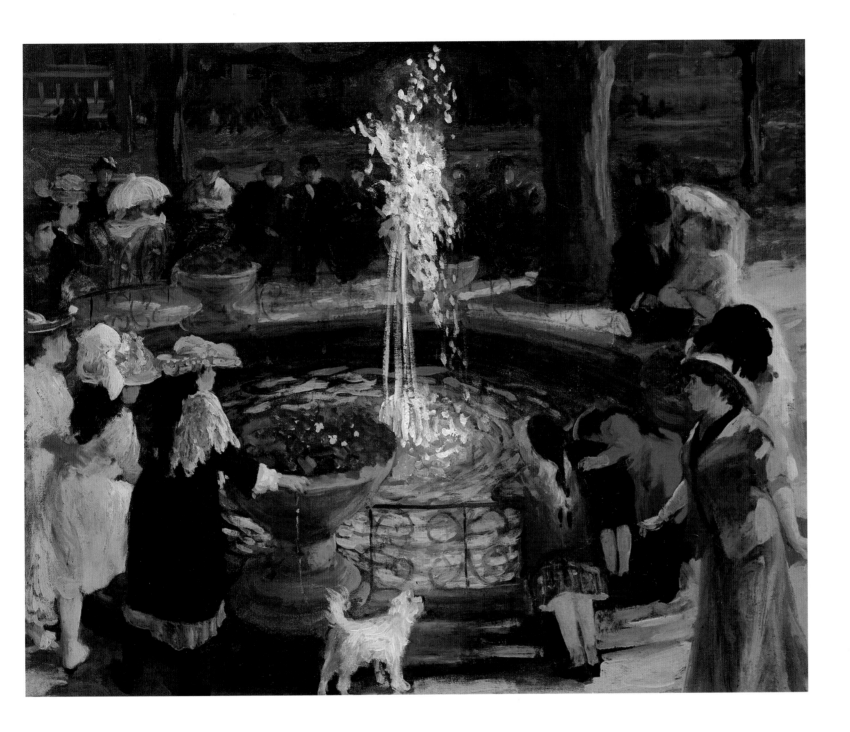

Notes
3 *Ibid.*, p. 64, diary entry for
 23 September 1906
4 *Ibid.*, pp. 209 and 218, diary
 entries from 26 March and
 11 May 1908
5 John Sloan, *Gist of Art*
 (New York: American Artists
 Group, Inc., 1939), p. 214

with its little personal rainbow gleaming and fading, coming and going in the sunlight on the spray.'[3]

In March 1908, after participating in February's attention-getting exhibition of paintings by the group which became known as The Eight, Sloan entered *Throbbing Fountain* in the exhibition organised by the Pittsburgh Art League. But in his diary entry for 11 May 1908, he noted that *Throbbing Fountain* and another canvas, *Eleanor S.* were returned to him while only '*The Cot* and *Making Faces* are accepted and hung'.[4] Sloan, however, continued to think well of this picture, choosing it as an illustration for his book *Gist of Art* in 1939 and making the following comment: 'This circular basin with the jet at water level was a hypnotically attractive feature of old Madison Square. The pulsing spurts were full of rhythmic beauty. No useful purpose was served. Eliminated years ago.'[5]

George Bellows 1882–1925

11 A Grandmother

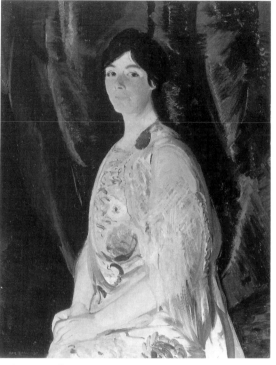

1914, oil on panel, 94 × 74.5 cm (37 × 29¼ in)
Inscribed on verso: 'A GRANDMOTHER/GEO BELLOWS/146 E 19TH/NY'

Provenance
H. V. Allison & Co., New York
Kennedy Galleries, Inc., New York
Thyssen-Bornemisza Collection, 1980

Literature
Emma Bellows, *The Paintings of George Bellows* (New York: Alfred A. Knopf, 1929), no. 27
Baur, pp. 20, 160, 90, illus., no. 64

Reproduced
H. V. Allison & Co., Advertisement for George Bellows Estate, *Art in America* 54
 (November 1966), p. 99, illus.

Exhibitions
New York, *The American View: Art from 1770–1978*, Kennedy Galleries, Inc.,
 6 December 1978–6 January 1979, no. 37
Vatican, 1983, no. 64; Lugano, 1984, no. 62
USA tour, 1984–86, no. 64

1 George Bellows, *The Spanish Shawl (Portrait of Sally Shaw)*
1914, oil on canvas, H. V. Allison & Co., New York

George Bellows painted *A Grandmother* during the summer of 1914 which he spent on Monhegan Island, ten miles off the coast of Maine. He had first visited Monhegan in 1911 with his former teacher Robert Henri. Bellows painted a number of portraits of the local residents during 1914, his third summer spent on the island. *A Grandmother* was painted as an anonymous archetype rather than as a commissioned portrait of a specific individual. Bellows, who painted many portraits commissioned by rich patrons during the year in New York, also chose to concentrate on portraits that summer, in part because the island's remarkable landscape no longer held the fascination it had during the two previous summers.[1]

His subject appears to be posing rather intently, resting stiffly erect in her chair. Her right hand is rather tense and she gazes at the artist. She is framed by the curtain at the right of the picture. Her identity as a grandmother seems clear by her facial wrinkles, grey hair, shawl, and perhaps the twinkle in her eyes. Bellows conveyed a gentleness about her.

At the time he painted *A Grandmother*, Bellows was under the influence of Denman Ross who advocated certain set palettes, including some which limited colours to fewer than four. The palette of this canvas is limited in this manner, focusing on dark and light contrasts. The red curtain and purple chair contrast to her dark dress and the gold background.

Bellows painted other such posed portraits during the summer of 1914. For example, he produced *The Spanish Shawl* (fig. 1) which is actually a portrait of Sally Shaw, another visitor to the island that summer. Like the older woman in *A Grandmother*, she also rests stiffly erect and her eyes look toward the painter, almost amused at his activity. In the best of Bellows' portraits, he achieves an iconic presence, imbuing a work like *A Grandmother* with universal significance.

Note
1 Charles H. Morgan, *George Bellows: Painter of America* (New York: Reynal & Company, 1965), p. 181

Rockwell Kent

12 The Settlement

1935–37, oil on canvas, 86.4 × 113 cm (34 × 44½ in)
Signed and dated lower left: 'Rockwell Kent 1935–37'

Provenance
Private collection
Hirschl & Adler Gallery, New York
Andrew Crispo Gallery, New York
Thyssen-Bornemisza Collection, 1981

Literature
Mary Stofflet, 'Hit Parade of American Painting', *Artweek* 11 (30 August 1980), p. 5, illus.

Reproduced
Advertisement for Hirschl & Adler Gallery, New York, *Antiques* 109 (June 1976), p. 1106

Exhibitions
San Francisco, CA, *American Painting*, John Berggruen Gallery, August 1980
New York, *American Masters of the Twentieth Century*, Andrew Crispo Gallery, January–February 1981

Rockwell Kent painted *The Settlement* during the period 1935–37, after two extended visits to Greenland in the early 1930s. In this painting, Kent depicted the snow covered mountains in the background with the Eskimos and their dogs in the foreground. It is hunting season and skins are shown drying in the sun.

At the time he painted *The Settlement*, Kent was working on a mural commission for the US Treasury Department in Washington, DC. The mural was to be located in a post office and was to depict the territory over which United States mail was delivered. At the same time, he became embroiled in political controversy because of his left-wing sympathies. Kent travelled to both Nome, Alaska, which may have inspired *The Settlement*, and to Puerto Rico to research the scenes of his mural. He researched so carefully that he boasted: 'I got every kind of information as to details and equipment and if, when I finished my picture, there is a single rivet in the dog harness out of place, it won't be my fault.'[1]

Note
1 David Traxel, *An American Saga: The Life and Times of Rockwell Kent* (New York: Harper & Row, Publishers, 1980), pp. 179–80

Early Modernists

Oscar Bluemner 1867–1938

13 Red Towards Blue

1933, tempera on cardboard, 73.7 × 99 cm (21½ × 31 in)
Signed lower left: 'BLMR'

Provenance
Marie Harriman Gallery, New York
James Graham & Sons, New York
Harry Spiro, New York
Andrew Crispo Gallery, New York
Thyssen-Bornemisza Collection, 1973

Exhibitions
New York, *Oscar F. Bluemner: Composition for Color Themes*, Marie Harriman Gallery, 2–26 January 1935, no. 22
New York, *Oscar Bluemner*, James Graham & Sons, 15 November–10 December 1956, no. 21
New York, *Oscar Bluemner*, Graham Gallery, 7–31 December 1960, no. 7
New York, *Oscar Bluemner: Paintings, Drawings*, New York Cultural Center, 16 December 1969–8 March 1970,
 no. 72
New York, *Pioneers of American Abstraction*, Andrew Crispo Gallery, 17 October–17 November 1973, no. 12

Oscar Bluemner painted *Red Towards Blue* in 1933 while living in South Braintree, Massachusetts. That year, he adapted the name Florianus as his middle name. Although this cold and harsh picture includes architecture and nature in the form of a tree, it is clearly a symbolic rather than realistic depiction.

Bluemner has chosen to limit his palette to concentrate on only a few colours, mainly red, ice blue and green. The German-born and educated Bluemner was influenced by the mystical colour symbolism in Goethe's *Zur Farbenlehre*, published in 1810.[1] He commented on 'colors as carriers of "sorrow and joy" in Goethe's meaning' and declared: 'Above all I profess myself as [a] collaborator with the new German theory of light and color, which further developed Goethe's color principles with modern scientific methods. . . .'[2]

Bluemner's landscape has a sterility to it. The tree has no leaves or branches visible and the ground is bare. The architecture is stark and angular without any warmth. Although Bluemner won a Royal Academy Medal for a painting of an architectural subject in England in 1892, studied architecture at the Königliche Technische Hochschule in Charlottenburg, trained in an architect's office in New York, and subsequently practised architecture himself for a period, he chose to render this architecture unembellished.

The almost palpable depression in Bluemner's *Red Towards Blue* probably relates to the dreary economic climate and to the artist's personal losses as well. When Bluemner's wife died in 1926, he had to borrow money from an art patron to pay for her funeral. Distraught, he moved from New Jersey to Massachussets to live with his son and daughter. This stark scene attests to the artist's sorrow and solemnity at the time he painted it.

Notes
1 Johann Wolfgang von Goethe, *Zur Farbenlehre* (Tübingen, 1810); English translation by Charles Lock Eastlake, *Theory of Colours* (London: John Murray, 1840)
2 Quoted in Judith Zilczer, *Oscar Bluemner: The Hirshhorn Museum and Sculpture Garden Collection* (Washington, DC; Smithsonian Institution Press, 1979), p. 10

Oscar Bluemner 1867–1938

14 Red and White

1934, tempera, 58.5 × 81.5 cm (23 × 32 in)
Signed lower left: 'BLMR'

Provenance
James Graham & Sons, New York
Harry Spiro, New York
Andrew Crispo Gallery, New York
Thyssen Bornemisza Collection, 1974

Literature
Zafran, p. 155, no. 61

Exhibitions
New York, *Oscar F. Bluemner: Composition for Color Themes*, Marie Harriman Gallery, 2–26 January 1935, no. 18
New York, *Oscar Bluemner: Paintings, Drawings*, New York Cultural Center, 16 December 1969–8 March 1970,
 no. 79
New York, *Pioneers of American Abstraction*, Andrew Crispo Gallery, 17 October–17 November 1973, ex. cat.
Australian tour, 1979–80, no. 61
Munich, *Amerikanische Malerei 1930–1980*, Haus der Kunst, 1981–82, no. 41
Vatican, 1983, no. 75; Lugano, 1984, no. 73
USA tour, 1984–86, no. 75

Bluemner's strictly limited palette in his painting *Red and White* of 1934 is totally invented. He has painted a winter snow scene, utilising blue as much as the colours of the title. The bare trees in the foreground set up an almost screen-like effect against the background landscape. The gracefully arched bridge unifies the composition. Snow defines this landscape conveying the cold mood of the scene which is empty of life.

The architecture includes a medieval-like tower evoking historical associations which seem out of place here. Otherwise, the architecture is nondescript, providing angular geometric shapes. In choosing to limit his palette, Bluemner hoped to emphasise the emotional potential of the colours he chose. He frequently worked with great amounts of red and even called himself the 'Vermillionaire' because of this preference.[1]

Bluemner once explained his idea of colour and the imagination to a patron as follows:

Whenever, in chemically pure imagination, one colour-sensation fuses with a correlated form, you have an aesthetic compound of a higher (psychological) order, an element of painting. When sulphur and mercury are heated together they form a new substance, vermillion, of new and different properties. Thus a painting, when it is a compound of emotion and reality, of colour fused with form, has properties absolutely different from those of either alone. It is not any more the original feeling, or the experience; there are no longer the objects, the things, the 'what'.[2]

Notes
1 Quoted from Oscar Bluemner, 'What and When is Painting Today' (October 1929), in *Oscar Bluemner: Paintings, Drawings* (New York: New York Cultural Center, 1969). n.p.
2 *Ibid.*

Patrick Henry Bruce 1881–1936

15 Peinture/Nature Morte
formerly Formes

c. 1923–24, oil and pencil on canvas, 63.5 × 81.3 cm (25 × 32 in)

Provenance

Henri-Pierre Roche, Paris
Mme Henri-Pierre Roche, Paris
M. Knoedler & Co., Inc., New York
Jon Streep

Noah Goldowsky Gallery, New York
Mr and Mrs Henry M. Reed, Montclair, NJ
Kennedy Galleries, Inc., New York
Thyssen-Bornemisza Collection, 1980

Literature

Hilton Kramer, 'Rediscovering the Art of Patrick Henry Bruce', *The New York Times* (17 July 1977), illus., p. D21
Gail Levin, *Synchromism and American Color Abstraction, 1910–1925* (New York: George Braziller, 1978), p. 42
Mimi Crossley, 'Bruce's Reputation Salvaged', *The Houston Post* (30 April 1978), illus.
William C. Agee and Barbara Rose, *Patrick Henry Bruce, American Modernist: A Catalogue Raisonné* (New York:
 Museum of Modern Art, 1979), pp. 201–202, illus. no. 23
Baur, pp. 21, 162, 95, illus., no. 69

Exhibitions

New York, Noah Goldowsky Gallery, 1967
From Synchromism Forward: A View of Abstract Art in America. circulated by the American Federation of Arts,
 12 November 1967–17 November 1968
Montclair, NJ, *Synchromism from the Henry M. Reed Collection*, Montclair Art Museum, 6–27 April 1969, no. 7
Montclair, NJ, *American Still Life in New Jersey Collections*, Montclair Art Museum, 25 October–13 December 1970,
 no. 8
Huntington, NY, *The Students of William Merritt Chase*, Heckscher Museum, 18 November–30 December 1973,
 no. 55, illus., p. 29
Katonah, NY, *American Painting, 1900–1976, pt 1, The Beginnings of Modernism, 1900–1934*, Katonah Gallery,
 1 November 1975–4 January 1976, no. 4, illus.
Houston, TX, *Modern American Painting, 1910–1940: Toward a New Perspective*, Museum of Fine Arts,
 1 July–25 September 1977, no. 10, illus., p. 15
Patrick Henry Bruce: American Modernist, 1979, no. 23
 Houston, TX, Museum of Fine Arts
 New York, Museum of Modern Art
Vatican, 1983, no. 70; Lugano, 1984, no. 68
USA tour, 1984–86, no. 69
Cologne, *Pioniere der Abstrakten Kunst aus der Sammlung Thyssen-Bornemisza*, Galerie Gmurzynska, 1–30 September
 1986, p. 188 colour pl.

Patrick Henry Bruce's *Peinture/Nature Morte* of about 1923–24 is one of a series of abstract still-lifes that he painted in Paris during the 1920s. He based these abstract shapes on actual objects including vases, fruit and boater hats. The painting is considered to be in the fourth group of this still-life series, in which the amount and complexity of the objects is increased dramatically.[1] Some objects rest upon others on a tabletop which is tilted towards the picture plane.

Bruce was inspired by the work of Cézanne. This influence can be seen in the tilting of the table top laden with objects as well as the intentional decision to leave some areas of the canvas bare, seemingly unfinished. Bruce worked out the shapes first in pencil and then filled in the shapes with densely applied areas of flat colour. In this canvas, red, black and tones of blue and green are emphasised. In all of this series the range of colours is kept to a minimum and shape and contour are emphasised rather than tone or painterly effects.

Note
1 William C. Agee and Barbara Rose, *Patrick Henry Bruce, American Modernist: A Catalogue Raisonné* (New York: Museum of Modern Art, 1979), p. 35

Notes
2 *Ibid.*, p. 202
3 See Gail Levin, 'Patrick Henry Bruce and Arthur Burdett Frost, Jr.: From the Henri Class to the Avant-Garde', *Arts Magazine* 53 (April 1979), pp. 102–106

In the Agee and Rose catalogue raisonné, the condition of this painting comes under discussion, along with the twelve of the other paintings in this series:

Extensive erasures were made in the sphere at the left center, the cylinder at the lower left center, and the cylinder in the lower right corner; also in the long rectangular block at the center, most especially a line that also served to define the lower left edge of the 'vertical bar' at the center rear. The effect has been to make the picture thinner, less full, and less 'finished' than the artist intended.[2]

Nonetheless, despite this unfortunate alteration, this is one of the relatively rare examples of the artist's work. Bruce created a series of works which were respected by many of his contemporaries in the avant-garde – from the Delaunays and Matisse in Paris to a number of American friends and followers including Arthur Burdett Frost, Jr and James Daugherty.[3]

Ralston Crawford 1906–1978

16 Overseas Highway

1939, oil on canvas, 45.7 × 76.2 cm (18 × 30 in)
Signed lower left

Provenance
Private collection
Andrew Crispo Gallery, New York
Thyssen-Bornemisza Collection, 1978

Literature
Zafran, no. 68
John I. H. Baur, 'Vatican, Le Nouveau Gout Thyssen', *Connaissance des Arts* 379 (September 1983)
Baur, pp. 22, 111, illus., no. 85
'Amerikanische Malerei Aus der Sammlung Thyssen-Bornemisza', *Du* 5 (1984), p. 84, illus.

Exhibitions
Ralston Crawford, 1946
　　Santa Barbara, CA, Santa Barbara Museum of Art
　　San Francisco, CA, M. H. de Young Memorial Museum
　　Portland, OR, Portland Art Museum
　　Seattle, WA, Seattle Art Museum
New York, *20th Century American Painting and Sculpture*, Andrew Crispo Gallery, August–September 1978, no. 17
Australian tour, 1979–80, no. 68
Vatican, 1983, no. 85; Lugano, 1984, no. 83
USA tour, 1984–86, no. 85
The Machine Age in America, 1918–1941, 16 October 1986–14 February 1988, ex. cat.
　　Brooklyn, NY, Brooklyn Museum
　　Pittsburgh, PA, Museum of Art, Carnegie Institute
　　Los Angeles, CA, Los Angeles County Museum of Art
　　Atlanta, GE, High Museum of Art

Ralston Crawford's *Overseas Highway* of 1939 is one of several versions of this theme which held particular importance for the artist. He made at least three other oils of this image and twenty-five colour lithographs, as well as a drawing in ink and crayon. The subject of this painting is a bridge across the Key West highway in Florida, newly built at the time Crawford saw it. He was living in Maitland, Florida in 1937–38, as a result of having won the Bok Fellowship to the Research Studio there.

Crawford recalled: 'I remember at this particular point on the causeway I felt I was quite literally going to sea in my car. And amazingly enough, many years later when I was on my way to India I had a similar feeling – of crossing the desert on a ship when we went through the Suez Canal.'[1] He explained: 'When I painted *Overseas Highway* as a young man I did see an awful lot of space before me and it fascinated me. The perspective is used simply as a vehicle in relation to that space.'[2] Crawford also admitted that he saw a relationship between his work and the Surrealists: 'There are many pictures I've made which indicate my interest in Surrealism at that time. It was not my primary concern, but it was also not an inconsequential concern.'[3]

Crawford utilised linear perspective to create a dramatic effect. He has reduced detail to an absolute minimum while emphasising flat colour, shape and form. His work is linked to other artists associated with the Precisionist movement, including Charles Sheeler, Georgia O'Keeffe

Notes
1 Quoted in Jack Coward, 'The Collections; Recent Acquisition: *Coal Elevators*, by Ralston Crawford', St Louis Art Museum *Bulletin* (January–March 1978), pp. 10–15
2 *Ibid.*
3 *Ibid.*

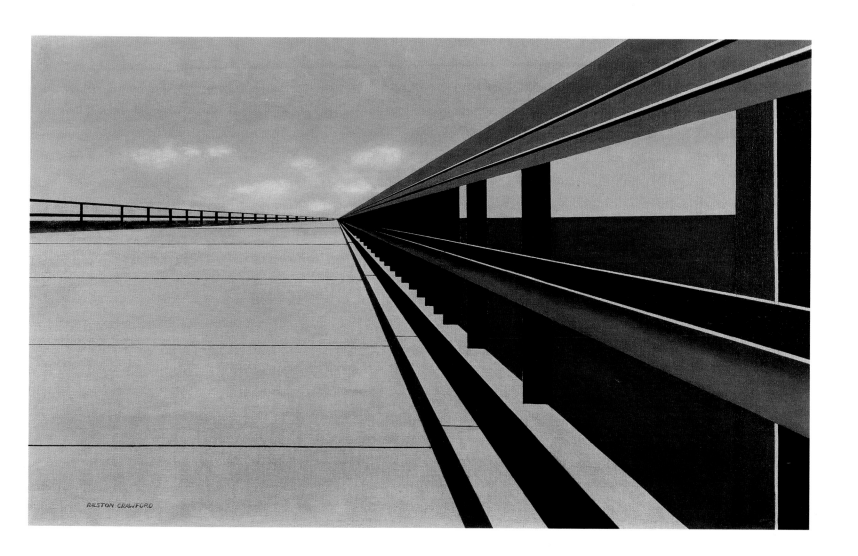

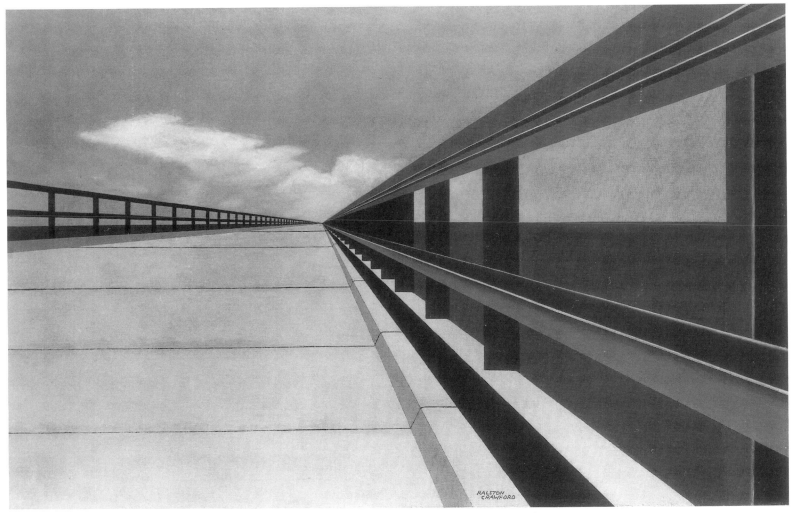

1 Ralston Crawford, *Overseas Highway*, 1939, oil on canvas, 71 × 114 cm (28 × 45 in), private collection

and Niles Spencer. Like each of these artists, Crawford depicted urban subjects with clean, sharp lines, ignoring the negative side of city and industrial images.

Crawford recalled the making of *Overseas Highway*:

I can remember my work on that painting, it was almost like writing. I put it right down, I didn't change anything basically in the design in the painting. I drew it, as I frequently do, I always do a certain amount of drawing on the canvas before I start to paint, usually always with charcoal. I had worked in this manner, put down my drawing and I proceeded to paint on it. That was it. There were no problems in relation to it. The continuing painting was simply as a matter of giving me paint quality, more substance.[4]

This version of *Overseas Highway* is smaller than Crawford's largest canvas on this theme (fig. 1), but larger than the smallest version. The cloud formations are noticeably different in each painting and each canvas is signed in a different place. Otherwise, these three oil versions are closely related. Crawford continued his interest in painting dramatic bridges the next year with *Whitestone Bridge* (fig. 2) which is even more startling and Surrealist in its impact.

Note
4 Quoted in William C. Agee, *Ralston Crawford* (New York: Twelve Trees Press, 1983), n.p., across from plate 18, from Joan Simon interview with Crawford, The Greenberg Gallery, St Louis, c. 1971

2 Ralston Crawford *Whitestone Bridge*, 1940 Memorial Art Gallery, University of Rochester, Rochester, NY

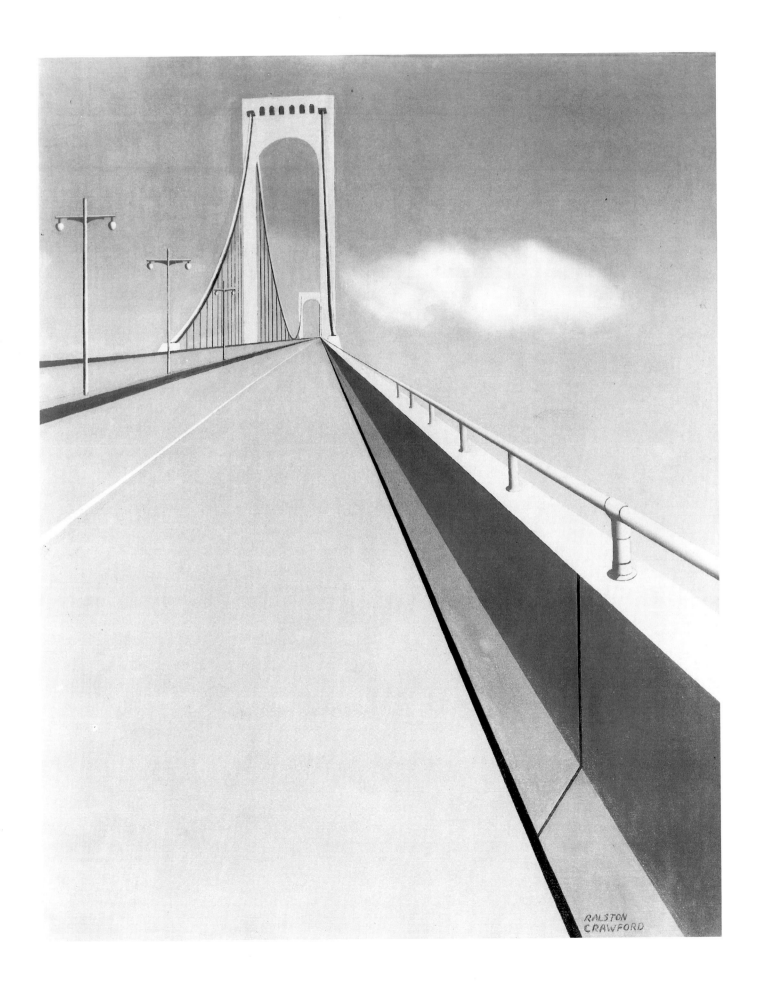

Stuart Davis 1894–1964

17 Sweet Caporal

1922, oil and watercolour on canvas board, 50.8 × 47 cm (20 × 18½ in)
Signed lower centre: 'Stuart Davis'

Provenance
Estate of the artist
Mrs Stuart Davis
Andrew Crispo Gallery, New York
Thyssen-Bornemisza Collection, 1973

Literature
Diane Kelder, ed., *Stuart Davis* (New York: Praeger Publishers, Inc., 1971), p. 6, pl. 1
Zafran, pp. 149–50, no. 47
Baur, pp. 21, 96, illus., no. 70

Exhibitions
Stuart Davis Memorial Exhibition, 1894–1964, May–November 1965, no. 18
 Washington, DC, National Collection of Fine Arts, Smithsonian Institution
 Chicago, IL, Art Institute of Chicago
 New York, Whitney Museum of American Art
 Los Angeles, CA, Art Galleries, University of California at Los Angeles
New York, *Pioneers of American Abstraction*, Andrew Crispo Gallery, 17 October–17 November 1973, no. 15, illus.
Lugano, *Collezione Thyssen-Bornemisza, Arte Moderna*, Villa Malpensata, 1 September–5 November 1978, no. 14,
 illus.
Australian tour, 1979–80, no. 47, illus.
USA tour, 1982–83, ex. cat.
Vatican, 1983, no. 71; Lugano, 1984, no. 69
USA tour, 1984–86, no. 70
Cologne, *Pioniere der Abstrakten Kunst aus der Sammlung Thyssen-Bornemisza*, 1–30 September 1986, p. 188,
 colour pl.

Stuart Davis painted *Sweet Caporal* in 1922 after the image of a crumpled tobacco box. This picture is one of several pictures of commercial products relating to cigarettes and tobacco painted in this period, including two oils, *Lucky Strike* (fig. 1) and *Bull Durham* (fig. 2) and a watercolour, *Cigarette Papers*, all of 1921. Davis presented commercial packaging squashed flat against the picture plane rather than in an illusionistic space. This approach links his work to images in earlier synthetic Cubist collages more than to an American nineteenth-century painting in the *trompe l'oeil* tradition.

 Earlier in 1921, Davis had produced actual collages in the Cubist manner, such as *ITLKSEZ*. Then, with these tobacco products pictures, he created simulated collages, featuring lettering from commercial labels which were painted rather than pasted on. In referring to the collage

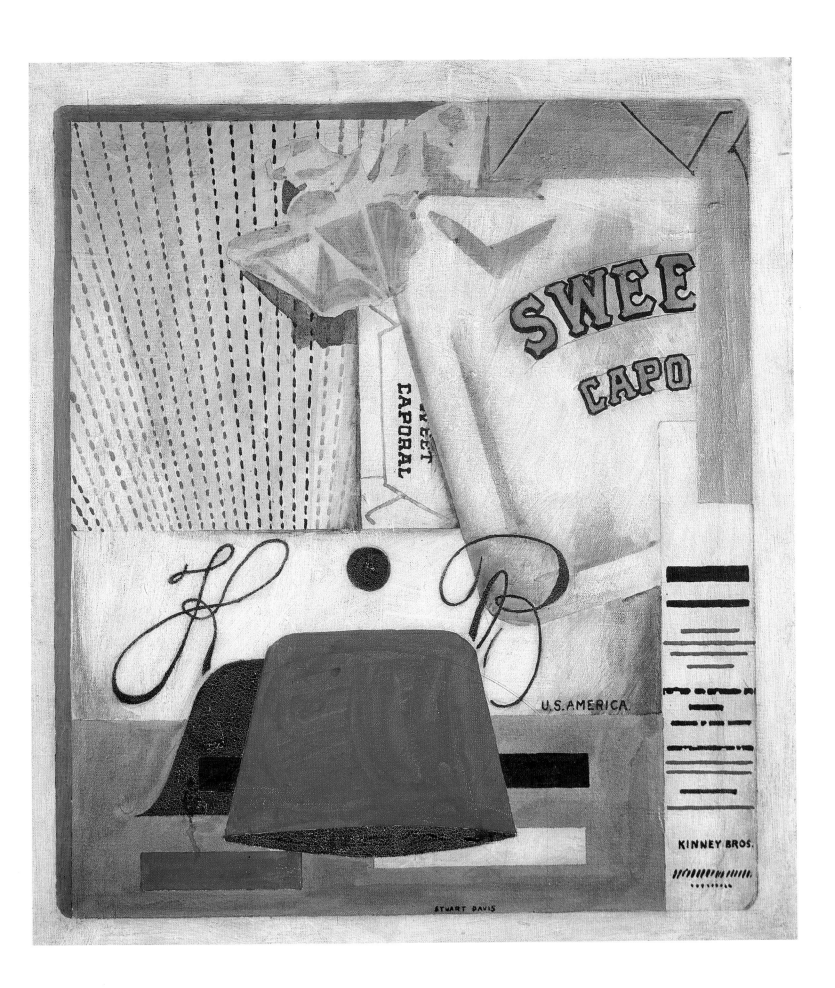

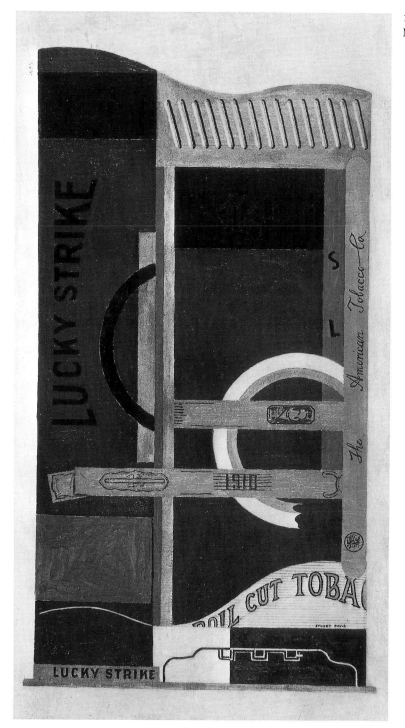

1 Stuart Davis, *Lucky Strike*, 1921
Museum of Modern Art, New York

sensibility, Davis tacitly acknowledged two-dimensionality by using these words or word frag-ments on the picture surface to replicate the surface of the object depicted.[1]

Davis was fascinated by modern packaging, which changed from bulk to individual packaging of small amounts, as a symbol of the achievement of what he viewed as a high civilisation in modern life.[2] He commented wryly: 'I do not belong to the human race but am a product made by the American Can Co. and the *New York Evening Journal*.'[3] Davis recorded that he wished to make pictures, not from geometric shapes, but from 'an alphabet of letters, numbers, canned goods labels, tobacco labels, in a word let these well known, purely objective things be used to

Notes
1 Diane Kelder, ed., *Stuart Davis* (New York: Praeger Publishers, Inc., 1971), p. 6
2 See Stuart Davis, Journal 1920–22, Collection of Wyatt H. Davis, May 1921, referred to in John R. Lane, *Stuart Davis: Art and Art Theory* (Brooklyn, NY: Brooklyn Museum, 1978), p. 94
3 *Ibid.*, Journal of 1920–22, April 1921

2 Stuart Davis, *Bull Durham*, 1921
Baltimore Museum of Art
Baltimore, MD

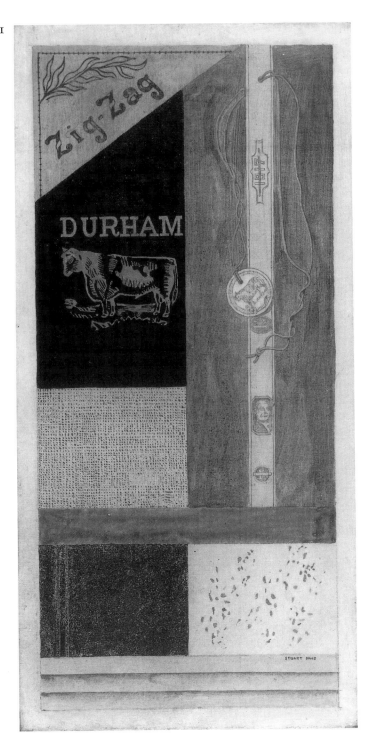

Notes
4 *Ibid.*, Journal of 1920–22,
 11 March 1921
5 See photographs of Davis
 smoking by Marvin P.Lazarus,
 on the cover of E.C.Goossen,
 Stuart Davis (New York: George
 Braziller, 1959) and by George
 Wetting, on back cover of Rudi
 Blesh, *Stuart Davis* (New York:
 Grove Press, Inc., 1960)

indicate location and size'.[4] Davis had in mind an anti-romantic, utilitarian picture which would have a direct impact on the spectator without illusionistic space.

Davis celebrates the commercial culture of the United States, clearly adding US AMERICA beneath the two labels reading SWEET CAPORAL, and next to the letters K and B standing for the manufacturer identified in the lower right corner: KINNEY BROS. Even the package Davis chose emphasises the patriotic colours red, white and blue. The product itself, SWEET CAPORAL, is a coarse tobacco used for rolling cigarettes, which presumably Davis smoked himself, as he was repeatedly photographed smoking.[5]

Stuart Davis 1894–1964

18 Tao Tea Balls and Teapot

1924, oil on canvas, 46 × 61 cm (18 × 24 in)
Signed and dated lower right: 'Stuart Davis '24'

Provenance
Estate of the artist
Andrew Crispo Gallery, New York
Thyssen-Bornemisza Collection, 1983

Exhibition
USA tour, 1984–86, no. 71

Tao Tea Balls and Teapot of 1924 is one of several still-lifes Davis painted during the early 1920s before his more abstract versions of his Eggbeater series in the latter part of that decade. This work is clearly more representational and traditional than its immediate successor, *Still Life – Three Objects* of 1925 (fig. 1), which already employs a flattened perspective and a decorative surface pattern.

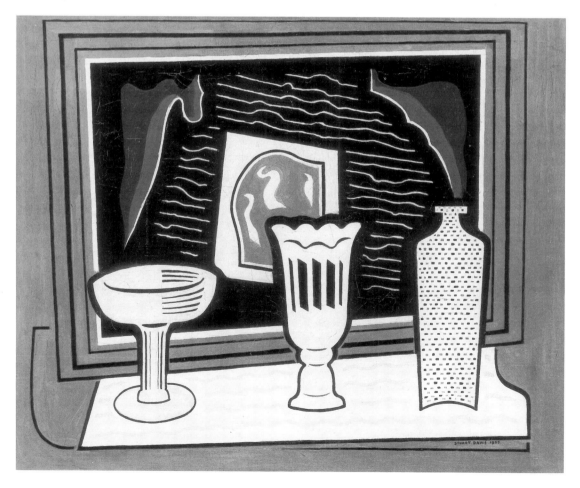

1 Stuart Davis, *Still Life – Three Objects*, 1925, Wadsworth Atheneum, Hartford, CT

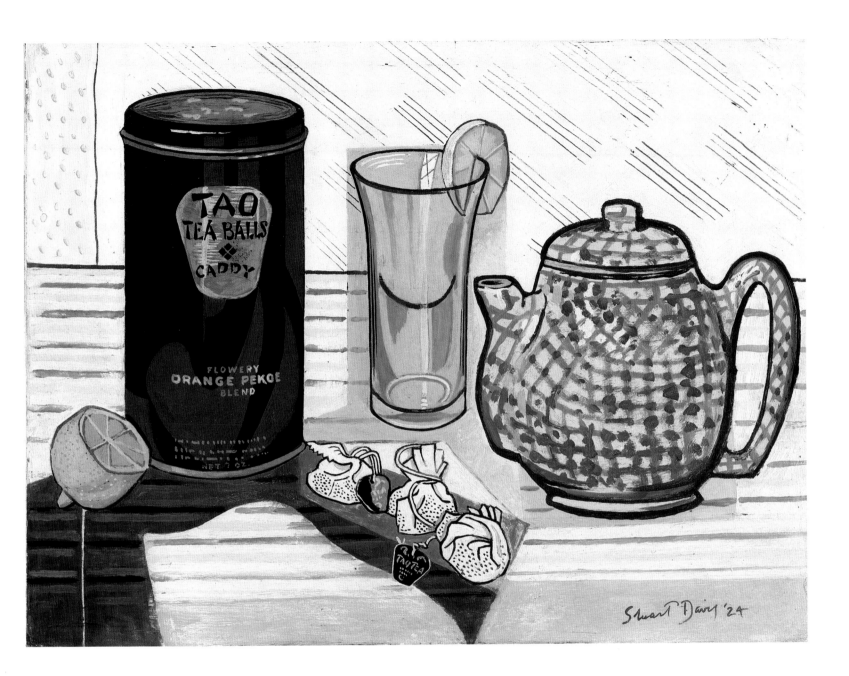

Note
1 Quoted in Diane Kelder, ed.,
 Stuart Davis (New York:
 Praeger Publishers, Inc., 1971)

This painting is in many ways a transitional work. The tea tin, glass and teapot are rendered to give the impression of three dimensions, while the striped surface upon which they rest appears to tilt toward the picture plane, creating an abstract, flattened effect. The dark shadow cast by the tea caddy seems almost like a piece of cut out paper and is not convincing but decorative. The tea bags are stippled so that they seem to be less than realistic. The blue shadow cast by the transparent glass seems totally contrived while the teapot is traditionally rendered. Only the teapot's brown rectangular shadow suggests that this is merely a flat painted image.

At the time he painted *Tao Tea Balls and Teapot*, Davis was moving rapidly in the direction of abstraction. A year earlier, in 1923, he wrote: 'No work of art can be true to nature in the objective sense. The nearer it approximates the natural appearance of objects the more it is likely to be far away from art.'[1] His understanding of this concept is reflected in this painting which helped clarify the direction he subsequently pursued.

Stuart Davis 1894–1964

19 Pochade

1958, oil on canvas, 132 × 152 cm (52 × 60 in)
Signed upper centre: 'Stuart Davis'; signed, titled and dated on stretcher

Provenance
The Downtown Gallery, New York
Edith Gregor Halpert, New York
Sale, Sotheby Parke Bernet, New York, Highly
 Important 19th and 20th Century American
 Paintings, Drawings, Watercolors and Sculpture
 from the Estate of the late Edith Gregor Halpert,
 14–15 March 1973, lot 45, illus.
Kennedy Galleries, Inc., New York
Thyssen-Bornemisza Collection, 1977

Literature
Time (15 December 1958), p. 58, p. 59, illus.
Alexander Eliot, *Art of Our Time* (New York: Times
 Inc., 1959)
E.C. Goosen, *Stuart Davis* (New York: George Braziller,
 1959), p. 26, pl. 75
Aldo Pellegrini, *New Tendencies in Art* (New York:
 Crown Publishers, Inc., 1966), p. 30, illus.

Diane Kelder, ed., *Stuart Davis* (New York: Praeger
 Publishers, Inc., 1971), p. 8
John R. Lane, *Stuart Davis: Art and Art Theory*
 (Brooklyn, NY: Brooklyn Museum, 1978),
 pp. 186–87, illus., p. 78
Zafran, pp. 165–66, no. 88
Lieberman, pp. 70–71, illus., no. 61
J.C. Suares, 'Raw Talents: A Selection of Childhood
 Works by Famous Artists', *Connoisseur* 213 (July
 1983), p. 52

Reproduced
Art News (New York, Summer 1958), p. 43, illus.
The New York Times (14 June, 1964), Sec. 2, p. 21,
 illus.
Art in America (New York, March/April 1973), p. 9,
 illus.
Sheldon Reich, 'The Halpert Sale, A Personal View',
 American Art Review I (September/October 1973),
 p. 83, illus.

Exhibitions
New York, *Spring Exhibition*, The Downtown Gallery, 1958
Iowa City, IA, University of Iowa Museum of Art, June 1958
Cincinnati, OH, Cincinnati Art Museum, 1958
New York, *Whitney Annual Exhibition*, Whitney Museum of American Art, November 1958
New York, *U.S.A.: 59*, New York Coliseum, 3–19 April 1959
Greensberg, PA, Westmoreland County Museum of Art, May–July 1959
East Lansing, MI, *1959 Purchase Exhibition*, Kresge Art Center Gallery, Michigan State University,
 October–November 1959
Chicago, IL, *64th American Exhibition*, Art Institute of Chicago, 1961
Kalamazoo, MI, Genevieve and Donald Gilmore Art Center, Kalamazoo Institute of Arts, September 1961, no. 11
New York, *Four Centuries of American Masterpieces*, Better Living Center, New York World's Fair,
 22 May–18 October 1964, no. 26
New York, *A Gallery Survey of American Art*, The Downtown Gallery, 1965
New York, *Contemporary Urban Vision*, New School for Social Research, February 1966, no. 11
Washington, DC, *Past and Present*, Corcoran Gallery of Art, April–September 1966
New York, *New York Painting and Sculpture: 1940–1970*, Metropolitan Museum of Art,
 18 October 1969–1 February 1970, no. 53
Washington, DC, *Edith Gregor Halpert Memorial Exhibition*, National Collection of Fine Arts, Smithsonian
 Institution, April 1972, no. 2
Corpus Christi, TX, *A Selection of American Paintings from the Estate of the late Edith Gregor Halpert, New York*, Art
 Museum of South Texas, 19 January–10 February 1973
New York, *Recently Acquired Masterpieces of the 19th and 20th Centuries*, Kennedy Galleries, Inc., 1977
Stuart Davis: Art and Art Theory, January–May 1978, no. 106
 Brooklyn, NY, Brooklyn Museum,
 Cambridge, MA, Fogg Art Museum
Australian tour 1979–80, no. 88
USA tour 1982–83, no. 61
Modern Masters from the Thyssen-Bornemisza Collection, May–December 1984
 Tokyo, National Museum of Modern Art February–August 1986
 Kumamoto, Kumamoto Prefectural Museum Madrid, Biblioteca Nacional, Salas Pablo Ruis Picasso
 London, Royal Academy of Arts, no. 102 Barcelona, Palau de la Virreina

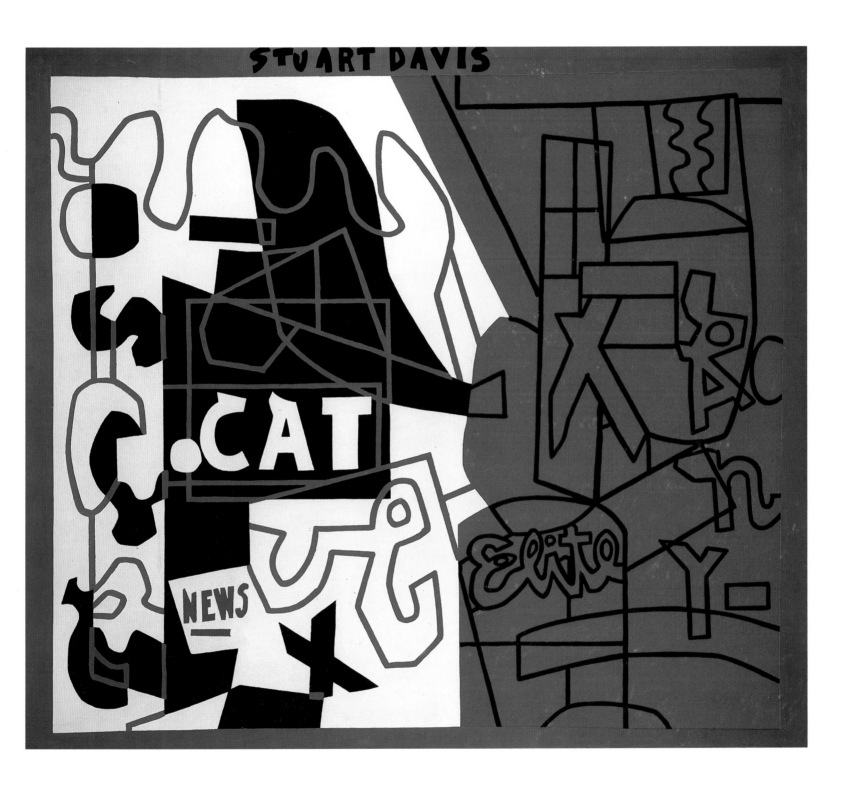

Pochade is an example of Stuart Davis' late style. The name is French for 'rough sketch', but this painting is actually not at all spontaneously executed, but based on a number of careful studies executed in 1957. Davis noted that the painting was in what he termed his 'New Universal Style'.[1] He included many words including 'ANY', 'CAT', 'NEWS' and 'Elite', and he placed his own name prominently at the top of the canvas. Davis also employed symbols such as a large X, just to the left of ANY.

At least three sketches for *Pochade* are known to exist in the Stuart Davis Papers at Harvard University.[2] On one rough sketch for this painting, the artist noted: 'The process of Awareness consists of Feeling in Indentification with an Object in Art this Identification is consciously translated into a *Color-Position Object* and the practical technique to execute it Directly.' On a later sketch, he noted: 'Size is a Color-Position product, not an Engineering problem. Size is a Spectator Problem, – a Category of Perception.' On the third sketch, he worked out what he called 'Size-Color Coordinates'. These sketches and comments indicate how clearly Davis worked out colour and line in *Pochade* and how its name belies its actual meaning.

Davis' style is bold and emblematic; it is poster-like and reflects the artist's own experience working on large-scale murals. A rhythm is created by the variety of words and shapes overlapping in transparent layers. This is the rhythm of the city where Davis first enjoyed the jazz music that he loved. The word 'CAT' possibly refers to this context. Jazz is reflected in Davis' painting earlier in major abstract works like *American Painting* (1932–51) or *The Mellow Pad* (1945–51).

In addition to the sketches on paper discussed above, there are two other versions of *Pochade* (fig. 1) which Davis painted on large-scale canvases in outline form without colour. In both of these canvases, the major difference in the composition is the elimination of the c in front of AT, making this word all the more enigmatic. Davis did not intend his paintings to be read or translated. Nonetheless, some have interpreted his abstract forms quite literally, seeing the dark form on the left of *Pochade* as Davis himself, 'seated and smoking a cigar', and the right side of the painting as 'an interior of the artist's studio, replete with a television set'.[3]

The power of *Pochade* is its bold and emphatic graphic strength which is clarified by Davis' decision to limit his palette to the simple combination of red, green, black and white. Davis demonstrated in this painting that he could create a large impact with a minimum of means.

Notes
1 Stuart Davis Papers, Fogg Art Museum, Cambridge, MA, Index 27, October 1957, as quoted in John R. Lane, *Stuart Davis: Art and Art Theory* (Brooklyn, NY: Brooklyn Museum, 1978), p. 186
2 *Ibid.*
3 Lieberman, p. 71

1 Stuart Davis, *Study for Pochade*, 1958, oil on canvas, Estate of the artist

Charles Demuth

20 The Primrose

1916–17, tempera on pasteboard, 42.5 × 31.7 cm (16¾ × 12½ in)

Provenance
Daniel Gallery, New York
Fernand Howald, Columbus, OH

Columbus Gallery of Fine Arts, Columbus, OH
Kennedy Galleries, Inc., New York
Thyssen-Bornemisza Collection, 1981

Literature
Index of Twentieth Century Artists 2, no. 10 (July 1935), p. 147
Emily Edna Farnham, *Charles Demuth: His Life, Psychology and Works* (Columbus, OH: Ph.D. dissertation, Ohio State
 University, 1959), vol. 2, no. 363, pp. 552–53; illus., vol. 3, fig. 80, p. 834
Marcia Tucker, *American Paintings in the Fernand Howald Collection* (Columbus, OH: Columbus Gallery of Fine Arts,
 1969), p. 21, no. 17
Emily Farnham, *Charles Demuth: Behind a Laughing Mask* (Norman, OK: University of Oklahoma Press, 1970),
 pp. 148 and 204
Alvord L. Eiseman, *A Study of the Development of an Artist: Charles Demuth* (New York: Ph.D. dissertation, New York
 University, 1975), I, pp. 230–39, illus., p. 235
Thomas E. Norton, ed., *Homage to Charles Demuth, Still Life Painter of Lancaster* (Ephrata, PA, 1978), p. 62
Alvord L. Eiseman, *Charles Demuth* (New York: Watson-Guptill Publications, 1982), p. 43

Exhibitions
Columbus, OH, *Inaugural Exhibition*, Columbus Gallery of Fine Arts, January–February 1931, no. 49
Washington, DC, *Charles Demuth: Exhibition of Watercolors and Oil Paintings*, Phillips Memorial Art Gallery, 3–25
 May 1942, no. 53
New York, *Charles Demuth*, Museum of Modern Art, 7 March–11 July 1950, no. 26, p. 90
Copenhagen, Denmark, *Art in Embassies Program of the International Council of the Museum of Modern Art*,
 US Embassy residence, 25 August 1961–20 May 1964
Akron, OH, *Paintings by Charles Demuth, 1893–1935*, Akron Art Institute, 16 April–12 May 1968, no. 68
Cincinnati, OH, *Three American Masters of Watercolor: Marin, Demuth, Pascin*, Cincinnati Art Museum,
 14 February–16 March 1969, no. 43
Charles Demuth – The Mechanical Encrusted on the Living, October 1971–April 1972, no. 63, p. 82, illus.
 Santa Barbara, CA, Art Gallery, University of California at Santa Barbara
 Berkeley, CA, University Art Museum, University of California
 Washington, DC, Phillips Collection
 Utica, NY, Munson-Williams-Proctor Institute
Vatican, 1983, no. 80; Lugano, 1984, no. 78
USA tour, 1984–86, no. 80

Charles Demuth's *The Primrose* of 1916–17 is unusual in the artist's oeuvre; with *Cottage Window* of about the same period, it is one of two known flower pieces executed in tempera. *The Primrose* is also a depiction of a window as is clear by the crossing lines representing window panes. The lines of the panes are placed asymmetrically which adds visual interest to the entire composition.

Demuth placed this potted plant against a dark black ground, as if one was on the outside looking in at a plant which was growing toward the sunlight. The paint was applied dryly as there is evidence of the brush dragged across the width of the composition to create the window pane. Pencil lines defining the forms are also visible, especially along the stems and terracotta pot. Demuth allowed much of the brown pasteboard surface to show through his paint.

The Primrose is painted in a more reserved and controlled manner than many of this artist's flower pieces. Demuth tended to paint his watercolours of flowers with very loose sensuous washes and often depicted the flowering plants as they looked growing in garden patches.

Charles Demuth 1883–1934

21 Church in Provincetown, No. 2

1919, watercolour on paper, 44.4 × 34.2 cm ($17\frac{1}{2}$ × $13\frac{1}{2}$ in)
Signed and dated lower left: 'C. Demuth 1919'

Provenance
Nassau Gallery, New York
Sale, Parke-Bernet Galleries, New York, 8 May 1957, lot 67
Sale, Sotheby Parke Bernet, New York, American 20th Century Paintings, 14 December 1973, lot 81
Andrew Crispo Gallery, New York
Thyssen-Bornemisza Collection, 1973

Literature
Baur, pp. 21, 165, 107, illus., no. 81

Exhibitions
New York, Montross Gallery, 1920
New York, *Ten Americans: Masters of Watercolor*, Andrew Crispo Gallery, 16 May–30 June 1974, no. 33
2 Jahrzehnte Amerikanische Malerei 1920–1940, June–December 1979, no. 71, p. 81, illus.
 Düsseldorf, Städtische Kunsthalle
 Zurich, Kunsthaus
 Brussels, Palais des Beaux-Arts
Vatican, 1983, no. 81; Lugano, 1984, no. 79
USA tour, 1984–86, no. 81

Charles Demuth's *Church in Provincetown, No. 2* of 1919 is an example of the artist's work in a style that has come to be known as either Precisionism or Cubist-Realism. This latter term reflects the artist's application of the principles of French Cubism to scenes from reality, rather than seeking to create abstract pictures.[1] The term Precisionism came into use during the 1920s, when some of the artists showing at the Daniel Gallery were also called the Immaculates.[2] Precise technique, unmodulated colour, and smooth, hard edges are characteristic of this style.

Demuth was in close contact with French modernist styles through his various trips to Paris, particularly in 1913 when he associated with the circle of Gertrude and Leo Stein, Marsden Hartley and others. He was impressed by Cézanne's work, especially his watercolours. Demuth would also have known the work of the Italian Futurists who had made such a noisy début in Paris. Later, in New York, Marcel Duchamp must have influenced him to consider more mechanical forms.

Church in Provincetown, No. 2 utilises directional diagonal lines which operate like rays or beams of light dividing solid forms into component parts. These lines give his static architectural images a new dynamism and a sense of only momentary stasis. The forms themselves do not disintegrate in Demuth's pictures. Overlapping beams create new geometric shapes of transparent colour combinations, but the images remain entirely recognisable.

Notes
1 For a discussion of the style Cubist-Realism, see Milton W. Brown, *American Painting: From the Armory Show to the Depression* (Princeton, NJ: Princeton University Press, 1955), p. 114
2 See Martin Friedman, *The Precisionist View in American Art* (Minneapolis, MN: Walker Art Center, 1960), p. 11 and the more recent study, Karen Tsujimoto, *Images of America: Precisionist Painting and Modern Photography* (Seattle, WA: University of Washington Press, 1982)

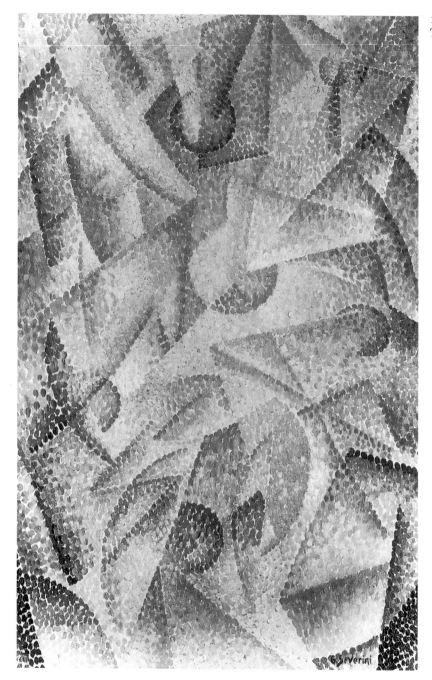

1 Gino Severini, *Expansion de la lumière*, 1912
Thyssen-Bornemisza Collection, Lugano

Demuth's rays clearly derive from his knowledge of work by the Futurists, like Gino Severini's *Expansion de la lumière* of 1912 (fig. 1). Severini was living and exhibiting in Paris during Demuth's stay and the two may even have met, but Demuth certainly would have seen the exhibition of the Italian's work held in New York at Stieglitz's gallery, '291', in March 1917.

These rays first occur in Demuth's work in 1917. For example, in *Bermuda, no. 2* (fig. 2) a watercolour of that year, Demuth shows these beams of light radiating out of the form and sails of a schooner. He depicted other similar towers in *Back-Drop of East Lynne*, a tempera painting of 1919 (fig. 3) and in *Lancaster*, a tempera of 1921 (fig. 4). In *Back-Drop of East Lynne*, as in *Church in Provincetown, No. 2*, the rooftops animated by the diagonal beams of light are the subject of the composition. These are soaring forms in counterpoint with falling light creating a dramatic impact.

2 Charles Demuth, *Bermuda no. 2 (The Schooner)*
1917, watercolour, Metropolitan Museum of Art
New York

3 Charles Demuth, *Back-Drop of East Lynne*, 1919
tempera, Sheldon Memorial Art Gallery, University of
Nebraska, Lincoln, NE

4 Charles Demuth, *Lancaster*, 1921, tempera
Albright-Knox Art Gallery, Buffalo, NY

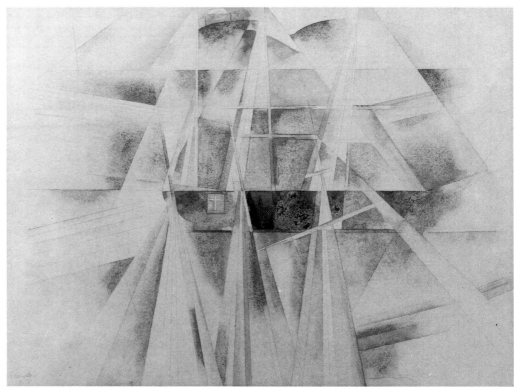

2

3

4

Charles Demuth 1883–1934

22 Love, Love, Love. Homage to Gertrude Stein

1928, oil on wood, 51 × 53 cm (20 × 23¾ in)

Provenance
Robert Locher
Richard Weyand
The Downtown Gallery, New York
Edith Gregor Halpert, New York
Sale, Sotheby Parke Bernet, New York, Highly Important 19th and 20th Century American Paintings, Drawings,
 Watercolors and Sculpture from the Estate of the Late Edith Gregor Halpert, 14–15 March 1973, lot 47, illus.
Andrew Crispo Gallery, New York
Thyssen-Bornemisza Collection, 1973

Literature
Abraham A. Davidson, 'The Poster Portraits of Charles Demuth', *Auction* (September 1969), pp. 28–31, illus.
Emily Farnham, *Charles Demuth: Behind a Laughing Mask* (Norman, OK: University of Oklahoma Press, 1971), illus.,
 pl. 32–A
Sheldon Reich, 'The Halpert Sale, A Personal View', *American Art Review* (September–October 1973), p. 78
Kermit Champa, 'Charlie was Like That', *Artforum* 12 (March 1974), p. 55, illus.
James Mellow, *Charmed Circle: Gertrude Stein and Company* (New York: Praeger Publishers, Inc., 1974), p. 192, illus.
James Mellow, 'Gertrude Stein Among the Dadaists', *Arts Magazine* (May 1977), p. 125, illus.
Abraham A. Davidson, 'Demuth's Poster Portraits', *Artforum* 17 (November 1978), p. 55, illus.
Zafran, no. 54
'Die Moderne Sammlung Thyssen-Bornemisza', *Du* 2 (1980), illus., p. 62
Alvord L. Eiseman, *Charles Demuth* (New York: Watson-Guptill Publications, 1982), p. 72

Exhibitions
New York, *Charles Demuth: 30 Paintings*, The Downtown Gallery, 20 May–7 June 1958
Ogunquit, ME, *7th Annual Exhibition*, Ogunquit Museum of Art, 1959, no. 23
Cincinnati, OH, Cincinnati Art Museum, 1961
Washington, DC, *Edith Gregor Halpert Collection*, Corcoran Gallery of Art, 1962
New York, *Signs and Symbols, U.S.A., 1780–1960*, The Downtown Gallery, 1963, no. 40, illus.
New York, *New York City Paintings by American Artists, 1913–1963*, The Downtown Gallery, 1964
New York, *A Gallery Survey of American Art*, The Downtown Gallery, 1965
Harrisburg, PA, *Charles Demuth of Lancaster*, William Penn Memorial Museum, 1966
New York, *42nd Anniversary Exhibition*, The Downtown Gallery, 1967
Charles Demuth – The Mechanical Encrusted on the Living, October 1971–April 1972, no. 107, p. 69, illus.
 Santa Barbara, CA, Art Gallery, University of California at Santa Barbara
 Berkeley, CA, University Art Museum, University of California
 Washington, DC, Phillips Collection
 Utica, NY, Munson-Williams-Proctor Institute
Corpus Christi, TX, *A Selection of American Paintings from the Estate of the late Edith Gregor Halpert, New York*,
 Art Museum of South Texas, 19 January–10 February 1973
New York, *Pioneers of American Abstraction*, Andrew Crispo Gallery, 17 October–17 November 1973
New York, *20th Century American Painting*, Andrew Crispo Gallery, 1974, no. 7
The Modern Spirit. American Painting: 1908–1935, August–November 1977, no. 91, p. 62, p. 52, illus.
 Edinburgh, Royal Scottish Academy
 London, Hayward Gallery
Lugano, *Collezione Thyssen-Bornemisza, Arte Moderna*, Villa Malpensata, 1 September–5 November 1978, no. 17,
 illus.
Australian tour, 1979–80, no. 54

In *Love, Love, Love. Homage to Gertrude Stein* of 1928, Charles Demuth has painted a tribute to the woman who was a great patron of artists of his generation.[1] Demuth became a part of Stein's coterie during his 1913 stay in Paris. Among her voluminous writings, Stein herself created many literary portraits of her friends. Her intentionally obscure prose relates to experiments with abstraction by Cubists and other modernist painters in her circle.

Demuth would have known the earlier symbolic or non-literal portraits of his contemporaries, especially those of his good friend Marsden Hartley, as well as those of Francis Picabia, Arthur Dove and Marius de Zayas. His concept of a poster portrait may own to his knowledge of lettering in the work of Hartley, Gerald Murphy and Stuart Davis. The hard-edged iconic image is also present in the work of all of these artists.

In addition to Gertrude Stein, some of his other portrait subjects were writers, William Carlos Williams and Eugene O'Neill, and painters, Georgia O'Keeffe and John Marin. Each portrait contains specific references to its subject without being physically descriptive of the subject's appearance.

In the case of Gertrude Stein, Demuth included a mask, the numbers 1 2 3, and parts of the word LOVE repeated three times on a diagonal. The mask occurs in another of Demuth's so-called poster portraits, that entitled *Longhi on Broadway (Homage to Eugene O'Neill)* (fig. 1) which represents the playwright Eugene O'Neill, who evidently used masked actors in some of his plays, such as *The Great God Brown*.[2] The portrait of Stein follows that of O'Neill by just one year.

Just what the mask meant to Demuth is open to question. The O'Neill portrait contains two, one in red hanging on a whiskey bottle, and one in blue leaning against the bottle. Its title also refers to the Italian eighteenth-century painter, Pietro Longhi, whose Venetian subjects were sometimes shown wearing masks.

Stein's mask is white, set against a red and black ground, divided by a broken diagonal line. Although Stein also occasionally wrote plays, this would not fully account for the use of the mask as her chief symbol. Perhaps Demuth also refers to her inscrutable expression and to her unusual psychological insight behind the masks of her portrait subjects.

The numbers 1 2 3 may refer to Stein's frequent repetition in her writing, such as the infamous comment: 'A rose is a rose is a rose'. It has been pointed out that she particularly liked to refer to the number three, as in her *Three Lives*, published in 1909; she also observed meeting geniuses in threes, and dancers in threes.[3] This would also account for the word LOVE which appears three times. Demuth must have felt particularly fond of Stein who, like him, was a homosexual, a bohemian individual who lived apart from conservative society.

Demuth's *Love, Love, Love* inspired Pop artist Robert Indiana who admitted that Demuth's 1928 poster portrait of William Carlos Williams called *I saw the Figure 5 in Gold* is his 'favourite American painting'.[4] He created *Imperial Love* which repeats the word LOVE twice in a painting of 1966 and both a painting and a sculpture based on this theme in 1972.

Notes
1 The subject of this painting was identified in 1956 by Demuth's intimate friend, Robert Locher
2 Abraham A. Davidson, 'Demuth's Poster Portraits', *Artforum* 17 (November 1978), p. 54
3 *Ibid.*, p. 55, refers to passages from Stein's *Autobiography of Alice B. Toklas* of 1933, but Demuth must have heard her mention such experiences
4 Quoted in *Indiana's Indianas* (Rockland, ME: William A. Farnsworth Library and Art Museum, 1982), p. 6

1 Charles Demuth, *Longhi on Broadway (Homage to Eugene O'Neill)*, 1927, William H. Lane Foundation, on loan to Boston Museum of Fine Arts, Boston, MA

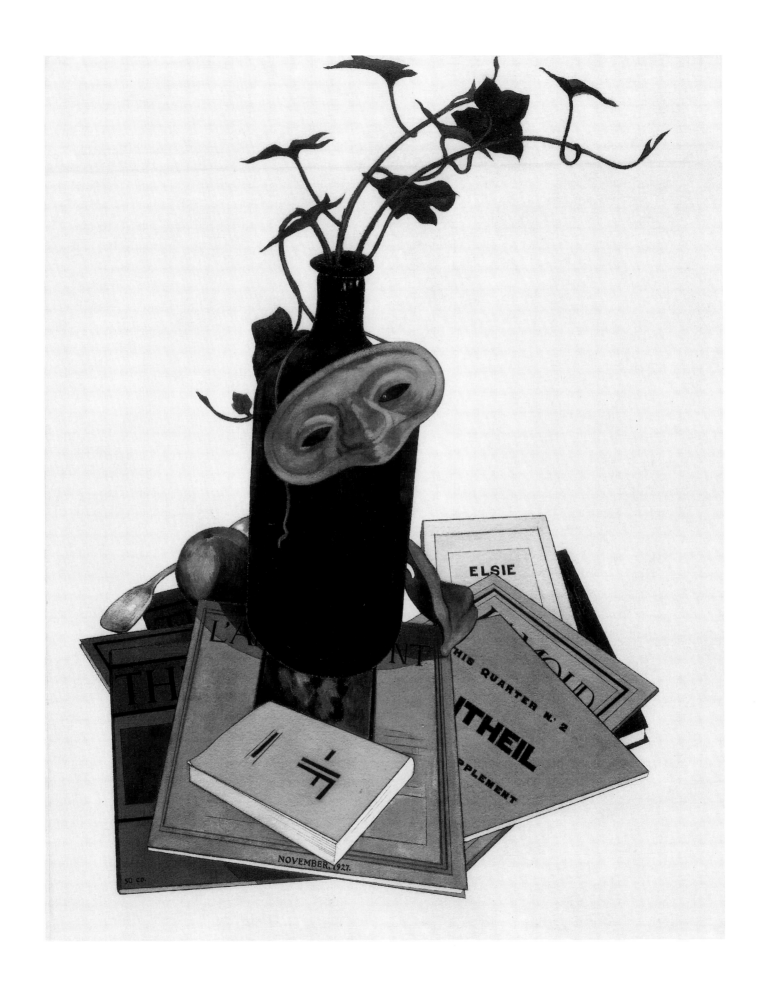

Charles Demuth 1883–1934

23 Red and Yellow Tulips

1933, watercolour on paper, 24.7 × 35 cm ($9\frac{3}{4}$ × $13\frac{3}{4}$ in)
Signed lower right: 'C. Demuth '33'

Provenance
Mrs Augustin Demuth, Lancaster, PA
Miss Mary E. Herr, Lancaster, PA
Constance Wright, New York
Kennedy Galleries, Inc., New York
Thyssen-Bornemisza Collection, 1979

Exhibitions
Vatican, 1983, no. 82; Lugano, 1984, no. 80
USA tour, 1984–86, no. 82

Red and Yellow Tulips of 1933 is a testament to Charles Demuth's love of painting flowers. By all accounts, he was an aesthete. He was in delicate health, largely due to an early hip injury and later due to his having diabetes. Although he began painting flowers in his formative years, he never seemed to tire of this endlessly varied subject. Demuth saw in flowers more than just blossoms; he saw, it is clear, a metaphor for his own fragile existence.

Compared to his flower paintings of the 1910s, these later flower pictures are less precious and the flowers are more substantially rendered. These tulips are shown in several stages of opening, but it is clear that they will all fade, wilt and die. His flowers have often been described as sinister, but here the feeling is more ominous than sinister. Demuth has represented the transience of beauty.

Under the influence of Cézanne, Demuth makes good use of the whiteness of the paper. These lush flowers almost appear to float against a deep space. He worked in pencil outline and then filled in with colour washes. He caught the textures of the smooth petals, the stamen and the leaves. The view is quite close and some of the flowers are cropped by the paper's edge.

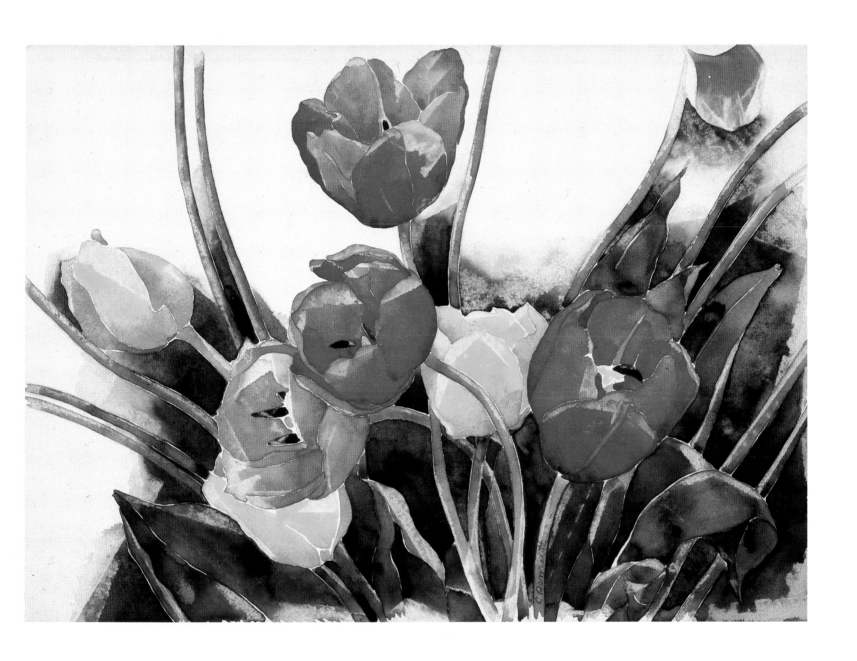

Charles Demuth 1883–1935

24 Zinnias

1933, watercolour on paper, 33 × 25.5 cm (13 × 10 in)
Signed left of lower centre: 'C. Demuth '33'

Provenance
Mrs Thomas G. Cousins
Baruch M. Feldman, Philadelphia, PA
Dr and Mrs Irving Frederick Burton
Sale, Sotheby Parke Bernet, New York, Collection of Dr and Mrs Irving Frederick Burton, 18 October 1972, lot 42
Kennedy Galleries, Inc., New York
Thyssen-Bornemisza Collection, 1979

Reproduced
Advertisement for Sotheby's sale of 18 October 1972, *Arts Magazine* 47 (September 1972), p. 3, illus.

Exhibitions
New York, *Charles Demuth: 30 Paintings*, The Downtown Gallery, 20 May–7 June 1958
Charles Demuth – The Mechanical Encrusted on the Living, October 1971–April 1972, p. 85, no. 116
 Santa Barbara, CA, Art Gallery, University of California at Santa Barbara
 Berkeley, CA, University Art Museum, University of California
 Washington, DC, Phillips Collection
 Utica, NY, Munson-Williams-Proctor Institute
Vatican, 1983, no. 83; Lugano, 1984, no. 81
USA tour, 1984–86, no. 83

Executed just two years before his death, Charles Demuth's *Zinnias* of 1933 is another example of his late style of flower painting. In the face of his losing struggle with diabetes, this picture is remarkably cheerful. The flowers, all shades of orange and coral, animate the composition.

Demuth worked on white paper, leaving much of it bare. Even some of the petals were only outlined in pencil, never filled in. Demuth had a plentiful supply of flowers from his mother's garden when he was living in his native town, Lancaster, Pennsylvania. The colourful, bright flowers in *Zinnias* create a lively image against the softer green leaves. Demuth's flowers evoke poetic feelings, deeper than merely the appearance of the blossoms he portrayed.

Demuth commented on the inspiration that he had found in contemporary European art: 'John Marin and I drew our inspiration from the same source, French modernism. He brought his up in buckets and spilt much along the way. I dipped mine out with a teaspoon, but never spilled a drop'.[1]

Note
1 Quoted in Andrew Carnduff Ritchie, *Charles Demuth* (New York: Museum of Modern Art, 1950), p. 16

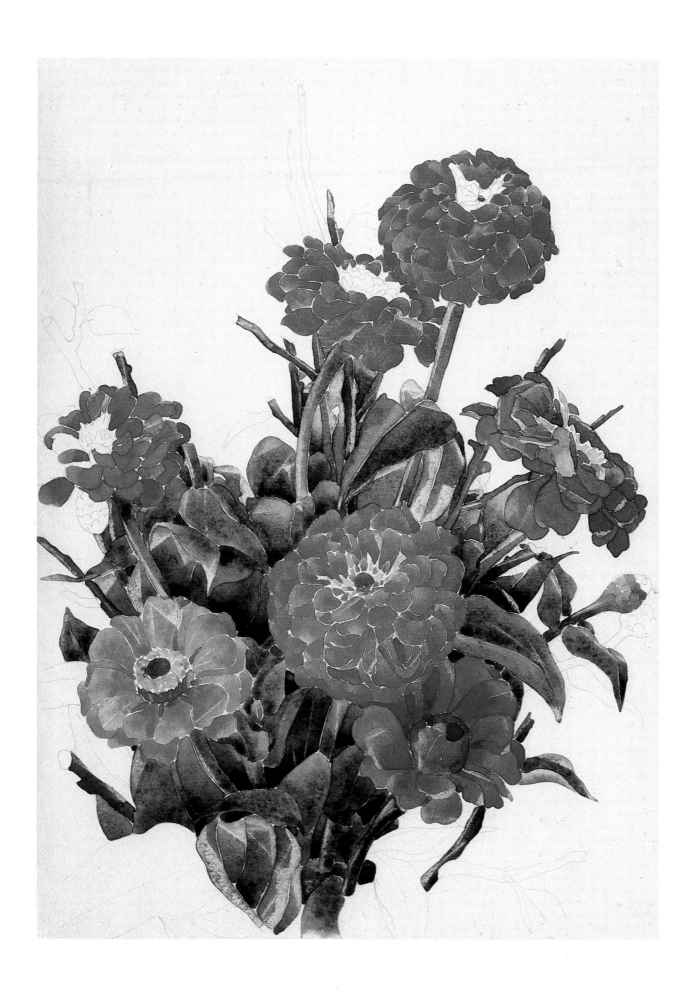

Arthur G. Dove 1880–1946

25 Orange Grove in California – Irving Berlin

1927, oil on cardboard, 50.8 × 38.1 cm (20 × 15 in)

Provenance
The Intimate Gallery, New York
Edward Alden Jewell, New York
Henry Bluestone, Mt Vernon, NY
Andrew Crispo Gallery, New York
Thyssen-Bornemisza Collection, 1975

Literature
Edward Alden Jewell, *Modern Art: Americans* (New York: Alfred A. Knopf, 1930), frontispiece illus.
Frederick S. Wight, *Arthur G. Dove* (Berkeley, CA: University of California Press, 1958), pp. 54–56
Ann Lee Morgan, *Arthur Dove: Life and Work, With a Catalogue Raisonné* (Newark, DE: University of Delaware Press, 1984), p. 52 and pp. 155–56, illus., p. 158

Exhibitions
New York, *Arthur G. Dove Paintings*, The Intimate Gallery, 12 December–11 January 1927, no. 4
New York, *Seven American Painters*, Museum of Modern Art, December 1944–May 1945 (circulating)
New York, *Twentieth-Century American Painting and Sculpture*, Andrew Crispo Gallery, June–September 1976
Lugano, *Collezione Thyssen-Bornemisza, Arte Moderna*, Villa Malpensata, 1 September–5 November 1978, no. 21
2 Jahrzehnte Amerikanische Malerei 1920–1940, June–December 1979, no. 55, p. 151
 Düsseldorf, Städtische Kunsthalle
 Zurich, Kunsthaus
 Brussels, Palais des Beaux-Arts
Vatican, 1983, no. 73; Lugano, 1984, no. 71
USA tour, 1984–86, no. 73

Arthur Dove's *Orange Grove in California – Irving Berlin* of 1927 is one of several abstract works by this artist based on musical themes. These include two works based on George Gershwin's *Rhapsody in Blue*, as well as *I'll Build a Stairway to Paradise – Gershwin*, all painted in 1927. Dove had also experimented with musical analogy during the early 1910s in abstract works such as *Music* and *Sentimental Music* (fig. 1), both of about 1913.[1] He returned to this theme in the early 1920s with *Chinese Music* and *Factory Music, Silver, Yellow, Indian-Red and Blue*, both of about 1923. Dove explained: 'The music things were done to speed the line up to the pace at which we live today. . . . The line was a moving point reducing the moving volume to one dimension. From then on it is expressed in terms of color as music is in terms of sound.'[2]

The critic of the *New York Times*, Edward Alden Jewell, bought *Orange Grove in California – Irving Berlin* and used a reproduction of this picture as the frontispiece for his book on American art published in 1930. In 1943, Jewell commented on his choice: 'It belongs to a certain period . . . which I have always considered, in its way, Dove's "top"! He has never to my knowledge done anything else like it – much more calligraphic than the paintings with their large abstract forms that came afterward.'[3]

Notes
1 For a discussion of musical analogy for abstraction among Dove's American contemporaries, see Gail Levin, 'Die Musik in der frühen amerikanischen Abstraktion', in Karin von Maur, ed., *Vom Klang der Bilder: Die Musik in der Kunst des 20. Jahrhunderts* (Munich: Prestel-Verlag, 1985), pp. 368–73
2 Quoted in Frederick S. Wight, *Arthur G. Dove* (Berkeley, CA: University of California Press, 1958), p. 55
3 *Ibid.*, pp. 55–56

A member of the circle of photographer and art dealer Alfred Stieglitz, Dove was one of the first Americans to learn about Wassily Kandinsky's art and theory.[4] He owned a copy of the first German edition (1912) of *Uber das Geistige in der Kunst* and a copy of the almanac *Der Blaue Reiter*, the latter inscribed 'Mar. 19, 1913 from Mr. Stieglitz'. Dove's pastel, *Sentimental Music* resembles Kandinsky's improvisations, particularly in its dark lines and sensuous floating shapes. What might have appealed to Dove was Kandinsky's contention that music 'has devoted itself not to the reproduction of natural phenomena, but to the expression of the artist's soul and to the creation of an autonomous life of musical sound'.[5]

In 1927, when Dove was painting his pictures based on the popular music of Gershwin and Berlin, he also produced an abstract work entitled *Improvisation* which is especially close to Kandinsky's many works of the same title. In his treatise, *Uber das Geistige in der Kunst*, Kandinsky defined an improvisation as 'a largely unconscious, spontaneous expression of inner character, non-material nature'.[6]

Dove painted while listening to music on the radio or phonograph, making his later musical compositions more physical than theoretical responses.[7] By the 1920s, it was no longer necessary for artists like Dove to keep searching for a theoretical justification for painting abstractions. In the midst of the Jazz Age, popular music was simply something to celebrate and painting was an appropriate vehicle for the artist to express this enthusiasm. Musical themes also occur later on in Dove's work: *Swing Music (Louis Armstrong)* of 1938 and *Primitive Music* of 1944.

In *Orange Grove in California – Irving Berlin*, Dove has caught the jazz rhythms so popular in the 1920s. He casually painted against a brown cardboard ground and allowed much of it to show through. He plays the syncopating and spiralling black lines off the white and cooler blue areas. This is not just an abstract painting, but Dove's interpretation of the joyful impact of the music he loved.

Notes
4 For a discussion of Kandinsky's influence on American artists, see Sandra Gail Levin, 'Wassily Kandinsky and the American Avant-garde, 1912–1950' (New Brunswick, NJ: Ph.D. dissertation, Rutgers University, May 1976)
5 Wassily Kandinsky, *Concerning the Spiritual in Art* (New York: George Wittenborn, Inc., 1947), p. 40
6 *Ibid.*, p. 77
7 Ann Lee Morgan, *Arthur Dove: Life and Work, With a Catalogue Raisonné* (Newark, DE: University of Delaware Press, 1984), pp. 69–70

1 Arthur G. Dove, *Sentimental Mus* c. 1913, Metropolitan Museum of A New York

Arthur G. Dove 1880–1946

26 U.S.

1940, oil on canvas, 50.8 × 81.3 cm (20 × 32 in)
Signed lower centre: 'Dove'

Provenance
An American Place, New York
Duncan Phillips, Washington, DC
Bernice Cross
Terry Dintenfass Gallery, New York
Mr and Mrs Carl Lobell, New York
Andrew Crispo Gallery, New York
Thyssen-Bornemisza Collection, 1975

Literature
Ann Lee Morgan, *Arthur Dove: Life and Work, With a Catalogue Raisonné* (Newark, DE: University of Delaware Press, 1984), p. 270, illus.

Exhibitions
New York, *Arthur G. Dove; Exhibition of New oils and Water Colors*, An American Place, 30 March–14 May 1940, no. 3
New York, *Some Marins – Some O'Keeffes – 'Some Show'*, An American Place, 17 October–11 December 1940
Washington, DC, *Retrospective Exhibition of Paintings by Arthur G. Dove*, Phillips Memorial Art Gallery, 18 April–22 September 1947
New York, *Essences: Arthur G. Dove*, Terry Dintenfass Gallery, 28 January–22 February 1975
Arthur Dove and Duncan Phillips: Artist and Patron, June 1981–November 1982, no. 62, illus., pp. 120–21
 Washington, DC, Phillips Collection
 Atlanta, GA, High Museum of Art
 Kansas City, MO, William Rockhill Nelson Gallery and Atkins Museum of Fine Arts
 Houston, TX, Museum of Fine Art
 Columbus, OH, Columbus Museum of Art
 Seattle, WA, Seattle Art Museum
 Milwaukee, WI, New Milwaukee Art Center
Vatican, 1983, no. 72; Lugano, 1984, no. 70
USA tour, 1984–86, no. 72

1 Arthur G.Dove, *Goat*, 1935, oil on canvas
Metropolitan Museum of Art, New York

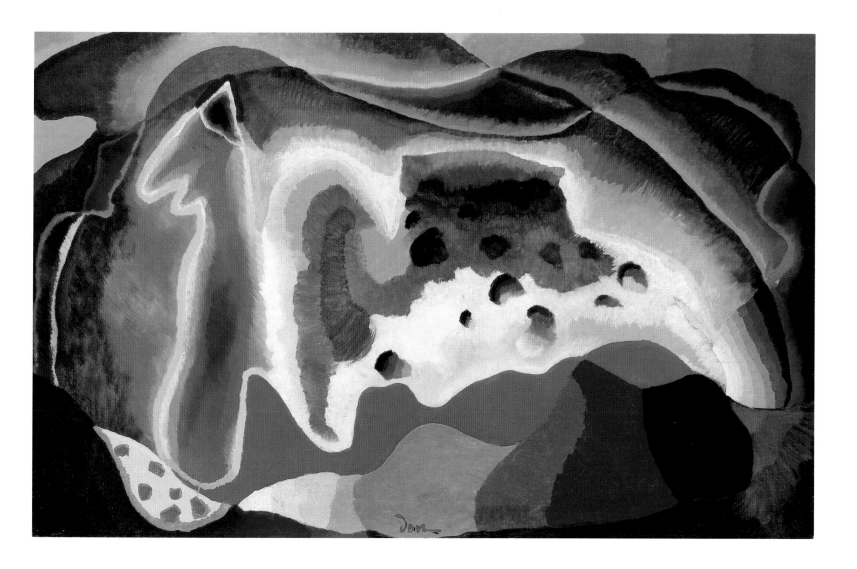

Note
1 Quoted in Frederick S. Wight,
Arthur G. Dove (Berkeley, CA:
University of California Press,
1958), p. 75

U.S., which Dove painted in 1940, has also been called *Color Carnival* and, more recently, has been wrongly titled *U.S. 1940*. Dove painted this work while living in an old sea front post office in Centerport, Long Island. He had suffered a heart attack in January 1939 and his recovery was complicated by kidney disease. Nonetheless, he kept painting, writing to his dealer Stieglitz in the winter of 1940, telling him that his paintings were 'improving so fast that the last ones do seem to be the best, which is not always the case. Have some large ones, 20 × 32'.[1] Among these latter works was *U.S.*

Dove's works are very closely tied to nature. *U.S.* is typically composed of flowing biomorphic shapes. Its palette is a combination of natural, earth tones and bright red, placed prominently to energise the whole. This painting relates to the much more calligraphic *Orange Grove in California – Irving Berlin* of 1927 [25] in its continued use of line to animate the entire composition.

The forms of *U.S.* are much more solid, typical in Dove's later work. Although fully abstract, this work may harbour a reference to natural form in its abstraction. It may be usefully compared with Dove's canvas, *Goat* of 1935 (fig. 1). Like its precursor, *U.S.* contains horizontal rhythms and curves. Furthermore, the red protruberances on the left, might represent an extraction or abstraction of some sort of animal head. But these paintings are meant to be perceived as abstract harmonies, celebrated for their sensual colour and form.

Arthur G. Dove 1880–1946

27 Blackbird

1942, oil on canvas, 43.2 × 61 cm (17 × 24 in)
Signed and dated lower centre: 'Dove 42'

Provenance
The Downtown Gallery, New York
Robert Ellison, New York
Andrew Crispo Gallery, New York
Thyssen-Bornemisza Collection, 1976

Literature
Zafran, pp. 159, 91, illus. no. 72
Lieberman, p. 66, no. 57
Ann Lee Morgan, *Arthur Dove: Life and Work, With a Catalogue Raisonné* (Newark, DE: University of Delaware Press, 1984), p. 283, illus., p. 284

Exhibitions
New York, *Painting and Sculpture from 16 American Cities*, Museum of Modern Art, 1942, no. 68
New York, *Arthur G. Dove: Paintings – 1942–43*, An American Place, 11 February–17 March 1943, no. 13
San Francisco, CA, *Paintings of Arthur Dove*, San Francisco Museum of Art, 22 April–18 May 1947
New York, *Special Exhibition of Paintings by Dove*, The Downtown Gallery, 28 February–24 March 1956
Tucson, AZ, *The Bird in Art*, University of Arizona, 7 November 1964–3 January 1965
Fort Worth, TX, *Arthur Dove*, Museum of Modern Art touring exhibition, Fort Worth Art Center, 3–24 March 1968
New York, *Selected American Masters*, Andrew Crispo Gallery, July–October 1975
New York, *Arthur Dove*, Andrew Crispo Gallery, 12–29 November 1975
Lugano, *Collezione Thyssen-Bornemisza, Arte Moderna*, Villa Malpensata, 1 September–5 November 1978, no. 20, illus.
Australian tour, 1979–80, no. 72
USA tour, 1982–83, no. 57

On 7 June 1942, Arthur Dove wrote to Alfred Stieglitz: 'Have been watching a blackbird drying off after his bath – in tree – in front of me here. Good for one '43 Dove painting, I hope.'[1] Dove continued to find his subjects in nature, even though he was in poor health during his last years. As late as January 1943, Dove described another bird: 'The sea gulls are flying by the window and their beaks look like ivory thrown slowly through space.'[2] Confined by his frail state and unable to travel the short distance to New York City, perhaps flying birds represented a metaphor for the freedom Dove could no longer have.

As abstract as *Blackbird* is, one can see a pointed beak, such as had fascinated him on the sea gulls, and a large eye. The dark blue and black lines which radiate out in diagonals appear to be the wings and body of the bird itself. Although abstract, with no realistic details like feathers, Dove has painted the spirit of the blackbird, spreading its wings and ruffling its feathers, perhaps drying off after the bath as the artist reported that he had witnessed. The yellow and orange at the top of the composition might represent the presence of sunlight.

Other bird images and references have occurred in his work. As early as 1905, while working as an illustrator, Dove created a calendar of birds and beasts. He produced a number of abstract works with titles relating to seagulls during the 1920s and 1930s. Among his later paintings are *Woodpecker* (1941) which is also known as *Red, Olive and Yellow*, *Quawk Bird* (1942) and *Blue jay Flew up in a tree* (1943). Dove found poetry in the most ordinary incidents of nature. His powers of observation were keen and he never grew bored with the simple pleasures of the world around him.

Notes
1 Quoted in Ann Lee Morgan, *Arthur Dove: Life and Work, With a Catalogue Raisonné* (Newark, DE: University of Delaware Press, 1984), p. 283
2 Quoted in Frederick S. Wight, *Arthur G. Dove* (Berkeley, CA: University of California Press, 1958), p. 78

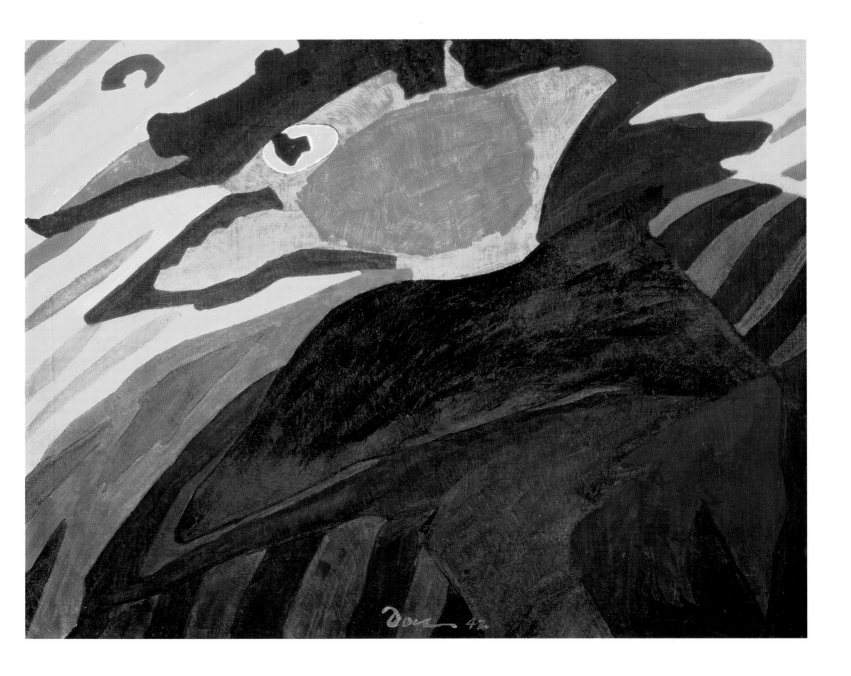

Marsden Hartley 1877–1943

28 Musical Theme No. 2 (Bach Preludes et Fugues)

1912, oil on canvas mounted on masonite, 60.9 × 50.8 cm (24 × 20 in)

Provenance
Private collection
Andrew Crispo Gallery, New York
Thyssen-Bornemisza Collection, 1983

Literature
Barbara Haskell, *Marsden Hartley* (New York: New York University Press, 1980), p. 29, p. 28, illus.
Gail Levin, 'Die Musik in der frühen amerikanischen Abstraktion' in Karin von Maur, ed., *Vom Klang der Bilder: Die
 Musik in der Kunst des 20. Jahrhunderts* (Munich: Prestel-Verlag, 1985), pp. 368–69, p. 30, illus., cat. no. 4

Reproduced
Advertisement for Andrew Crispo Gallery, New York, *Art Quarterly* (Winter 1979), no. 1
Advertisement for Andrew Crispo Gallery, New York, *Arts Magazine* (January 1980), back cover

Exhibition
Stuttgart, *Die Musik in der Kunst des 20. Jahrhunderts*, Staatgalerie, 6 July–22 September 1985, no. 4

Marsden Hartley's *Musical Theme No. 2 (Bach Preludes et Fugues)* of 1912 is one of several such themes painted during his first visit to Paris. There he came into contact with the ideas of Wassily Kandinsky who wrote of comparing 'the elements of one art with those of another', stressing 'music is found to be the best teacher'.[1] Hartley wrote to his dealer Alfred Stieglitz that he showed his work to 'a German painter from Munich who is working on the musical principle' and who claimed that Hartley's work 'was the first to express pure mysticism in this modern tendency'.[2] He may have been referring to Auguste Macke who visited Robert Delaunay in Paris in October 1912. Hartley too had visited Delaunay's studio and may have linked the German artist to Munich (rather than Bonn where he actually lived) because of his involvement with the almanac *Der Blaue Reiter* which was published there. Furthermore, when he visited Delaunay, Macke accompanied Franz Marc, who with Kandinsky had edited *Der Blaue Reiter*.

Hartley's reference to Bach links him to a number of his European contemporaries. Macke painted his abstraction *Colour Composition (Homage to Johann Sebastian Bach)* in 1912 (fig. 1). That same year Georges Braque created an untitled Cubist still-life with the name Bach written boldly upon it and the Czech artist Frantisek Kupka, then living in Paris, painted and exhibited his *Amorpha, Fugue à deux couleurs* (fig. 2) in the Salon d'Automne.

Hartley, who did not like to admit to having been influenced by other artists, wrote to his niece stressing the originality of his own efforts 'to paint music – or the equivalent of sound in

Notes
1 Wassily Kandinsky, *Concerning the Spiritual in Art* (New York: Wittenborn, Inc., 1947), pp. 39–40
2 Marsden Hartley to Alfred Stieglitz, letter of December 1912, Stieglitz Archives, Beinecke Rare Book and Manuscript Library, Yale University, New Haven, CT

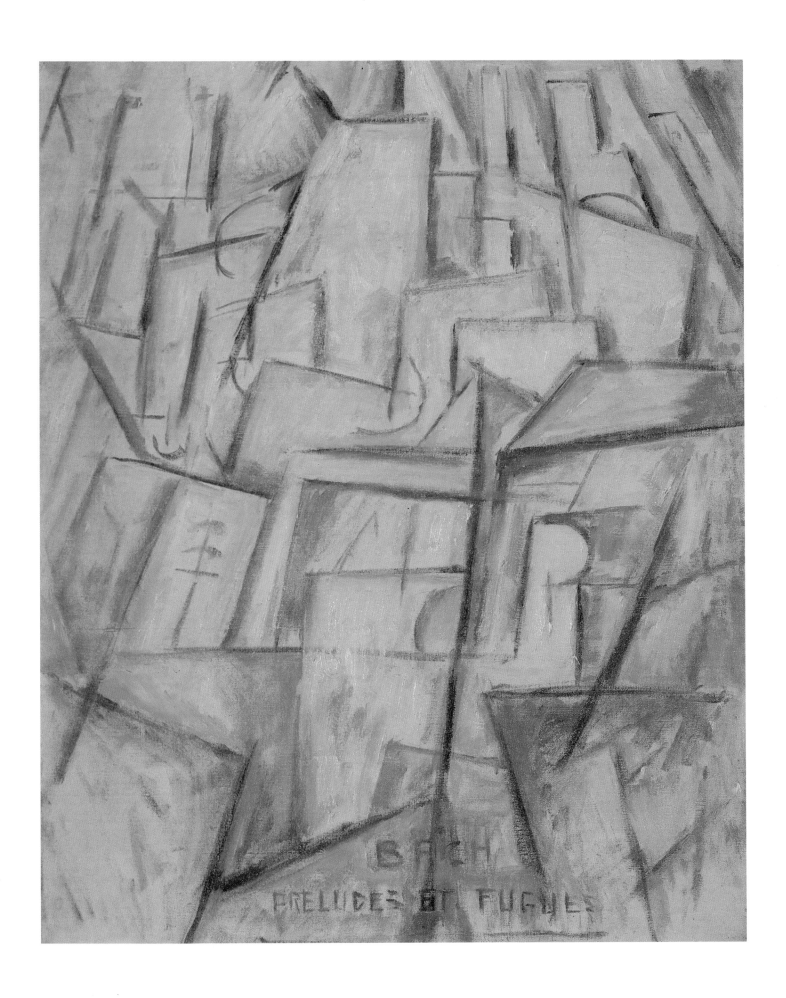

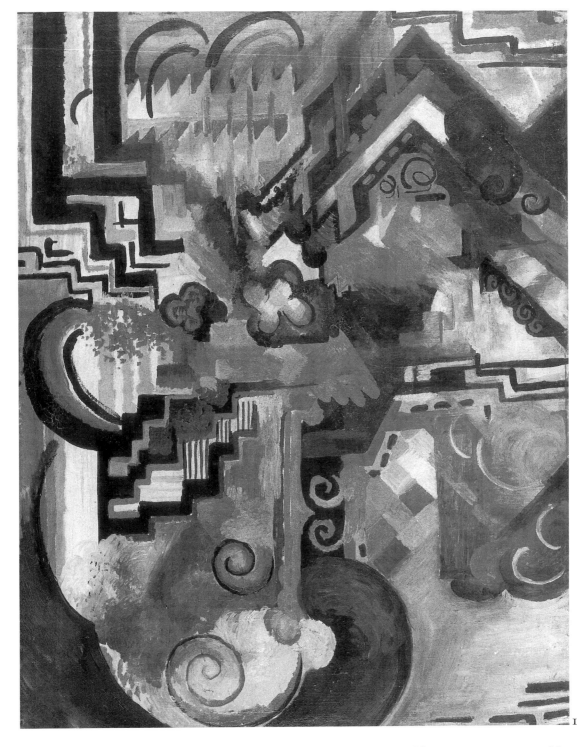

1

1 Auguste Macke
*Colour Composition
(Homage to Johann Sebastian Bach)*
1912, Wilhelm-Hack-Museum
Ludwigshafen

2 Frantisek Kupka
Amorpha, Fugue à deux couleurs
1912, National Gallery, Prague

colour. . .'[3] He had described his new canvases to Stieglitz as 'not like Picasso – it is not like Kandinsky not like any "Cubism" – It is what I call for want of a better name subliminal or cosmic cubism. . .'[4]

Although more colourful than Picasso's monochromatic cubist compositions, Hartley's *Musical Theme No. 2 (Bach Preludes et Fugues)* nonetheless emulated the linear shapes and patterns of Picasso's contemporary works such as *The Architect's Table* of 1912, owned by his friend Gertrude Stein, and even the drawing *Nude* of 1910 owned by Stieglitz. The heavy lines, semicircles, and other linear patterns in Hartley's picture appear to have been inspired by these works which he knew well.

Notes
3 Marsden Hartley to Norma
 Berger, letter of 30 December
 1912, Yale
4 Marsden Hartley to Alfred
 Stieglitz, letter received
 20 December 1912, Yale

2

This painting is closely related to several of Hartley's other musical themes of this period. *Musical Theme No. 1 (Bach Preludes)* of 1912, its immediate precursor, contains similar lines and shapes, as does *Musical Theme* (1912). Slightly later, in late 1912, or early 1913, Hartley painted *Musical Themes (Oriental Symphony)* which contains symbols relating to Eastern mysticism. In *Musical Theme No. 2 (Bach Preludes et Fugues)*, the forms appear to move upward with a kind of surging rhythm which Hartley may have intended to suggest the impact of the exuberant music which inspired him. Bach's preludes and fugues embody the ambition of the Baroque toward pure, balanced tonal architecture on a monumental scale. Hartley has tried to capture Bach's musical structure in the rhythmic forms of his painting.

Walt Kuhn

29 Bathers on a Beach

1915, oil on canvas, 76 × 102 cm (30 × 40 in)
Signed lower left: 'Walt Kuhn'

Provenance
Maynard Walker Gallery, New York
Hirschl & Adler Gallery, New York
Kennedy Galleries, Inc., New York
Thyssen-Bornemisza Collection, 1977

Literature
Phillip Rhys Adams, *Walt Kuhn, Painter His Life and
Work* (Columbus, OH: Ohio State University Press,
1978), pl. 48, cat. no. 22, p. 21

Reproduced
Advertisement for Kennedy Galleries, Inc., New York,
Burlington Magazine (April 1966), illus., p. XXXVI

Exhibitions
Tucson, AZ, *Painter of Vision, A Retrospective of Oils,
Watercolors and drawings by Walt Kuhn*, University
of Arizona Art Gallery, 6 February–31 March
1966, p. 43, no. 22
Vatican, 1983, no. 89; Lugano, 1984, no. 87
USA tour, 1984–86, no. 89
*The Advent of Modernism: Post-Impressionism in North
American Art, 1900–1918*, 30 October 1986–19
April 1987
Atlanta, GA, High Museum of Art
Brooklyn, NY, Brooklyn Museum
Calgary, Alberta, Glenbow Museum

1 Henri Matisse, *Le Luxe II*, c. 1907–1908
Royal Museum of Fine Arts, Copenhagen

Note
1 Phillip Rhys Adams, *Walt Kuhn, Painter His Life and Work* (Columbus, OH: Ohio State University Press, 1978), p. 66

Walt Kuhn painted *Bathers on a Beach* in 1915, probably while spending the summer with his family in Ogunquit, Maine. It has been suggested that Kuhn may have utilised cut-out coloured paper shapes to create his composition and that he blotted the sky with damp newspaper as Rousseau had in order to avoid obvious brushstrokes.[1] Nonetheless, it is certain that Kuhn is responding to the influence of the work of Henri Matisse, exhibited just two years earlier in the New York Armory Show of which Kuhn, himself, was an organiser.

Kuhn emulates Matisse's flat areas of bright colour and even the type of scene, featuring joyous leisure activity. He had, for example, just seen Matisse's bathers by the sea in *Le Luxe II* (fig. 1), a painting in the Armory Show. Kuhn's painting includes a much more vast strip of beach and, of course, his bathers are not nude mythical goddesses, but American families by the seashore. Kuhn may have been influenced as well by his American colleague Maurice Prendergast who also painted scenes of the seashore in a Post-Impressionist style.

Walt Kuhn 1877–1949

30 Chorus Captain

1935, oil on canvas, 102 × 76.5 cm (40 × 30 in)
Signed lower right: 'Walt Kuhn/1935'

Provenance
Estate of the artist
Kennedy Galleries, Inc., New York
Thyssen-Bornemisza Collection, 1979

Exhibitions
New York, *The Eyes of America: Art from 1792 to 1979*, Kennedy Galleries, Inc., 1–26 May 1979, illus.
Vatican, 1983, no. 90; Lugano, 1984, no. 88
USA tour, 1984–86, no. 90

In *Chorus Captain* of 1935, Kuhn drew upon his experience working in the theatre. During the summer of 1922, he had worked designing and directing various acts for Michio Ito's *Pinwheel Revue* which played at the Earl Carrol Theater that season.[1] Kuhn, who was fascinated by clowns, is perhaps best known for these images. He seems to have felt unusual empathy for his subjects, who were sometimes merely models posing as performers, whom he dressed up and painted.

Unlike his contemporary Reginald Marsh who depicted entire burlesque and side shows in action, Kuhn was much more interested in the individual and in the unique psychology of each performer. From the late 1920s to the late 1940s, he typically painted these performers set against a solid background, lost in thought, often in a rather melancholy mood. In the *Chorus Captain*, the subject does not even make eye contact with the spectator or the artist, preferring instead to cast her eyes downwards expressing a palpable sadness.

Kuhn must have been aware of Picasso's sensitive portrayals of performers during that artist's so-called Blue Period and Rose Period from about 1901 to 1906. In works like Picasso's *The Actor* of 1904–1905 (fig. 1) to *The Family of Saltimbanques* of 1905 (fig. 2), Kuhn perceived symbolic implications that he pursued in his own work. His *Chorus Captain* expresses his understanding of mood and his ability to communicate his feelings.

Note
1 Phillip Rhys Adams, *Walt Kuhn, Painter His Life and Work* (Columbus, OH: Ohio State University Press, 1978), p. 88

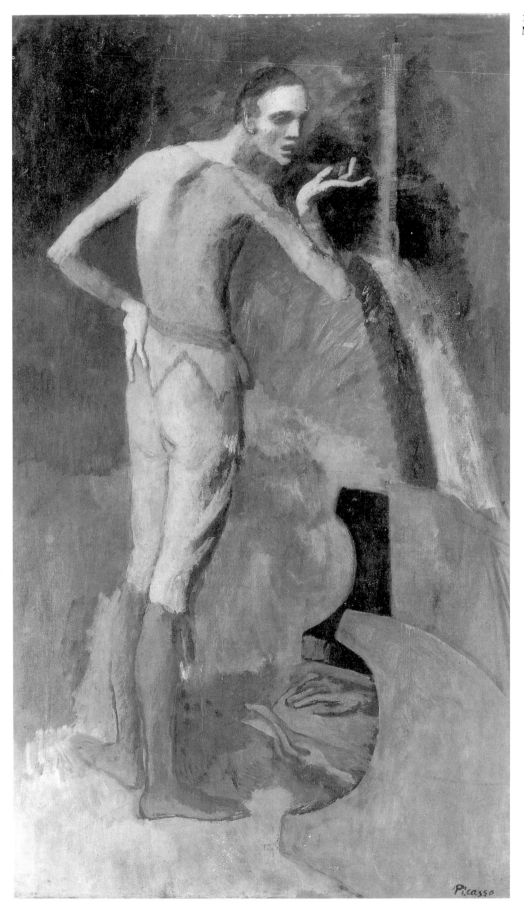

1 Pablo Picasso, *The Actor*, 1904–1905
Metropolitan Museum of Art, New York

2 Pablo Picasso, *The Family of Saltimbanques*, 1905, National Gallery of Art, Washington, DC

Walt Kuhn 1877–1949

31 Chico in Top Hat

1948, oil on canvas, 58.4 × 53.3 cm (23 × 21 in)

Provenance
Maynard Walker Gallery, New York
Kennedy Galleries, Inc., New York
Harry Spiro, New York
Andrew Crispo Gallery, New York
Thyssen-Bornemisza Collection, 1975

Literature
Mahonri Sharp Young, 'Letter from USA: Fantastics and Eccentrics', *Apollo* LXXXIV (June 1967), p.467, illus.
Fridolf Johnson, 'Walt Kuhn: American Master', *American Artist* (December 1967), p.57, illus.
Phillip Rhys Adams, *Walt Kuhn, Painter His Life and Work* (Columbus, OH: Ohio State University Press, 1978),
 cat.no.531, p.233

Exhibitions
Tucson, AZ, *Painter of Vision: A Retrospective Exhibition of Oils, Watercolors and Drawings by Walt Kuhn*, University of
 Arizona Art Gallery, 6 February–31 March 1966
New York, *Walt Kuhn 1877–1949*, Kennedy Galleries, Inc., 1967, cat.no.50, illus.
New York, *Important American Art 1903–1972*, Kennedy Galleries, Inc., 1972, cat.no.15
New York, *European and American Masterpieces*, Andrew Crispo Gallery, 1975, no.35
Lugano, *Collezione Thyssen-Bornemisza, Arte Moderna*, Villa Malpensata, 1 September–5 November 1978, no.57,
 illus.
Australian tour, 1979–80, no.81

In the last year of his life, Walt Kuhn painted Chico twice, once as *Chico in Top Hat* and once as *Chico in Silk Hat*. Kuhn's sense of tragedy is apparent in Chico's melancholy expression. He confronts the viewer bravely as if he has nothing more to lose. At the time he painted Chico, Kuhn's own career had been eclipsed by new developments in art and his sales were faltering.

Kuhn found clowns an enormously attractive subject, rich in nuance and possibility. He wrote to John Ringling of his admiration for Charlie Chaplin: 'I can truthfully say, that everything I have seen of his was of the highest order, extremely unique, and most amusing. His "Tramp Clown Act" was a classic. I am positive that he is a man of great ideas.'[1]

Kuhn depicts his model with a gaunt face and hollow cheeks, intense piercing blue eyes, and brooding lips. Chico is shown all made up as a clown, but he is a sorrowful character, not a light-hearted jester. His bare chest makes him seem especially vulnerable. Kuhn lets us know that this man is posing, calm momentarily, concealing his deeper thoughts beneath his top hat from which his red hair peeks out.

Note
1 Phillip Rhys Adams, *Walt Kuhn, Painter His Life and Work* (Columbus, OH: Ohio State University Press, 1978), p.89

John Marin 1870–1953

32 Abstraction

1917, watercolour on paper, 40.6 × 48.3 cm
 (16 × 19 in)
Signed lower left: 'Marin 17'

Provenance
Estate of the artist
Kennedy Galleries, Inc., New York
Thyssen-Bornemisza Collection, 1982

Literature
Sheldon Reich, *John Marin: A Stylistic Analysis
 and Catalogue Raisonné* (Tucson, AZ: University
 of Arizona Press, 1970), pp. 110–13, 446,
 no. 17.3
John I. H. Baur, 'Le Nouveau Gout Thyssen',
 Connaissance des Arts 379 (September 1983),
 p. 68, illus.

Exhibitions
Vatican, 1983, no. 67; Lugano, 1984, no. 65
USA tour, 1984–86, no. 67

1 Marsden Hartley, *Military*, 1913, Wadsworth Atheneum, Hartford, CT

John Marin's *Abstraction*, a colourful watercolour of 1917, is one of a remarkable series of non-objective experiments at this time. It is difficult to link the shapes in this composition to any forms Marin might have observed in nature. It is likely, as has been suggested, that he has responded to the abstract work of his contemporaries such as Marsden Hartley, Stanton Macdonald-Wright or Morgan Russell.[1]

Based on visual similarities and the friendship between Hartley and Marin, the obvious inspiration for this watercolour appears to be Hartley's *Military* (fig. 1), an oil painting of 1913, which originally was known as *Brass Band with Numbers.* Not only has Marin adapted the lines of sound coming out of the end of a round horn, but also the jagged points suggesting further sounds. His choice of a clear, bright palette is another quality similar to Hartley. Hartley's *Brass Band with Numbers* was owned by Stieglitz himself and therefore is a painting that Marin would certainly have seen.

Marin's experiments with purely abstract compositions are rare, for he preferred to paint in an abstract manner, with images still somewhat recognisable. Hartley did not continue long with such abstract compositions either, preferring instead to return to nature. Marin, however, painted at least six of these experimental abstractions in 1917, just a year after his somewhat abstract *Weehawken Sequence*, where his source in nature was more easily identifiable.

Note
1 Sheldon Reich, *John Marin: A Stylistic Analysis and Catalogue Raisonné* (Tucson, AZ: University of Arizona Press, 1970), pp. 112–13. Reich did not, however, find the closest probable source in Hartley's work, discussed below

John Marin

33 Lower Manhattan

1923, watercolour on paper, 67.3 × 54.6 cm (26½ × 21½ in)
Signed lower right: 'Marin 23'

Provenance
The Intimate Gallery, New York
George F. Of, New York
The Downtown Gallery, New York
Howard N. Garfinkle
Kennedy Galleries, Inc., New York
Thyssen-Bornemisza Collection, 1977

Literature
Sheldon Reich, *John Marin: A Stylistic Analysis and Catalogue Raisonné* (Tucson, AZ: University of Arizona Press, 1970), pp. 152–53, fig. 121, p. 523, no. 23.41

Exhibitions
New York, *Recent Watercolors by John Marin*, The Intimate Gallery, 16 February–8 March 1924, no. 21
Chicago, IL, *6th International Watercolor Exhibition*, Art Institute of Chicago, 3–30 May 1926
New York, *New York City*, The Downtown Gallery, 12 May–5 June 1964, no. 16
Allentown, PA, *The City and American Painting*, Allentown Art Museum, 20 January–4 March 1973, illus.
New York, *The City as a Source*, Kennedy Galleries, Inc., 16 November–3 December 1977, no. 32

In his watercolour, *Lower Manhattan*, Marin depicted not only something of the appearance of the busy city of New York, but he conveyed the city's urban energy, colour and chaos. His shifting lines and forms suggest the brisk movement of the downtown area of the city. A sense of a crowd passing in the street is given by the passage in the lower centre composed of red and blue dashes on a wash ground. The towering skyscrapers with their multiple windows are visible looming up overhead.

We cannot, however, literally interpret all of the forms of this watercolour which remains suggestive but in no way descriptive. Marin caught instead the rhythms of the metropolis and made them visible through his selected colours, forms and shapes. *Lower Manhattan* is one in a continuing series that Marin painted of this area at various phases of his career. This example can best be compared with others of the early twenties: *Lower Manhattan (Composing Derived from top of Woolworth)* of 1922 (fig. 1) or *Lower Manhattan from the River, No. 1* of 1921 (fig. 2). Marin also continued these rhythmic abstractions of lower Manhattan in his etchings of the 1910s.

1 John Marin, *Lower Manhattan (Composing Derived from top of Woolworth)*, 1922, Museum of Modern Art, New York

2 John Marin, *Lower Manhattan from the River, No. 1*, 1921, Metropolitan Museum of Art, New York

John Marin 1870–1953

34 New York Series

1927, watercolour and tempera on paper, 67×54 cm ($26\frac{1}{4} \times 21\frac{1}{4}$ in)
Signed lower right: 'Marin 27'

Provenance
Mr and Mrs John Marin, Jr, New York
Kennedy Galleries, Inc., New York
Thyssen-Bornemisza Collection, 1981

Literature
Sheldon Reich, *John Marin: A Stylistic Analysis and Catalogue Raisonné* (Tucson, AZ: University of Arizona Press,
 1970), p. 583, no. 27.35
Mahonri Sharp Young, 'Scope and Catholicity: Nineteenth and Twentieth-Century American Painting', *Apollo*
 CXVIII (July 1983), p. 88, illus.
John I. H. Baur, 'Introduction', *John Marin's New York* (New York: Kennedy Galleries, Inc., 1981), n.p.

Exhibitions
John Marin: A Retrospective Exhibition, 1947, no. 34
 Boston, MA, Institute of Modern Art
 Washington, DC, Phillips Memorial Art Gallery
 Minneapolis, MN, Walker Art Center
New York, *Paintings and Drawings by John Marin: New York 1910–1944*, The Downtown Gallery,
 10 August–8 September 1948, no. 15
Evanston, IL, *Five American Masters of Watercolor*, Terra Museum of American Art, 5 May–12 July 1981, illus.
New York, *John Marin's New York*, Kennedy Galleries, Inc., 13 October–6 November 1981, no. 30
Vatican, 1983, no. 69; Lugano, 1984, no. 67
USA tour, 1984–86, no. 68

New York Series, John Marin's watercolour of 1927, is one of many depictions of the city
produced by Marin from the 1910s to 1952, the year before he died, when he represented the
views from his window in New York Hospital. Marin, for all the time that he spent in Maine and
elsewhere, was fascinated by the shapes and tempo of New York. He explored all aspects of the
city, representing its bridges, churches, harbour, ferryboats, streets and skyscrapers.

His style was influenced by his knowledge of French modernism, particularly Cubism, but he
took what he wanted and ignored the rest. Marin saw New York as a paradigm of modernity
and he celebrated its soaring buildings and busy streets. In *New York Series*, Marin conveys the
kind of compacted space and vertical congestion that one thinks of amid the skyscrapers of
lower Manhattan. His device of outlining the shapes of the skyscrapers acts like a frame within
a frame, suggesting a view that might be seen out of the window of another skyscraper.

John Marin 1870–1953

35 Figures in a Waiting Room

1931, oil on canvas, 55.8 × 68.5 cm (22 × 27 in)
Signed lower right: 'Marin 31'

Provenance
Estate of the artist
Kennedy Galleries, Inc., New York
Thyssen-Bornemisza Collection, 1981

Literature
Sheldon Reich, *John Marin: A Stylistic Analysis and Catalogue Raisonné* (Tucson, AZ: University of Arizona Press, 1970), p. 206, fig. 180, illus., p. 218, p. 631, no. 31.5
John I. H. Baur, 'Introduction', *John Marin's New York* (New York: Kennedy Galleries, Inc., 1981), n.p.

Exhibitions
Trenton, NJ, *John Marin*, New Jersey State Museum, 3 December 1950–21 January 1951, no. 1
Tucson, AZ, *John Marin 1870–1953*, University of Arizona Art Gallery, 9 February–10 March 1963, no. 90
Montclair, NJ, *John Marin, America's Modern Pioneer*, Montclair Art Museum, 23 February–29 March 1964, no. 33
John Marin 1870–1953, July 1970–June 1971, no. 85
 Los Angeles, CA, Los Angeles County Museum of Art New York, Whitney Museum of American Art
 San Francisco, CA, M.H. de Young Memorial Museum Washington, DC, National Collection of Fine Arts,
 San Diego, CA, Fine Arts Gallery of San Diego Smithsonian Institution
New York, *John Marin's New York*, Kennedy Galleries, Inc., 13 October–6 November 1981, no. 37

1 John Marin, *Figures in a New York Subway*, 1931
Terra Museum of American Art, Evanston, IL

In 1931, when Marin painted *Figures in a Waiting Room*, he displayed an atypical interest in representing figures. As it was, Marin's figures were generalised, impersonally conceived and anonymous. Still, at this time they were much more clearly defined than those previously depicted in his crowded cityscapes.

Much earlier, in Paris in 1910, Marin made a watercolour, *Girl Sewing*, which focuses on the figure seen in profile. Then he followed in 1911, with two portraits of Mrs Paul Haviland, the wife of the photographer in the Stieglitz circle. But these themes were soon abandoned in favour of cityscapes and landscapes with their distant, more impersonal vistas.

During the 1930s, Marin experimented with representing the figure in a number of contexts

including on the New York subway, in restaurants, in the circus and at the beach. He made very few intimate interior scenes like *Figures in a Waiting Room* which might depict patients at the doctors. While his few portraits of this period demonstrate his lack of interest in making a sympathetic, convincing portrayal, his modernist distortions were chosen intentionally.

Figures in a Waiting Room can best be compared with Marin's oil of the same year, *Figures in a New York Subway* (fig. 1). In both paintings, the figures are shown in static poses with only the most selective inclusion of details. The spaces are partially defined and much is left to the imagination. Marin suggested what the scene was like, but he never clearly defined it or included any of the anecdotal detail of Reginald Marsh or some other more illustrative painter.

John Marin 1870–1953

36 Eastport, Maine

1933, watercolour on paper, 43 × 33.6 cm (17 × 13¼ in)
Signed lower right: 'Marin 33'

Provenance
The Downtown Gallery, New York
Lawrence and Barbara Fleischman, Detroit, MI
Kennedy Galleries, Inc., New York
Thyssen-Bornemisza Collection, 1979

Literature
E.P. Richardson, *Painting in America From 1502 to the Present* (New York: Thomas Y. Crowell Co., 1966), p. 339,
 fig. 157, illus., p. 375
Sheldon Reich, *John Marin: A Stylistic Analysis and Catalogue Raisonné* (Tucson, AZ: University of Arizona Press,
 1970), p. 653, no. 33.7

Exhibitions
Detroit, MI, *John Marin 1870–1953*, Detroit Institute of Arts, 1954, no. 32
Detroit, MI, *Collection in Progress, Selections from the Lawrence and Barbara Fleischman Collection of American Art*,
 Detroit Institute of Arts, 1955, no. 34, illus.
Nine Generations of American Art, United States Information Agency circulating exhibition throughout Europe and
 Israel, 1955–60
New York, *The American View: Art from 1770 to 1978*, Kennedy Galleries, Inc., 6 December 1978–6 January
 1979, no. 49, illus.

Marin painted *Eastport, Maine* in 1933, the year he discovered the country around Addison called Cape Split. The next year he purchased property and a house at Cape Split and lived there during the summers until his death. Marin adored the sea and commented: 'Here the sea is so damned insistent that houses and land things won't appear much in my pictures.'[1] Indeed, in this watercolour, the focus is on a number of boats and the sea.

This watercolour is a variant of *Eastport Docks, Maine Coast*, executed the same year.[2] The later work is somewhat clearer in definition with the forms of the boats more easily readable. Marin enjoyed letting his abstract forms dissolve into one another; thus in *Eastport, Maine*, only the form of the green sailing boat is truly distinctive. The disposition of Marin's forms here reflects his knowledge of modern art, particularly Cubism and Futurism, but the end result has an American picturesqueness about it.

Notes
1 Quoted in Dorothy Norman,
 *The Selected Writings of John
 Marin* (New York: Pellegrini &
 Cudahy, 1949), p. ix
2 See Sheldon Reich, *John Marin:
 A Stylistic Analysis and Catalogue
 Raisonné* (Tucson, AZ:
 University of Arizona Press,
 1970), for a reproduction of
 this work, whereabouts
 unknown, see cat. no. 33.6,
 p. 653

Georgia O'Keeffe 1887–1986

37 Abstraction

1920, oil on canvas, 71 × 61 cm (28 × 24 in)
Signed on verso with monogram and star and dated: '20'

Provenance
Edith Gregor Halpert, New York
Sale, Sotheby Parke Bernet, New York, Highly Important 19th and 20th Century American Paintings, Drawings,
 Watercolors and Sculpture from the Estate of the Late Edith Gregor Halpert, 14–15 March 1973, lot 49, illus.
Thyssen-Bornemisza Collection, 1973

Literature
Zafran, pp.147–48, no.42

Exhibitions
New York, *Alfred Stieglitz presents: One hundred oils, watercolors, pastels and drawings by Georgia O'Keeffe*, Anderson
 Galleries, January–February 1923
Bennington, VT, *Georgia O'Keeffe*, Bennington College, 1959
Washington, DC, *Edith Gregor Halpert Collection*, Corcoran Gallery of Art, 1962
Iowa City, IA, *American Pioneer Artists*, University of Iowa, 1962, illus.
New York, *Pioneers of American Abstraction*, Andrew Crispo Galleries, 17 October–17 November 1973, no.92
Australian tour, 1979–80, no.42
Vatican, 1983, no.76; Lugano, 1984, no.74
USA tour, 1984–86, no.76
Cologne, *Pioniere der Abstrakten Kunst aus der Sammlung Thyssen-Bornemisza*, Galerie Gmurzynska, 1–30 September
 1986, p.192, colour pl.

Georgia O'Keeffe's *Abstraction* of 1920 relates to a number of her other abstract paintings of this early period, particularly *Orange and Red Streak* of 1919. *Abstraction* contains a dramatic red and yellow streak against a deep blue ground. This canvas suggests a sense of the mystery of the heavens and the planetary bodies. The whitish disk might represent the moon. Just a few years earlier, in 1917, O'Keeffe had made watercolours inspired by the night skies: *Starlight Night* and an evocative series called *Evening Star*. She painted *New York with Moon* in 1925 and was continuously aware of the magic of the night sky.

O'Keeffe noted: 'It is surprising to me to see how many people separate the objective from the abstract. . . . The abstraction is often the most definite form for the intangible thing in myself that I can only clarify in paint.'[1] O'Keeffe had undoubtedly been influenced by Arthur Wesley Dow, her teacher at Teachers College at Columbia University in New York, who claimed that one of the most significant aesthetic issues of the day was 'ceasing to make representation a standard but comparing the visual arts with music'.[2]

Through another of her teachers, Alon Bement, with whom she studied at the University of Virginia, O'Keeffe had been introduced to Wassily Kandinsky's treatise, *The Art of Spiritual Harmony*, which also encouraged her development of abstraction. O'Keeffe's abstractions relate as well to her intense love of nature, while her colours often depart from nature to reflect her vivid imagination.

Notes
1 Quoted from *Georgia O'Keeffe* (New York: Viking Press, 1976), n.p. across from plate 88, *Dark Abstraction*, 1924
2 Arthur Wesley Dow, 'Modernism in Art', *American Magazine of Art* VIII (January 1917), p.116

Georgia O'Keeffe 1887–1986

38 Shell and Old Shingle VI

1926, oil on canvas, 76.2 × 46 cm (30 × 18 in)

Provenance
The Downtown Gallery, New York
Mr and Mrs Charles Claggett
Kennedy Galleries, Inc., New York
Thyssen-Bornemisza Collection, 1980

Literature
Lloyd Goodrich, *Georgia O'Keeffe* (New York: Whitney Museum of American Art, 1970), illus. no. 47, p. 19
Georgia O'Keeffe, *Georgia O'Keeffe* (New York: Viking Press, 1976), illus., p. 51
'Amerikanische Malerei Aus der Sammlung Thyssen-Bornemisza', *Du* 5 (1984), p. 87

Exhibitions
New York, *Georgia O'Keeffe Paintings*, The Intimate Gallery, 11 January–27 February 1927
Georgia O'Keeffe Retrospective Exhibition, October 1970–April 1971, no. 47
 New York, Whitney Museum of American Art
 Chicago, IL, Art Institute of Chicago
 San Francisco, CA, San Francisco Museum of Art
Vatican, 1983, no. 77; Lugano, 1984, no. 75
USA tour, 1984–86, no. 77

Shell and Old Shingle VI of 1926 is one of a series that O'Keeffe based on a weathered shingle and a clam shell. She created increasingly abstract compositions, eventually ending up with a landscape of Lake George which she realised later continued the colour and form of the shingle (turned on its side and painted horizontally). Lloyd Goodrich commented that O'Keeffe painted the Shell and Old Shingle series with such 'delicate skill' and 'a sensuous feeling for pigment' that he was reminded that she had won a still-life prize in William Merritt Chase's class at the Art Students League in New York.[1]
 O'Keeffe herself recalled the circumstances of this painting:

We were shingling the barn and the old shingles, taken off, were free to fly around. Absentmindedly I picked up a loose one and carried it into the house and up to the table in my room. On the table was a white clam shell brought from Maine in the spring. I had been painting it and it still lay there. The white shape of the shell and the grey shape of the weathered shingle were beautiful against the pale grey leaf on the faintly pink-lined pattern of the wallpaper. Adding the shingle got me painting again.[2]

O'Keeffe began with small realistic depictions of the shingle and a portion of the shell, adding parts of two green leaves from a glass on the table to the first and third versions. The larger second version is closest to the sixth version and is identical in size. The smaller fourth version, painted from a closer vantage point, appears even more abstract.
 O'Keeffe liked to work in series and had begun to do so quite early in her career, with her 1915 watercolours. She sometimes painted as many as six or more pictures around a single theme. And she would often return to a theme many years after she had first painted it. Her idea was that of transformation, usually with nature as a point of departure. She remarked: 'Sometimes I start in very realistic fashion, and as I go on from one painting to another of the same thing, it becomes simplified till it can be nothing but abstract.'[3]

Notes
1 Lloyd Goodrich, *Georgia O'Keeffe* (New York: Whitney Museum of American Art, 1970), p. 19
2 *Georgia O'Keeffe* (New York: Viking Press, 1976), n.p., across from plate 51
3 Quoted in Lloyd Goodrich, *op. cit.*, p. 19

Georgia O'Keeffe 1887–1986

39 New York with Moon

1925, oil on canvas, 122 × 76.2 cm (48 × 30 in)

Provenance
The Intimate Gallery, New York
Mr and Mrs Eugene Meyer
Mr and Mrs Peter Meyer
Arcadia, Inc., Washington, DC
Thyssen-Bornemisza Collection, 1981

Literature
Georgia O'Keeffe, *Georgia O'Keeffe* (New York: Viking
 Press, 1976), illus., p. 17
Mahonri Sharp Young, 'Scope and Catholicity:
 Nineteenth- and Twentieth-Century American
 Paintings', *Apollo* CXVIII (July 1983), p. 87, illus.

Reproduced
Advertisement for Arcadia, Inc., Washington, DC,
 Antiques 121 (January 1982), p. 151

Exhibition
New York, *Georgia O'Keeffe, Fifty Recent Paintings*, The
 Intimate Gallery, February–March 1926

Georgia O'Keeffe recalled that when she painted *New York with Moon* in 1925, it was her first painting of New York. She was living in two rooms on the 30th floor of the Shelton on Lexington Avenue. She remembered: 'I had never lived up so high before and was so excited that I began talking about trying to paint New York.'[1] *New York with Moon*, a depiction of 47th Street at night, was her first New York painting. She noted: 'There was a street light in the upper foreground at about the Chatham Hotel.'[2]

O'Keeffe had hoped to show *New York with Moon* in the Seven Americans show that her husband Alfred Stieglitz organised at the Anderson Galleries in 1925.[3] However, Stieglitz, who had pointed out to her that even men found it difficult to paint New York skyscrapers, refused to allow her to show this picture, preferring instead to exhibit her more feminine, large-scale flower paintings. A year later, when O'Keeffe had her own show at The Intimate Gallery, she insisted that Stieglitz hang this picture on a wall between two windows. The day that her exhibition opened, *New York with Moon* was sold for $1200, the first purchase of the show. She gloated: 'From then on they let me paint New York.'[4]

O'Keeffe's city scenes of skyscrapers can best be understood in the context of work by her contemporaries who have come to be seen as Precisionists. These include 1920s depictions of city skyscrapers by Charles Demuth, Charles Sheeler, George Ault and Louis Lozowick. Another inspiration was the work of contemporary photographers, in particular the work of Stieglitz himself, but also others in their circle, such as Paul Strand. This period was still an age of optimism when the skyscraper usually symbolised modernity and progress.

O'Keeffe once admitted: 'One can't paint New York as it is, but rather as it is felt.'[5] To look at her skyscraper paintings is to appreciate the woman who is a displaced nature-lover, having grown up in the mid-western countryside. There is a sense of crowding, airlessness and op-pression present in these pictures. O'Keeffe is as always fascinated by the moon and the sun, as befits a girl who grew up under the broad skies of the Wisconsin prairie.

In *New York with Moon*, the round white disc of the moon slips sensuously in and out of the passing clouds. The sky is still blue, but the buildings, cast in shadow, are mere silhouettes against it. The street light by the Chatham seems an unearthly presence, its aura almost like a halo. And the red sky of dusk at the base of the painting, setting off the spire of a church steeple, creates a Surrealist-like effect, although it is unlikely that O'Keeffe could have known such work by her contemporaries in Paris at this early date.

Notes
1 *Georgia O'Keeffe* (New York:
 Viking Press, 1976), n.p., across
 from plate 17, *New York with
 Moon*
2 *Ibid.*
3 Besides O'Keeffe, these artists
 included Charles Demuth,
 Arthur G. Dove, Marsden
 Hartley and John Marin, as
 well as photographers Paul
 Strand and Stieglitz himself
4 Laurie Lisle, *Portrait of an Artist*
 (New York: Washington Square
 Press, 1980), p. 188–89
5 *Ibid.*, p. 189

O'Keeffe's subsequent cityscapes include *Shelton Hotel, New York No. 1* (1926), *City Night* (1926), *The Shelton with Sunspots* (1926), *Radiator Building – Night, New York* (1927), and *New York Night* (1929). She seemed to have preferred the mystery of nocturnal scenes, rather than the raking sunlight she loved for flowers and other rural architectural subjects. In any event, perhaps because she had shown she could paint them and no longer needed to, O'Keeffe ceased painting views of the city in 1929. But in the few superb examples she created, O'Keeffe showed that it did not take a man to deal effectively with the structure of architecture.

Georgia O'Keeffe 1887–1986

40 From the Plains II

1954, oil on canvas, 122 × 183 cm (48 × 72 in)

Provenance
The Downtown Gallery, New York
Susan and David Workman
Kennedy Galleries, Inc., New York
Thyssen-Bornemisza Collection, 1977

Literature
Georgia O'Keeffe, *Georgia O'Keeffe* (New York: Viking Press, 1976), pl. 3
'Accent on Art: Eight Settings at the Andrew Crispo Gallery',
 Interior Design 48 (February 1977), p. 101
Lieberman, pp. 66–67, no. 58

Exhibitions
New York, *Georgia O'Keeffe, New Paintings*, The Downtown Gallery, 29 March–23 May 1955, cat. no. 14
New York, *The Museum and Its Friends: 18 Living American Artists*, Whitney Museum of American Art,
 5 March–12 April 1959
Georgia O'Keeffe Retrospective Exhibition, October 1970–April 1971, no. 107
 New York, Whitney Museum of American Art
 Chicago, IL, Art Institute of Chicago
 San Francisco, CA, San Francisco Museum of Art
Katonah, NY, *American Painting, 1900–1976, II. The American Scene and New Forms of Modernism, 1935–1954*,
 Katonah Gallery, 17 January–14 March 1976
USA tour, 1982–83, no. 58
Houston, TX, *The Texan Landscape 1900–1986*, Museum of Fine Arts, 17 May–7 September 1986, p. 74, colour pl.

O'Keeffe painted *From the Plains I* in 1919, thirty-five years earlier than *From the Plains II* of 1954. Her ability and desire to create a second version of this much earlier painting is characteristic of her career. In 1957, she explained these two paintings' meaning for her: 'It was painted from something I heard very often – a very special rhythm that would go on for hours and hours. That was why I painted it again a couple of years ago.'[1]

The concept of *From the Plains I* occurred to O'Keeffe as a result of living in Amarillo, Texas, where in 1912–13, she was supervisor of art in the state schools. In 1916 and 1917, she returned to Texas as the art supervisor for West Texas State Normal School in Canyon. She recalled: 'For days we would see large herds of cattle with their clouds of dust being driven slowly across the plains toward the town.'[2] She was struck by the loud and sad sound of the cattle in their pens which she described as 'particularly haunting at night'.

In *From the Plains I*, O'Keeffe captured the sense of the wide empty Texas cattle country with its haunting rhythmic sound of the cattle objecting to being in pens and, perhaps, the lower part of her canvas refers to the dust stirred up in this dry land. *From the Plains II*, which is a horizontal composition rather than vertical like its precursor, gives an even greater sense of the vastness of the Texas plains. Both contain the jagged, arched curves of light reaching across the landscape and metaphorically across the canvas. The latter canvas might represent the brilliant colour of sunset or sunrise, while the power of sunlight is apparent in both works.

In the later painting, O'Keeffe relies on the sensation of distant memory, rather than the more immediate response from which she created the earlier version. Thus, *From the Plains II*, is simplified and, if possible, even more abstract than its predecessor. She offers the viewer a visual equivalent of what for her was a very memorable sensation of sight, sound and temperature. O'Keeffe's very special world view opens up a door to her poetic imagination.

Notes
1 Quoted in Lloyd Goodrich, *Georgia O'Keeffe* (New York: Whitney Museum of American Art, 1970), p. 27
2 *Georgia O'Keeffe* (New York: Viking Press, 1976), across from plate 2, *From the Plains I*

Georgia O'Keeffe 1887–1986

41 White Iris No. 7

1957, oil on canvas, 102 × 76.2 cm (40 × 30 in)
Signed on label on back: O'Keeffe'

Provenance
Private collection
Kennedy Galleries, Inc., New York
Thyssen-Bornemisza Collection, 1979

Literature
Barth David Schwartz, 'The Baron's Americans', *Connoisseur* 214 (January 1984), p. 66, illus.
Baur, pp. 21–22, 105, illus., no. 79

Exhibitions
American Masters of the 20th Century, May–September 1982, no. 40
 Oklahoma City, OK, Oklahoma Art Center
 Evanston, IL, Terra Museum of American Art
Vatican, 1983, no. 79; Lugano, 1984, no. 77
USA tour, 1984–86, no. 79

Like so many of O'Keeffe's large-scale flower paintings, *White Iris No. 7* of 1957 is one of a series. She enjoyed exploring the shapes and colours of flowers observed at close range. These compositions achieve a monumentality not generally associated with flower painting. O'Keeffe's paintings of flowers have also suggested interpretations – particularly sexual ones – that the artist has rejected. She commented: 'A flower is relatively small. Everyone has many associations with a flower – the idea of flowers. You put out your hand to touch the flower – lean forward to smell it – maybe touch it with your lips almost without thinking – or give it to someone to please them.'[1]

O'Keeffe claimed that she enlarged her depictions of flowers so that others could see the flower as she did, noting that if she had painted them small as she saw them, no one would notice what else she saw: 'So I said to myself – I'll paint what I see – what the flower is to me but I'll paint it big and they will be surprised into taking time to look at it – I will make even busy New Yorkers take time to see what I see of flowers.'[2]

The analogies to sensuous female forms identified in O'Keeffe's flower paintings by feminists and others are evidently not conscious on the artist's part and she has repeatedly corrected such interpretations. She has argued: 'Well – I made you take time to look at what I saw and when you took time to really notice my flower you hung all your own associations with flowers on my flower and you write about my flower as if I think and see what you think and see of the flower – and I don't.'[3]

O'Keeffe appears to have been influenced by photography in these large-scale close-up focus pictures of flowers. She was probably most indebted to Stieglitz's good friend Paul Strand, whose work was sometimes shown in the same exhibitions as her own. Besides white and black irises, O'Keeffe painted large-scale renditions of many other flowers, including jack-in-the-pulpits, orchids, trumpet flowers, larkspur, sunflowers, cala lilies, poppies and jimson weeds. These flower paintings are perhaps her best-known images.

Notes
1 *Georgia O'Keeffe* (New York: Viking Press, 1976), across from plate 23
2 *Ibid.*
3 *Ibid.*, across from plate 24, *An Orchid*, 1941

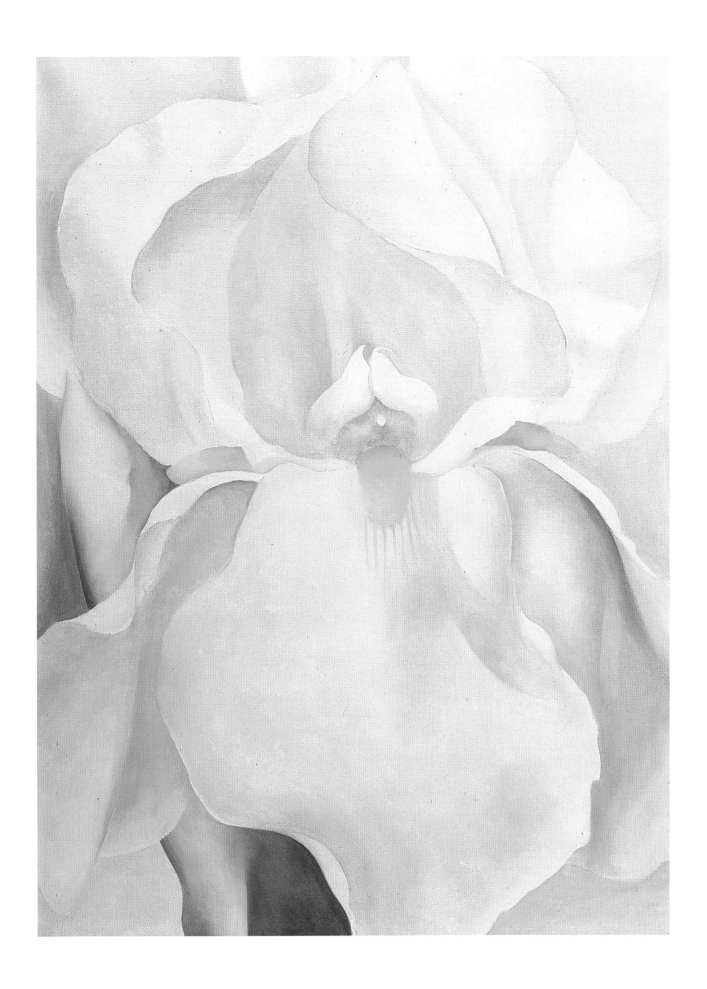

Man Ray 1890–1976

42 Trou de Serrure

1928, oil on canvas, 45.7 × 38.1 cm (18 × 15 in)
Signed and dated lower right: 'Man Ray 1928'

Provenance
William Copley, New York
Gloria de Hererra, Paris
Private collection, London
Andrew Crispo Gallery, New York
Thyssen-Bornemisza Collection, 1979

Literature
'Le Surrealisme in 1929', *Variétés* (June 1929), facing p. 46

Exhibition
Brussels, *Trois Peintres Surrealistes: Rene Magritte, Man Ray, Yves Tanguy*, Palais des Beaux-Arts, 12–22 December
 1937, no. 35

Man Ray painted *Trou de Serrure*, which translates as key-hole, in 1928 in Paris where he had
been living since 1921. As a Dadaist, Man Ray is witty and clever in his imagery. We see not
only the key-hole but what the key-hole's use can be: a peep hole. This is the old eye to the key-
hole joke from so many movies which Man Ray, an avant-garde film maker, would have
known well.

The image of the eye is one that had earlier caught Man Ray's attention. He uses the image of
an eye cut from a photograph which he mounted on the moving pendulum of a metronome
and called *Indestructible Object* in 1923. He also used the cut-out image of an eye in his *Boule
sans neige* of 1927, just one year before he painted *Trou de Serrure.* And Man Ray continued to
use the image of the eye in his work throughout his career.

Years later, in 1959, Man Ray came back to the image of the key and key-hole in *Le Songe
d'une clé de nuit.* He clearly intended an erotic meaning in both the key-hole as a metaphor for
female anatomy and as a likely spot for a secret voyeur. *Trou de Serrure* is Man Ray's punning
image of the Peeping Tom. It seems apparent, therefore, that the abstract key-like image on the
right of the composition is also a phallic image, suggesting activity going on on the other side of
the door. But Man Ray, then participating in Surrealist exhibitions in Paris, was far from
explicit; enigma was his game and he wanted to keep us guessing.

Charles Sheeler 1883–1965

43 Wind, Sea and Sail

1948, oil on canvas, 51 × 61 cm (20 × 24 in)
Signed and dated lower right: 'Sheeler 48'

Provenance
The Downtown Gallery, New York
Harold S. Goldsmith
Edith Gregor Halpert, New York
Sale, Sotheby Parke Bernet, New York, Highly
 Important 19th and 20th Century American
 Paintings, Drawings, Watercolors and Sculpture
 from the Estate of the Late Edith Gregor Halpert,
 14–15 March 1973, lot 64
Andrew Crispo Gallery, New York
Thyssen-Bornemisza Collection, 1975

Literature
Constance Rourke, *Charles Sheeler: Artist in the
 American Tradition* (New York: Harcourt, Brace,
 1938), p. 92
New York Times (3 July 1955), section 2, p. 6x, illus.
Dagbladet (Oslo, Norway, October 1955), p. 159, illus.
Lillian N. Dochterman, *The Stylistic Development of the
 Work of Charles Sheeler* (Iowa City, OH: Ph.D.
 dissertation, State University of Iowa, 1963),
 p. 459, no. 48.291, illus.
Martin Friedman, *Charles Sheeler* (New York: Watson-
 Guptill Publications, 1975), p. 159, illus.
Zafran, p. 162, no. 80

Reproduced
Advertisement for Kennedy Galleries, Inc., New York, *Connoisseur* 185 (April 1974), p. 65, illus.

Exhibitions
Brooklyn, NY, *Coast & Sea: A Survey of American Marine Painting*, Brooklyn Museum, 1948, no. 107
New York, *Charles Sheeler*, The Downtown Gallery, 1949, no. 6
Oslo, Norway, The American Embassy, 1955
Iowa City, IA, University of Iowa, 1955
New York, *The Museum and Its Friends: 18 Living American Artists*, Whitney Museum of American Art,
 5 March–12 April 1959
Washington, DC, *The Edith Gregor Halpert Collection*, Corcoran Gallery of Art, January 1960
New York, *Recently Acquired American Masterpieces of the 19th and 20th Centuries*, Kennedy Galleries, Inc., 1974,
 no. 28, illus.
New York, *European and American Masterpieces*, Andrew Crispo Gallery, 1975, no. 50
Australian tour, 1979–80, no. 80

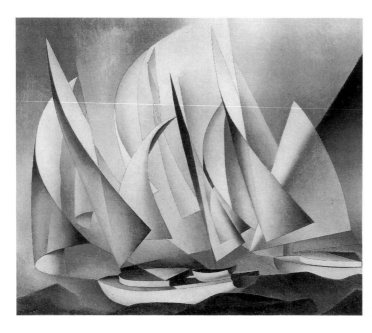

1 Charles Sheeler, *Pertaining to Yachts and Yachting*, 1922
Philadelphia Museum of Art, Philadelphia, PA

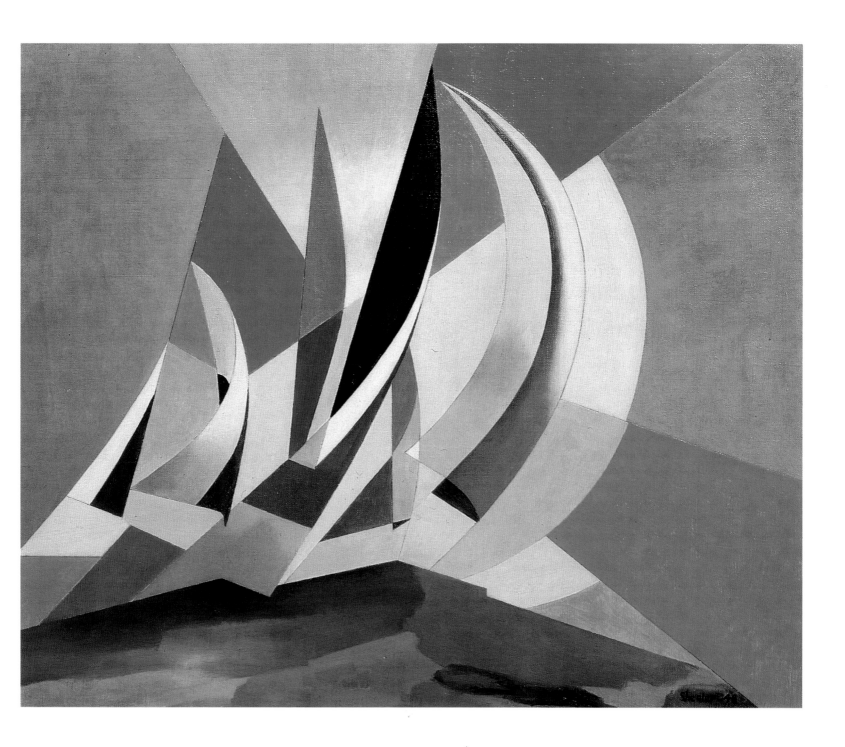

Notes
1 Quoted in Constance Rourke,
 *Charles Sheeler: Artist in the
 American Tradition* (New York:
 Harcourt, Brace, 1938), p. 92
2 See Gail Levin, *Synchromism
 and American Color Abstraction,
 1910–1925* (New York:
 George Braziller, 1978)

Charles Sheeler painted *Wind, Sea and Sail* in 1948, continuing the theme he had painted in *Pertaining to Yachts and Yachting* in 1922 (fig. 1). The transparent forms of the latter painting reveal Sheeler's interest in modernist styles deriving from Cubism. He was familiar with Cubism from his trip to Paris in 1909 and from the 1913 Armory Show in New York.

Sheeler loved the visual grace of sailing boats which he also made the subject of a lithograph entitled *Yachts* in 1924. Sheeler spoke of these yacht pictures as 'studies in polyphonic form'.[1] His Cubist stylisations suggest the illusion of movement, a very appropriate image for a yacht. The entire yacht in *Wind, Sea and Sail* is composed of geometric shapes, not unlike the artist's early experiments from the 1910s.[2]

Charles Sheeler 1883–1965

44 Canyons

1951, oil on canvas, 63.5 × 56 cm (25 × 22 in)
Signed and dated lower right: 'Sheeler 1951'

Provenance
Edith Gregor Halpert, New York
Sales, Sotheby Parke Bernet, New York, Highly Important 19th and 20th Century American Paintings, Drawings,
 Watercolors and Sculpture from the Estate of the Late Edith Gregor Halpert, 14–15 March 1973, lot 26
Thyssen-Bornemisza Collection, 1973

Reproduced
The New York Times, Book Section (17 January 1954)
Time Magazine (13 January 1955)
The Christian Science Monitor (8 November 1955)
The Memphis Sunday Times (15 November 1964)
The London Times (26 July 1965)
Advertisement for Sotheby's sale of 14–15 March 1973, *Arts* 47 (February 1973), p. 3

Exhibitions
New York, *Paintings, 1949–1951, by Charles Sheeler*, The Downtown Gallery, 13–31 March 1951, no. 7
Philadelphia, PA, Pennsylvania Academy of the Fine Arts, December 1951
New York, *New York Paintings*, Perls Galleries, April 1952
Los Angeles, CA, Los Angeles County Fair, July 1953
New York, *Modern Design*, The Downtown Gallery, October 1953
Houston, TX, Museum of Fine Arts, January 1954
Detroit, MI, *Ben Shahn, Charles Sheeler, Joe Jones*, Detroit Institute of Arts, March 1954
Lincoln, NE, University of Nebraska, February–April 1955
Buffalo, NY, Albright-Knox Gallery, December 1956
Des Moines, IA, Des Moines Art Center, May 1957
New York, *Art Our Children Live With*, New School for Social Research, December 1957
New York, *City Paintings, 1913–1963, by American Artists*, The Downtown Gallery, May 1964
New York, *39th Anniversary Exhibition*, The Downtown Gallery, October 1964
London, *Six Decades of American Art*, Leicester Gallery, July 1965
Flint, MI, *Realism Revisited*, Flint Institute of Art, April 1966, no. 44
Fort Worth, TX, Amon Carter Museum of Western Art, November–December 1966
San Diego, CA, *20th Century American Art*, Fine Arts Gallery, February–March 1968
Washington, DC, *Edith Gregor Halpert Memorial Exhibition*, National Collection of Fine Arts, Smithsonian Institute,
 April 1972, no. 25
Corpus Christi, TX, *A Selection of American Paintings from the Estate of the Late Edith Gregor Halpert, New York*,
 Art Museum of South Texas, 19 January–10 February 1973
Vatican, 1983, no. 84; Lugano, 1984, no. 82
USA tour, 1984–86, no. 84

Charles Sheeler's painting, *Canyons* of 1951, refers to the vast and deep valleys created by the
skyscrapers which crowd Manhattan. These narrow canyons exist without much sunlight for
most of the day, the surrounding towering buildings oppressively blocking out the views and
breezes as well as the sun. Sheeler, who photographed the city as well as painted it, employed
transparent planes to give a sense of shadow and magic to the vista he depicted. Like a black-
and-white photograph, his painting *Canyons* is executed in a limited palette, stressing form over
colour. The colours chosen are cool or dark, with no warm reds to enliven this view.

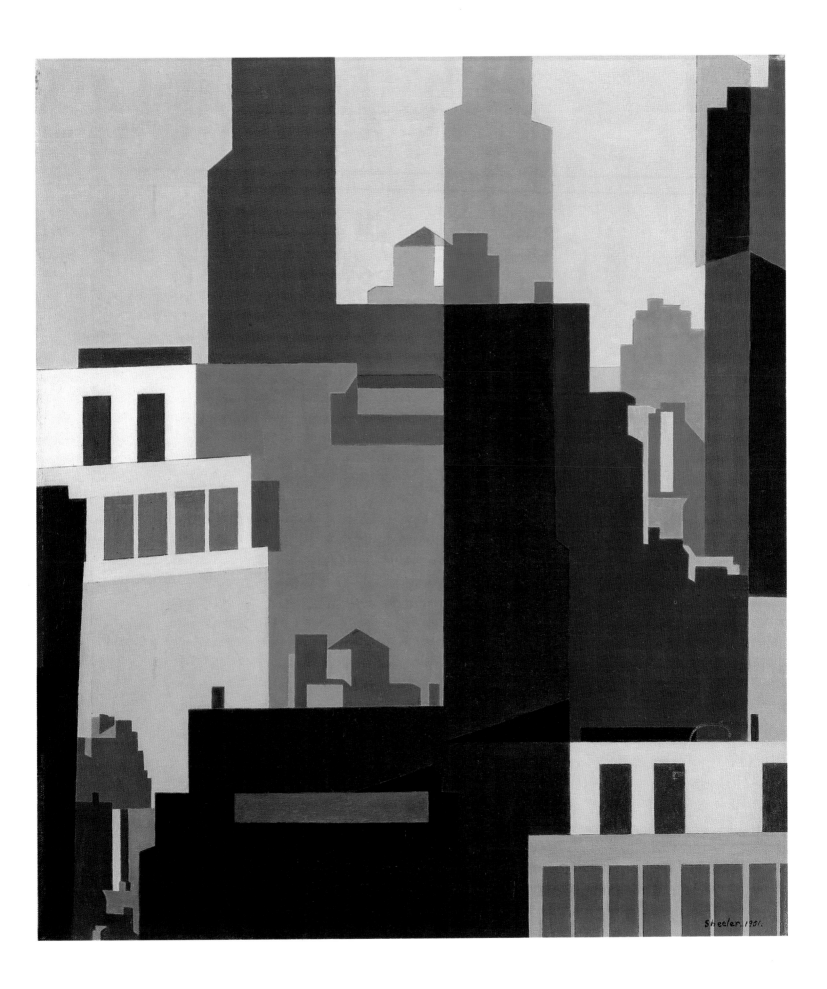

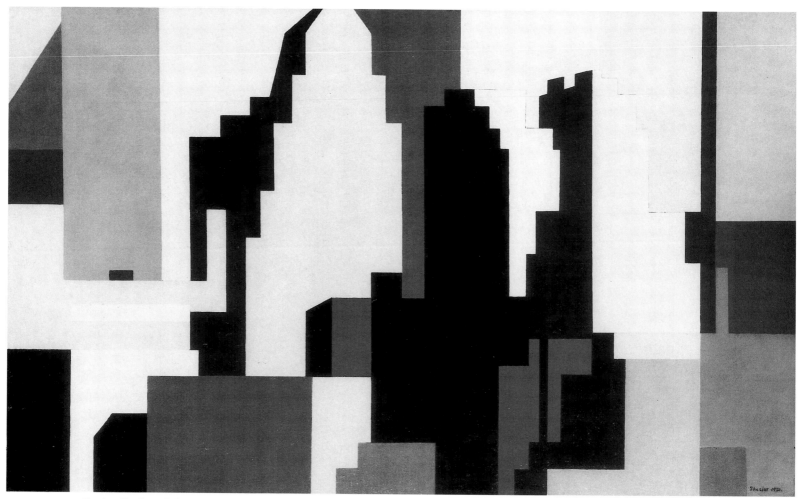

1 Charles Sheeler, *Skyline*, 1950, Wichita Art Museum, Wichita, KS

Sheeler has emphasised the flat planes of these geometric towers, simplifying the whole, eliminating unnecessary details. This is the world of the machine age. We see this urban space without people, but expect to see robots instead. Sheeler's *Canyons* relates to his many other views of the city, particularly *Skyline* of 1950 (fig. 1) and *New York No. 2* of 1951 (fig. 2) which both employ a similar hard-edged geometry. The latter painting uses a worm's eye perspective looking up at the soaring towers. *Canyons* and *Skyline*, however, confront the skyscrapers head on at eye level, perhaps from another skyscraper.

2 Charles Sheeler, *New York No. 2*
1951, Munson-Williams-Proctor Institute
Utica, NY

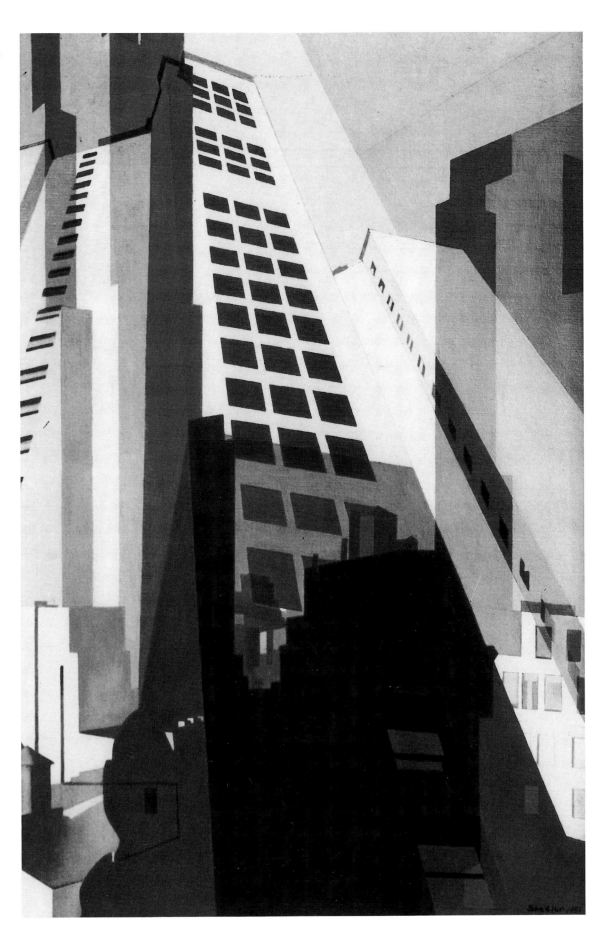

Charles Sheeler 1883–1965

45 Ore Into Iron

1953, tempera on plexiglass, 23×17.2 cm ($9 \times 6\frac{3}{4}$ in)

Provenance
Edith Gregor Halpert, New York
Sale, Sotheby Parke Bernet, New York, Highly Important 19th and 20th Century American Paintings, Drawings,
 Watercolors and Sculpture from the Estate of the Late Edith Gregor Halpert, 14–15 March 1973, lot 28
Thyssen-Bornemisza Collection, 1973

Literature
George M. Craven, 'Sheeler at Seventy-five', *College Art Journal* 18, no. 2 (Winter 1959), p. 140

This small painting on plexiglass is a version of a larger oil on canvas, also called *Ore into Iron*, and painted the same year. As a photographer, Sheeler had been working on two corporate commissions in 1952, just a year before painting *Ore into Iron*. He made much of these new visual experiences in his subsequent paintings. The version of *Ore into Iron*, painted on plexiglass, was produced as a study for the larger oil, as Sheeler had frequently painted miniature pictures in watercolour or tempera and then enlarged these compositions.

During the late 1940s, Sheeler had employed glass panels as a means of developing his compositions. The idea of transparency and superimposed images intrigued him, probably as a result of his familiarity with double exposures and printing processes in photography. The collector William Lane, who owns the larger version of *Ore into Iron*, gave Sheeler some sheets of plastic, since the fragility of glass had been a problem. Sheeler generally worked out his

designs in tempera on paper and then further developed these conceptions with tempera on plexiglass before producing a larger version in oil. Further studies and versions might then be made depending on Sheeler's interests at the moment.

Ore into Iron represents the blast furnaces of Pittsburgh and derives from his photographic record of this site. This image is also closely related to the subsequent series of paintings called *Continuity* (fig. 1) dating from 1957. Sheeler viewed industrial architecture and settings with an optimism perhaps less comprehensible today than when he produced these images. We see only the clean soaring geometric forms, graceful and bold; the viewer is not intended to think of industrial pollution or other such complications, but to see these images as icons of progress.

1 Charles Sheeler, *Continuity* 1957, Fort Worth Art Center Fort Worth, TX

Charles Sheeler 1883–1965

46 Composition around Yellow No. 2

1958, tempera on paper, 14.9 × 17.7 cm (5½ × 7 in)
Signed and dated lower right: 'Sheeler 1958'

Provenance
The Downtown Gallery, New York
Edith Gregor Halpert, New York
Sale, Sotheby Parke Bernet, New York, Highly Important 19th and 20th Century American Paintings, Drawings,
 Watercolors and Sculpture from the Estate of the Late Edith Gregor Halpert, 14–15 March 1973, lot 32
Thyssen-Bornemisza Collection, 1973

Sheeler's painting *Composition around Yellow No. 2* of 1958 continues to explore the issue of transparency. Intersecting planes of colour lend to this representation of buildings an air of abstraction. Sheeler used crisp sharp-edged planes to define the shapes of buildings. Only a few details such as dark rectangular windows interrupt the flat planes. The yellow about which the composition revolves is that on the end of a barn-like structure and, strangely enough, the colour of the sky. The rest of the palette is mostly white and shades of grey and purple with a patch of green for grass.

During this period of his career, Sheeler was painting rural Shaker architecture with its simple lines and geometric shapes. He was evidently attracted to the purity of these forms and to their naturally abstract qualities. Sheeler emphasised the rhythmic overlapping of patterns of light and shadow falling on the structures. He did a number of paintings at this time which focused on colour relationships, and approached abstraction.

Max Weber

1881–1961

47 New York

1913, oil on canvas, 101 × 81.3 cm (40 × 32 in)
Signed and dated lower left: 'Max Weber '13'

Provenance
Wright Ludington, Santa Barbara, CA
Edith Gregor Halpert, New York
Sale, Sotheby Parke Bernet, New York, Highly Important 19th and 20th Century American Paintings, Drawings,
 Watercolors and Sculpture from the Estate of the Late Edith Gregor Halpert, 14–15 March 1973, lot 35, illus.
Carl D. Lobell, New York
Andrew Crispo Gallery, New York
Thyssen-Bornemisza Collection, 1977

Literature
Max Weber (New York: American Artists Group, Inc., 1945), n.p., illus.
Alfred Werner, *Max Weber* (New York: Harry N. Abrams, Inc., 1975), pp. 43 and 61, p. 48, illus.
Zafran, p. 145, no. 36
Lieberman, p. 36, no. 27
Mahonri Sharp Young, 'Scope and Catholicity: Nineteenth- and Twentieth-Century American Paintings', *Apollo*
 CXVIII (July 1983), p. 86, illus.

Exhibitions
London, *Third Grafton Group Exhibition*, Alpine Gallery, 1913
Paris, *Exposition Max Weber*, Gallerie Bernheim-Jeune, 26 January–13 February 1924, cat. no. 8
New York, *43rd Anniversary Exhibition*, The Downtown Gallery, 1948
San Francisco, CA, *The Collection of Wright Ludington*, Museum of Art, 1948
New York, *Abstract Painting and Sculpture in America*, Museum of Modern Art, 1951, p. 32, no. 106, p. 37, illus.
Cincinnati, OH, Contemporary Art Center, Dayton Art Institute, Cincinnati Art Museum, September–November
 1957
Washington, DC, Opening Exhibition, National Collection of Fine Arts, Smithsonian Institution, 1968
Washington, DC, *Edith Gregor Halpert Memorial Exhibition*, National Collection of Fine Arts, Smithsonian Institution,
 April 1972, no. 31
Corpus Christi, TX, *A Selection of American Paintings from the Estate of the Late Edith Gregor Halpert, New York*,
 Art Museum of South Texas, 19 January–10 February 1973
New York, *American Masters*, Andrew Crispo Gallery, 1977, no. 88
Lugano, *Collezione Thyssen-Bornemisza, Arte Moderna*, Villa Malpensata, 1 September–5 November 1978, no. 106
Australian tour, 1979–80, no. 36
USA tour, 1982–83, no. 27
Cologne, *Pioniere der Abstrakten Kunst aus der Sammlung Thyssen-Bornemisza*, Galerie Gmurzynska, 1–30 September
 1986, p. 194, colour pl.

Max Weber's *New York* of 1913 is an American's original synthesis of European modernist
styles, particularly Cubism and Fauvism. Having studied with Matisse in Paris, Weber also met
Picasso and became close friends with Henri Rousseau. His three years in Paris enriched his
vision so that when he returned to New York in 1909, he was ready to see the city with a fresh
eye.

New York includes fragments of observed places – from the cables of the Brooklyn Bridge
across the top of the composition to an aerial view of Battery Park in lower Manhattan along
the bottom edge of this picture. The forms of tall skyscrapers pile up the height of the composition
angled energetically at diagonals. Weber depicted not only the appearance, but also the energy
of this busiest of cities.

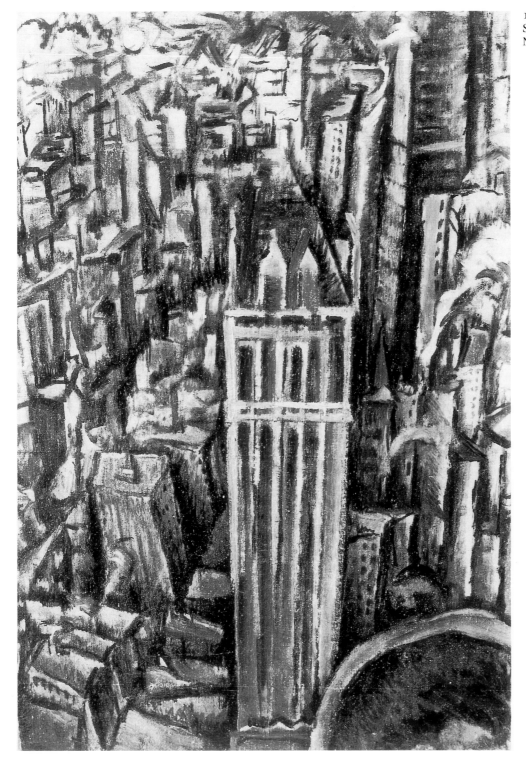

1 Max Weber, *Woolworth Building*, 1912
Stephen and Sybil Stone Foundation
Newton Center, MA

When Weber exhibited *New York* in London in 1913, a local critic wrote in the London *Times* that while 'no one could guess even that it was a representation of a place', it possessed 'a logic of its own like the logic of some scientific diagram', adding 'One feels that it is not a pure caprice of the artist, while the form and colour certainly have an abstract beauty.'[1] Weber had earlier painted an aerial view of New York in *Woolworth Building* of 1912 (fig. 1) and he was soon to make further paintings recording the special magic of New York, for example, *New York at Night* (fig. 2) and *Grand Central Terminal* [48], both of 1915.

Note
1 Quoted in Alfred Werner, *Max Weber* (New York: Harry N. Abrams, Inc., 1975), p. 43

2 Max Weber, *New York at Night*, 1915
James and Mari Michener Collection
Archer M. Huntington Art Gallery
University of Texas, Austin, TX

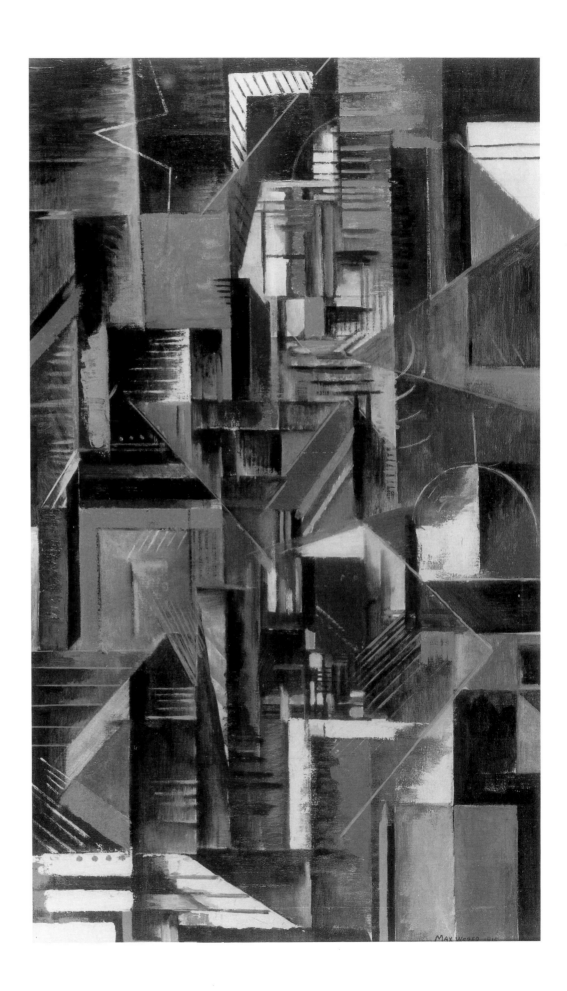

Max Weber 1881–1961

48 Grand Central Terminal

1915, oil on canvas, 152.4 × 101.6 cm (60 × 40 in)
Signed and dated lower left: 'Max Weber 1915'

Provenance
Bernard Danenberg Galleries, New York
Private collection
Andrew Crispo Gallery, New York
Thyssen-Bornemisza Collection, 1973

Literature
Douglas Cooper, *The Cubist Epoch* (London: Phaidon Press Limited, 1970), p.178
Alfred Werner, 'Who is Max Weber?', *Art and Artists* 6 (April 1971), p. 20, illus.
Alfred Werner, *Max Weber* (New York: Harry N. Abrams, Inc., 1975), p. 50, illus., pl. 63
Percy North, *Max Weber: American Modern* (New York: Jewish Museum, 1982), pp. 58–60
Baur, pp. 21, 92, illus., no. 66

Reproduced
Advertisement for Bernard Danenberg Galleries, New York, *Art News* 69 (May 1970), p. 70

Exhibitions
New York, *Max Weber*, Montross Gallery, December 1915 (as *A Comprehension of the Grand Central Terminal*)
New York, *Max Weber*, Paul Rosenberg & Co., 11 January–12 February 1944, no. 6
Newark, NJ, *Max Weber*, Newark Museum, 1 October–15 November 1959, no. 18
New York, *Fifty Years of Painting by Max Weber*, Bernard Danenberg Galleries, 15 April–10 May 1969, no. 12
Max Weber The Years 1906–1916, organised by Bernard Danenberg Galleries, 1970–72
 Roswell, NM, Roswell Museum and Art Center
 Oshkosh, WI, Paine Art Center & Arboretum
 Davenport, IA, Davenport Municipal Art Gallery
 Lincoln, MA, De Cordova Museum
 Ft Lauderdale, FL, Ft Lauderdale Museum of the Arts
 Austin, TX, University of Texas
 Albuquerque, NM, University of New Mexico
 Ft Worth, TX, Amon Carter Museum of Western Art
 Storrs, CT, University of Connecticut Museum of Art
New York, *Pioneers of American Abstraction*, Andrew Crispo Gallery, 17 October–17 November 1973, no. 148
Max Weber: American Modern, October 1982–November 1983, no. 39
 New York, Jewish Museum
 West Palm Beach, FL, Norton Gallery and School of Art
 San Antonio, TX, McNay Art Institute
 Omaha, NE, Joslyn Art Museum
Vatican, 1983, no. 66; Lugano, 1984, no. 64
USA tour, 1984–86, no. 66

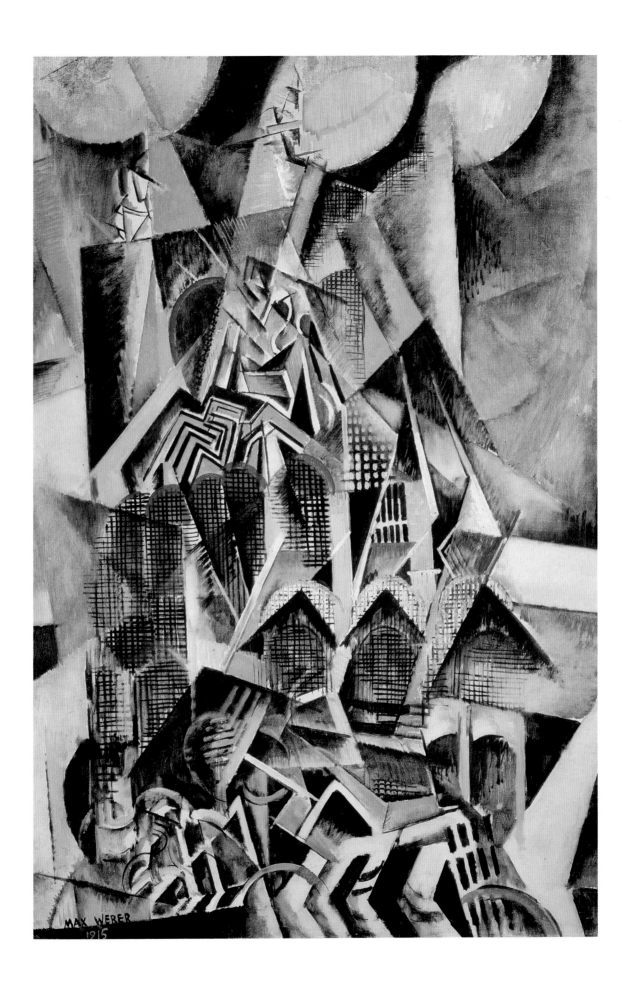

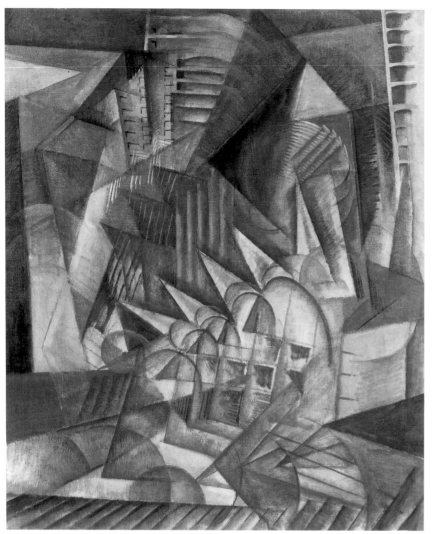

1 Max Weber, *Rush Hour, New York*, 1915, National Gallery of Art Washington, DC

2 Max Weber, *New York Department Store*, 1915 Detroit Institute of Arts, Detroit, MI

Max Weber painted *Grand Central Terminal* in 1915, a year in which he produced a group of abstractions around the theme of New York City. The rhythms of urban life had become his subject matter and these paintings depict the rapid movements that make up the pulse of the big city. Among his related subjects painted that year are *Rush Hour, New York* (fig. 1), *New York Department Store* (fig. 2) and *New York at Night*. In *Rush Hour, New York*, as in *Grand Central Terminal*, Weber is concerned with the surging crowds, pouring out of the skyscrapers at rush hour, timed like ocean waves at high tide. He was fascinated by this sea of humanity, but chose not to depict individual figures, preferring to convey the essential dynamism of the crowd in the city.

Weber had adapted his rather dark brown-toned palette from the Cubists, but his attempt to depict movement in his paintings probably resulted from his admiration of Marcel Duchamp's *Nude Descending a Staircase No. 2* of 1912 (fig. 3) which captured so much attention when it was shown in New York in the Armory Show of 1913. Weber is not only interested in depicting movement in and out of space, but also the duration of time. He has captured the sense of anonymity of the large city, as well as the chaotic, hectic passage of time spent there.

3 Marcel Duchamp
Nude Descending a Staircase No. 2, 1912
Philadelphia Museum of Art, PA

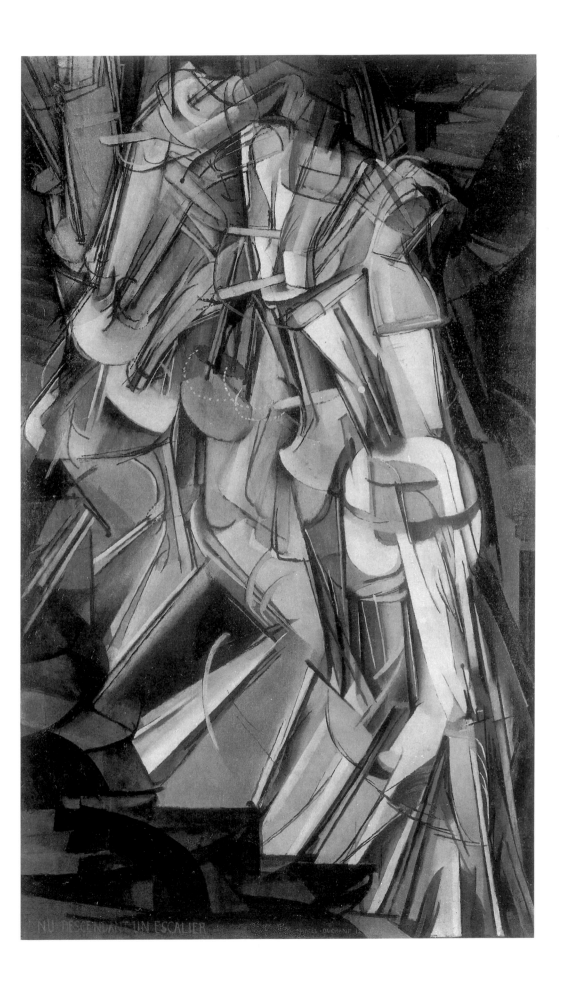

The 1930s
Realism, Magic Realism, Regionalism and Social Realism

Ivan Albright 1897–1983

49 There Comes a Time

1969, gouache on canvas, 41 × 51 cm (16 × 20 in)
Signed lower right: 'Ivan Albright'

Provenance
Private collection
Kennedy Galleries, Inc., New York
Thyssen-Bornemisza Collection, 1979

Literature
Michael Croydon, *Ivan Albright* (New York: Abbeville Press, 1978), pp. 262 and 264, pl. 135

Reproduced
Advertisement for Kennedy Galleries, Inc., New York, *Art in America* 65 (November 1977), p. 48

Exhibitions
Vatican, 1983, no. 108; Lugano, 1984, no. 106
USA tour, 1984–86, no. 107

Ivan Albright's *There Comes a Time* of 1969 resulted from a trip the artist made to Plainfield, Vermont, where he stayed at the Marsh Plain Motel.[1] Planning to paint a still-life, he had brought with him some turn-of-the-century memorabilia which had come from his mother-in-law. He painted these objects before the motel window with a view of snow-covered mountains in the distance. His original plan had been to include an apple core in the painting to 'carry the past down to the present'.[2] In the end, he used the old framed print to attain this effect.

Albright has been continuously interested in visions of the past, as he put it:

A picture – a fantasy – flashes of reality and flashes of memory. The passing reality, the dream, the memory. A flash of green sunlight – a sun spot – a cool shadow – a piece of realistic curtain – a splinter of wood. After image – a bit of sky – a patch of grass.... Trees travelling over a hill – love for an object – a cake of soap – a dish – Sunlight – the moon – part of a head.[3]

This interest in the past is certainly true in this painting as well as in many others. It contains a strange mixture of objects: a Spanish fan, mantilla, flowered tray, pitcher, framed picture of an art museum gallery of the past with sculptures on pedestals and women wearing long dresses. All of this is in sharp contrast to the view through the window which is of a barn and houses before mountains in the snow.

The soft colours of Albright's palette here recall his early works. His attention to detail is precise and his emphasis is on carefully rendered line rather than the painterly texture of heavy brushwork. About the painting of still-lifes, Albright explained: 'I walk about and put things in different positions to break up the deadness of their eternal death.'[4] Yet it is the past with which he is preoccupied in this mysterious and evocative canvas.

Notes
1 For the source of this account, see Michael Croydon, *Ivan Albright* (New York: Abbeville Press, 1978), pp. 261–62
2 *Ibid.*, refers to Albright's notebook no. 22 of March–November 1971
3 *Ibid.*, notebook no. 24 of June 1968–July 1969
4 Quoted in John Davis Stamm, 'The Shadows of Ivan Albright', *Yankee* III, no. 10 (October 1971), p. 130

Thomas Hart Benton 1889–1975

50 The City (New York Scene)

1920, oil on canvas, 86.4 × 63.5 cm (34 × 25 in)
Signed and dated lower right: 'B Th H 20'

Provenance
Graham Gallery, New York
Private collection, New York
Andrew Crispo Gallery, New York
Thyssen-Bornemisza Collection, 1975

Literature
Thomas Hart Benton, *An American in Art. A Professional and Technical Autobiography* (Lawrence, KS: University Press of Kansas, 1969), p. 87, illus.
Matthew Baigell, *Thomas Hart Benton* (New York: Harry N. Abrams, Inc., 1974), p. 71, pl. 33, as *New York, Early Twenties*
Zafran, pp. 148–49, no. 44

Exhibitions
New York, *Thomas Hart Benton*, Graham Gallery, 26 November–28 December 1968, no. 7, illus.
Australian tour, 1979–80, no. 44

Thomas Hart Benton's *The City (New York Scene)*, also published as *New York, Early Twenties*, was painted in 1920, so that the latter title makes little sense. The location depicted is Madison Square at the corner of Broadway, Fifth Avenue and 25th Street. In the park itself, the statue is of Governor William Seward by Randolph Rogers and the flagpole commemorates the victories of the First World War. Straight ahead, is the tomb of Major General Worth built in 1857.

By 1924, Benton wrote: 'The connection between form and subject is far more vital than is commonly supposed', and he suggested: 'A revival of interest in subject will get the artist out of his narrow Bohemianism....'[1] This was a radical departure from his earlier, more colourful, abstract work of the 1910s, influenced by the Synchromists, Morgan Russell and Stanton Macdonald-Wright, the latter a close friend of Benton's.[2]

Notes
[1] Thomas Hart Benton, 'Form and the Subject', *The Arts* v (June 1924), pp. 303–308, reprinted in Matthew Baigell, ed., *A Thomas Hart Benton Miscellany* (Lawrence, KS: University Press of Kansas, 1971), p. 13 and pl. 16
[2] For a discussion of the Benton's earlier work, see Gail Levin, 'Thomas Hart Benton, Synchromism, and Abstract Art', *Arts Magazine* 56 (December 1981), pp. 144–48

I

2 Camille Pissarro, *The Avenue de l'Opéra, sun on a winter morning*, 1898, Musée de Saint Denis, Reims

1 Thomas Hart Benton, *Untitled (Cityscape)*, c. 1920
Salander-O'Reilly Gallery
New York

About 1920, Benton also produced a small cityscape study (fig. 1) showing a close-up view of skyscrapers, fire escapes, chimneys, and rooftops in a range of geometric shapes and soft colours reminiscent of the reductivist works by some of the Precisionists during the 1920s. This small composition represents the kind of buildings Benton depicted from afar in *The City (New York Scene)*.

This canvas captures the tempo and energy of New York with many pedestrians on the go and tall skyscrapers soaring overhead. Benton's vantage point is looking down, probably from some nearby rooftop. Such a bird's-eye perspective for a cityscape is reminiscent of the French Impressionists, particularly Pissarro (fig. 2). The lessons of Benton's stay in Paris from 1908 to 1911, when he experimented with Impressionism, had not been totally abandoned.

Thomas Hart Benton 1889–1975

51 Going Home

1934, oil on panel, 43.2 × 53.3 cm (17 × 21 in)
Signed lower right: 'Benton'

Provenance
Ferargil Galleries New York
Clarice Blumenthal, New York
Sale, Parke-Bernet Galleries, New York, Important American Paintings, Sculpture and Drawings. 18th, 19th and
 20th Century, 10 December 1970, lot 30, illus. on the cover and on p. 39
Mr and Mrs Alexander Frohlich, New York
Sale, Sotheby's, New York, Important American 19th and 20th Century Paintings, Drawings and Sculpture,
 6 December 1984, lot 209
Thyssen-Bornemisza Collection, 1984

Literature
Matthew Baigell, *Thomas Hart Benton* (New York: Harry N. Abrams, Inc., 1974), p. 106, pl. 71.

Exhibition
Paris, *Three Centuries of American Art*, Musée de Jeu de Paume, 24 May–31 July 1938, no. 9 (as '*Retour à la
 Maison*')

At the end of his long career, Thomas Hart Benton, referring to his opinion and that of his wife, Rita, characterised his painting of 1934, *Going Home*, as 'one of our favorites'.[1] Because he wanted this work included in the major monograph (listed above) on his art then underway, Benton went to the trouble to locate the purchaser of this work from a recent sale at an auction house. His letter to the collector in question prompted him to reminisce about this picture:

> In 1928 I was driving through the back country of North Carolina's Smokey Mountains with a student friend when we came up to the cart with the two kids in the back. As it was impossible to pass them on the narrow road we slowed down and followed. While we were following I made a pencil drawing. Your picture and later a lithograph was made from that drawing.[2]

The lithograph to which Benton referred is *Goin' Home* of 1937.[3]

Benton also referred to this same trip in both of his two autobiographies and identified his student friend as Bill Hayden, with whom he made several trips: 'We started out from New York in a station wagon, equipped for camping, and toured the southern mountains, the cotton and rice and sugar country of the Deep South, and the western cattle country and the Rockies. A mass of drawings came of this expedition. . . .'[4]

During the early 1930s, Benton engaged in verbal battles with both the Social Realists and the modernists. For him, New York City became a less and less hospitable place to live and he eventually became vocally anti-urban: 'The great cities are outworn. Humane living is no longer possible within them'.[5] For Benton, his travels to regional America were inspirational, suggesting works like *Going Home*.

Benton had included rural carts in earlier paintings such as *Cotton Pickers (Georgia)* (1928–29), *Romance* (1931–32), *Morning and a Sack of Meal* (c. 1933), and he had placed a cart in the centre of his painting, *Lonesome Road* (1927). In an age of increasing urbanism and tremendous growth in numbers of automobiles and highways, Benton's fascination with this antiquated mode of transport can be seen as an aspect of his romanticism.

Notes
1 Thomas Hart Benton to Mrs Alexander Frohlich, 1 March 1971, letter is in the Thyssen-Bornemisza Collection
2 *Ibid.*
3 See Creekmore Fath, ed., *The Lithographs of Thomas Hart Benton* (Austin, TX, and London: University of Texas Press, 1979), p. 48, no. 14. In the lithograph, Benton reversed his image. This text refers to the painting, *Goin' Home* (sic), as having been produced in 1929, but all other texts refer to it as dating from 1934
4 Thomas Hart Benton, *An American in Art: A Professional and Technical Autobiography* (Lawrence, KS: University Press of Kansas, 1969), p. 61. See also the accounts of such journeys in Thomas Hart Benton, *An Artist in America* (New York: Robert McBride & Co., 1937), pp. 80–124
5 Benton, *An Artist in America*, p. 261

Thomas Hart Benton 1889–1975

52 Pop and the Boys

1963, oil on canvas, 67.7 × 47.7 cm ($26\frac{5}{8}$ × $18\frac{3}{4}$ in)
Signed lower right: 'Benton 63'

Provenance
Graham Gallery, New York
Dr and Mrs William Nuland, Scarsdale, NY
Andrew Crispo Gallery, New York
Thyssen-Bornemisza Collection, 1976

Literature
Matthew Baigell, *Thomas Hart Benton* (New York: Harry N. Abrams, Inc., 1974), pl. 205, illus.
Zafran, pp. 167–68, no. 93

Exhibitions
New York, *American Painters of the 19th and 20th Centuries*, The Gallery of Modern Art, n.d.
New York, *Thomas Hart Benton*, Graham Gallery, 26 November–28 December 1968
New York, *20th Century American Painting and Sculpture*, Andrew Crispo Gallery, 1976, no. 17
Australian tour, 1979–80, no. 93
Vatican, 1983, no. 86; Lugano, 1984, no. 84
USA tour, 1984–86, no. 86

Thomas Hart Benton's *Pop and the Boys* of 1963 is a painting which is characteristic of the Regionalist movement with which Benton was associated in the 1930s. Together with Grant Wood, John Steuart Curry and others, Benton celebrated the local populace and themes of the American mid-west. In this picture, a group of farmers gather together to make music and occupy themselves during the winter season. The bare tree on the upper right suggests that the harvest has long since passed and that their work load lightened for the present, leaving time for idling and amusement.

This kind of theme is very American on the surface, but on reflection it is the heir to the *kermesse* pictures of Pieter Bruegel and Peter Paul Rubens. Benton paints a kind of bird's-eye perspective, looking down on the musicians, evoking in the viewer a sense of participation. His composition is enlivened by colour such as the red cap of the farmer looking over the shoulder of the guitarist. Benton has included many seemingly incidental details such as the two farmers talking to each other in the middle ground. These anecdotal vignettes make the scene more convincing, adding the visual equivalent of sub-plots.

Although Benton admitted to the failure of Regionalism, he never personally gave up this style or subject matter.[1] *Pop and the Boys* is a typical late example of this idiom. Earlier, Benton had depicted farmers repeatedly and local folk musicians also appear in his work as in: *Country Dance* (1928), *Missouri Musicians* (1931) and *The Arts of the West* (1932). Benton also painted portraits of individual musicians and himself enjoyed music a great deal. Thus, *Pop and the Boys* is a quintessential Benton theme.

Note
1 See Thomas Hart Benton, *An American in Art* (Lawrence, KS: University Press of Kansas, 1969), p. 190

Charles Burchfield 1893–1967

53 Haunted Evening

1919, watercolour on paper, 40.6 × 63.5 cm (16 × 25 in)
Signed and dated lower right: 'C. Burchfield 1919'

Provenance
C. Arthur Burchfield
Mr and Mrs Henry E. Ritcher, West Seneca, NY
Lawrence and Barbara Fleischman, Detroit, MI
Mrs David Weiss
Kennedy Galleries, Inc., New York
Sale, Sotheby Parke Bernet, New York, American 19th and 20th Century Paintings, Drawings, Watercolors and
 Sculpture, 21 April 1978, lot 125
Thyssen-Bornemisza Collection, 1978

Literature
The Dial LXVIII (April 1920), p. 478, illus.
John I. H. Baur, Charles Burchfield (New York: The MacMillan Company, 1956), pp. 32–33
Joseph S. Trovato, Charles Burchfield, Catalogue of Paintings in Public and Private Collections (Utica, NY:
 Munson-Williams-Proctor Institute, 1970), p. 86, no. 538
John I. H. Baur, The Inlander: The Life and Work of Charles Burchfield, 1893–1967 (Newark, DE: University of
 Delaware Press, 1982), p. 94, illus. fig. 67, and p. 96

Exhibitions
New York, Drawings in Watercolor by Charles Burchfield, Kevorkian Gallery, 16–28 February 1920, no. 50
Charles Burchfield, January 1956–February 1957, no. 31, pl. 17, illus.
 New York, Whitney Museum of American Art
 Baltimore, MD, Baltimore Museum of Art
 Boston, MA, Museum of Fine Arts
 San Francisco, CA, San Francisco Museum of Art
 Los Angeles, CA, Los Angeles County Museum
 Washington, DC, Phillips Collection
 Cleveland, OH, Cleveland Museum of Art
Worcester, MA, The Dial and the Dial Collection, Worcester Art Museum, 30 April–8 September 1959, no. 8

Charles Burchfield commented that *Haunted Evening*, painted in 1919 was 'A reminiscence of South Carolina where I spent six months in the Army. . . . A man coming home to his little cabin, carrying his sack of provender, fearful of the eerie, haunted, skull-like woods that stands behind his home, against a lurid sunset sky.'[1] The previous year Burchfield had become interested in conveying the current adverse social and economic conditions and in trying to portray the 'hardness of human lives', even creating portraits of houses expressing the misery all around them.[2]

Burchfield has surely succeeded in communicating these uneasy feelings in *Haunted Evening*. The only figure, that of a male, stooped over from the weight of his thoughts and his burden, is truly a downtrodden figure. His awkwardness is emphasised by his head and feet which seem too large for his height. We are made to compare his stature with that of the dead tree stump in the middle distance on the right. The little cabin is a pitiful sight, its haphazard boards and roof seem about to collapse. This is an extremely expressive picture, full of moodiness and gloom.

Notes
1 Quoted in Jack Baur, *Charles Burchfield* (New York: Whitney Museum of American Art, 1956), n.p., next to pl. 17
2 See Joseph S. Travato, *Charles Burchfield, Catalogue of Paintings in Public and Private Collections* (Utica, NY: Munson-Williams-Proctor Institute, 1970), p. 73

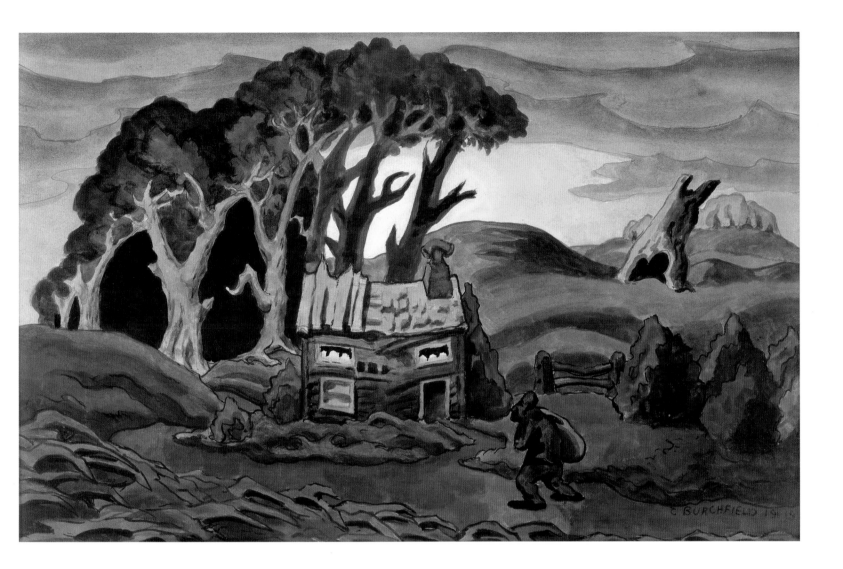

Note
3 Alfred H. Barr, Jr, 'Introduction',
 *Charles Burchfield: Early
 Watercolors* (New York:
 Museum of Modern Art, 1930),
 p. 5

The light in the sky is disconcerting and the trees seem to have come to life as threatening beings.

This watercolour is from Burchfield's early Romantic period which was celebrated by an exhibition at the Museum of Modern Art in 1930. Alfred Barr, who later showed little interest in Burchfield, championed this period of his career, noting that he had 'concentrated upon the expression of moods and emotions on the one hand, and on the other upon specific forces and even sounds and movements of nature. His method was neither vague nor spontaneous as is frequent in expressionistic painting, but deliberate and precise'.[3]

Burchfield utilised a palette of primarily earth tones dramatised by the interjection of the bright yellow light in the sky. The artist still in his twenties when he painted *Haunted Evening* was soon to abandon such imaginative scenes in favour of more realistic depictions of the world around him. His work would, however, maintain the sense of movement seen here: that of clouds, trees, the wind and other natural phenomena.

Charles Burchfield 1893–1967

54 July Drought Sun

1949–60, watercolour on paper, 114.3 × 137.2 cm (45 × 54 in)
Signed and dated lower right: 'C.B. 1949–60'

Provenance
Mr and Mrs Charles S. Trattler, Kings Point, NY
Harry Spiro, New York
Private collection, Detroit, MI
Andrew Crispo Gallery, New York
Thyssen-Bornemisza Collection, 1977

Literature
Margaret Breuning, 'Burchfield's Recent Work', *Arts* 35 (January 1961), p. 50, illus.
Joseph S. Trovato, *Charles Burchfield, Catalogue of Paintings in Public and Private Collections* (Utica, NY:
 Munson-Williams-Proctor Institute, 1970), p. 282, no. 1213

Exhibitions
New York, *Paintings by Charles Burchfield*, Frank K.M. Rehn Gallery, 3–28 January 1961
New York, *Charles Burchfield Watercolors*, Andrew Crispo Gallery, 1976, no. 7
New York, *20th Century American Painting and Sculpture*, Andrew Crispo Gallery, 1977, no. 2
Australian tour, 1979–80, no. 85

Burchfield began *July Drought Sun* in 1949 and reworked and finished it in 1960, at the time he was seeking to return to the style of his earlier work. He must have begun this watercolour while he was in Duluth teaching summer classes at the University of Minnesota. While there, Burchfield met the editor of a local newspaper who was a Finnish immigrant and who introduced him to many Finnish writers' depictions of landscape and nature. This enhanced his own awareness of the subtleties of the seasons and the weather which he conveys in this watercolour.

In the foreground the wilted vegetation has turned brown and appears to be drooping over, waiting for rain. In the distance a pond on the horizon is shown to be evaporating on the hot July day, literally being sucked up by the heat of the sun. The sun itself is encircled by bright orange and appears intense and powerful, raining its unforgiving rays down upon the parched landscape. In this work, Burchfield's paint is applied in short, animated lines, creating a sense of frenzy in nature rather than calm.

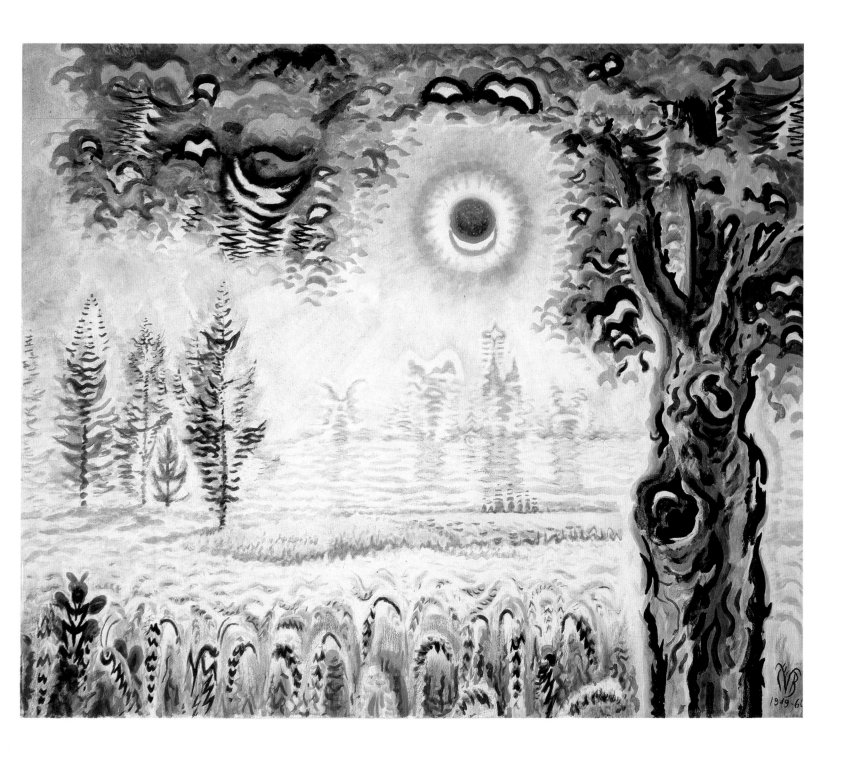

Charles Burchfield 1893–1967

55 Cicada Woods

1950–59, watercolour, crayon and chalk on paper, 103 × 132 cm (40½ × 52 in)
Signed with monogram and dated lower right: 'CB 1950–59'

Provenance
Estate of the artist
Kennedy Galleries, Inc., New York
Thyssen-Bornemisza Collection, 1980

Literature
Joseph S. Trovato, *Charles Burchfield, Catalogue of Paintings in Public and Private Collections* (Utica, NY: Munson-Williams-Proctor Institute, 1970), p. 276, no. 1179

Exhibitions
Utica, NY, *The Nature of Charles Burchfield – A Memorial Exhibition*, Munson-Williams-Proctor Institute, 9 April–31 May 1970
Vatican, 1983, no. 92; Lugano, 1984, no. 90
USA tour, 1984–86, no. 92

Burchfield evidently decided to rework this watercolour which he had earlier considered finished enough to sign. An early photograph of this watercolour is extant, showing a signed work but missing important changes that the artist made subsequently including the washing out of large areas and other additions made in crayon and chalk.[1]

Burchfield spent his summer in 1950 teaching at both Ohio University in Athens, Ohio and at the University of Buffalo. *Cicada Woods* might have been painted at either place. It is surely the sound of this mysterious, seldom seen, insect that Burchfield attempted to evoke with his watercolour. The eerie steady hum of the cicadas fill the late summer air, although some varieties appear only in cycles, taking longer than a decade to mature to the short-lived humming state.

Burchfield's rhythmic animated lines suggest the repetitious sound of the cicada. The clouds which seem to rise in patterns against the sky also evoke the sound, like a diagram of an echo. Burchfield's woods are enigmatic and dense. Amid the thick lush late summer foliage, we see the outlines of some unknown creatures, more from the artist's imagination than from reality. His aim is to tease us into sharing his fantasies about the mysterious forms found in nature.

Note
1 Joseph S. Trovato, *Charles Burchfield, Catalogue of Paintings in Public and Private Collections* (Utica, NY; Munson-Williams-Proctor Institute, 1970)

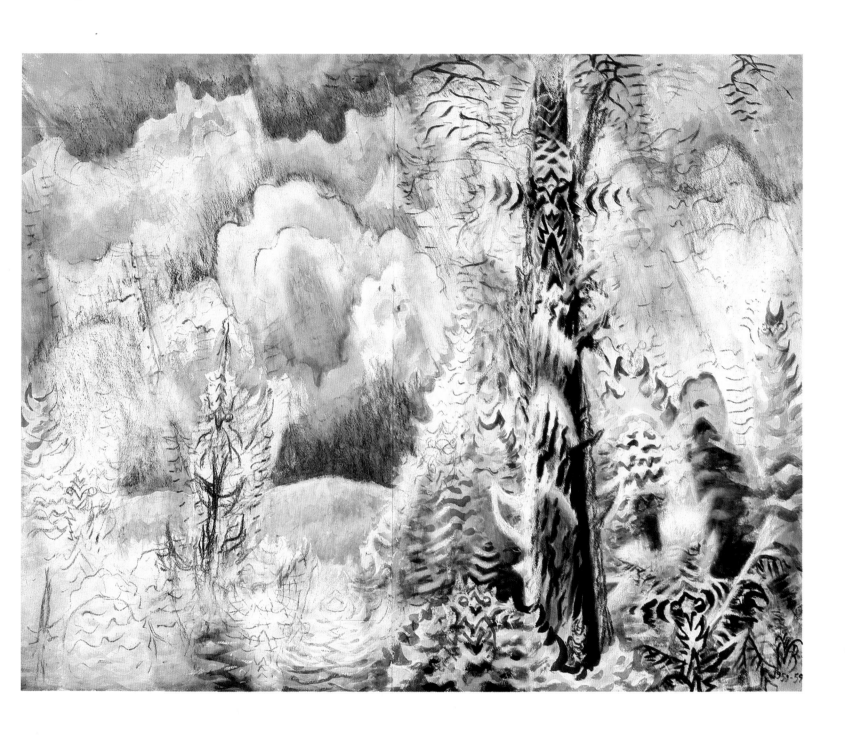

Charles Burchfield 1893–1967

56 Orion in Winter

1962, watercolour on paper, 122 × 137 cm (48 × 54 in)
Signed with monogram and dated lower right: 'CB 1962'

Provenance
Estate of the artist
Kennedy Galleries, Inc., New York
Thyssen-Bornemisza Collection, 1977

Literature
Joseph S. Trovato, *Charles Burchfield, Catalogue of Paintings in Public and Private Collections* (Utica, NY:
 Munson-Williams-Proctor Institute, 1970), p. 296, no. 1260
Matthew Baigell, *Charles Burchfield* (New York: Watson-Guptill Publications, 1976), p. 156, pl. 42
Baur, pp. 22, 119, illus., no. 93
John I. H. Baur, *The Inlander: The Life and Work of Charles Burchfield, 1893–1967* (Newark, DE: University of Delaware
 Press, 1982), pp. 248, 252, and 252, illus., pl. XLVIII

Exhibitions
Buffalo, NY, *Charles Burchfield: Recent Paintings*, Upton Hall Gallery, State University College at Buffalo,
 24 April–19 May 1963
Philadelphia, PA, *Paintings by Charles Burchfield*, Peale House Galleries of the Pennsylvania Academy of the Fine
 Arts, 3 December 1964–3 January 1965
Tucson, AZ, *Charles Burchfield, His Golden Year, A Retrospective Exhibition of Watercolors, Oils and Graphics*,
 University of Arizona Art Gallery, 14 November 1965–9 January 1966, pl. 24
New York, *Charles Burchfield*, Frank K. M. Rehn Gallery, 3–29 October 1966
Buffalo, NY, Dedication, Charles Burchfield Center, State University College at Buffalo, 9 December 1966
Buffalo, NY, Exhibition in connection with Burchfield Commemorative Program, Charles Burchfield Center,
 State University College at Buffalo, 1 October 1967–30 January 1968
Buffalo, NY, Inaugural Tribute Exhibition, Charles Burchfield Center, State University College at Buffalo,
 10 May–27 September 1968
Buffalo, NY, *Burchfield International Exhibition: Paintings from Museums and Private Collections from Different Countries*,
 Charles Burchfield Center, State University College at Buffalo, 21 October 1968–16 February 1969
Utica, NY, *The Nature of Charles Burchfield – A Memorial Exhibition*, Munson-Williams-Proctor Institute,
 9 April–31 May 1970
Vatican, 1983, no. 93; Lugano, 1984, no. 91
USA tour, 1984–86, no. 93

Burchfield's *Orion in Winter* of 1962 is a celebration of the season. The title refers to the constellation Orion which is named for the giant hunter of Boeotia who, after his death, was placed among the stars on the equator east of Taurus. This dramatic constellation visible in the winter sky inspired and haunted Burchfield. In 1962, he explained that he was referring to the many notes and sketches that he had made as a young man forty-five years earlier in 1917.[1] Burchfield felt that 1917 was his 'golden year', during which he was quite productive and experimented with the visualisation of sounds.[2]

Orion in Winter is an evocative, fantastic scene of the snow seen under the stars in the moonlight. There are fabulous swirls in the sky representing the starlight and reflections on the frigid stream of water in the middle ground. It is a miraculous night sky like that on a Christmas card. In this painting, Burchfield depicts nature in general and winter in particular as surprising and delightful.

Notes
1 Joseph S. Trovato, *Charles Burchfield, Catalogue of Paintings in Public and Private Collections* (Utica, NY: Munson-Williams-Proctor Institute, 1970), p. 295
2 *Ibid.*, p. 55

Charles Burchfield 1893–1967

57 Dream of a Storm at Dawn

1963–66, watercolour on paper, 76.2 × 102 cm (30 × 40 in)
Signed with monogram and dated lower left: 'CB 1963–1966'

Provenance
Frank K.M. Rehn Gallery, New York
Mr and Mrs Joseph Kriegler, Lackawana, NY
Kennedy Galleries, Inc., New York
Thyssen-Bornemisza Collection, 1981

Literature
Joseph S. Trovato, *Charles Burchfield, Catalogue of Paintings in Public and Private Collections* (Utica, NY: Munson-Williams-Proctor Institute, 1970), p. 314, no. 1323

Exhibitions
New York, *Charles Burchfield*, Frank K.M. Rehn Gallery, 3–29 October 1966
Buffalo, NY, Dedication, Charles Burchfield Center, State University College at Buffalo, 9 December 1966
Buffalo, NY, Inaugural Tribute Exhibition, Charles Burchfield Center, State University College at Buffalo, 10 May–27 September 1968
Buffalo, NY, Permanent and Loan Collection Exhibition, Charles Burchfield Center, State University College at Buffalo, 1971
New York, *Charles E. Burchfield, The Late Years and Selected Earlier Works*, Kennedy Galleries, Inc., 10 October–3 November 1979, no. 31
Vatican, 1983, no. 94; Lugano, 1984, no. 92
USA tour, 1984–86, no. 94

Burchfield's watercolour, *Dream of a Storm at Dawn* of 1963–66, is a romantic late work which dramatises the landscape and focuses on the marvellous qualities of natural phenomena. The artist has included rain and a rainbow, lightning and sunlight. The trees on the left appear almost as if they are on fire. Man and nature are contrasted as small log cabins are visible just behind the pond surrounded by many tree stumps, the reminder of man's endeavours.

Nature is at once threatening, as is shown by the lightning in the sky on the upper right, and promising, as is suggested by the brilliant colourful rainbow. Man might mar the landscape cutting its trees to build shelter or to stay warm, but nature prevails in the end, burning trees with bolts of lightning or causing floods.

Burchfield's late style is expressive and dramatic. He returned to the rhapsodic visions of his youth and continued to explore the secrets of nature. His is an expressionist vision, a poetic celebration of his perceptions of the natural world around him. He conveyed mood through the natural phenomena that he depicted in his expansive watercolours of the landscape. It is Burchfield's emotional quality that distinguishes his watercolours, making them very personal communications, individual responses to the tiniest natural events as well as to the more obvious phenomena such as storms and seasonal changes.

Guy Pène du Bois 1884–1958

58 Le Viol

c. 1927, oil on canvas, 101.6 × 72.6 cm (40 × 30 in)
Signed lower left: 'Guy Pene du Bois'

Provenance
Estate of the artist
Andrew Crispo Gallery, New York
Thyssen-Bornemisza Collection 1979

Literature
Amerika Traum und Depression 1920/40 (Berlin Akademie der Kunste, 1980), no. 116, p. 175
Baur, pp. 163, 100, illus., no. 74

Exhibitions
Amerika Traum und Depression 1920/40, November 1980–February 1981, no. 116
 Berlin, Akademie der Kunste
 Hamburg, Kunstverein
Vatican, 1983, no. 74; Lugano, 1984, no. 72
USA tour, 1984–86, no. 74

Guy Pène du Bois probably painted *Le Viol* about the same time as he painted *Americans in Paris* in 1927 during one of the periods he was living in France. He chose a title which means 'violation' or 'rape' and was surely aware of the painting *The Interior* by Degas that had come to be known by this title. Degas placed a man standing against the door of an interior watching a woman intensely. Du Bois is much more explicit. The setting he has chosen is that of a street of cheap hotel rooms, a sign offering 'ROOMS' is visible in the distance. This suggests that the setting may have been America rather than Paris, although such advertising might have appeared in English there.

In *Le Viol*, we see a man, his expression partially hidden by the shadow cast by his hat, grabbing the forearm of a woman, pulling her in his direction. He holds the railing of the entry and turns his head abruptly toward the street, apparently to see if he is being watched. He is, of course, for Guy Pène du Bois has cast the spectator in the role of witness or voyeur. The woman holds her hat on her head and looks glum, although she makes no apparent effort to resist. Her tense lips are bright red, her eyes cast downward. She is neatly and elegantly dressed, wearing a skirt that skims the top of her knees and a belt that shows off her tiny waistline.

Guy Pène du Bois utilised the compositional device of standing figures seen against a vertical railing in several paintings of the late 1920s: *Racetrack Deauville* (1927), *Americans in Paris* (1927) and *Approaching Storm, Racetrack* (1929). In *Le Viol*, the rail is repeated on a diagonal back into the depth of the painting.

Le Viol captures a dramatic moment. It is a nocturnal painting. Du Bois would have known the contemporary nocturnal scenes by his friend Edward Hopper but those never depict such violence or action. This painting may have had a literary reference but exactly what inspired the artist has not yet come to light. Nonetheless the impact of the composition is undiminished.

Guy Pène du Bois 1884–1958

59 Forty-second Street

1945, oil on canvas, 82.5 × 66 cm (32½ × 26 in)
Signed lower right: 'Guy Pene du Bois'

Provenance
Mr and Mrs Howard Weingrow, Old Westbury, NY
Warren Adams Collection, New York
Andrew Crispo Gallery, New York
Thyssen-Bornemisza Collection, 1981

Literature
Betsy Fahlman, 'Guy Pene du Bois: A Reevaluation' in *Guy Pene du Bois: Artist about Town* (Washington DC:
 Corcoran Gallery of Art, 1980), no. 82, p. 96, illus., pp. 37–38

Exhibition
Washington, DC, *Guy Pene du Bois: Artist about Town*, Corcoran Gallery of Art, 10 October–30 November 1980,
 no. 82, p. 96, illus.

Guy Pène du Bois painted *Forty-second Street* in 1945, several years after he had suffered his second heart attack. He was painting less because of his poor health and his work was not selling well, causing him to terminate his relationship with the Kraushaar Gallery who had represented him for more than twenty-five years.[1] At least one writer had observed the effect of du Bois' troubles on this canvas: 'His previous biting wit and impassive monumental figures are replaced by a genial view of vulnerable insubstantial humans. He has lost none of his powers of sharp observation of contemporary types, but the mood is nostalgia tinged with ennui'.[2]

Guy Pène du Bois was a keen observer of human behaviour. He liked to depict people he might see passing by. These promenade pictures began as early as his first stay in Paris in 1905 and they continue through to *Forty-second Street*. *Americans in Paris* of 1927 (fig. 1) is very much in this tradition. At least one of the four women turns her face towards the artist-spectator. In *Forty-second Street*, we see more people and more faces; the sensation is that of the crowd rushing past in mid-town Manhattan in the heart of New York City.

Notes
1 For more on this period, see
 Betsy Fahlman, 'Guy Pene du
 Bois: A Reevaluation' in *Guy
 Pene du Bois: Man about Town*
 (Washington, DC: Corcoran
 Gallery of Art, 1980),
 pp. 36–39
2 *Ibid.*, pp. 37–38

The skyscrapers are visible in the distance reminding the viewer that these are New York's sophisticated ladies elegantly dressed in the latest fashions. The artist has paid considerable attention to their dresses as well as to their hats, jewellery, high-heeled shoes and bright red lipstick. The two women in the foreground steal our attention; two more women on the right and two men on the left stand out from the crowd behind them. The strong sunlight and shadows on the pavement suggest that this is the lunch-hour crowd.

Guy Pène du Bois' figures are more stylised and less like illustrations than those of his contemporary Reginald Marsh who painted similar street scenes in New York. There is perhaps some similarity between du Bois' generalised figures and those in the early work of Edward Hopper, his friend and fellow classmate at the New York School of Art. Yet, du Bois never attained Hopper's solemn monumentality.

Forty-second Street is filled with incident and the ambiance of New York. We see the woman on the right catch the arm of the woman on the left who gracefully twists her neck, turning her face towards her companion. The casual gesture the woman on the right makes with her hand toward her friend allows her to wave her arm across the centre of this composition. This event holds our attention, provokes our curiosity, and animates the whole.

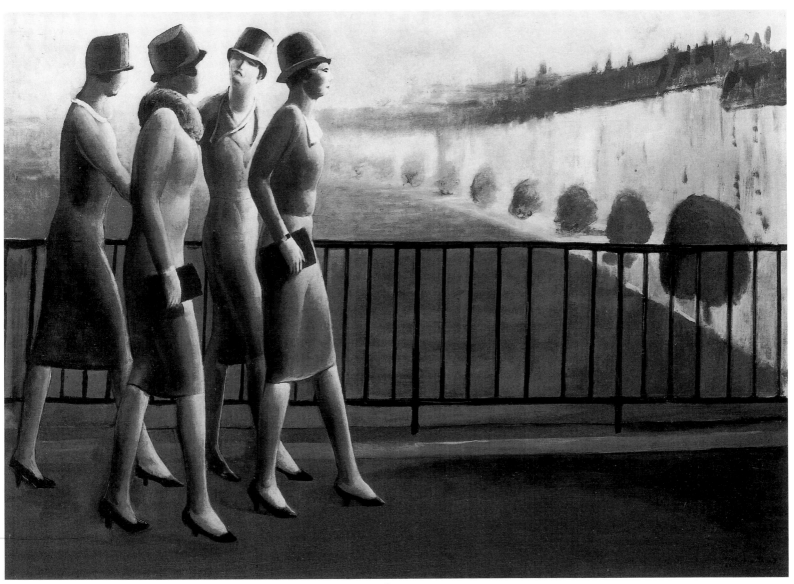

1 Guy Pène du Bois, *Americans in Paris*, 1927, Museum of Modern Art, New York

Edward Hopper

1882–1967

60 Self-portrait

c.1904, oil on canvas, 50.8 × 40.6 cm (20 × 16 in)

Provenance
Private collection
Kennedy Galleries, Inc., New York
Thyssen-Bornemisza Collection, 1977

Literature
Gail Levin, *Edward Hopper at Kennedy Galleries* (New York: Kennedy Galleries, Inc., 1977), no. 1, illus.
Gail Levin, 'Patrick Henry Bruce and Arthur Burdett Frost, Jr.: From the Henri Class to the Avant-garde', *Arts Magazine* 53 (April 1979), p.103, illus., fig.4, p.102
Gail Levin, *Edward Hopper: The Art and the Artist* (New York: W.W. Norton & Co., 1980), p.9, pl.15
Edward Hopper 1882–1967 (London: Arts Council of Great Britain, 1981), no.7
Gail Levin, *Edward Hopper* (New York: Crown Publishers, Inc., 1984), p.10, frontispiece illus.

Exhibitions
New York, *Edward Hopper at Kennedy Galleries*, Kennedy Galleries, Inc., 11 May–8 June 1977, no.1
Edward Hopper: The Art and the Artist, September 1980–February 1982
New York, Whitney Museum of American Art
London, Hayward Gallery
Amsterdam, Stedelijk Museum
Düsseldorf, Städtische Kunsthalle
Chicago, IL, Art Institute of Chicago
San Francisco, CA, San Francisco Museum of Modern Art

1 Edward Hopper, *Self-portrait*, 1903, charcoal on paper
National Portrait Gallery, Smithsonian Institution, Washington, DC

This somewhat melancholy *Self-portrait* is painted in the dark palette characteristic of students at the New York School of Art where Hopper studied portraiture with both William Merritt Chase and Robert Henri, his favourite teacher at the school. Several oil self-portraits and many portraits survive from Hopper's student years. All are painted in the same dark tones and painterly brushstrokes. Hopper also produced many self-portrait caricatures during his formative years. His focus on himself cannot be attributed entirely to his lack of another willing model, for he was always pensive and introspective.

This canvas, which has the name 'Bruce' painted boldly across the entire back of the canvas, was evidently discarded or given to Hopper by his classmate at the New York School of Art, Patrick Henry Bruce, when he left to go to Paris in late 1903. An x-ray of this painting revealed that Hopper turned Bruce's frontal portrait upside down to paint this self-portrait in profile.[1]

Hopper's *Self-portrait* can also be dated by its style including the somber palette and thick, brushy paint application. The style coincides with the date Bruce left their art class. This canvas bears comparison with a charcoal *Self-portrait* sketch dated November 1903 (fig.1), which is also a three-quarter profile view but from the opposite direction. We can recognise the similarity of approach and Hopper's long straight hair which he would soon lose to baldness. Upon leaving art school and his portrait class, Hopper lost interest in both repeated self-portraits and portraits which he only occasionally painted.

Note
1 Conducted by the author with the assistance of Professor Lawrence J. Majewski, Institute of Fine Arts, New York University. See Gail Levin, 'Patrick Henry Bruce and Arthur Burdett Frost, Jr.: From the Henri Class to the Avant-garde', *Arts Magazine* 53 (April 1979), p.103

Edward Hopper 1882–1967

61 Girl at a Sewing Machine

c. 1921, oil on canvas, 48.3 × 46 cm (19 × 18 in)
Signed lower left: 'EDWARD HOPPER'

Provenance
Frank K. M. Rehn Gallery, New York
Mr and Mrs John Clancy
Kennedy Galleries, Inc., New York
Thyssen-Bornemisza Collection, 1977

Literature
Memorial Exhibition: Lee Gatch, Hans Hofmann, Edward Hopper, Henry Schnakenberg, Charles Sheeler (New York:
 American Academy of Arts and Letters, 1971), no. 3
In Search of the Present: The American Prophets (Coral Gables, FL: Lowe Art Museum, University of Miami, 1973),
 no. 49
Sound and Silence: Charles E. Burchfield/ Edward Hopper (New Britain, CT: New Britain Museum of American Art,
 1973), no. 48.
Oils and Watercolors by Edward Hopper (Ogunquit, ME: Museum of Art, 1975) no. c-4, illus.
Gail Levin, *Edward Hopper at Kennedy Galleries* (New York: Kennedy Galleries, Inc., 1977), no. 1, illus.
Gail Levin, *Edward Hopper: The Complete Prints* (New York: W. W. Norton & Co., 1979), p. 30, fig. 48
Zafran, pp. 20, 149, no. 45
Gail Levin, *Edward Hopper: The Art and the Artist* (New York: W. W. Norton & Co., 1980), p. 9, pl. 15
Edward Hopper 1882–1967 (London: Arts Council of Great Britain, 1981), no. 11, no. 64
Edward Hopper: Das Frühwerk (Münster: Westfalisches Landesmuseum für Kunst und Kulturgeschichte, 1981),
 pp. 30, 35, 36, 39–40, fig. 11
Lieberman, p. 58, no. 49
Gail Levin, *Edward Hopper* (New York: Crown Publishers, Inc., 1984), p. 40, p. 20, illus.

Exhibitions
New York, *Memorial Exhibition: Lee Gatch, Hans Hofmann, Edward Hopper, Henry Schnakenberg, Charles Sheeler*,
 American Academy of Arts and Letters, 1971, no. 3
Coral Gables, FL, *In Search of the Present: The American Prophets*, Lowe Art Museum, University of Miami, 1973,
 no. 49
New Britain, CT, *Sound and Silence: Charles E. Burchfield/Edward Hopper*, New Britain Museum of American Art,
 1973, no. 48
Ogunquit, ME, *Oils and Watercolours by Edward Hopper*, Museum of Art, 1975, no. c-4
New York, *Edward Hopper at Kennedy Galleries*, Kennedy Galleries, Inc., 11 May–8 June 1977, no. 1
Australian tour, 1979–80, no. 45
Edward Hopper: The Art and the Artist, September 1980–February 1982
 New York, Whitney Museum of American Art
 London, Hayward Gallery
 Amsterdam, Stedelijk Museum
 Düsseldorf, Städtlische Kunsthalle
 Chicago, IL, Art Institute of Chicago
 San Francisco, CA, San Francisco Museum of Modern Art
USA tour, 1982–83, no. 49

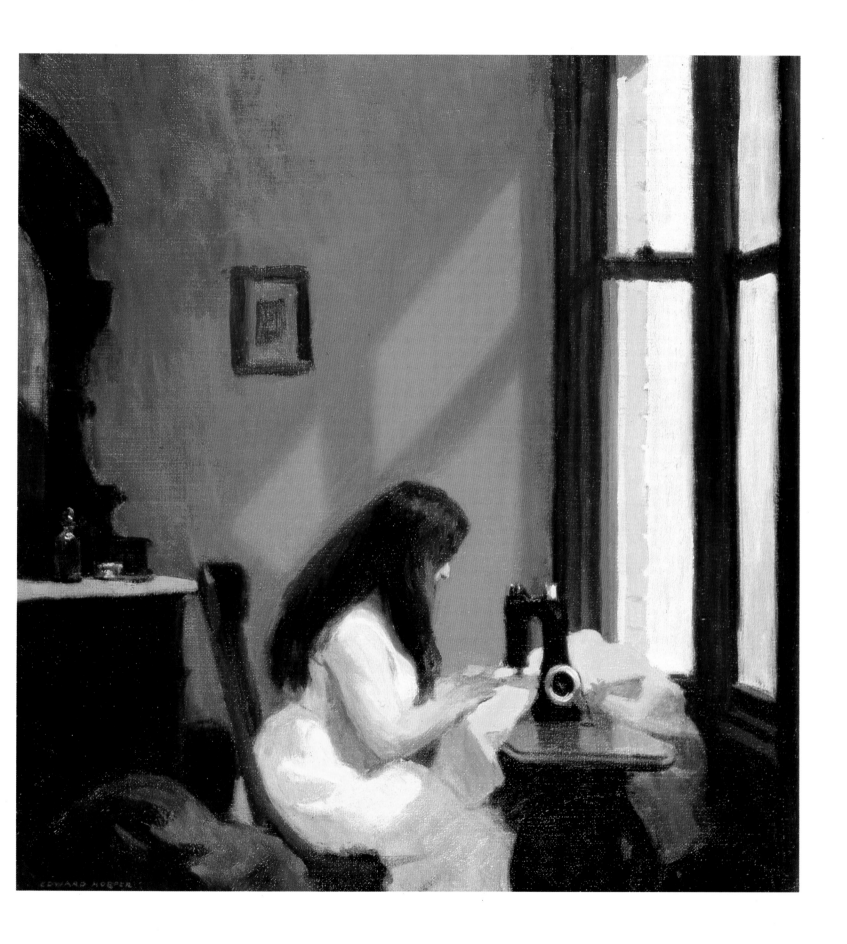

Girl at a Sewing Machine is one of the first oils in what can be considered Hopper's mature style. The focus on the solitary figure observed unaware and the attention to sunlight pouring in the window are characteristic aspects of Hopper's style. The artist has cast the spectator in the role of voyeur. As in his etching *East Side Interior* of 1922 (fig. 1), a woman is shown sewing by a window which helps to define the space. A framed picture hangs on the wall in both compositions. In the painting, however, as opposed to the etching, the woman concentrates on her sewing.

During the early 1920s, Hopper painted several canvases of solitary women alone in interiors, seemingly unaware of the artist looking on. In addition to *Girl at a Sewing Machine*, *Moonlight Interior* (1921–23) and *New York Interior* (c.1921) deal with this theme. In each of these compositions, the curved figure of the woman is set within the geometrical architectural elements of the domestic interior.

The long-haired female in each of these canvases appears to be the same model. A slight glimpse of her nose peeking out from behind her mane of hair is as much as we see of her. We know that after Hopper married in July 1924 his wife Jo insisted that she be his only model. Since we know that their courtship began in earnest in Gloucester during the summer of 1923, we may ask who this woman was. If not imaginary, this figure may be based upon a life model Hopper sketched in the group sessions he attended at the Whitney Studio Club or elsewhere. While he certainly might have observed his sister Marion sewing, she would not have posed for the nude in *Moonlight Interior*.

At this time in his career, Hopper found inspiration in the work of John Sloan, particularly in his response to the environment of New York after he had moved there from Philadelphia. 'Sloan not having been abroad, has seen these things with a truer and fresher eye than most,' commented Hopper.[1] Hopper's choice of subject matter at this time probably reflects Sloan's influence. The woman observed unaware in a domestic interior occurred in Sloan's work such as *The Cot*, an oil of 1907, which Hopper had seen in the 1908 exhibition of The Eight, or *Three A.M.*, an oil of 1909, which Hopper saw in the Independents Exhibition of 1910, in which he participated.

In many ways, *Girl at a Sewing Machine* suggests Hopper's subsequent investigation of the theme of the solitary woman in an interior seen with sunlight streaming in through a window which he explored in a number of later works including: *Eleven A.M.* (1926), *Room in Brooklyn* (1932), *Morning in a City* (1944) and *Morning Sun* (1952).

Note
1 Edward Hopper, 'John Sloan and the Philadelphians', *The Arts* 11 (April 1927), p.171

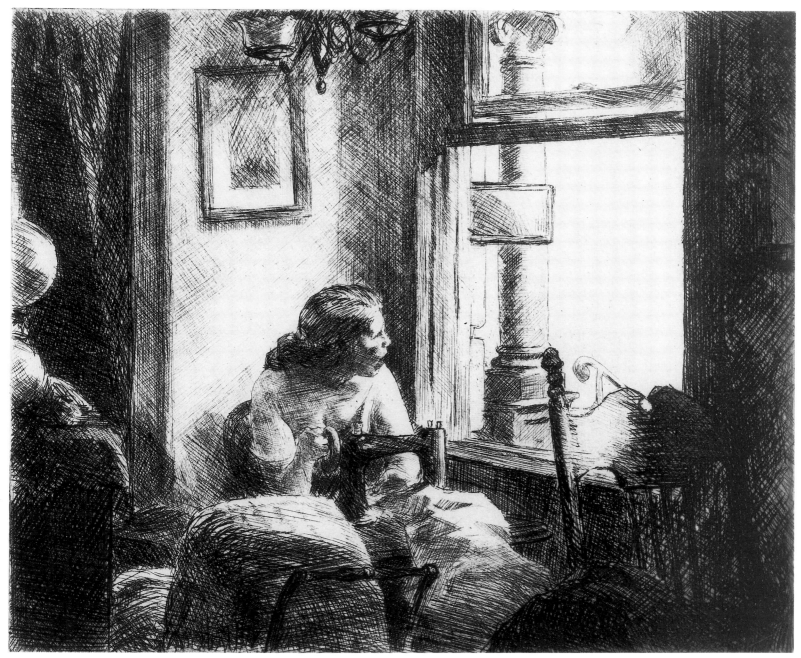

1 Edward Hopper, *East Side Interior*, 1922, etching, British Museum, London

Edward Hopper 1882–1967

62 Two Nude Models

1922–24, sanguine on paper, 56 × 38 cm (22 × 15 in)
Signed and inscribed lower right: 'Edward Hopper/To my wife Jo'

Provenance
Mrs Edward Hopper
Private collection
Kennedy Galleries, Inc., New York
Thyssen-Bornemisza Collection, 1976

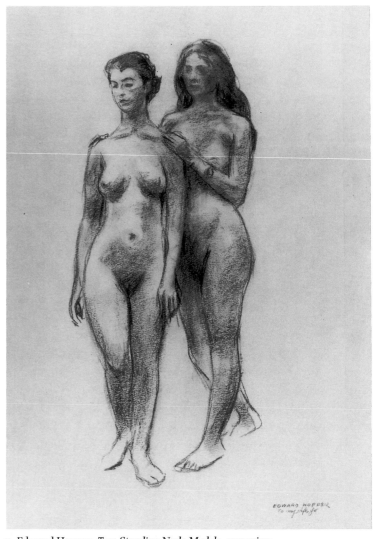

1 Edward Hopper, *Two Standing Nude Models*, sanguine
Whitney Museum of American Art, New York

This drawing depicts the same two models who appear in a sanguine drawing of two standing nudes (fig. 1). Also inscribed 'To my wife Jo', these drawings may represent Hopper's attempt to pacify Jo who resented his having models other than herself. Hopper probably sketched these two women in the sketch classes at the Whitney Studio Club in New York, then at 10 West Eighth Street. The artists each contributed twenty-five cents as a fee to pay for the cost of the model or models.

In both of these related drawings, Hopper experimented with depicting the two female bodies close together, one seen just behind the other. This drawing of two models together is not a characteristic Hopper subject or pose and so the models' position must have been determined by others working there. Nonetheless, Hopper catches the model on the left with her head downcast, a moody posture that would occur in paintings like *Hotel Room* of 1931 [65]. The rough sketchy nature of the line in this drawing suggests that it was quickly executed.

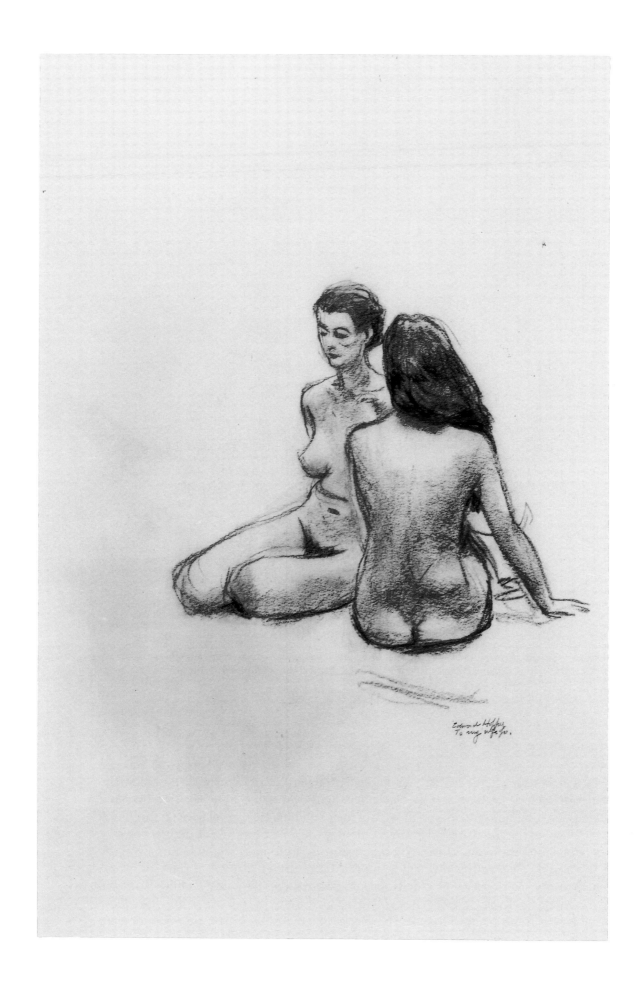

Edward Hopper 1882–1967

63 My Roof

1928, watercolour on paper, 35 × 30 cm (14 × 20 in)
Signed lower right: 'Edward Hopper, New York'

Provenance
Frank K. M. Rehn Gallery, New York
Dr and Mrs Henry H. M. Lyle
Van Brink Galleries
Mr and Mrs Leo J. Goldshlag, New Rochelle, NY
Kennedy Galleries, Inc., New York
Thyssen-Bornemisza Collection, 1977

Literature
Lloyd Goodrich, *Edward Hopper* (New York: Harry N. Abrams, 1971), illus., p. 80
Baur, pp. 23, 170, 126, illus., no. 100

Exhibitions
New York, *Exhibition by Edward Hopper*, Frank K. M. Rehn Galleries, 21 January–2 February 1929, cat. no. 13
New York, *Edward Hopper Retrospective*, Museum of Modern Art, 1933, cat. no. 50
Chicago, IL, *Exhibition of Paintings by Edward Hopper*, Arts Club of Chicago, 2–16 January 1934, cat. no. 40
Pittsburgh, PA, *An Exhibition of Paintings, Water Colors and Etchings by Edward Hopper*, Museum of Art, Carnegie
 Institute, 11 March–25 April 1937
New York, *A History of American Watercolour Paintings*, Whitney Museum of American Art, 27 January–
 25 February 1942
Edward Hopper Retrospective Exhibition, February–July 1950, no. 101
 New York, Whitney Museum of American Art
 Boston, MA, Museum of Fine Arts
 Detroit, MI, Detroit Institute of Arts
Edward Hopper, September 1964–May 1965, no. 100
 New York, Whitney Museum of American Art
 Chicago, IL, Art Institute of Chicago
 Detroit, MI, Detroit Institute of Arts
 St Louis, MO, St Louis Art Museum
Edward Hopper 1882–1967 Oils Watercolors Etchings, July–October 1971, no. 28
 Rockland, ME, William A. Farnsworth Library and Art Museum
 Philadelphia, PA, Pennsylvania Academy of the Fine Arts
New York, *Edward Hopper at Kennedy Galleries*, Kennedy Galleries Inc., 11 May–8 June 1977, no. 20
Vatican, 1983, no. 100; Lugano, 1984, no. 98
USA tour, 1984–86, no. 100

Jo Hopper listed this work in the record book she kept of Edward's work and made the comment: '3 Washington Square, North, N.Y. City. Skylight & light over hall & grey glass red tin rim'.[1] This watercolour is painted outdoors on the roof of their building. Hopper focused on the play of light and shadow on the structures on his roof: chimneys, smokestacks and skylights.

This watercolour continued a theme he had begun in a group of watercolours in 1926: *Roofs of Washington Square*, *Skylights* and an untitled and unsigned view of rooftops. These works finally resulted in Hopper's oil, *City Roofs*, painted in 1932. That same year he also began *November, Washington Square*, in which he painted the view from his roof down onto the square with the Judson Church in the distance. Hopper, who liked his solitude, probably enjoyed working in the isolation of his own roof convenient to his top floor studio.

Note
1 These volumes, bequeathed to Lloyd Goodrich, are now in the Collection of the Whitney Museum of American Art. This watercolour is listed in Volume I, p. 67

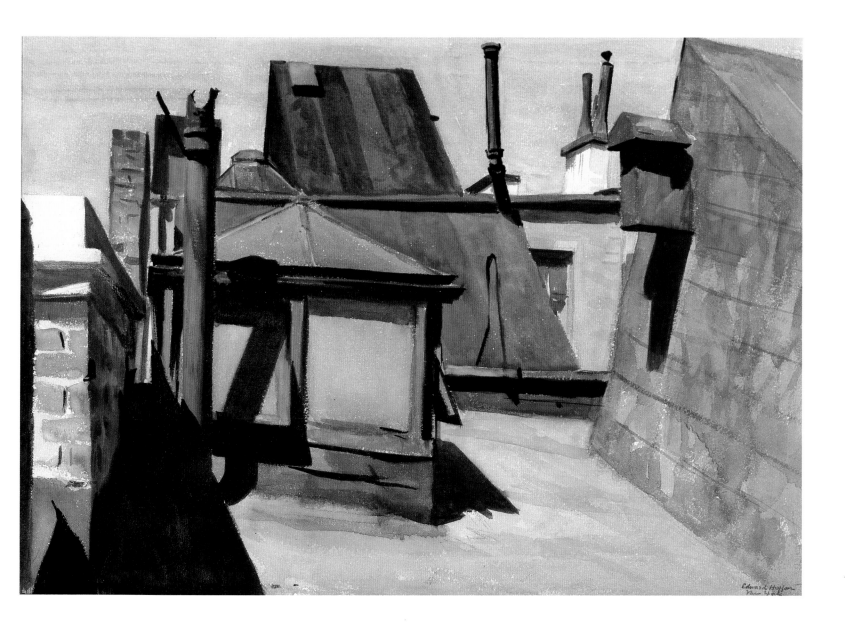

Note
2 Quoted in Lloyd Goodrich,
 Edward Hopper (New York:
 Harry N. Abrams, 1971), p. 31

Hopper organised his composition so that the geometric shapes of the chimneys and skylights set up an almost abstract harmony of shapes. *My Roof* depicts a space that seems enclosed and secure shut off from the rest of the busy city down below. The large structure on the far right is the enclosure over the stairway and the door leading to the hallway beneath and Hopper's studio.

Hopper captured light in this watercolour with a remarkable sense of reality. He once expressed his desire in painting: 'What I wanted to do was to paint sunlight on the side of a house.'[2] In this work, we sense the artist's earnestness and appreciate the ordinary structures which held visual significance for him.

Edward Hopper 1882–1967

64 Rocky Cove

1929, watercolour on paper, 34.2 × 49.5 cm (13½ × 19½ in)
Signed and inscribed lower right: 'Edward Hopper/Two Lights, Me.'

Provenance
Frank K.M. Rehn Gallery, New York
Rolf Dessauer
Kennedy Galleries, Inc., New York
Thyssen-Bornemisza Collection, 1977

Literature
A Selection of 20th Century American Masterpieces (New York: Kennedy Galleries, Inc., 1973), cat. no. 33, illus.
Baur, pp. 23, 170, 125, illus., no. 99

Exhibitions
Philadelphia, PA, *The Fortieth Annual Philadelphia Water Color and Print Exhibition, and the Forty-first Annual Exhibition of Miniatures*, Pennsylvania Academy of the Fine Arts, 25 October–29 November 1942
New York, *A Selection of 20th Century American Masterpieces*, Kennedy Galleries, Inc., 7 November–1 December 1973, no. 33
Vatican, 1983, no. 99; Lugano, 1984, no. 97
USA tour, 1984–86, no. 99

Hopper's wife Jo listed this work in the record book that she kept; next to Hopper's sketch, she wrote: 'near Maxwell's, much in silhouette'.[1] Hopper painted this watercolour during the summer of 1929 when he and his wife were living at Two Lights, Maine, on the coast not far south of Portland. They had returned to Two Lights after an earlier stay there in the summer of 1927.

Hopper focused on three large dark rocks in the left foreground and showed the sandy beach, the sea and the low cliff on the other side of the cove with the red roof of a house visible in the distance. The pale sky is that of an overcast day. Hopper also painted two unsigned watercolours related to *Rocky Cove*.[2]

Hopper painted his watercolours outdoors on location, often working in his car as a kind of mobile studio. He first sketched in the subject faintly in pencil and then continued to work in watercolour. Except for boyhood works and commercial illustrations, Hopper only began to work in watercolour during the summer of 1923 while staying in Gloucester, Massachusetts. He favoured outdoor scenes, particularly architecture, the coast and nautical subjects. The absence of any figures in *Rocky Cove* is typical.

Notes
1 This watercolour is listed in Volume I, p. 70
2 These are in the Hopper Bequest to the Whitney Museum of American Art, New York: accession numbers 70.1139 and 70.1153

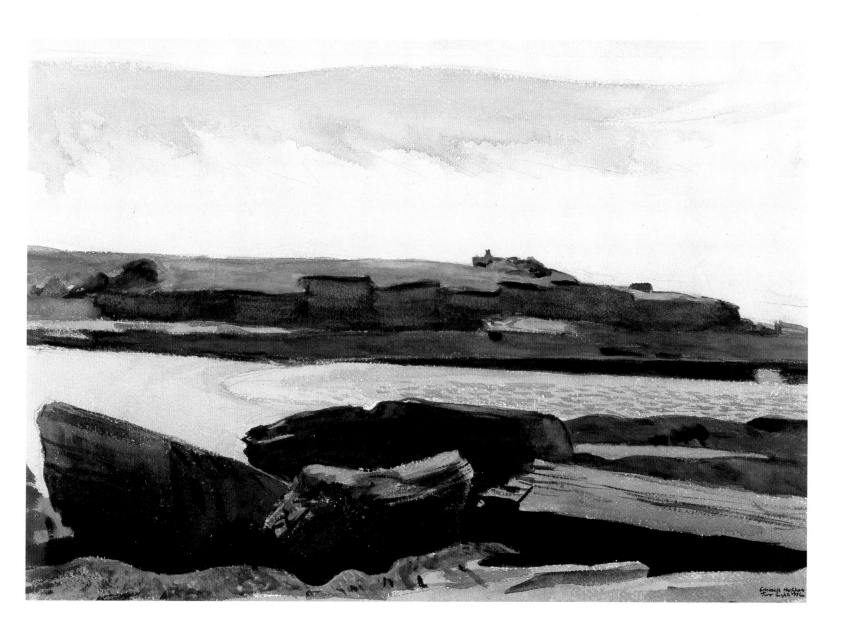

Edward Hopper 1882–1967

65 Hotel Room

1931, oil on canvas, 152.4 × 165.7 cm (60 × 65 in)
Signed lower right: 'Edward Hopper'

Provenance
Frank K.M. Rehn Gallery, New York
Mr and Mrs Nate B. Spingold, New York
Sale, Sotheby Parke Bernet, New York, Collection of Watercolours and Drawings by Charles Demuth; American
 19th and 20th Century Paintings and Sculpture, 28 October 1976, lot 175
Kennedy Galleries, Inc., New York
Thyssen-Bornemisza Collection, 1977

Literature
Guy Pène du Bois, *Edward Hopper* (New York: Whitney Museum of American Art, 1931). p.17
'Hopper is a Realist', *Life* 2 (3 May 1937), p.45, p.46, illus.
James Thrall Soby, *Contemporary Painters* (New York: Museum of Modern Art, 1948), p.38
Suzanne Burrey, 'Edward Hopper: The Emptying Spaces', *The Art Digest* 29 (1 April 1955), p.9, p.10, illus.
'Today's Collectors: Colin and Spingold', *Art News* 58 (April 1960), p.31, illus.
Matthew Baigell, 'The Beginnings of "The American Wave" and the Depression', *Art Journal* 27 (Summer 1968),
 p.394, fig.5
John Canaday, *Culture Gulch* (New York: Farrer Straus, and Giroux, 1969), p.51, illus.
Lloyd Goodrich, *Edward Hopper* (New York: Harry N. Abrams, 1971), p.104, p.110, illus.
Studs Terkel, 'The Captured Moment of Change', *Life* 71 (12 November, 1971), p.8, illus.
Gail Levin, *Introduction to Edward Hopper at Kennedy Galleries* (New York: Kennedy Galleries, Inc., 1977), n.p., illus.,
 pl.15
Elena Mikhatovna, *Edward Hopper* (Moscow: Fine Arts, 1977), in Russian
Gail Levin, *Edward Hopper: The Art and the Artist* (New York: W.W. Norton & Co., 1980), p.49, pl.249
John Hollander, 'Hopper and the Figure of Room', *Art Journal* 41 (Summer 1981), p.158, fig.5
Charles Millard, 'Edward Hopper', *Hudson Review* 34 (1 October, 1981), p.395
Ernst-G. Güse, 'Bemerkungen zu Edward Hopper' in *Edward Hopper: Das Frühwerk* (Münster: Westfalisches
 Landesmuseum für Kunst und Kulturgeschichte, 1981), p.40, fig.13
Lieberman, p.58, no.50
Gail Levin, *Edward Hopper* (New York: Crown Publishers, Inc., 1984), p.79, p.56 and cover, illus.

Exhibitions
Pittsburgh, PA, *30th Annual International Exhibition of Paintings*, Museum of Art, Carnegie Institute, 15 October–
 6 December 1931, no.39, illus., pl.69
Philadelphia, PA, *127th Annual Exhibition*, Pennsylvania Academy of the Fine Arts, 24 January–13 March 1932,
 no.65
New York, *A Chapter in American Art*, Frank K.M. Rehn Gallery, May 1932
St Louis, MO, *Twenty-seventh Annual Exhibition of Paintings by American Artists*, St Louis Art Museum,
 15 August–16 October 1932, no.18
New York, *Edward Hopper Retrospective*, Museum of Modern Art, 1 November–7 December 1933, no.21, illus.
Chicago, IL, *Exhibition of Paintings by Edward Hopper*, Arts Club of Chicago, 2–16 January 1934, no.16
Pittsburgh, PA, *Exhibition of Paintings, Water Colors, and Etchings by Edward Hopper*, Museum of Art, Carnegie
 Institute, 11 March–25 April 1937, no.20
Detroit, MI, *Group Exhibition of Paintings by American Artists*, Detroit Institute of Arts, 1–28 April 1940, no.37
San Francisco, CA, *Golden Gate International Exposition*, Palace of the Fine Arts, 25 May–28 September 1940,
 no.1368
Nebraska Art Association's 65th Annual Exhibition, February–May 1955
 Lincoln, NE, University Galleries, University of Nebraska
 Omaha, NE, Joslyn Art Museum
Edward Hopper, September 1964–May 1965, no.26
 New York, Whitney Museum of American Art
 Chicago, IL, Art Institute of Chicago
 Detroit, MI, Detroit Institute of Arts
 St Louis, MO, City Art Museum of St Louis

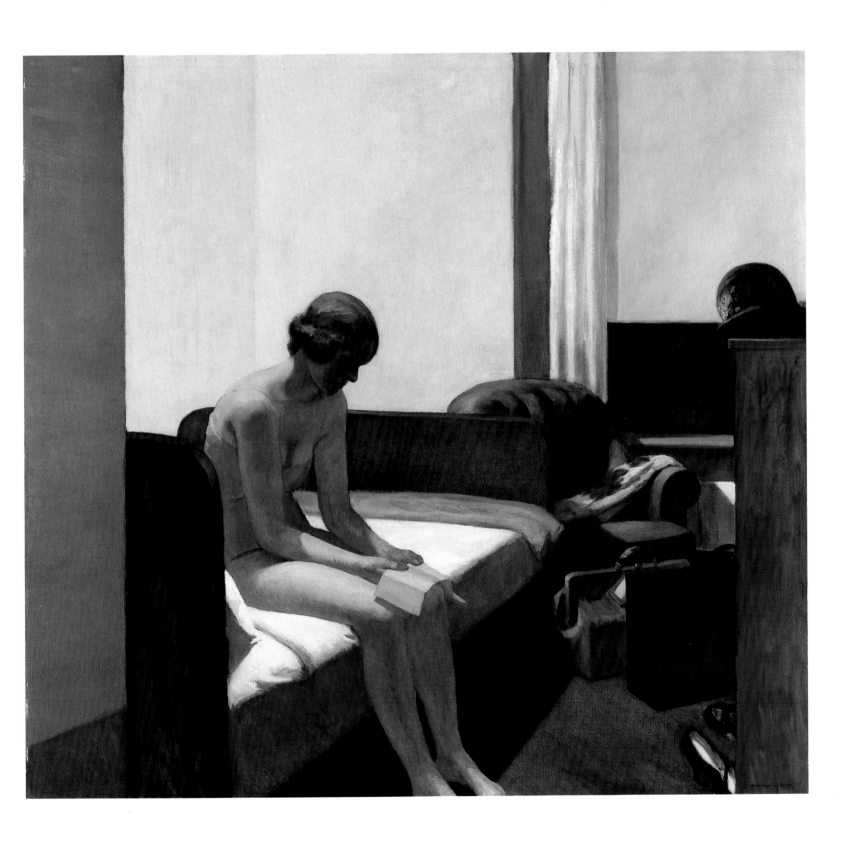

Sao Paulo, Brazil, *Sao Paulo 9*, Museum of Modern Art, 22 September 1967–8 January 1968, pp. 19, 24, 160, pl. B
New York, *Edward Hopper at Kennedy Galleries*, Kennedy Galleries, Inc., 11 May–8 June 1977, no. 15
2 Jahrzehnte Amerikanische Malerei 1920–1940, June–December 1979, no. 65
 Düsseldorf, Städtische Kunsthalle
 Zurich, Kunsthaus
 Brussels, Palais des Beaux-Arts
New York, *Edward Hopper: The Art and the Artist*, Whitney Museum of American Art, 23 September–10 December
 1980
Paris, *Les Realismes 1919–1939*, Musée National d'Art Moderne, Centre Georges Pompidou, 17 December
 1980–20 April 1981, p. 523, p. 245, illus.
USA tour, 1982–83, no. 50
Modern Masters from the Thyssen-Bornemisza Collection, May 1984–August 1986, no. 90
 Tokyo, National Museum of Modern Art
 Kumamoto, Kumamoto Prefectural Museum
 London, Royal Academy of Arts
 Nürnburg, Germanisches Nationalmuseum
 Düsseldorf, Städtische Kunsthalle
 Florence, Pitti Palace
 Paris, Musée d'Art Moderne de la Ville de Paris
 Madrid, Biblioteca Nacional, Salas Pablo Ruiz Picasso
 Barcelona, Palau de la Virreina

Hotel Room of 1931 is one of Hopper's most ambitious canvases. Its theme, solitude, is central to his oeuvre. Its scale is monumental and its composition is simple and spare. This is a painting from the years of Hopper's first great successes. It is painted just one year after *Early Sunday Morning* and *Tables for Ladies*, both of which were quickly acquired by New York museums.

Hopper arranged *Hotel Room* around verticals and diagonals which define the interior space. We know that it is night because of the darkened view through the window. The floor tilts forward towards the picture plane in the manner of Degas and other French Impressionists. Solid masses of colour accentuate the whole: the green floor, the white walls of the corner and the grey of the left foreground wall, the yellow window shade, the browns of the wood furniture, and the lavender blanket at the foot of the bed. Using relatively few details, Hopper has created a powerful formal arrangement, one that even appeals to abstract artists.[1] He has also conveyed several levels of meaning.

A tall, slender young woman is shown sitting on the bed, motionless, her head downcast, and tightly holding on to a folded piece of paper which we know is a time table from Jo's comment in Hopper's record book.[2] She appears to be somewhat distressed as conveyed by her glum expression, stooped posture, and belongings strewn about the room.

Hopper's idea for this composition must ultimately be attributed to his interest in French illustrators. He brought back from Paris a copy of *Les Maîtres Humoristes* for January 1908 featuring Jean-Louis Forain's illustrations. In one example, a young woman in dishabillé, is shown seated on the edge of a bed, placed at an angle across the left side of the picture, similar to Hopper's later composition. In an interior space defined by the corner of the room and a picture frame on the wall behind her, she looks thoughtfully at the boots of her lover. Hopper's space is also defined by the corner of the room on the left behind the angled bed, but on the right he put a window in place of a framed picture. Hopper tilted his floor much as Forain had in his illustration, carefully adding vertical accents to counterbalance it – the band of blue on the left and the wood chest of drawers on the right. In an article he had written just four years before he painted *Hotel Room*, Hopper praised 'the great French delineators of manners, Daumier, Gavarni, Toulouse-Lautrec and Forain'.[3]

This is the first of several paintings Hopper painted of hotel rooms and lobbies: *Hotel Lobby* (1943), *Hotel by a Railroad* (1952), *Hotel Window* (1956) and *Western Motel* (1957). He was fascinated with travelling which he often did in search of new inspiration. He once admitted: 'To me the most important thing is the sense of going on. You know how beautiful things are when you're travelling.'[4]

Notes
1 Richard Diebenkorn, for example, was observed admiring this painting in the retrospective at the Whitney Museum in 1980–81
2 Jo recorded this picture in Volume I, p. 80, and noted that it was delivered to the Rehn Gallery on 25 April 1931
3 Edward Hopper, 'John Sloan and the Philadelphians', *The Arts* 11 (April 1927), p. 171
4 Quoted in William C. Seitz, *Edward Hopper in Sao Paulo 9* (Washington, DC: Smithsonian Institution Press, 1969), p. 22

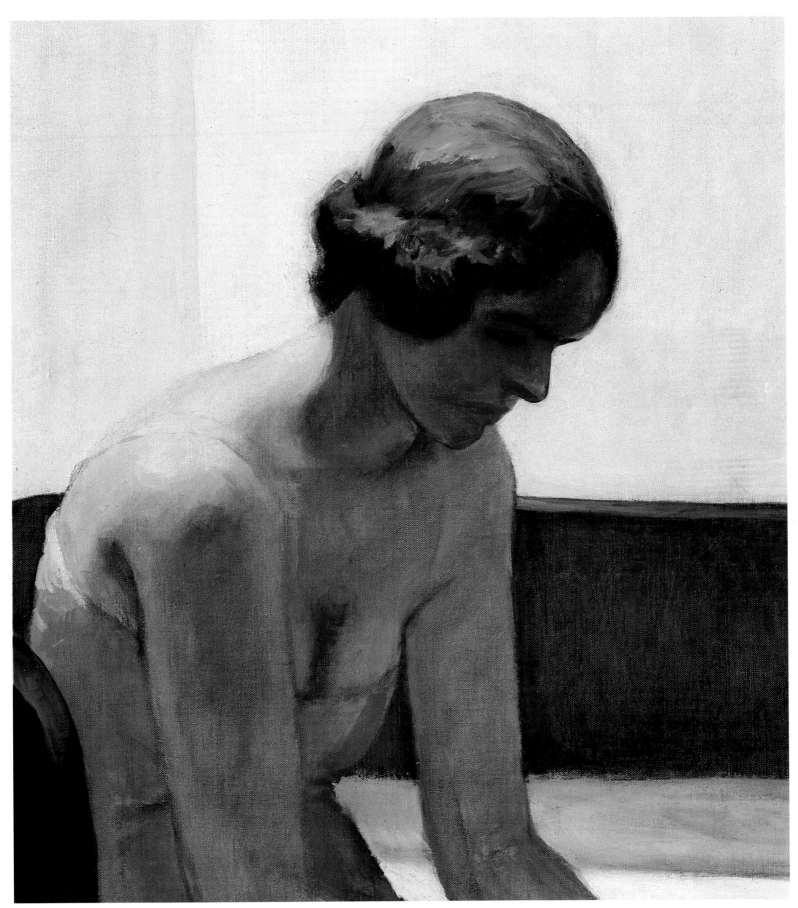

[65] detail

Edward Hopper 1882–1967

66 Dead Tree and Side of Lombard House

1931, watercolour on paper, 48.5 × 70 cm (19 × 27½ in)
Signed lower right: 'Edward Hopper'

Provenance
Frank K.M.Rehn Gallery, New York
Private collection
Kennedy Galleries, Inc., New York
Thyssen-Bornemisza Collection, 1976

Literature
Baur, pp.23, 170, 127, illus., no.101

Exhibitions
Philadelphia, PA, *The Thirty-first Annual Philadelphia Water Color Exhibition, and the Thirty-second Annual Exhibition of Miniatures*, Pennsylvania Academy of the Fine Arts, 5 November–10 December 1933
Lincoln, NE, *52nd Annual Exhibition of Contemporary Art*, Nebraska Art Association, University of Nebraska, 1–29 March 1942
Vatican, 1983, no.101; Lugano, 1984, no.99
USA tour, 1984–86, no.101

Jo Hopper listed this *Dead Tree and Side of Lombard House* of 1931 in the record book next to a sketch of the work and commented: 'Dead tree dark'.[1] Hopper painted this watercolour in South Truro on Cape Cod during the second summer he and Jo spent there. They lived in a rented house nearby which they dubbed 'Bird Cage Cottage' because the rain and wind entered so easily. Three years later they built their own house in South Truro and subsequently spent almost every summer there. Because the warm weather lasted longer on Cape Cod, they chose it rather than Maine or Cape Ann in Massachusetts where they had spent previous summers.

Hopper painted a number of watercolours which focus on dead trees: *Dead Trees* (1923), *House with Dead Tree* (1932) and *Four Dead Trees* (1942). This was more than just coincidence; probably it reflects the artist's pessimism. Hopper had sketched and painted cemeteries and a tombstone store in the 1920s. Death imagery occurs in his boyhood work and in some of his Paris drawings, notably *On the Quai: The Suicide* of 1906–1907.

While Hopper painted the sunlight against the front façade of the *Lombard House*, he chose to focus on the side in shadow, framed, as it were, by the dark outline of the bare, dead tree, an unexpected sight in mid-summer. He also depicted a flagpole, picket fence and the two small buildings which flank the large white house set in the gently rolling hills of Truro. Hopper's pencil underdrawing is still partially visible and he left white areas in the sky to serve as clouds.

Note
1 This work is listed in Volume I, p.75

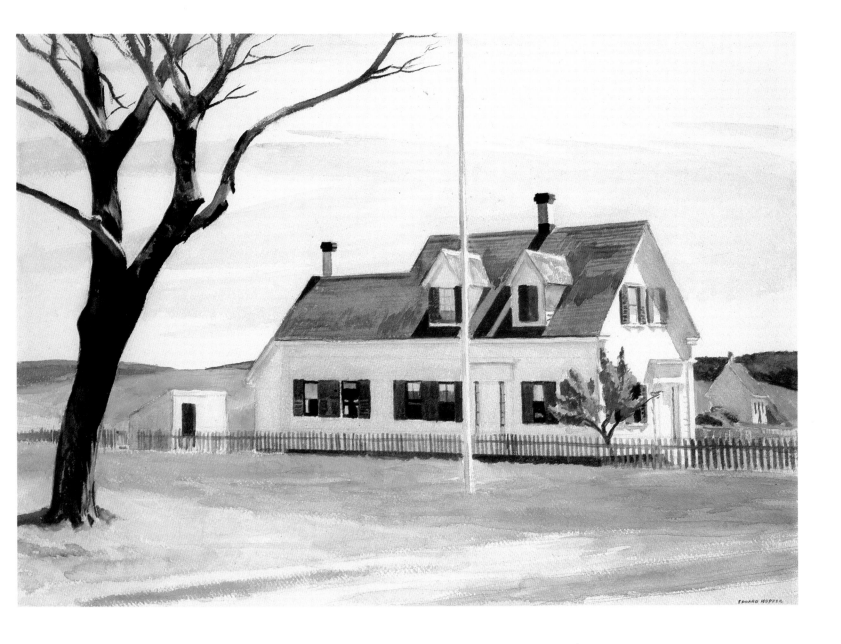

Edward Hopper 1882–1967

67 The Martha McKeen of Wellfleet

1944, oil on canvas, 81.3 × 167 cm (32 × 50 in)
Signed lower right: 'Edward Hopper'

Provenance
Frank K.M.Rehn Gallery, New York
Harold Harris, Ellenville, NY
Kennedy Galleries, Inc., New York
Thyssen-Bornemisza Collection, 1980

Literature
Edward Hopper (New York: American Artists Group,
 Inc., 1945), illus. inside front cover
Lloyd Goodrich, 'Portrait of the Artist', *Woman's Day*
 29 (February 1965), p. 37, illus.
Lloyd Goodrich, *Edward Hopper* (New York: Harry N.
 Abrams, Inc., 1971), p. 254, illus.
Gail Levin, 'Edward Hopper as Printmaker &
 Illustrator: Some Correspondences', *The Print
 Collector's Newsletter* 10 (September/October
 1979), p. 123
Gail Levin, *Edward Hopper: The Art and the Artist* (New
 York: W. W. Norton & Co., 1980), p. 49, pl. 249
Edward Hopper 1882–1967 (London: Arts Council of
 Great Britain, 1981), no. 99
Gail Levin, *Edward Hopper* (New York: Crown
 Publishers, Inc., 1984), p. 69, p. 83, illus.

Exhibitions
Pittsburgh, PA, *Painting in the United States – 1945*,
 Museum of Art, Carnegie Institute, 11 October–9
 December 1945, no. 295, pl. 43
Lincoln, NE, *Fifty-sixth Annual Exhibition of
 Contemporary Art*, Nebraska Art Association, 3–31
 March 1946, no. 58

New York, *33rd Annual Summer Exhibition*, Museum
 of Modern Art, 2 June–25 August 1946
Boston, MA, *Thirty Massachusetts Painters in 1947*,
 Institute of Modern Art, 7 November–26
 December 1947, no. 24
San Francisco, CA, *Third Annual Exhibition*, California
 Palace of the Legion of Honor, 1 December
 1948–16 January 1949
Columbia, SC, *Thirteenth Annual Southeastern Circuit:
 Contemporary American Painting*, Columbia
 Museum of Art, 30 September–21 October 1951,
 no. 16
Edward Hopper, September 1964–May 1965, no. 44
 New York, Whitney Museum of American Art
 Chicago, IL, Art Institute of Chicago
 Detroit, MI, Detroit Institute of Arts
 St Louis, MO, St Louis Art Museum
Edward Hopper: The Art and the Artist, September
 1980–February 1982
 New York, Whitney Museum of American Art
 London, Hayward Gallery
 Amsterdam, Stedelijk Museum
 Düsseldorf, Städtische Kunsthalle
 Chicago, IL, Art Institute of Chicago
 San Francisco, CA, San Francisco Museum of
 Modern Art
Vatican, 1983, no. 102; Lugano, 1984, no. 100
USA tour, 1984–86, no. 102

Although, according to Jo Hopper's notation in the record book, *The Martha McKeen of Wellfleet* represents a late August morning off Cape Cod and Hopper began this painting on 10 August, he did not complete the canvas until after he returned to New York in December 1944.[1] Jo also recorded a subtitle, 'Where Gulls Fill Their Gullets'. When Hopper was asked about the title of this painting by the publisher of a small monograph of his work, he responded emphatically:

> I should like to retain the title 'The Martha McKeen of Wellfleet' if possible. The young lady that
> the picture is named after has taken us sailing in Wellfleet harbor so often that the title has a
> sentimental value for us and Martha McKeen also. The title was given purposely to please her and
> I think it would make her feel badly if it were to be changed. There is no vessel with this name as
> far as I know. It was named after our friend.[2]

Hopper was inspired to paint this and some of his other sailing pictures by sailing with Martha and Reggie McKeen of Wellfleet, a much younger couple. He had been forced to give up sailing on his own by Jo who thought it was too dangerous. While the canvas was in progress, the Hoppers also went to Provincetown so that he could study the gulls at a fish house on the railroad wharf. Jo felt that the man depicted at the tiller might be Hopper himself.

Notes
1 This is recorded in Volume III,
 p. 7. Although published as
 The Martha McKean of Wellfleet
 the record book gives a different
 spelling
2 Edward Hopper to Samuel
 Golden, letter of 2 November
 1945, referring to the use of
 this painting as the frontispiece
 of the monograph *Edward
 Hopper* (New York: American
 Artists Group, Inc., 1945)

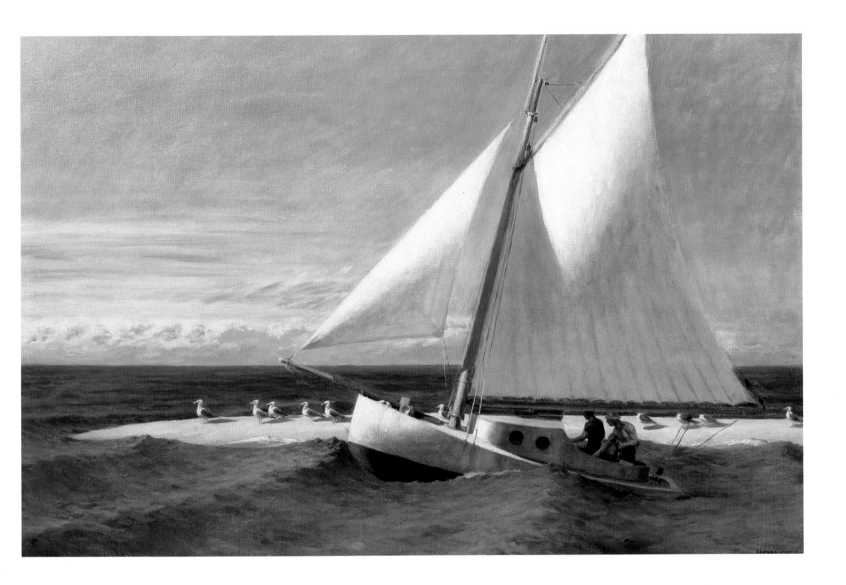

Ever since he built a catboat as a teenager, Hopper adored sailing. His love of solitude must have enhanced his enjoyment of sailing. He sketched numerous sailing boats as a boy in his hometown, Nyack, New York, a Hudson River port that had a shipbuilding industry during that time. The first painting he ever sold was *Sailing* the only work he exhibited in the famous New York Armory Show of 1913.

Although sailing boats appear in the oils he painted in Gloucester, the next action pictures occur in watercolour: *The Dory* (1929) and *Yawl Riding a Swell* (1935). *The Martha McKeen of Wellfleet* follows three other canvases of sailing scenes: *The Long Leg* (1935), *Ground Swell* (1939) and *The Lee Shore* (1941). Each of these paintings utilises a horizontal strip of sky and sea, and sometimes land, parallel to the picture plane. Hopper's only preparatory sketch for *The Martha McKeen of Wellfleet* reveals that he originally considered placing a standing figure near the mast rather than the two seated men seen in the final painting.

His resolution is an impressive canvas with strong blue tonalities played off against the white sails and sand bar. Sunlight dramatises the entire composition and the gulls cast blue shadows. The action appears rather frozen in time, but Hopper effectively captured the great strength of the sea and man's momentary harmony with it.

Reginald Marsh

68 The Battery

c. 1926, oil on canvas, 76.2 × 101.6 cm (30 × 40 in)
Posthumously signed lower right: 'Reginald Marsh (FMM)' by the artist's widow, Felicia Meyer Marsh

Provenance
Estate of Felicia Meyer Marsh
Frank K. M. Rehn Gallery, New York
Andrew Crispo Gallery, New York
Thyssen-Bornemisza Collection, 1978

Literature
Lloyd Goodrich, *Reginald Marsh* (New York: Harry N. Abrams, Inc., 1972), illus. in colour, p. 19

Reproduced
Advertisement for Frank K. M. Rehn Gallery, New York, *Art in America* 66 (May–June 1978), p. 157

Exhibitions
New York, *Early Paintings: Reginald Marsh*, Frank K. M. Rehn Gallery, 25 November–December 1974
New York, *Twentieth-Century Painting and Sculpture*, Andrew Crispo Gallery, August 1978

The Battery is one of Marsh's early oils, painted just after his three-year stint as a staff illustrator for the New York *Daily News* where he drew a daily column of theatrical sketches. At the time Marsh was involved in designing theatre curtains for 'The Greenwich Village Follies' and he had recently collaborated with Robert Edmond Jones on curtains and sets for the Provincetown players. These facts are brought to mind by the stage-like look of this canvas. Three fashionably-clad women enter along the right foreground of the composition; next to the post in the left middleground, three men at leisure are conversing. Three other men are looking out to sea in the distance. The background consists of blue sky, sea and nautical traffic in the port. The grey foreground, empty except for the figures just described, looks much like a stage with the sea and sky just a painted backdrop.

In his early oil paintings, Marsh evidently recorded scenes that he observed first hand, while in later work he relied on sketches and photographs that he greatly altered in the creative process in his studio. Marsh later admitted that he had had difficulty with his first paintings in oil. He began his career as a graphic artist and the transition to full colour and solid pigment brought complications. 'I still shied away from oil,' he remembered, 'the attempts I infrequently made ended always in an incoherent pasty mess. . . .'[1] Marsh found watercolour an easier medium in this formative period.

Marsh's narrative skill is already apparent. He dramatically conveys the effect of the wind with the billowing smoke from the tug boats in the harbour and one of the women holding on to her hat in the breeze. The tallest of the men conversing is momentarily distracted by the appearance of the three women and he gazes in their direction. The bright sunny day is conveyed by the clear bright colours and the shadows cast by the figures.

Note
1 Quoted in Lloyd Goodrich, *Reginald Marsh* (New York: Harry N. Abrams, Inc., 1972), p. 30

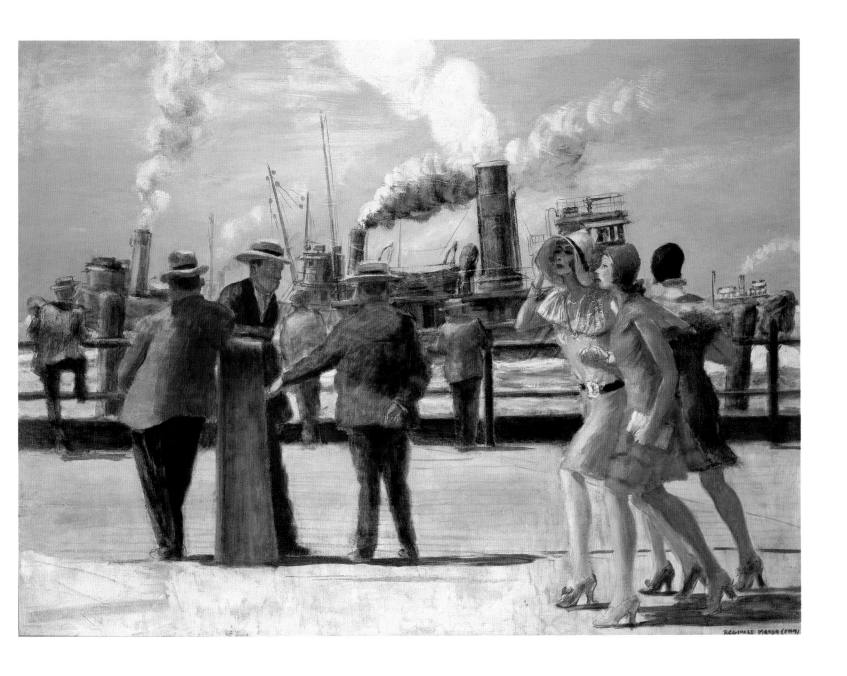

In *The Battery*, Marsh depicted the public park on the southern tip of Manhattan Island where one could have a marvellous view of New York Harbor. The people are well-dressed; the men all sport hats and jackets and the women wear high-heeled pumps and the short dresses then fashionable among the 'flappers' of the period called the 'roaring twenties'. Marsh possessed intense powers of observation and he would later develop a sharp wit and an ability to convey stunning social commentary and satire in his depictions of urban life. This early work is a more direct recording of what the artist observed and it is also much less crowded than Marsh's city scenes of the 1930s.

Reginald Marsh 1898–1954

69 Smoko, The Human Volcano

1933, tempera on panel, 91.4 × 121.9 cm (36 × 48 in)

Provenance
Frank K.M.Rehn Gallery, New York
Mr and Mrs Joel Harnett, New York
Andrew Crispo Gallery, New York
Thyssen-Bornemisza Collection, 1978

Literature
Lloyd Goodrich, *Reginald Marsh* (New York: Harry N.Abrams, Inc., 1972), illus., p. 99
Marilyn Cohen, *Reginald Marsh's New York: Paintings, Drawings, Prints and Photographs* (New York:
 Dover Publications, Inc., 1983), pp. 8–12, illus., p. 94

Exhibitions
New York, *The New York Painter: A Century of Teaching: Morse to Hofmann*, Marlborough-Gerson Gallery,
 27 September–14 October 1967, illus., p. 68
Tucson, AZ, *Eastside–Westside, all around the town: A Retrospective of Paintings, Watercolors and Drawings by Reginald
 Marsh*, University of Arizona, 1969, illus., p. 39, cat.no. 25
New York, *Reginald Marsh: The Art of Popular Entertainment*, Vincent Astor Gallery, New York Public Library at
 Lincoln Center, 6 September–19 November 1977
New York, *20th Century American Masters*, Andrew Crispo Gallery, April 1978
Australian tour, 1979–80, no. 60
Vatican, 1983, no. 97; Lugano, 1984, no. 95
USA tour, 1984–86, no. 97

Smoko, The Human Volcano is one of Reginald Marsh's lively Coney Island paintings, depicting the popular-priced Brooklyn beach resort and amusement park which attracted New York's large urban populace during the Great Depression of the 1930s. Easily and inexpensively accessible by subway, Coney Island offered a welcome sea breeze to the masses confined in the city on a hot summer day. Marsh first went to the Brooklyn amusement park on assignment as an illustrator at the suggestion of Frank Crowninshield, the editor of *Vanity Fair* magazine.[1]

Marsh loved the boisterous crowds and chaotic activity that he observed at Coney Island and so he began to make regular sketching trips there, finding constant inspiration for his paintings. Marsh explained his response to Coney Island to his friend the artist Edward Laning: 'I've been going out there every summer, sometimes three or four days a week. On the first trip each summer I'm nauseated by the smell of stale food, but after that I get so I don't notice it. I like to go there because of the sea, the open air, and the crowds – crowds of people in all directions, in all positions, without clothing, moving – like the compositions of Michelangelo and Rubens.'[2] Around the time he painted *Smoko, the Human Volcano*, he wrote to his wife Felicia, a landscape painter who spent her summers in Vermont, telling her of his most recent afternoon at the beach at Coney Island: 'The wind was fresh and strong blowing great whitecaps in on the seas – the sea a rich blue – The crowd as thick as ever I've seen, much to my delight. The noise of the beach could be heard for miles and there was scarce room on the sand to sit down. . . .'[3]

Notes
1 Edward Laning, *The Sketchbooks of Reginald Marsh* (Greenwich, CT: New York Graphic Society, Ltd, 1973), p. 58
2 *Ibid.*, p. 58
3 Reginald Marsh to Felicia Meyer Marsh, undated letter of c.1933–34, as quoted in Marilyn Cohen, *Reginald Marsh's New York: Paintings, Drawings, Prints and Photographs* (New York: Dover Publications, Inc., 1983), pp. 5–6

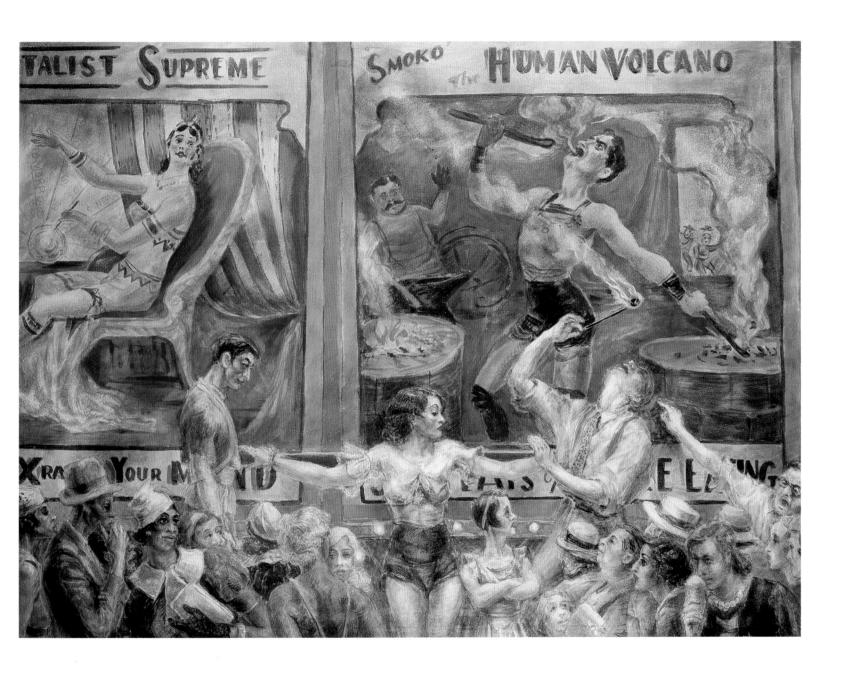

Marsh made a sketch for *Smoko, the Human Volcano* on one of these jaunts to Coney Island. In the sketch, both the figure of Smoko and the woman wearing shorts standing just below are clearly visible. But Marsh did not rely on his sketches alone to compose this canvas; he also took photographs of his subject. Although his attitude towards his photographs was casual, he saw them as snapshots, a kind of visual note-taking, rather than as finished works of art, the photographs' subjects are in the documentary tradition of some of his contemporaries such as Bernice Abbott and Walker Evans. In his use of photography in the service of his painting, Marsh can be compared to some of his contemporaries, including Ben Shahn and Ralston Crawford.

Four of Marsh's photographs which he used for *Smoko, the Human Volcano* show that he faithfully recorded the publicity logo from the billboard of the sideshow: '[FA]TALIST SUPREME' and 'Smoko the HUMAN VOLCANO: STARTLING FEATS OF FIRE EATING'.[4] To the left of Smoko's billboard image, Marsh depicted a poster of a female fortune teller or psychic who points to her crystal ball with phrases like 'TOMORROW' emanating from it. Beneath her the caption reads: 'X-RAY YOUR MIND'. In the painting, Smoko, standing before his image on the billboard, is depicted performing his act, about to swallow fire. Wearing a wide print tie and orange braces, he dramatically throws his head back, about to insert the flaming torch. To the right of the female performer scantily clad with a bare midriff and shorts, Marsh painted an ill-proportioned female midgette, wearing a headband in her hair, a bright red dress and lipstick, also visible in the photographs. Marsh placed the spectator among the crowd, looking up at the performers.

The palette of this painting, dominated by red, yellow and blue, is bright and bold, compatible with its festive theatrical subject matter. Edward Laning commented: 'I believe Marsh was stage-struck always; he, too, was an entertainer. He appreciated the "higher" forms of theatrical art, but it was in its "lower" forms that he found what he needed.'[5] *Smoko, the Human Volcano* can be compared to *Pip & Flip*, another of Marsh's colourful, raucous sideshow pictures, painted the previous year. In both, the billboards in the background seem like a scenic backdrop for the figures who occupy centre stage in the painting. Marsh's pictures of this period are full of activity and have even been called cinematic in their effect.[6]

Smoko, the Human Volcano, like many of Marsh's pictures of the 1930s, is painted in egg tempera, a medium which he found more appealing than oil, in part because of its properties including transparency, which were closer to watercolour.[7] His preference for tempera was shared by some of his contemporaries, particularly Thomas Hart Benton. Marsh had studied with Kenneth Hayes Miller from 1927 to 1928 at the Art Students League. Miller, who also concentrated on painting the figure, had an important influence on Marsh and they became good friends. As late as 1944, Marsh admitted that he still showed all of his pictures to his former teacher and commented: 'One of the greatest things that has happened to me is his guidance.'[8]

Smoko, the Human Volcano exemplifies Marsh's ability as a reporter to capture the essential atmosphere and mood of what he observed. His background as an illustrator served him well as a painter, as did his experience in set design. There is nothing static or posed about his compositions. Marsh managed to imbue his pictures with a dynamism and a humour which give them a personal stamp. His astute power of observation also makes his paintings reflective of their times. They are evocative not only of some particular drama, but of an entire era.

Notes
4 Cohen, *op. cit.*, p. 11, identifies the second billboard image as an 'Orientalist', however, the crystal ball and the writing on the wall belie this identification. She is clearly a fortune teller or psychic
5 Laning, *op. cit.*, p. 82
6 See Cohen, *op. cit.*, p. 12 and Matthew Baigell, *American Scene: American Painting of the 1930* (New York: Praeger Publishers, Inc., 1974), p. 13
7 Laning, *op. cit.*, p. 21
8 Quoted in Lloyd Goodrich, *Reginald Marsh* (New York: Harry N. Abrams, Inc., 1972), p. 30

[69] detail

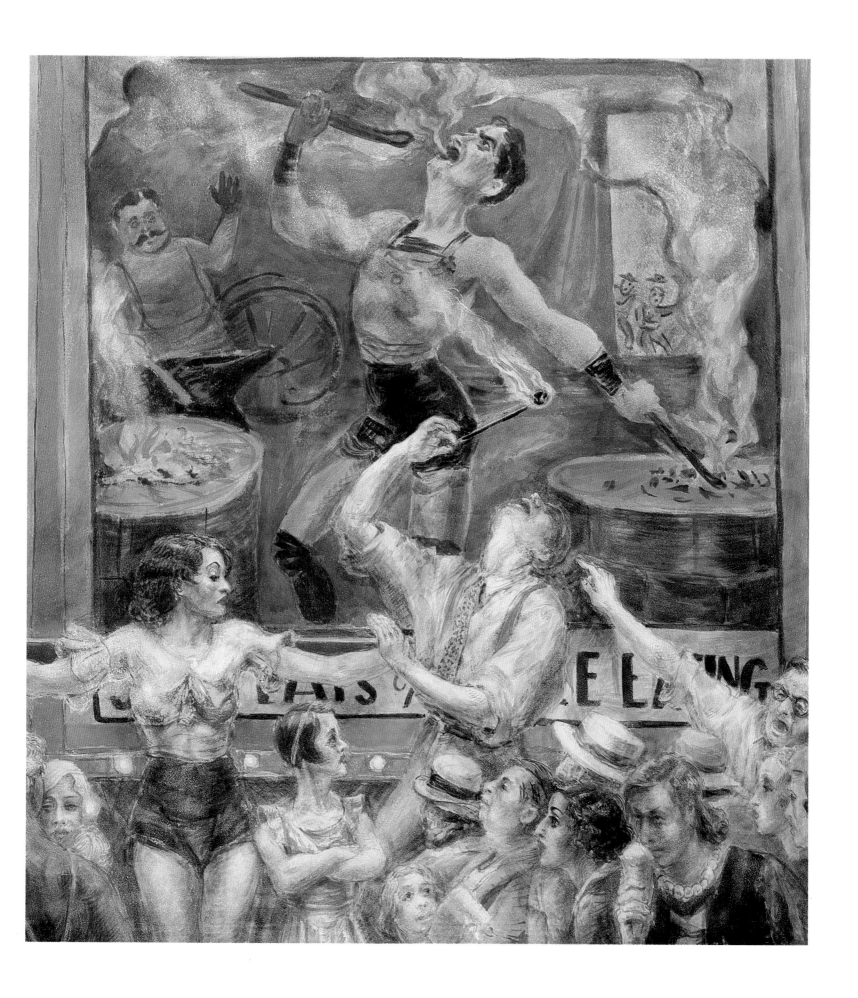

Reginald Marsh 1898–1954

70 Food Store (The Death of Dillinger)

1938, tempera, 71.1 × 50.8 cm (28 × 20 in)
Signed lower right: 'REGINALD MARSH '38'

Provenance
Private collection, New York
Andrew Crispo Gallery, New York
Thyssen-Bornemisza Collection, 1978

Exhibition
New York, *Selections from the Gallery Collection*,
Andrew Crispo Gallery, March 1978, no.17

Food Store (The Death of Dillinger) of 1938 depicts the murder of the notorious Depression era gangster John Dillinger by the Federal Bureau of Investigation in Chicago outside the Biograph Theater on Lincoln Avenue on 22 July 1934, a hot and muggy Sunday. Marsh was commissioned to illustrate this grizzly event for *Life* magazine's Modern History Series.[1] In addition to this version, Marsh also produced a watercolour *Death of Dillinger*, in 1939. Marsh depicted the pivotal moment in this drama when Dillinger, his gun drawn in self-defence, falls to the ground victim of the G-men's bullets.[2] Several are shown with their drawn guns aimed directly at him.

In the foreground, the composition features Anna Sage and Polly Hamilton, the two women who accompanied Dillinger, disguised by dyed hair, moustache and a facelift. Spotting Hamilton dressed in red tipped off G-man Melvin Purvis who sat nearby, parked in his car. Having held his fire to spare the crowd, Purvis unsuccessfully sought Dillinger inside the theatre. But two hours later, Purvis' ambush paid off and the G-men shot Dillinger when he failed to surrender at their demand.

Revealing his propensity for illustration work, Marsh frequently included a literary caption in the form of a sign in the background or the headline of a newspaper prop. In this composition, Marsh utilised the contrast of the theatre marquee and the unfolding action to add an ironic comment to this real-life drama, itself worthy of a typical thirties gangster movie. Where the marquee states 'Manhattan Melodrama', this is a Chicago story with national implications. It was hot and muggy that July day, making the advertised 'ICED Fresh AIR' seem all the more inviting. But for Dillinger, it was really hot outside, as, in the language of the gangster films of the era, he was on the way to 'the deep freeze'. Marsh shows us only a fragment of the sign for the Biograph Theater and instead ironically features the sign for a Food Store on the corner. As the name of the theatre implies, this is Dillinger's life story – or at least the end of it. This is not the nourishment the Food Store promises but a brutal death instead.

Marsh depicted the two attractive, fashionably clad women much as he represented other women in his pictures. Only Polly Hamilton, wearing the telltale red dress, turns to observe the moment of Dillinger's death. In the distance, beyond the G-men, other smaller figures are seen on a street corner, perhaps watching the scene unfold. This was a perfect commission for Marsh who liked to depict crowds, dramatic action, and theatre marquees and other signs. It represents a successful blending of his skills as a narrative painter and as an illustrator.

Painted in tempera, like many of Marsh's best pictures of the 1930s, *Food Store (The Death of Dillinger)*, features a large amount of bright red on the right side of the composition, from Polly Hamilton's dress to the sign of the Food Store. In contrast, the left side of the painting which depicts Dillinger's violent and bloody death, is almost colourless, subdued, like an illustration in black and white. This powerfully evokes death, while on the right the two women step lively – away from the violent death of Dillinger into the sunlight.

Notes
1 'Death of Dillinger', *Life Magazine* 8 (11 March 1940), pp. 70–71, illustrates a related work in watercolour by this title and explains the event depicted in this painting
2 G-men are special agents for the Federal Bureau of Investigation

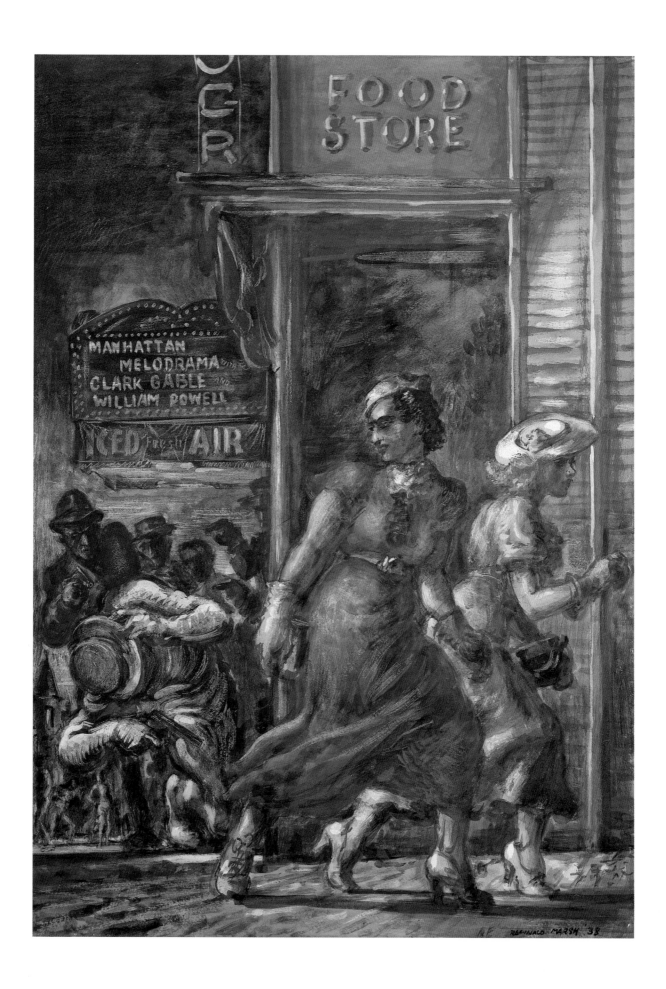

Ben Shahn 1898–1969

71 French Workers

1942, tempera on board, 101.6 × 144.8 cm (40 × 57 in)
Signed lower right: 'Ben Shahn'

Provenance
The Downtown Gallery, New York
Lee Ault, New York
Andrew Crispo Gallery, New York
Thyssen-Bornemisza Collection, 1975

Literature
James Thrall Soby, *Ben Shahn Paintings* (New York: George Braziller, 1963), no. 27
'Maler als Photographen – Photographen als Maler', *Du* 10 (1980), p. 60, illus.
Kenneth W. Prescott, *Prints and Posters of Ben Shahn* (New York: Dover Publications, Inc., 1981), p. xxiii

Exhibitions
2 Jahrzehnte Amerikanische Malerei, 1920–1940, June–December 1979, no. 130
 Düsseldorf, Städtische Kunsthalle
 Zurich, Kunsthaus
 Brussels, Palais des Beaux-Arts
Vatican, 1983, no. 95; Lugano, 1984, no. 93
USA tour, 1984–86, no. 95

1 Ben Shahn, *This is Nazi Brutality*, 1943
Museum of Modern Art, New York

Note
1 Quoted in Kenneth W. Prescott,
Prints and Posters of Ben Shahn
(New York: Dover Publications,
Inc., 1981), p. xxiii

Ben Shahn's entire career reveals political awareness and social concern. His *French Workers* of 1942 was painted when he was designing posters for the United States Office of War Information, only two of which were published as offset lithographs. One of these two posters included this image along with the caption: 'We French workers warn you . . . defeat means slavery, starvation, death'. The second such poster was *This is Nazi Brutality* dated 1943 (fig. 1).

Shahn once recalled discussions he participated in about what a war poster should be: 'It must be neither tricky nor smart . . . It has to have dignity, grimness, urgency . . . visual and not verbal.'[1] Shahn's image succeeds in his own terms. This poster is a solemn reminder of a pitiful moment in history, where the moral strength of humanity was called into question.

Shahn's ability to capture the spectator's attention is impressive. He forces us to read an official Vichy decree, written on bright red paper to capture our attention and to witness a crowd of French workers being rounded up like cattle going to market. Man's inhumanity to man is the artist's theme and through the force of his conscience and graphic strength, he touches his audience.

Ben Shahn 1898–1969

72 Four Piece Orchestra

1944, tempera on masonite, 45.7 × 60.1 cm (18 × 24 in)

Provenance
S.J.Perelman, Erwinna, PA
Sale, Sotheby Parke Bernet, New York, American 19th and 20th Century Paintings, Drawings, Watercolors and
 Sculpture, 21 April 1977, lot 195
Thyssen-Bornemisza Collection, 1977

Literature
Margaret Breuning, 'Ben Shahn Looks Upon the Seamy Side', *Art Digest* 19 (1 December 1944), p.17
James Thrall Soby, *Ben Shahn* (Harmondsworth, Middlesex, England: Penguin Books, Ltd, 1947), no. 22, illus.
James Thrall Soby, *Ben Shahn Paintings* (New York: George Braziller, 1963), no. 24, illus.
Bernarda Bryson Shahn, *Ben Shahn* (New York: Harry N. Abrams, Inc., 1970), p.154, illus.

Exhibitions
New York, *Shahn Paintings*, The Downtown Gallery, 14 November–2 December 1944
New York, *Ben Shahn*, Museum of Modern Art, 30 September 1947–4 January 1948, illus.
Venice, *2 Pittori: de Kooning, Shahn*, XXVII Biennale Internationale d'Art, 1954
The Works of Ben Shahn, International Council of the Museum of Modern Art, New York,
 December 1961–June 1962, no.15, illus.
 Amsterdam, Stedelijk Museum
 Brussels, Palais des Beaux-Arts
 Rome, Galleria Nationale d'Arte Moderna
 Vienna, Graphische Sammlung Albertina
Fort Worth, TX, *Image to Abstraction*, Amon Carter Museum of Western Art, 1976
Vatican, 1983, no.96; Lugano, 1984, no.94
USA tour, 1984–86, no.96

Shahn's sensitive portrayal of his fellow man is once again apparent in his painting of 1944, *Four Piece Orchestra*. The inflated title pokes gentle fun at the three worker-musicians who play a cello, violin, and guitar and harmonica. That one worker alone constitutes two pieces of this orchestra suggests that they are all reaching to greater goals. Two are clearly working class, dressed in overalls and short-sleeved shirts, while the third is conservatively dressed in a business suit and tie. He resembles more closely a trained musician dressed to play in an orchestra, but his hands are a ghastly colour.

The fact that these three musicians play outdoors suggests that the scene is an allegory, symbolising some situation beyond their own. That Shahn was interested in such symbolism at this time is attested to by his painting entitled *Allegory* of 1948 (fig. 1). All of the instruments in *Four Piece Orchestra* except the cello are likely to appear in country music. Shahn evidently commented that the cellist in the suit was a coal miner, but with his ghastly hands and grim expression, he reminds one more of an undertaker.[1] The bare trees suggest the desolation of winter, but it is obviously not cold to the men in shirt sleeves. The desolation suggested by both the barren trees and the glum expressions of the musicians must therefore refer to some larger issue. Since Shahn painted this picture in 1944, he must be alluding to the Second World War. Whether Shahn meant something more specific with these figures is unclear, but their solemnity suggests that he did.

The landscape is so strange that it could just as well be a stage set. The grass is depicted by a pattern that looks more like a carpet. The light in the sky is eerie and these musicians surely play a mournful tune. The musician has traditionally been a symbol of the fascination of death, as in the Pied Piper of Hamelin. Shahn himself explained:

> The paintings which I made toward the close of the war . . . did not perhaps depart sharply in style or appearance from my earlier work, but they had become more private and more inward-looking. A symbolism which I might once have considered cryptic now became the only means by which I could formulate the sense of emptiness and waste that the war gave me, and the sense of the littleness of people trying to live on through the enormity of war.[2]

Notes
1 James Thrall Soby, *Ben Shahn Paintings* (New York: George Braziller, 1963), p. 18
2 John D. Morse, ed., *Ben Shahn* (New York: Praeger Publishers, Inc., 1972), p. 84

1 Ben Shahn, *Allegory*, 1948, Fort Worth Art Museum, Fort Worth, TX

Ben Shahn 1898–1969

73 Riot on Carol Street

1944, tempera on board, 71 × 51 cm (28 × 20 in)
Signed lower right: 'Ben Shahn'

Provenance
The Downtown Gallery, New York
Edith Gregor Halpert, New York
Sale, Sotheby Parke Bernet, New York, Highly Important 19th and 20th Century American Paintings, Drawings,
 Watercolors and Sculpture from the Estate of the Late Edith Gregor Halpert, 14–15 March 1973, lot 84, illus.
Kennedy Galleries, Inc., New York
Thyssen-Bornemisza Collection, 1977

Literature
Zafran, p. 160, no. 75

Exhibitions
New York, Lee Nordess Gallery, 1960
Fort Worth, TX, *Image to Abstraction*, Amon Carter Museum of Western Art, 1976
Australian tour, 1979–80, no. 75

Shahn's *Riot on Carol Street* of 1944 is one of several paintings he created to express his sympathies with workers, injustice of any kind and social protest. By the early 1930s, he had taken on as his themes the historic Dreyfus case in France as well as the contemporary trial and execution of the anarchists Sacco and Vanzetti, and the trial and imprisonment of labour leader Tom Moody.

The simplified scene depicted is a protest march of faceless, gesturing women workers, while the managerial men appear to be complacently watching from safely inside the factory windows. The red building is dramatic, as is the red-streaked street, suggesting the passionate feelings behind this riot. We have no doubt where Shahn's sympathies lay. He does not present us with all the issues, just the situation of the victims with which we are supposed to identify.

Ben Shahn

74 Carnival

1946, tempera on masonite, 55.9 × 75.5 cm (22 × 29¾ in)
Signed lower right: 'Ben Shahn'

Provenance
The Downtown Gallery, New York
Mr and Mrs Benjamin Tepper, NJ
Private collection, New York
Kennedy Galleries, Inc., New York
Thyssen-Bornemisza Collection, 1979

Literature
James Thrall Soby, 'Ben Shahn', Museum of Modern Art *Bulletin* (Summer 1947), p. 43
James Thrall Soby, *Ben Shahn* (Harmondsworth, Middlesex, England: Penguin Books, Ltd, 1947), illus., pl. 26
Selden Rodman, *Portrait of the Artist as an American* (New York: Harper, 1951), pp. 136, 138, illus.

Exhibition
New York, *Ben Shahn*, Museum of Modern Art, 30 September 1947–4 January 1948, p. 43

According to Selden Rodman, the strange imagery of Ben Shahn's *Carnival* of 1946 can be explained by a terrible event in the artist's personal life, the tragic death by drowning of Shahn's younger brother, Hyman, at the summer home of Ben and his wife Tillie over twenty years earlier.[1] Rodman associates the sleeping man with Ben Shahn himself as a young man, 'dreaming uneasily of the happy married life of another young man'.[2]

Whether or not we accept this interpretation, which seems somewhat unlikely because of the twenty years or so intervening between this tragedy and his representation, it seems clear that Shahn employed symbolic meanings and associations in his art. The uneasily sleeping man does appear to dream the otherwise incongruous background imagery. The couple in the amusement park ride in a car with the number 2; a second image of a couple stand, arms affectionately around one another. Thus, the content seems to be more about loneliness as opposed to the companionship of being part of a twosome.

Notes
1 Selden Rodman, *Portrait of the Artist as An American* (New York: Harper, 1951), pp. 136–40
2 *Ibid.*, p. 140

Ben Shahn 1898–1969

75 Identity

1968, mixed media, 101.6 × 69.8 cm (40 × 27½ in)
Signed lower left: 'Ben Shahn'

Provenance
Mr and Mrs Howard S. Levin
Kennedy Galleries, Inc., New York
Thyssen-Bornemisza Collection, 1977

Literature
Emily Genauer, 'Art and the Artist', *New York Post* (5 October 1968), p. 46
Emily Genauer, 'On the Arts/Commentaries on Our Times', *Newsday* (5 October 1968), pp. 33w–34w, illus.
Bernarda Bryson Shahn, *Ben Shahn* (New York: Harry N. Abrams, Inc., 1970), pp. 85 and 272, illus., no. 344

Reproduced
Advertisement for Kennedy Galleries, Inc., New York, *Art Journal* 33 (Summer 1974), p. 302
Advertisement for Kennedy Galleries, Inc., New York, *Art News* 73 (Summer 1974), p. 29

Exhibitions
Philadelphia, PA, *American Watercolors, Prints and Drawings: 164th Annual Exhibition*, Pennsylvania Academy of
 the Fine Arts and the Philadelphia Watercolor Club, 17 January–2 March 1969
Ben Shahn, A Retrospective, April–September 1970
 Kuruma City, Japan, Ishibashi Memorial Hall
 Tokyo, National Museum of Modern Art
 Sapporo, Imai Department Store of Hokkaido
 Osaka, Osaka City Museum
Allentown, PA, *Ben Shahn*, Allentown Art Museum, 12 January–9 February 1975
New York, *One Hundredth Anniversary Exhibition of the Art Students League*, Kennedy Galleries, Inc., 6–29 March
 1975

Ben Shahn's *Identity* of 1968 contains the following well-known statement from the Talmud written in Hebrew across the top of the composition: 'If I am not for myself, who will be for me? But as I am only for myself, what am I? And if not now, when?' The image itself consists of five pairs of skinny, pole-like arms supporting clasping hands, described by one critic as 'like the luminous last blooms in a fading garden. The linear patterns traced by clenched fists echo and develop the patterns of the frieze of Hebrew script.'[1]

Shahn produced *Identity* in 1968, one of the most tumultuous of years which included riots at universities from New York's Columbia to the Sorbonne in Paris. The war in Vietnam had created extreme division in America where young people everywhere questioned and protested. Thus, Shahn's image was a timely one. He had maintained his political awareness and spoke out in person, opposing the Vietnam war. Just four years earlier, Shahn proclaimed: 'Consider Vietnam. Any dunce could see the folly of our tactics in that country. The people there have about as much will-to-power as a basket of hungry kittens. They don't seem to care anything about freedom – even when force is applied, and that leaves us in a terribly embarrassing position.'[2]

Notes
1 Emily Genauer, 'Art and the Artist', *New York Post* (5 October 1968), p. 46
2 Ben Shahn, 'Remarks to "The New Republic" on the Occasion of Its 50th Anniversary', in John D. Morse, ed., *Ben Shahn* (New York: Praeger Publishers, Inc., 1972), p. 212

Raphael Soyer

b. 1899

76 Girl with Red Hat

c. 1940, oil on canvas, 76.8 × 43.2 cm (30¼ × 17 in)
Signed lower left: 'Raphael Soyer'

Provenance
Private collection
Forum Gallery, New York
Private collection
Andrew Crispo Gallery, New York
Thyssen-Bornemisza Collection, 1980

Exhibitions
Vatican, 1983, no. 105; Lugano, 1984, no. 103
USA tour, 1984–86, no. 105

Raphael Soyer, a keen observer of people, painted *Girl with Red Hat* around 1940. His inspiration for this canvas came when he accompanied his wife Rebecca on a shopping trip and observed a woman before a mirror. He had long been attracted to depicting the working classes whom he observed in the streets of New York.

Soyer arranged to have a model pose for him in order to produce this picture. Of this particular model, he recalled only that she posed twice in different costumes and then she just disappeared.[1] He commented 'I used to do a lot of those things – a kind of genre painting. I don't do them any more because it's not done any more. No specific reason. . . . Everyone was different in those days, now it's impossible.'[2]

During this period, Soyer produced a number of canvases of working class women including *Shop Girls* (c. 1936), *Office Girls* (1936), *Lunch Hour* (1936) and *Window Shoppers* (1938). It is interesting that as this woman regards herself in the mirror, we see her companion's reflection rather than her own. Soyer has observed this woman's self-absorption and vanity. He has focused our attention on her red hat, adding very bright lipstick to match. Her companion's gaze and posture, as well as her own expression, reflect a contemplative mood. Soyer has written: 'In my opinion, if the art of painting is to survive, it must describe and express people, their lives and times. It must communicate. . . .'[3]

Notes
1 Author's interview with Raphael Soyer, 1 June 1985, New York
2 *Ibid.*
3 Quoted in Lloyd Goodrich, *Raphael Soyer* (New York: Whitney Museum of American Art, 1967), p. 5

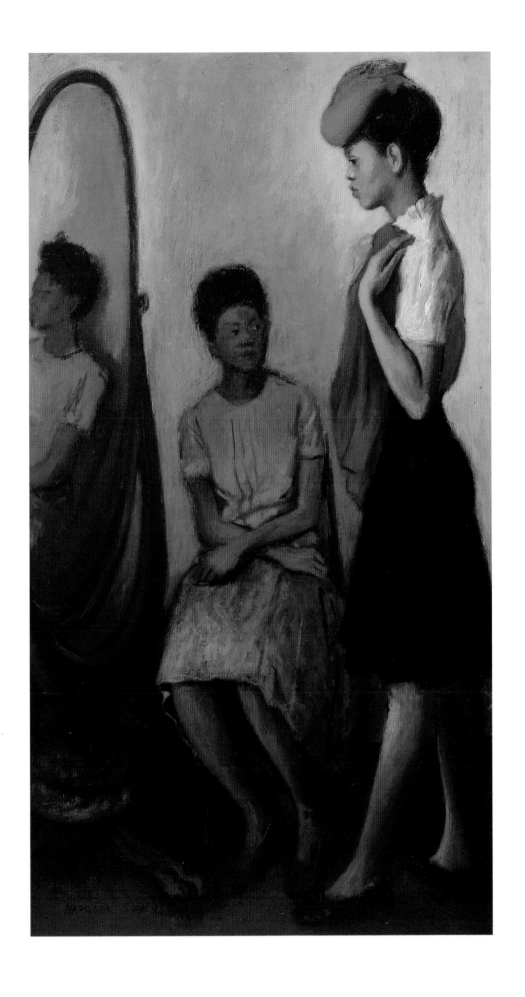

Raphael Soyer

b. 1899

77 Self-portrait

1980, oil on canvas, 61 × 50.8 cm (24 × 30 in)
Signed lower right: 'Raphael Soyer'

Provenance
Forum Gallery, New York
Andrew Crispo Gallery, New York
Thyssen-Bornemisza Collection, 1981

Literature
Abram Lerner, *Soyer Since 1960* (Washington, DC: Smithsonian Institution Press, 1982), n.p.
Mahonri Sharp Young, 'Scope and Catholicity: Nineteenth- and Twentieth-Century American Painting', *Apollo*
 CXVIII (July 1983), p. 88, fig. 11

Exhibitions
New York, *Raphael Soyer: Recent Work*, Forum Gallery, 17 October–21 November 1981
Washington, DC, *Soyer Since 1960*, Hirshhorn Museum and Sculpture Garden, 1982, no. 17

Soyer painted this *Self-portrait* in 1980 at the age of eighty. His approach is honest and direct, showing his most vulnerable side. We observe the artist in a moment of deep concentration, sombre and intense, but lacking any kind of cavalier attitude that one might expect with his long-lived acclaim. He stands before his easel, palette and brush in hand, and is in the process of painting.

Soyer has painted many self-portraits, perhaps even forty or more. He has also drawn and etched self-portraits. He commented: 'When you paint yourself, it's like a soliloquy. You almost talk to yourself.'[1] This reflects his introspective personality and his curiosity which leads him to explore and reveal his deeper self. The portrait has occupied Soyer throughout his long career and he has often painted and sketched his artist friends. His portraits are sensitive depictions of diverse personalities.

In this *Self-portrait*, Soyer included a small painting, a copy that he made after Masaccio's *Tribute Money*, which hangs on his studio wall. He has painted himself standing in his studio before a wall which is stained from repair made to the plaster. He commented:

> I love this wall. At one time it began to crumble. They plastered it up and wanted to paint the studio. I said, no please leave it the way it is. I love the wall. I like things that get old, not because of their antique value, because of the quality that they assume. An old chair acquires a wonderful quality. I like old clothes. I like people disheveled. . . . I always liked old things.[2]

A realist and a humanist, Soyer is sensitive and caring about any subject that he selects including his own image.

Notes
1 Author's interview with Raphael Soyer, 11 June 1985, New York
2 *Ibid.*

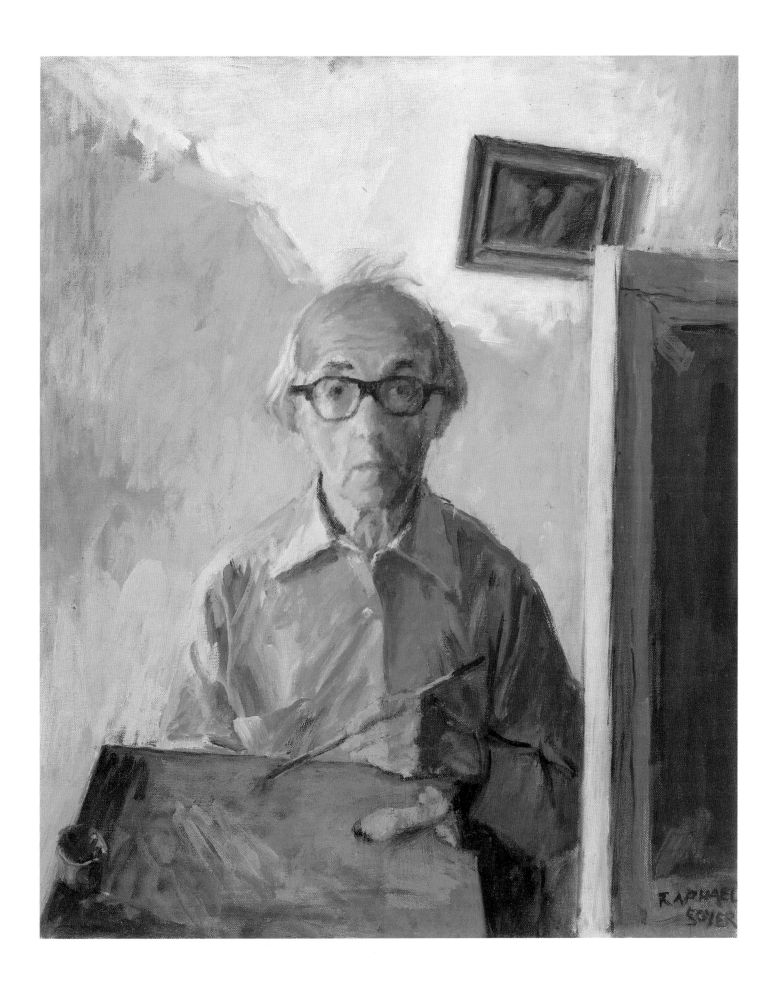

Abstract Expressionism and the New York School

Arshile Gorky

78 Hugging/Good Hope Road II (Pastoral)

1945, oil on canvas, 64.77 × 82.87 cm ($25\frac{1}{2}$ × $32\frac{5}{8}$ in)
Signed and dated lower left: 'A. Gorky/ 45'

Provenance
Julien Levy
Mr and Mrs Sidney Janis
Museum of Modern Art, Sidney and Harriet Janis Collection, New York
Andrew Crispo Gallery, New York
Thyssen-Bornemisza Collection, 1977

Literature
Clement Greenberg, 'Art', *The Nation* 162 (4 May 1946), 552 (as *Hugging*)
Julien Levy, *Arshile Gorky* (New York: Harry N. Abrams, Inc., 1966), pl. 128
Foreword by Alfred H. Barr, Jr, Introduction by William Rubin, *Three Generations of Twentieth-Century Art: the
 Sidney and Harriet Janis Collection of the Museum of Modern Art* (New York: Museum of Modern Art, 1972)
Alfred H. Barr, Jr, *Painting and Sculpture in the Museum of Modern Art: 1929–1967* (New York: Museum of Modern
 Art, 1977), p. 545
Zafran, p. 161, no. 77
Harry Rand, *Arshile Gorky: The Implications of Symbols* (Montclair, NJ: Allanheld & Schram, 1980), pp. 103,
 105–107, 126, 159, 104 illus. (figs 7–2)
Diane Waldman, *Arshile Gorky 1904–1948 A Retrospective* (New York: Harry N. Abrams, Inc., 1981), pl. 185
Jim M. Jordan and Robert Goldwater, *The Paintings of Arshile Gorky: A Critical Catalogue* (New York: New York
 University Press, 1982), pp. 457–58, no. 298
Lieberman, pp. 68–69, illus., no. 59

Exhibitions
New York, *Arshile Gorky Paintings 1946*, Julien Levy Gallery, 16 April–4 May 1946, no. 8 (as *Hugging*)
Arshile Gorky Paintings, Drawings, Studies, December 1961–March 1962, no. 76 (as *Pastoral*)
 New York, Museum of Modern Art
 Washington, DC, Gallery of Modern Art
Hartford, CT, *Connecticut Collects*, Wadsworth Atheneum, Summer–9 September 1962
New Haven, CT, *Max Ernst, Arshile Gorky from the Collection of Julien Levy*, Yale University Art Gallery, 19 March–
 3 May 1964, no. 22, illus.
New York, *Selected Works from Two Generations of European and American Artists: Picasso to Pollock*, Sidney Janis
 Gallery, 3–27 January 1967, no. 44. illus.
The Sidney and Harriet Janis Collection, Museum of Modern Art, New York, 1968–71
 Minneapolis, MN, Minneapolis Insititute of Art
 Portland, ME, Portland Art Museum
 Pasadena, CA, Pasadena Art Museum
 San Francisco, CA, San Francisco Museum of Art
 Seattle, WA, Seattle Art Museum
 Dallas, TX, Dallas Museum of Fine Arts
 Buffalo, NY, Albright-Knox Art Gallery
 Cleveland, OH, Cleveland Museum of Art
 Basel, Kunsthalle
 London, Institute of Contemporary Arts
 Berlin, West Germany, Akademie der Kunst
 Nürnburg, Kunsthalle
 Stuttgart, Württembergischer Kunstverein
 Brussels, Palais des Beaux-Arts
 Cologne, Kunsthalle
New York, *The New American Painting and Sculpture: The First Generation*, Museum of Modern Art,
 18 June–5 October 1969, no. 22
El Arte del Surrealismo, International Council of the Museum of Modern Art, New York, 1971–73
 Bogatá, Colombia, Museo de Arte Moderno
 Buenos Aires, Argentina, Centro de Arte y Comunicación
 Montevideo, Uruguay, Museo Nacional de Artes Plásticas
 Caracas, Venezuela, Museo de Bellas Artes
 Lima, Peru, Instituto de Arte Contemporáneo
 Santiago, Chile, Museo de Bellas Artes
 Mexico City, Mexico, Museo de Arte Moderno
 Auckland, New Zealand, Auckland City Art Gallery
 Sydney, Australia, Art Gallery of New South Wales
 Melbourne, Australia, National Gallery of Victoria
 Adelaide, Australia, Art Gallery of South Australia
New York, *Three Generations of Twentieth-Century American Art: the Sidney and Harriet Janis Collection of the Museum
 of Modern Art*, Museum of Modern Art, 1972

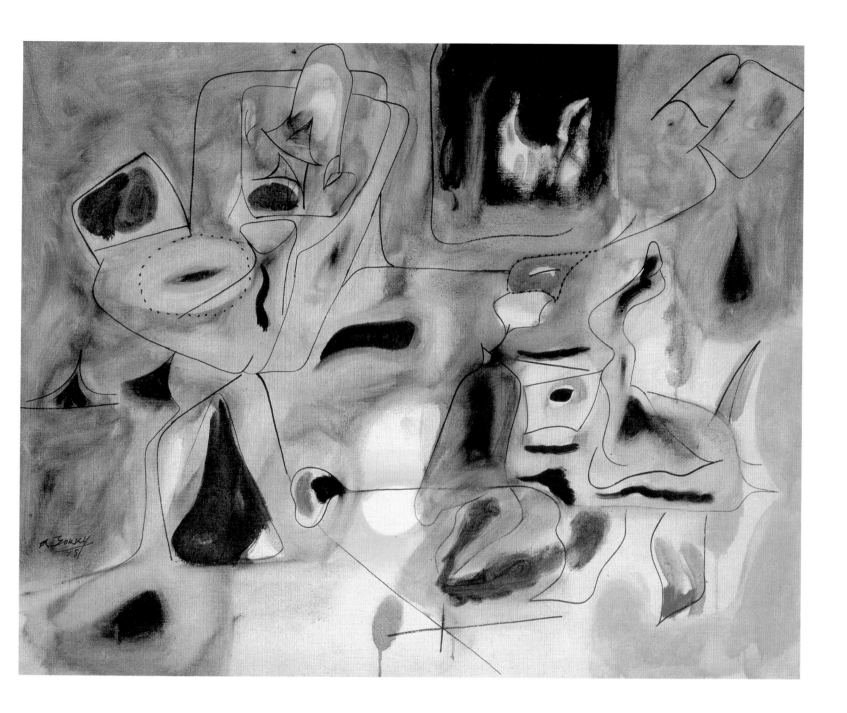

New York, *Subjects of the Artists*, Whitney Museum of American Art (Downtown branch), 22 April–28 May 1975
American Art Since 1945: From the Collection of the Museum of Modern Art, 1975–77
 Worcester, MA, Worcester Art Museum Omaha, NE, Joslyn Art Museum
 Toledo, OH, Toledo Art Museum Greenville, SC, Greenville County Museum
 Denver, CO, Denver Art Museum Richmond, VA, Museum of Fine Arts
 San Diego, CA, Fine Art Gallery Bronx, NY, Bronx Museum of Art
 Dallas, TX, Dallas Museum of Fine Arts
New York, *20th Century American Masters of Painting and Sculpture*, Andrew Crispo Gallery, 1977, no. 72
New York, *Summer Loan Exhibition from Private Collections*, Metropolitan Museum of Art, 1978
Australian tour, 1979–80, no. 77
Arshile Gorky 1904–1948: A Retrospective, April 1981–February 1982, no. 185
 New York, Solomon R. Guggenheim Museum
 Dallas, TX, Dallas Museum of Art
 Los Angeles, CA, Los Angeles County Museum of Art
USA tour, 1982–83, no. 59

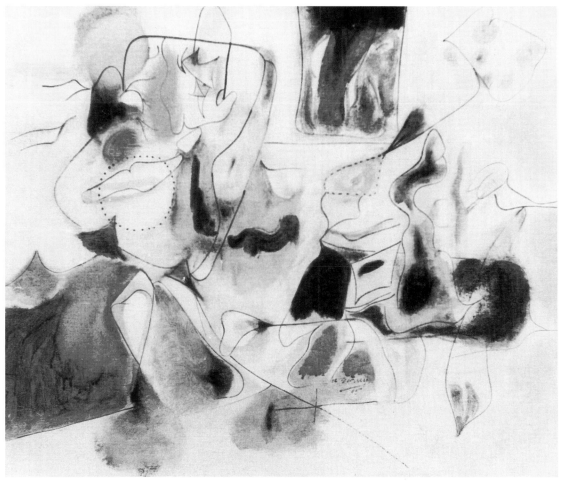

1 Arshile Gorky, *Impatience*, 1945, oil on canvas, Collection of Mr Sidney Kohl, Milwaukee, WI

Arshile Gorky painted *Hugging* also known as *Good Hope Road* II *(Pastoral)*, in 1945; the second title is after the address of his artist friend David Hare in whose Roxbury, Connecticut house he and his family lived in 1944 and 1945. This picture is a part of a series which Jim Jordan claims began with *Impatience* (fig. 1) (Collection of Mr Sidney Kohl), also of 1945, and which Harry Rand argues preceded *Impatience*.[1] According to Jordan, *Good Hope Road* I is probably known today under some other title.[2]

This picture was sold by the Museum of Modern Art on 13 December 1977 'in order to acquire another work by Gorky, *The Leaf of the Artichoke is an Owl*' of 1944.[3] The Museum of Modern Art identified the painting by the title *Good Hope Road* II *(Pastoral)* which Harry Rand disputes, preferring the original title *Hugging*, used by Gorky's friend and dealer Julien Levy in his monograph on the artist. Levy to whom Gorky gave this picture, recalled that Gorky described the painting to him as representing him, his dog (a Lhasa) and a cow.[4]

Rand discounts this interpretation as merely something that the artist would do to 'visually link the piece to the person to whom it was a gift'.[5] His own interpretation is a rather elaborate analysis of this picture:

> A warm interior view treated with the most tender sensibility, the picture represents a scene of lovemaking. In the painting's left-corner a couple sits; they embrace gently on a couch. Both undressed the woman sits on the man's lap . . . they kiss . . . The picture has been filled out with the particulars of an interior scene within a cogent space . . . a view through a window in the middle left allows an extreme long distance to be represented by a single mountain on the horizon.[6]

Notes
1 Harry Rand, *Arshile Gorky: The Implications of Symbols* (Montclair, NJ: Allanheld & Schram, 1982), p. 105
2 Jim M. Jordan and Robert Goldwater, *The Paintings of Arshile Gorky: A Critical Catalogue* (New York: New York University Press, 1982), p. 458
3 Rand, *op. cit.*, p. 114
4 Julien Levy in conversation with Rand, 8 March 1973, quoted in Rand, *op. cit.*, p. 113
5 *Ibid.*, p. 113
6 *Ibid.*, pp. 103–105

Notes

7 Wassily Kandinsky, *Concerning the Spiritual in Art* (New York: Wittenborn, Schultz, 1947), p. 63. For a discussion of the influence of Kandinsky's work on Gorky, see Gail Levin, 'Miró, Kandinsky, and the Genesis of Abstract Expressionism', in Robert Carleton Hobbs and Gail Levin, in *Abstract Expressionism: The Formative Years* (Ithaca, NY: Cornell University Press, 1981), pp. 33–35

8 For a discussion of these works, see Rose-Carol Washton Long, 'Kandinsky's Vision of Utopia as a Garden of Love', *Art Journal* 43 (Spring 1983), pp. 50–60

While it is extremely difficult to read all the symbols that Rand identifies in this picture, it is likely that although some such personal inconography was intended, the artist probably did not expect it to be literally interpreted.

Gorky's theme in *Hugging* may also reflect the artist's interest in the work of Wassily Kandinsky with whom, in the catalogue of his exhibition at the Julien Levy Gallery in 1945, he falsely claimed to have studied. Gorky's desire to be associated with Kandinsky attests to his admiration for the artist's work at this time. Gorky knew Kandinsky's treatise *Concerning the Spiritual in Art* and must have symphathised with the Russian artist's insistence that feelings like joy or grief were 'only material expressions of the soul' and that shades of colour 'awaken in the soul emotions too fine to be expressed in prose'.[7] He must have been familiar with paintings like Kandinsky's 1912 *Improvisation No. 27* (fig. 2) and *Improvisation No. 25*, both subtitled *Garden of Love*, and containing abstract shapes depicting a couple embracing.[8]

2 Wassily Kandinsky, *Improvisation No. 27 (Garden of Love)*, 1912, Metropolitan Museum of Art, New York

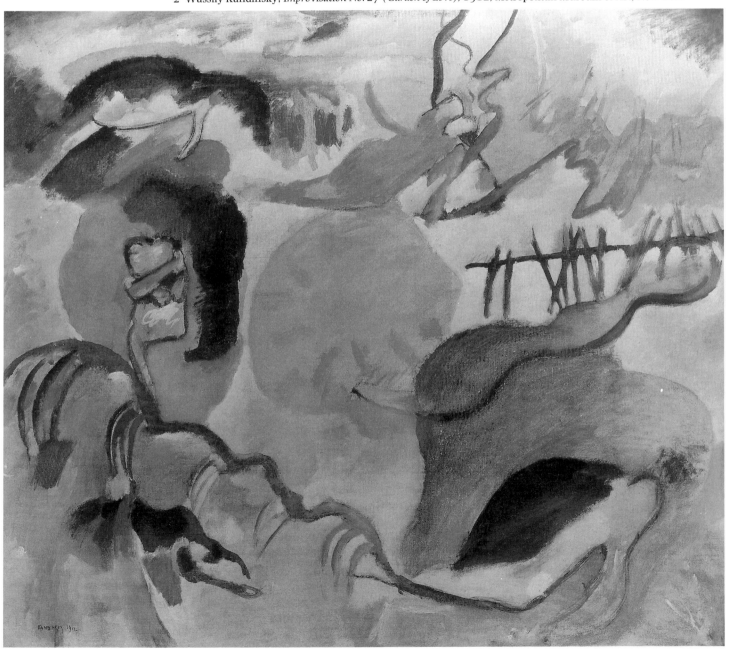

Arshile Gorky 1905–1948

79 Last Painting/The Black Monk

1948, oil on canvas, 78.11 × 100.97 cm (30¾ × 39¾ in)
Signed lower left: 'A. Gorky'

Provenance
Estate of the artist
Private collection
Andrew Crispo Gallery, New York
Thyssen-Bornemisza Collection, 1978

Literature
Ethel K. Schwabacher, *Arshile Gorky Memorial
 Exhibition* (New York: Whitney Museum of
 American Art, 1951), p. 41
Ethel K. Schwabacher, *Arshile Gorky* (New York:
 MacMillan Company, 1957), pp. 128, 140, 148,
 illus.
Sonya Rudikoff, 'Gorky and Tomlin', *Partisan Review*
 (Winter 1958), p. 159
Harold Rosenberg, *Arshile Gorky: the Man, the Time,
 the Idea* (New York: Horizon Press, Inc., 1962),
 p. 122

Julien Levy, *Arshile Gorky* (New York: Harry N.
 Abrams, Inc., 1966), p. 10, pl. 208
'Die Moderne Sammlung Thyssen-Bornemisza', *Du 2*
 (1980), p. 62, illus.
Harry Rand, *Arshile Gorky: The Implications of Symbols*
 (Montclair, NJ: Allanheld & Schram, 1980),
 pp. 111, 203–204, 207–10, 240 (colour pl. v)
Diane Waldman, *Arshile Gorky 1904–1948
 A Retrospective* (New York: Harry N. Abrams, Inc.,
 1981), pl. 185
Jim M. Jordan and Robert Goldwater, *The Paintings of
 Arshile Gorky: A Critical Catalogue* (New York: New
 York University Press, 1982), pp. 540–41, no. 360
Lieberman, pp. 68–69, illus., no. 60
William C. Seitz, *Abstract Expressionist Paintings in
 America* (Cambridge, MA: Harvard University
 Press, 1983), no. 92

Exhibitions
New York, *Arshile Gorky Memorial Exhibition*, Whitney Museum of American Art, 5 January–18 February 1951,
 no. 55
Princeton, NJ, *Arshile Gorky*, Princeton University Art Museum, 6–26 October 1952, no. 23
New York, *Paintings by Arshile Gorky from 1929 to 1948*, Sidney Janis Gallery, 5 February–3 March 1962
Venice, XXXI Biennale Internationale d'Arte, 16 June–7 October 1962, no. 31
New York, *Arshile Gorky Paintings, Drawings, Studies*, Museum of Modern Art, 17 December 1962, no. 121
Arshile Gorky: Paintings and Drawings, April–August 1965, no. 105
 London, Tate Gallery
 Brussels, Palais des Beaux-Arts
 Rotterdam, Museum Boymans van Beuningen
Arshile Gorky 1904–1948: A Retrospective, April 1981–February 1982, no. 249
 New York, Solomon R. Guggenheim Museum
 Dallas, TX, Dallas Museum of Art
 Los Angeles, CA, Los Angeles County Museum of Art
USA tour, 1982–83, no. 60
Cologne, *Europa/Amerika*, Museum Ludwig, 6 September–30 November 1986, p. 56, colour pl.

Julien Levy identified the meaning of Arshile Gorky's last painting, found on the artist's easel after his suicide, linking it to the fact that Gorky had been reading a short story, *The Black Monk* by Anton Chekhov.[1] Levy quoted from the text the passage that Gorky chose to illustrate:

> On the horizon, like a cyclone or waterspout, a great, black pillar rose from the earth to heaven. Its outlines were undefined; but from the first it might be seen that it was not standing still, but moving with inconceivable speed towards us, and the nearer it came the smaller and smaller it grew . . . a monk in black clothing with black hair and black eyebrows, crossing his hands upon his chest, was borne past, upright. His bare feet were above the ground . . . when he passed he again began to grow, flew across the river, struck inaudibly against the clay bank and pine trees, and, passing then, vanished like smoke.

This story tells of the degeneration of a man of considerable talent and assets, a situation with which Gorky clearly identified. He chose to portray on his canvas the object rapidly advancing, the Black Monk himself, a visionary personnage viewed through the delirium of the central character, Kovrin.[2]

Notes
1 Julien Levy, *Arshile Gorky*
 (New York: Harry N. Abrams,
 Inc., 1962), pp. 9–10
2 Harry Rand, *Arshile Gorky:
 The Implications of Symbols*
 (Montclair, NJ: Allanheld &
 Schram, 1982), p. 204
3 *Ibid.*

Rand sees this painting as depicting the distant Monk large and white and the Monk close by as the small black configuration in the right lower centre of the canvas, an inversion of traditional perspective.[3] Whether or not one accepts Rand's very specific interpretation of symbols – such as the haemorrhaging Monk collapsed and dead in the small rectangle on the upper left of the painting, just to the left of the tangle of red lines which he identifies as a pool of blood described in the Chekhov story – this painting clearly refers to Gorky's reading of this tale of suicide, so poignantly felt in his own despair.

Gorky evidently made no drawings or sketches preceding his last painting. Thus, this work is viewed as having made the transition from his Surrealist roots to the new, more spontaneously executed Abstract Expressionism, an American type of painting. Gorky had assumed a vanguard role in absorbing the tenets of the School of Paris painters, many of whom he knew during their wartime exile in New York. In the light of his personal mythology, he recast these ideas in a new and profound manner.

Hans Hofmann 1880–1966

80 Vase, Furniture, and Books ### 80 *verso* Untitled Still-Life

1935, casein and oil on board, 76 × 55 cm (29¾ × 21½ in) 1935, oil on board, 55 × 76 cm (21½ × 29¾ in)

Provenance
Estate of the artist
Andre Emmerich Gallery, New York
Andrew Crispo Gallery, New York
Thyssen-Bornemisza Collection, 1977

Literature
Zafran, p. 155, no. 62 and no. 62a

Exhibitions
New York, *20th Century American Masters of Painting*, Andrew Crispo Gallery, 1977, no. 70
Australian tour, 1979–80, nos 62, 62a

In 1935, when he started to paint after a long period of working only on drawings, Hans Hofmann had just opened his own art school in New York the previous autumn. It was probably just after that summer of 1935, in Provincetown, when Hofmann opened his summer school for the first time, that he painted this two-sided canvas. As we know that he had his summer students concentrate on landscapes, while in the winter his students worked on life drawings and still-lifes, we can assume that this composition was related to the concepts that he was teaching in New York.[1]

Hofmann's *Vase, Furniture, and Books* is painted in a palette of bright Fauvist colours, reflecting his knowledge of the work of artists in Paris, particularly Matisse and the Delaunays. His method of abstraction, particularly the use of transparency on the still-life objects, suggests his awareness of Cubism. Hofmann is already experimenting with planes of colour projecting and receding, what he later taught his students as the lessons of 'push and pull'.

The verso of this canvas is less traditional, retaining only a vestige of still-life in the inclusion of a white pitcher. The remainder of the composition contains flat geometric shapes of colour which seem to be parallel to the picture plane. Some areas are much more textured than others and the warm reds jump out at the viewer while the cooler blues and green recede. Hofmann's intention seems to have been to frame his still-life with abstract shapes of dynamic colour.

Note
1 See Cynthia Goodman, *Hans Hofmann as Teacher: Drawings by his Students* (New York: Metropolitan Museum of Art, 1979), n.p.

Hans Hofmann 1880–1966

81 Blue Enchantment

1951, oil on canvas, 152.4 × 121.9 cm (60 × 48 in)
Signed and dated lower right: '51/ Hans Hofmann'

Provenance
Andre Emmerich Gallery, New York
Private collection
Andrew Crispo Gallery, New York
Thyssen-Bornemisza Collection, 1978

Literature
Irving Sandler, *Hans Hofmann: The Years 1947–1952*
 (New York: Andre Emmerich Gallery, 1976), illus.
 on cover
Irving Sandler, 'Hans Hofmann and the Challenge of
 Synthetic Cubism', *Arts magazine* 50 (April 1976),
 p.105
Walter Darby Bannard, *Hans Hofmann Retrospective*
 (Houston, TX: Museum of Fine Arts, 1977), p.17,
 illus.

Exhibitions
Bennington, VT, *A Retrospective of the Paintings of Hans
 Hofmann*, Bennington College, 1955, no. 5
New York, *Hans Hofmann: The Years 1947–1952*,
 Andre Emmerich Gallery, 1976
Hans Hofmann Retrospective, October 1976–April
 1977, no.16
 Washington, DC, Hirshhorn Museum and
 Sculpture Garden
 Houston, TX, Museum of Fine Arts
Vatican, 1983, no.111; Lugano, 1984, no.109
USA tour, 1984–86, no.110

1 Pablo Picasso, *The Studio*
1928, Museum of Modern Art
New York

Hans Hofmann's *Blue Enchantment* of 1951 was painted at the time this artist was known as an Abstract Expressionist. Although fully abstract, elements of this composition suggest the influence of Picasso. The angular form Hofmann used on the right side of his composition resembles the kind of abstract portrait bust that Picasso included on the far left side of his painting *The Studio* of 1928 (fig. 1). Hofmann would have been familiar with this canvas from its presence in the permanent collection of the Museum of Modern Art in New York.

Hofmann painted this canvas rather thickly, applying pigment with a palette knife. His choice of colours is rather striking; he emphasised red and yellow against a brilliant blue ground, also including black and white and a touch of green. This composition also contrasts the hard-edged sharpness of most contours with the rough feathered effect of the black outline of the form on the right.

Hans Hofmann 1880–1966

82 Untitled

1965, oil on canvas, 122 × 91.4 cm (48 × 36 in)
Signed and dated lower right: 'Hans Hofmann/ 65'

Provenance
Estate of the artist
Andre Emmerich Gallery, New York
Andrew Crispo Gallery, New York
Thyssen-Bornemisza Collection, 1981

Exhibitions
Modern Masters from the Thyssen-Bornemisza Collection, May–December 1984
 Tokyo, National Museum of Modern Art
 Kumamoto, Kumamoto Prefectural Museum
 London, Royal Academy of Arts, no. 101
 February–August 1986
 Madrid, Biblioteca Nacional, Salas Pablo Ruiz Picasso
 Barcelona, Palau de la Virreina

Hofmann's *Untitled* painting of 1965 is from his Renate Series, painted at the end of his life, in honour of his second wife Renate. Composed of stark rectangles of bold, flat colour juxtaposed with dark brooding paint, this painting communicates the artist's emotion through gesture and colour. Hofmann stated his philosophy: 'At the time of making a picture I want to know what I'm doing; a picture should be made with feeling, not with knowing.'[1]

Although untitled, this work is associated with the nine paintings of the Renate Series all of which have emotionally expressive titles such as *Rhapsody, Profound Longing,* or *Lust and Delight.* Such titles coincide perfectly with the basic axiom of Hofmann's influential teaching, and, indeed, of his painting. This is that every formal or technical concept needs its equivalent in feeling to avoid seeming like mere decoration.[2] In this concept and in other ways, Hofmann owed a great debt to the influence of the Russian expatriate artist Wassily Kandinsky. Like Kandinsky, Hofmann painted abstractly, but was concerned with the spiritual content of his art: 'The spirit in a work of art is synonymous with its quality. The Real in art never dies because its nature is predominantly spiritual.'[3]

Notes
1 Quoted in Henry Geldzahler, *Hans Hofmann: The Renate Series* (New York: Metropolitan Museum of Art, 1972), p. 12
2 Harold Rosenberg, 'The Teaching of Hans Hofmann', *Arts magazine* (December 1970/ January 1971), p. 17
3 Quoted in William C. Seitz, *Hans Hofmann* (New York: Museum of Modern Art, 1963), p. 54

Willem de Kooning b. 1904

83 Abstraction

1949–50, mixed media on fibreboard, 37 × 46.5 cm ($14\frac{1}{2}$ × $18\frac{1}{8}$ in)
Signed upper left: 'de Kooning'

Provenance
Jerome Hill, New York
Sale, Christie's, London, Contemporary Art, 3 December 1974, lot 111, illus.
Thyssen-Bornemisza Collection, 1974

Literature
Monelle Hayote, 'L'Ecole de New York', *L'Oeil* (October 1976), p. 35, illus.
Zafran, p. 163, no. 82
John I.H. Baur, 'Le Nouveau Gout Thyssen', *Connaissance des Arts* 379 (September 1983), p. 68

Exhibitions
The Origins of the 20th Century in the Collection Thyssen-Bornemisza, 1976
 Tokyo, Seibu Museum of Art
 Kobe, Hyogo Prefectural Museum
 Fikuoka, Kitakyushu Municipal Museum
La Collection Thyssen-Bornemisza: Tableaux Modernes, February–May 1978, no. 48, illus.
 Brussels, Musée d'Ixelles
 Paris, Musée d'Art Moderne de la Ville de Paris
Australian tour, 1979–80, no. 82

Willem de Kooning's *Abstraction* of 1949–50 reveals the artist's process in abstracting from the world around him. On the right side of this composition, we are still able to see a three-dimensional space. There is a ladder leading to a window which is a source of light. Behind the ladder, outlined in red, is an entrance to this space. At the base of the ladder, we see a skull and a large spike or nail. These objects may have traditional Christian meaning. The ladder is one of the instruments of the Passion and is frequently included in depictions of the Descent from the Cross. The nail, because of its use in the Crucifixion of Christ, is also a symbol of the Passion. Across the top of the composition, de Kooning pressed his finger prints in black paint.

1 Willem de Kooning, *Attic Study*, 1949, De Menil Foundation Inc., Houston, TX

Evidence that this space depicted was actually de Kooning's studio is found by comparing the study for his 1949 painting *Attic*. In *Attic Study* (fig. 1), a similar ladder is visible in the upper left corner of the picture. The biomorphic shapes in this study are not unlike those in *Abstraction*. The figurative reference of shapes such as these is indicated by a comparison to works like *Seated Woman* of c. 1940 (fig. 2), where the legs of this figure form a yellow mass similar to the ones at the top of *Abstraction*.

This painting is an example of de Kooning's early gestural Abstract Expressionist style. The classicism of his earlier portraits has been fully eroded by a shattering of focus on any central image. The architectural forms of *Abstraction* refer back to earlier inclusion of rectangular window-like shapes used to organise space. There remains a very clear sense of three-dimensional space which would give way to a surface animation in the mature work.

2 Willem de Kooning, *Seated Woman*, c. 1940, Philadelphia Museum of Art, Philadelphia, PA

Willem de Kooning b. 1904

84 Red Man with Moustache

1971, oil on paper mounted on canvas, 207.5 × 91.5 cm (81½ × 36 in)
Signed lower left: 'de Kooning'

Provenance
Anthony D'Offay Gallery, London
Thyssen-Bornemisza Collection, 1984

Literature
Gabriella Drudi, *Willem de Kooning* (Milan: Fratelli Fabbri, 1972), no. 158, illus.
Harold Rosenberg, 'Interview with Willem de Kooning', *Art News* 71 (September 1972), p. 59
Harold Rosenberg, *Willem de Kooning* (New York: Harry N. Abrams, Inc., 1974), pl. 192
Barrie Hale, 'Willem de Kooning: The Pollock Gallery', *Artscanada* 31 (December 1974), p. 117, illus.
Jack Cowart, 'De Kooning Today', *Art International* (Summer 1979), pp. 8–17, illus.
Harry F. Gaugh, *Willem de Kooning* (New York: Abbeville Press, 1983), illus., p. 87, pl. 75
Curtis Bill Pepper, 'The Indomitable de Kooning', *The New York Times Magazine* (20 November 1983), p. 46, illus.

Exhibitions
Baltimore, MD, *Willem de Kooning: Paintings, Sculpture and Work on Paper*, Baltimore Museum of Art, 1972
Toronto, *Willem de Kooning*, Pollock Gallery, 18 October–15 November 1974
West Palm Beach, FL, *De Koonings: Paintings, Drawings, Sculptures 1967–75*, Norton Gallery of Art, 1975–76,
 no. 2, illus.
The Sculptures of de Kooning with Related Paintings, Drawings, and Lithographs, 1977–78, no. 30
 Edinburgh, Fruit Market Gallery
 London, Serpentine Gallery
New York, *Willem de Kooning in East Hampton*, Solomon R. Guggenheim Museum, 10 February–23 April 1978,
 no. 26, illus.
De Kooning, 1969–78, 1978–79, no. 1
 Cedar Falls, IA, University of Northern Iowa
 St Louis, MO, St Louis Art Museum
 Akron, OH, Akron Art Institute
Pittsburgh, PA, *Willem de Kooning: Pittsburgh International Series*, Museum of Art, Carnegie Institute,
 26 October 1979–6 January 1980, no. 40
East Hampton, NY, *Willem de Kooning: Works from 1951–1981*, Guild Hall, 1982
Munich, *Amerikanische Malerei 1930–1980*, Haus der Kunst, 14 November 1981–31 January 1982, no. 158,
 illus.
Ridgefield, CT, *Homo Sapiens: The Many Images*, Aldrich Museum of Contemporary Art, 1982
Willem de Kooning: The North Atlantic Light, 1960–63, 1983, no. 15, illus.
 Amsterdam, Stedelijk Museum
 Humlebaek, Denmark, Louisiana Museum of Modern Art
 Stockholm, Moderna Museet
Willem de Kooning: Drawings, Paintings, Sculpture, December 1983–September 1984, no. 232, illus.
 New York, Whitney Museum of American Art
 Berlin, Akademie der Kunst
 Paris, Musée National d'Art Moderne, Centre Georges Pompidou
Modern Masters from the Thyssen-Bornemisza Collection, February–August 1986, no. 96
 Madrid, Biblioteca Nacional, Salas Pablo Ruiz Picasso
 Barcelona, Palau de la Virreina

Willem de Kooning's *Red Man with Moustache* of 1971 has been called 'one of de Kooning's most entertaining figures – a synthesis of Bozo, Santa Claus, and Ingres's Monsieur Bertin. . . .'[1] Beneath the skeins of thick paint applied in broad gestural brushstrokes, we see the awkward figure of a standing man. The broad streak of paint across the lower portion of his head must be his moustache.

Note
1 Harry F. Gaugh, *De Kooning* (New York: Abbeville Press, 1983), p. 85

This loose gestural style has evolved considerably since de Kooning's beautifully drawn male figures of the late 1930s. *Red Man with Moustache* grew more directly out of de Kooning's series of women painted during the 1950s. There is even less drawing, however, in the later work than in the 1950s women such as *Woman II* of 1952 (fig. 1). The artist conveys a sense of vitality and movement in this loosely executed figure.

In choosing his title, we must ask if de Kooning, a Dutch immigrant, is painting the quintessential American, the Indian or Red Man, or just emphasising this hot, exciting colour. The artist's home in East Hampton, Long Island is situated in the midst of many landmarks which still bear their Indian names – from Accobonac Creek, which gave Jackson Pollock, his contemporary, a name for an entire series in the 1940s, to the neighbouring town, Amagansett.

De Kooning's enthusiastic use of the colour red began in the mid-1960s. This bold colour carries with it associations of passion, heat and loudness. Perhaps all of these associations apply to this unruly, dramatic figure. Already in his late sixties when he painted *Red Man with Moustache*, de Kooning seems to scream out that his is a passionate temperament, still full of vigour, not that of an aging quiet man.

1 Willem de Kooning
Woman II, 1952, Museum of Modern Art, New York

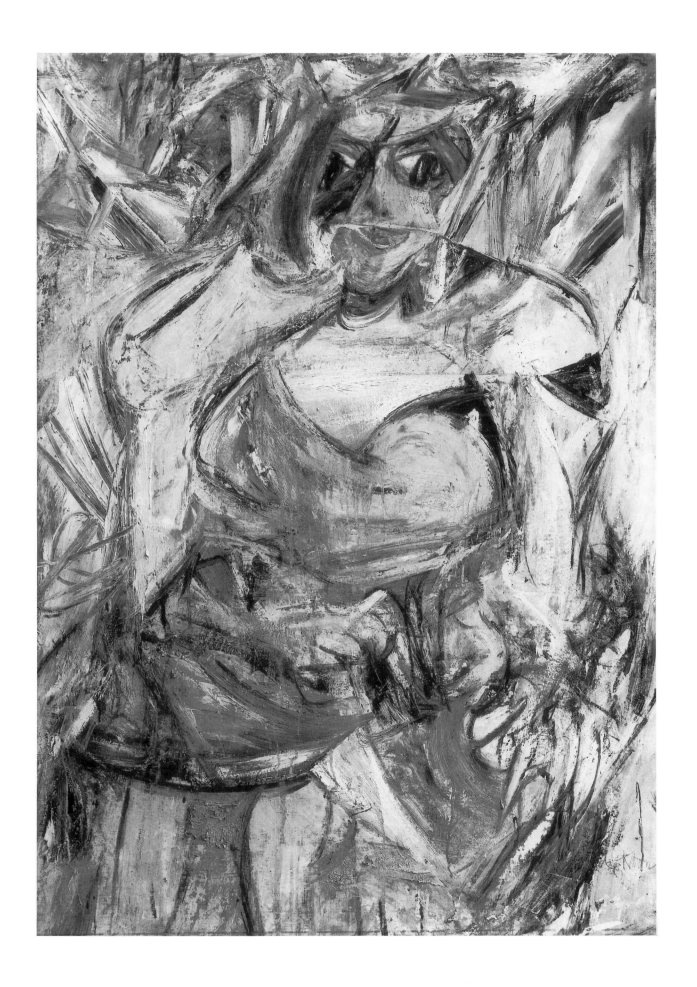

Lee Krasner 1908–1984

85 Red, White, Blue, Yellow, Black

1939, oil on paper with collage, 65.5 × 48.5 cm (25 × 19 ⅛ in)
Signed right of lower centre: 'L.K. '39'

Provenance
The Pace Gallery, New York
Andrew Crispo Gallery, New York
Thyssen-Bornemisza Collection, 1978

Literature
Ann Sutherland Harris and Linda Nochlin, *Women Artists: 1550–1950* (New York: Alfred A. Knopf, 1976), p. 333,
 no. 155, p. 331 illus.
Barbara Cavaliere, 'Interview with Lee Krasner', *Flash Art* (January–February 1980), p. 14, illus.

Exhibitions
Lee Krasner: Collages and Works on Paper, 1933–1974, January–April 1975, no. 18
 Washington, DC, Corcoran Gallery of Art
 Philadelphia, PA, Pennsylvania State University Museum of Art
Women Artists: 1550–1950, December 1976–November 1977, no. 155
 Los Angeles, CA, Los Angeles County Museum of Art
 Austin, TX, University Art Museum, University of Texas at Austin
 Pittsburgh, PA, Museum of Art, Carnegie Institute
 Brooklyn, NY, Brooklyn Museum
New York, *Twelve American Masters of Collage*, Andrew Crispo Gallery, 1978, no. 101, illus.
Australian tour, 1979–80, no. 67
Krasner/Pollock: A Working Relationship, August–December 1981, no. 18
 East Hampton, NY, Guild Hall Museum,
 New York, Grey Art Gallery and Study Center, New York University

Lee Krasner made *Red, White, Blue, Yellow, Black* of 1939 by reworking an older work, parts of which she glued onto a new sheet of paper to create this picture. This practice was something to which she frequently returned over the years. While Krasner first made collages in the 1930s, as late as the 1970s, she made collages on canvas out of some of her discarded drawings of the 1930s.

Krasner's palette in this painting reflects the influence of the Neo-plastic work of Piet Mondrian whom she later met in New York in 1940 at a party given by George L. K. Morris, the founder of American Abstract Artists of which she was a member. Most of her paintings of this period, however, vary somewhat from Mondrian's classic palette.

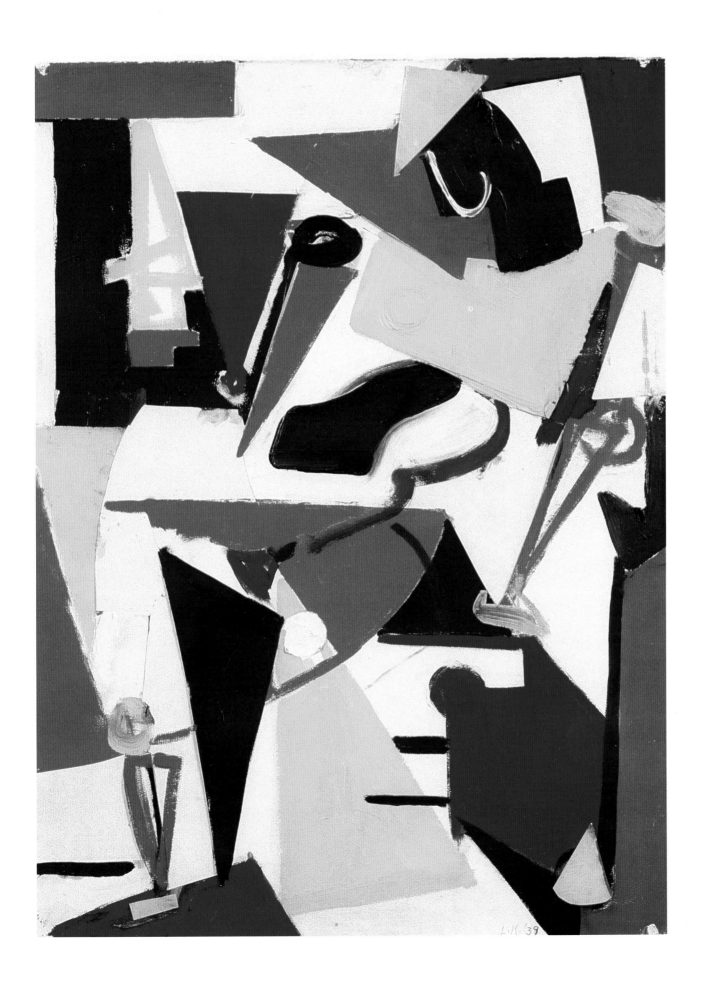

Krasner also knew Arshile Gorky at this time and, like him, she admired the work of Picasso. She had been studying with Hans Hofmann who taught her his push-pull theories of composition. Krasner created such abstraction as this based on still-life objects set up at the Hofmann School. For example, a more recognisable *Still Life* (fig. 1) in oil on paper, painted just a year earlier, demonstrates how she abstracted from recognisable objects that she observed. Yet in this work, all recognisable references to the object have disappeared, resulting in pure abstraction.

Even at this early point in her career, Krasner was well along to developing her most original work which would place her among her male contemporaries as one of the first generation of Abstract Expressionists. Her interests at this time parallel that of some her friends who would also be with her in the vanguard: Gorky, de Kooning and Ad Reinhardt.

1 Lee Krasner, *Still Life*, 1938, oil on paper, Museum of Modern Art, New York

Alfonso Ossorio b.1916

86 The Cross in the Garden

1950, gouache and collage, 85×61 cm ($33\frac{1}{2} \times 24$ in)

Provenance
Thyssen-Bornemisza Collection, 1981

Alfonso Ossorio's *The Cross in the Garden* of 1950 relates to his major project at that time – the decoration of the Catholic memorial Chapel of St Joseph the Worker, built by his family in the town of Victorias, on the island of Negros in the Philippines. The site had been destroyed during the Second World War and was being reconstructed to serve the community. Ossorio painted a large mural and made various studies for it, including *Mother Church* (1949) and other studies representing Christ. There are abstract passages in these studies which relate to *The Cross in the Garden*.

Two major influences on Ossorio's work at this stage of his career were the art of the Frenchman Jean Dubuffet whom he met in Paris in November 1949 and Jackson Pollock whose work he admired by 1947 and purchased by 1948.[1] Ossorio met Jackson Pollock and his wife Lee Krasner in 1949 in East Hampton on Long Island where he spent the summer. Ossorio was clearly attracted to the seemingly primitive or brutal expression of Pollock's drip paintings and of Dubuffet's almost childlike figures scrawled onto canvas.

In *The Cross in the Garden*, Ossorio refers to Christ's Passion, but the imagery is so abstract that on first glance one thinks more of the style, reflecting Pollock's influence. Yet the painting is strangely symmetrical and there appears to be a figure outlined in yellow beneath much of the calligraphic line. The figure's arms are outstretched and it resembles nothing so much as the crucifixion scene itself, suggested by the title. Ossorio's image here is suggestive rather than explicit, adding enigma to the visual interest created by his dynamic, bright line and colour.

Note
1 The source of this information is *Alfonso Ossorio* (East Hampton, NY: Guild Hall Museum, 19 July–17 August 1980), interview with Judith Wolfe

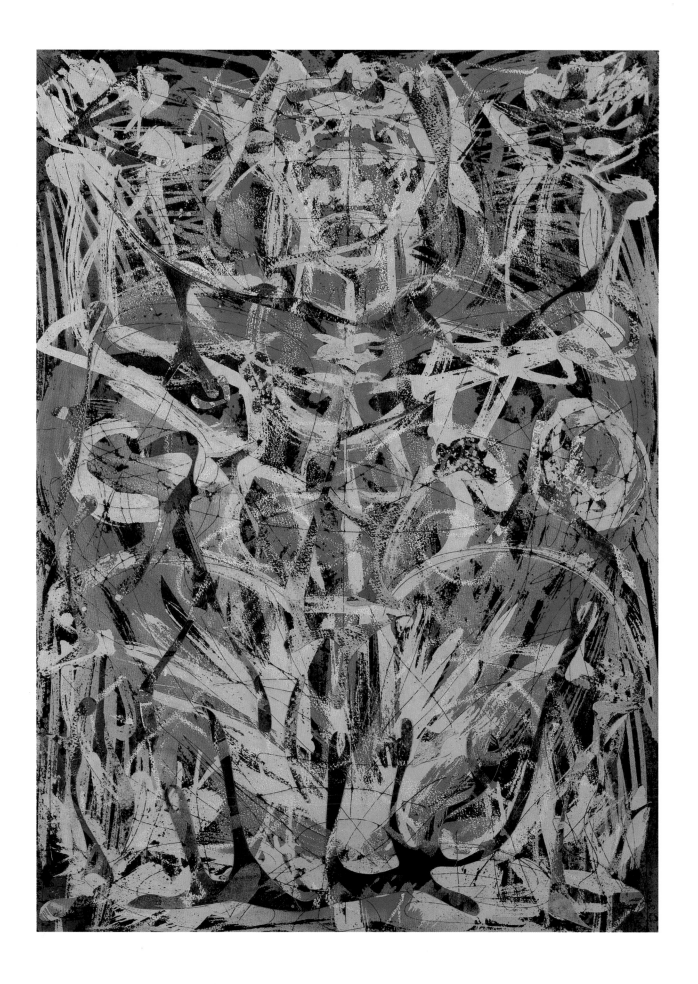

Jackson Pollock 1912–1956

87 Untitled

c. 1945, pastel, brush and enamel, and sgraffito on paper, 65.4 × 52.1 cm (25¾ × 20½ in)
Signed lower centre: 'Jackson Pollock'

Provenance
Sidney Janis Gallery, New York
Mr and Mrs Walter Bareiss, Greenwich, CT
Andrew Crispo Gallery, New York
Thyssen-Bornemisza Collection, 1978

Literature
Bryan Robertson, *Jackson Pollock* (New York: Harry N. Abrams, Inc., 1960), no. 126, illus.
Bernice Rose, *Jackson Pollock: Works on Paper* (New York: Museum of Modern Art, 1969), p. 56, illus.
Francis Valentine O'Connor and Eugene Victor Thaw, eds, *Jackson Pollock: A Catalogue Raisonné of Paintings,
 Drawings, and other Works* (New Haven, CT: Yale University Press, 1978), no. 994, vol. 4, pp. 68–69
Bernice Rose, *Jackson Pollock: Drawings into Painting* (New York: International Council of the Museum of Modern
 Art, 1979), pp. 21, 49, illus., no. 22

Exhibitions
New York, *Jackson Pollock Drawings*, Sidney Janis Gallery, 4–30 November 1957, no. 22
New York, *The Collection of Mr and Mrs Walter Bareiss: 50 Selections*, Museum of Modern Art, 23 April–11 May
 1958, no. 42
Jackson Pollock, April–September 1967, no. 27
 New York, Museum of Modern Art
 Los Angeles, CA, Los Angeles County Museum of Art
Jackson Pollock: Works on Paper, Museum of Modern Art, New York, February 1968–February 1969, no. 29
 Minneapolis, MN, Walker Art Center
 College Park, MD, University of Maryland
 Chicago, IL, Museum of Contemporary Art
 Seattle, WA, Seattle Art Museum
 Baltimore, MD, Baltimore Museum of Art
 Montreal, Canada, Montreal Museum of Fine Arts
 Waltham, MA, Rose Art Museum, Brandeis University
New York, *20th Century American Drawings*, Solomon R. Guggenheim Museum, 1975, no. 89
Baden-Baden, *Amerikanische Zeichner des 20 Jahrhunderts*, Staatliche Kunsthalle, 1975, no. 77
Jackson Pollock: Drawing into Painting, April 1979–March 1980, no. 22
 Oxford, England, Museum of Modern Art
 Düsseldorf, Städtische Kunsthalle
 Lisbon, Calouste Gulbenkian Foundation
 Paris, Musée d'Art Moderne de la Ville de Paris
 New York, Museum of Modern Art

Jackson Pollock painted this *Untitled* work about 1945, when he was still retaining some
figurative elements in his canvases, such as *Water Figure* (fig. 1) of that year. This small
spontaneous drawing allowed for experimentation and marks the direction he would soon take
in his large oils beginning with works like *Galaxy* of 1947 (fig. 2). The so-called 'drip' paintings
achieve on a larger scale what this small picture suggests.

Pollock's skeins of overlapping lines of paint build up a surface, veiling any imagery beneath
this net. These lines appear to dissolve about the edges of the picture. Much of the painting's
spontaneous execution seems to be expressed directly, conveying the artist's energy and
freedom from inhibition at this particular moment.

1 Jackson Pollock, *Water Figure*, 1945
Hirshhorn Museum and Sculpture Garden
Smithsonian Institution, Washington, DC

2 Jackson Pollock, *Galaxy*
1947, Joslyn Art Museum
Omaha, NE

Jackson Pollock 1912–1956

88 Untitled

1946, gouache on paper, 56.5 × 82.6 cm (22¼ × 32½ in)
Signed and dated lower right: 'Jackson Pollock 46'

Provenance
Isod From
Samuel From
George Bill
David Stuart Galleries, Los Angeles, CA
Sale, Sotheby Parke Bernet, New York, Important
 Post-War and Contemporary Art, 26 October
 1972, lot 6
J.Palumbo, Esq., London
Waddington Galleries, London
Mrs J.Curran, London
Andrew Crispo Gallery, New York
Thyssen-Bornemisza Collection, 1976

Literature
Ian Bennett, *A History of American Painting* (London:
 Hamlyn Publishing Group, 1973), p. 213, illus.

Francis Valentine O'Connor and Eugene Victor Thaw,
 eds, *Jackson Pollock: A Catalogue Raisonné of Paintings,
 Drawings, and Other Works* (New Haven, CT: Yale
 University Press, 1978), no. 1010, vol. 4, p. 84

Reproduced
Advertisement, *Artforum* 10 (October 1971), p. 26

Exhibitions
Jackson Pollock: Drawing into Painting, April 1979–
 March 1980, no. 30
 Oxford, England, Museum of Modern Art
 Düsseldorf, Städtische Kunsthalle
 Lisbon, Calouste Gulbenkian Foundation
 Paris, Musée d'Art Moderne de la Ville de Paris
 New York, Museum of Modern Art
Modern Masters from the Thyssen-Bornemisza Collection,
 May–December 1984
 Tokyo, National Museum of Modern Art
 Kumamoto, Kumamoto Prefectural Museum
 London, Royal Academy of Arts, no. 98

1 Jackson Pollock, *Circumcision*
1946, Solomon Guggenheim
Foundation, Venice

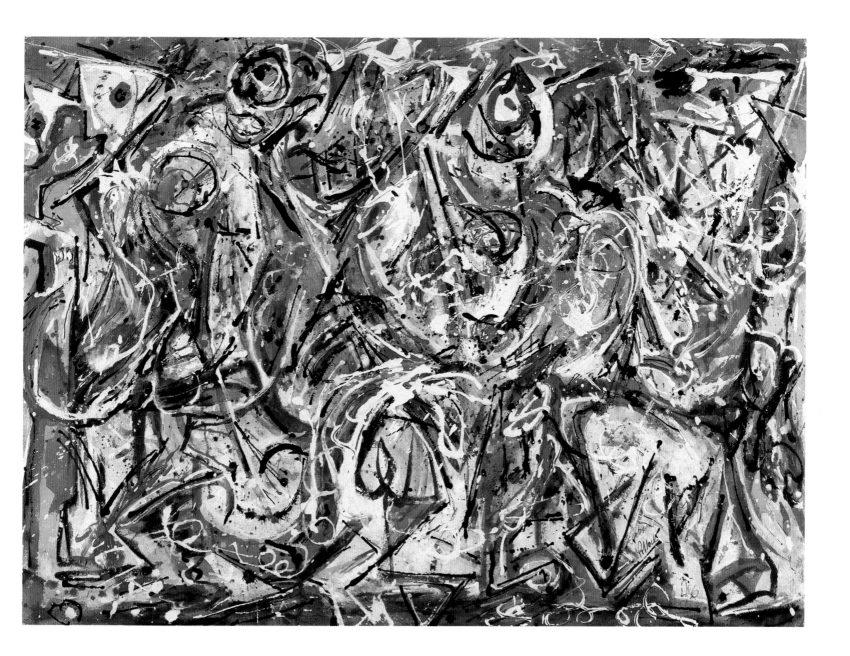

Notes
1 For example, Bryan Robertson, *Jackson Pollock* (New York: Harry N. Abrams, Inc., 1960), pp. 82–87
2 Quoted in Francis Valentine O'Connor and Eugene Victor Thaw, eds, *Jackson Pollock: A Catalogue Raisonné of Paintings, Drawings, and Other Works* (New Haven, CT: Yale University Press, 1978), p. 232

This *Untitled* gouache of 1946 is close in style to Pollock's oils *Circumcision* (fig. 1) painted that same year, as well as to *Portrait of H. M.* of c. 1945. In all of these compositions, there is a similar density of form and line, as well as circular swirls and triangular shapes. The gouache is even more energetic, explosive in its linear rhythms. Painting small-scale, in gouache on paper, Pollock probably felt even more spontaneous and free to experiment.

The red earth tone which circles through this very calligraphic composition is reminiscent of American Indian art which interested Pollock. Some critics have related his dripping of paint to Navaho sand paintings.[1] In 1944, Pollock commented:

> I have always been very impressed with the plastic qualities of American Indian art. The Indians have the true painter's approach in their capacity to get hold of appropriate images, and in their understanding of what constitutes subject matter. Their color is essentially Western, their vision has the basic universality of all real art. Some people find references to American Indian art and calligraphy in parts of my pictures. That wasn't intentional; probably was the result of early memories and enthusiasms.[2]

Jackson Pollock 1912–1956

89 Number 11

1950, oil and aluminium paint on masonite, 55.8 × 56.5 cm (22 × 22¼ in)
Signed lower right: 'J. Pollock'; and dated lower left: '50'

Provenance
Mr and Mrs Robert W. Dowling
Dr and Mrs Stuart Bartle
Andrew Crispo Gallery, New York
Thyssen-Bornemisza Collection, 1975

Literature
Francis Valentine O'Connor, *Jackson Pollock* (New York: Museum of Modern Art, 1967), p. 56
Francis Valentine O'Connor and Eugene Victor Thaw, eds, *Jackson Pollock: A Catalogue Raisonné of Paintings,*
 Drawings, and Other Works (New Haven, CT: Yale University Press, 1978), no. 284, vol. 2, p. 108
Zafran, pp. 163–64, no. 83
Ennery Taramelli, *Pollock (I classici della pittura)* (Rome: Curcio, 1980), no. 19

Reproduced
Catalogue of *Jackson Pollock*, Studio Paul Facchetti, Paris, 7–31 March 1952, in an installation photograph of the
 exhibition, *Jackson Pollock*, Betty Parsons Gallery, New York, 28 November–16 December 1950, n.p., top work
 in stack of four

Exhibitions
New York, *Jackson Pollock*, Betty Parsons Gallery, 28 November–16 December 1950
Lutherville, MD, Untitled one-man exhibition, Hilltop Theatre Art Room, 26 June–8 July 1951
Chicago, IL, *Ben Shahn, Willem de Kooning, Jackson Pollock*, The Arts Club of Chicago, 2–27 October 1951, no. 34
Paris, *Jackson Pollock*, Studio Paul Facchetti, 7–31 March 1952
New York, *Jackson Pollock*, Marlborough-Gerson Gallery, January–February 1964, no. 107
 (with wrong illustration)
New York, *European and American Masterpieces*, Andrew Crispo Gallery, 1975, no. 44
The Origin of the 20th Century in the Collection Thyssen-Bornemisza, 1976
 Tokyo, Seibu Museum of Art
 Kobe, Hyogo Prefectural Museum
 Fikuoka, Kitakyushu Municipal Museum
La Collection Thyssen-Bornemisza: Tableaux Modernes, October 1977–May 1978, no. 71
 Brussels, Musée d'Ixelles
 Paris, Musée d'Art Moderne de la Ville de Paris
Lugano, *Collezione Thyssen-Bornemisza: Arte Moderna*, Villa Malpensata, 1 September–5 November 1978, no. 91
Australian tour, 1979–80, no. 83
Munich, *Amerikanische Malerei 1930–1980*, Haus der Kunst, 14 November 1981–31 January 1982, no. 185

When Pollock first exhibited *Number 11* at the Betty Parsons Gallery in 1950, he identified it
and all of the works in the show with numbers. He gave titles to only four of the works, calling
them: *Shadows*, *Lavender Mist* (fig. 1), *Autumn Rhythm* and *One*.[1] This was a pivotal moment in
the artist's development and one of his most important exhibitions held at the end of a very
productive year.

Note
1 Francis Valentine O'Connor,
Jackson Pollock (New York:
Museum of Modern Art, 1967),
p. 56

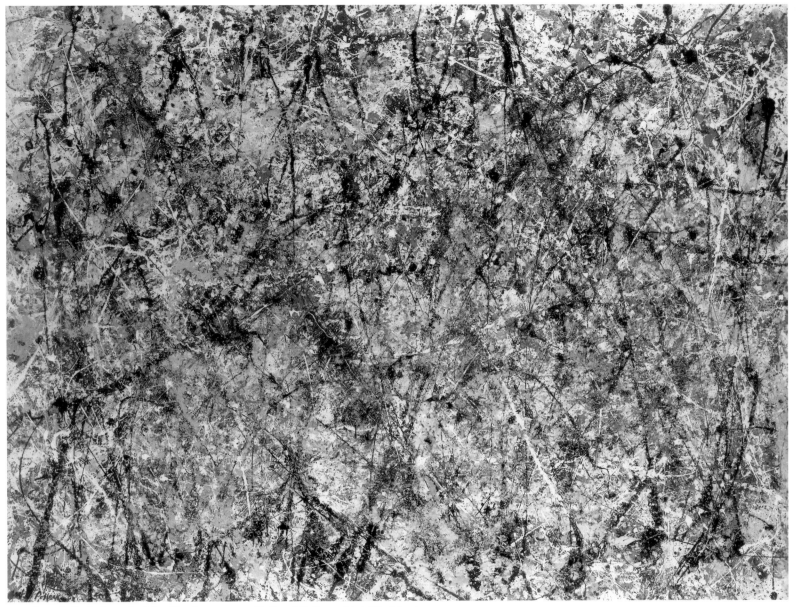

1 Jackson Pollock, *Lavender Mist: Number 1*, 1950, National Gallery of Art, Washington, DC

Jackson Pollock 1912–1956

90 Brown and Silver I

c. 1951, enamel and silver paint on canvas, 144.7 × 107.9 cm (57 × 42½ in)

Provenance
Lee Krasner Pollock
Marlborough Fine Art, London
Toninelli Arte Moderna, Milan
Thyssen-Bornemisza Collection, 1963

Literature
Lawrence Alloway, 'Pollock's Black and White
 Paintings', *Arts* 43, no. 7 (May 1969), p. 40
Francis Valentine O'Connor and Eugene Victor Thaw,
 eds, *Jackson Pollock: A Catalogue Raisonné of
 Paintings, Drawings, and Other Works* (New Haven,
 CT: Yale University Press, 1978), no. 317, vol. 2,
 p. 130
Ennery Taramelli, *Pollock (I classici della pittura)*
 (Rome: Curcio, 1980), no. 19

Reproduced
Museum of Modern Art *Bulletin*, 24, no. 2 (1956–57;
 reproduced as one of a run of paintings on a long
 canvas strip)
Jackson Pollock: Black and White, March 1969,
 Marlborough-Gerson Gallery, New York, no. 4,
 p. 21, reproduced sideways
Francis Valentine O'Connor, *Jackson Pollock: The Black
 Pourings* (Boston, MA: Institute of Contemporary
 Art, 1980), p. 8

Exhibitions
London, *Jackson Pollock: Paintings, Drawings and
 Watercolors from the Collection of Lee Krasner
 Pollock*, June 1961, Marlborough Fine Art Ltd,
 1961, no. 57
Düsseldorf, *Jackson Pollock*, Kunstverein für die
 Rheinlande und Westfalen, Kunsthalle,
 5 September–8 October 1961, no. 90
Zurich, *Jackson Pollock*, Kunsthaus, 29 October–24
 November 1961, no. 108
Rome, *Jackson Pollock*, Marlborough Galleria d'Arte,
 October–November 1962, no. 56

Milan, *Jackson Pollock*, Toninelli Arte Moderna, 1962,
 no. 56
Stockholm, *Jackson Pollock*, Moderna Museet,
 February–April 1963, no. 93
New York, *Jackson Pollock*, Marlborough-Gerson
 Gallery, January–February 1964, no. 124
Turin, *Il Cavaliere azzurro*, Galleria Civica d'Arte
 Moderna, 1971, no. 314
Bremen, *Moderne Kunst aus der Sammlung Thyssen-
 Bornemisza*, Kunsthalle, 1975, no. 68
*The Origin of the 20th Century in the Collection Thyssen-
 Bornemisza*, 1976
 Tokyo, Seibu Museum of Art
 Kobe, Hyogo Prefectural Museum
 Fikuoka, Kitakyushu Municipal Museum
La Collection Thyssen-Bornemisza: Tableaux Modernes,
 October 1977–May 1978, no. 72
 Brussels, Musée d'Ixelles
 Paris, Musée d'Art Moderne de la Ville de Paris
Lugano, *Collezione Thyssen-Bornemisza: Arte Moderna*,
 Villa Malpensata, 1 September–5 November 1978,
 no. 92
Jackson Pollock: Drawing into Painting, April 1979–
 March 1980, no. 77
 Oxford, England, Museum of Modern Art
 Düsseldorf, Städtische Kunsthalle
 Lisbon, Calouste Gulbenkian Foundation
 Paris, Musée d'Art Moderne de la Ville de Paris
 New York, Museum of Modern Art
*Modern Masters from the Thyssen-Bornemisza
 Collection*, May–December 1984
 Tokyo, National Museum of Modern Art
 Kumamoto, Kumamoto Prefectural Museum
 London, Royal Academy of Arts, no. 99
 February–August 1986
 Madrid, Biblioteca Nacional, Salas Pablo Ruiz
 Picasso
 Barcelona, Palau de la Virreina

Pollock painted *Brown and Silver I* about 1951 on a large strip of canvas which he then cut apart to create separate paintings. This is one of thirty-three canvases Pollock is known to have painted in 1951; of these, only eight include colours other than black. Here Pollock included shiny metallic paint. It has recently been argued that most of these canvases are figurative.[1]

While this painting does appear to have submerged or hidden images, it is not possible to identify exactly what these might be. This could represent a figure with raised arms, or it could be something else entirely. Very revealingly, Pollock remarked:

> I don't care for 'abstract expressionism' . . . and it's certainly not 'nonobjective', and not
> 'nonrepresentational' either. I'm very representational some of the time, and a little all of the
> time. But when you're painting out of your unconscious, figures are bound to emerge. We're all
> of us influenced by Freud, I guess. I've been a Jungian for a long time . . . painting is a state of
> being. . . .[2]

Notes
1 See, for example, Francis
 Valentine O'Connor, *Jackson
 Pollock: The Black Pourings
 1951–1953* (Boston, MA:
 Institute of Contemporary Art,
 1980), p. 9
2 Quoted in *ibid.*

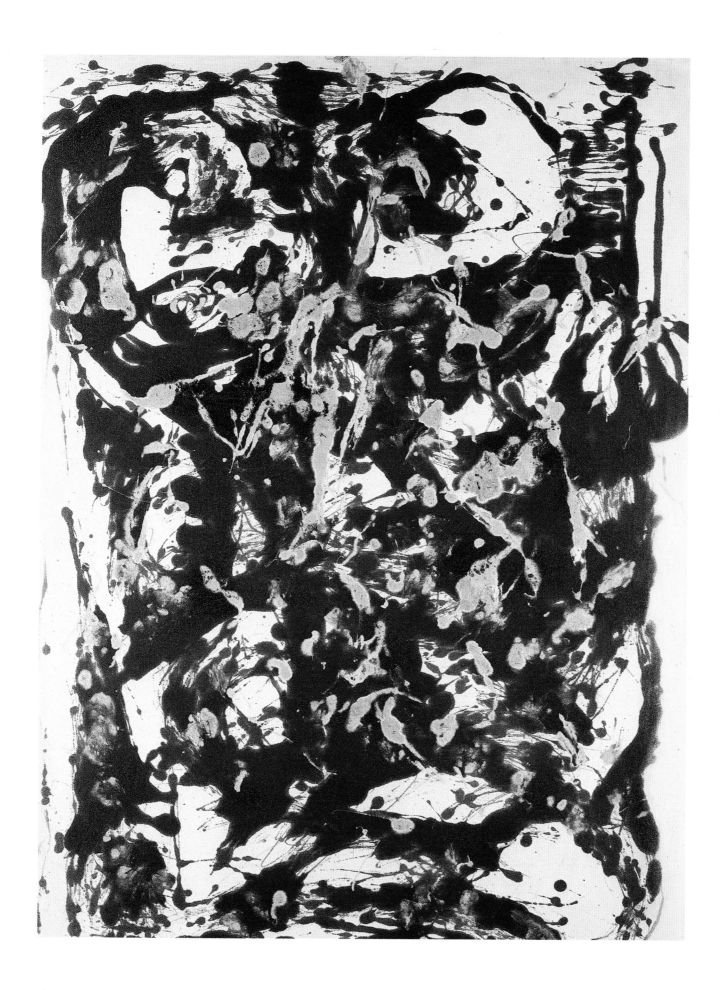

Richard Pousette-Dart b.1916

91 Composition

c.1942, oil on canvas, 94 × 111.8 cm (37 × 44 in)
Signed on a piece of wood attached to the stretcher: 'R Pousette-Dart'

Provenance
Willard Gallery, New York
Benjamin Baldwin, Long Island, NY
Sale, Sotheby Parke Bernet, New York, Post-War and Contemporary Art, 23–24 October 1975, lot 506,
 illus. in colour
Thyssen-Bornemisza Collection, 1975

Literature
Baur, pp. 23, 172, 134, illus., no. 108
Zafran, illus. in colour p. 92, no. 73

Exhibitions
New York, *Richard Pousette-Dart, Recent Paintings*, Willard Gallery, 1943
Australian tour, 1979–80, no. 73
Vatican, 1983, no. 109; Lugano, 1984, no. 107
USA tour, 1984–86, no. 108

Richard Pousette-Dart's *Composition* of c.1942 is characteristic of this artist's work during the formative years of Abstract Expressionism. Painted in a rich, jewel-like impasto, *Composition* is closely related to the artist's other work of this period – paintings like his monumental canvas, *Symphony No. 1, The Transcendental* or *Within the Room*, both also produced in 1942. The mysterious surface conceals layers of underpainting, covered by even thicker and denser splattered colour and white which serves to veil that which has gone before.

Pousette-Dart's desire to create a fully abstract art dates from his youth. The artist grew up in an environment enriched by his father Nathaniel's own painting and writing about art and his mother Flora's poetry.[1] He developed extremely sophisticated sensibilities at an early age. In a secondary school paper for a psychology course entitled 'Personality in Art', he wrote: 'The greater a work of art, the more abstract and impersonal it is, the more it embodies universal experience, and the fewer specific personality traits it reveals'. In another secondary school paper, 'Intuition – Intellect and Aesthetic Creation', Pousette-Dart discussed art as a product of intuition; he wrote: 'Pure aesthetic creation is the only thing in the world that is not destructive'.

Note
1 See *Paintings Watercolors Lithographs By Nathaniel Pousette-Dart* (New York: Clayton Spicer Press, 1946), and Flora Louise Pousette-Dart, *I Saw Time Open* (New York: Island Press, 1947). Nathaniel Pousette-Dart wrote, for example, monographs on Robert Henri, James McNeill Whistler, Childe Hassam, John Singer Sargeant and others in the Distinguished American Artist Series

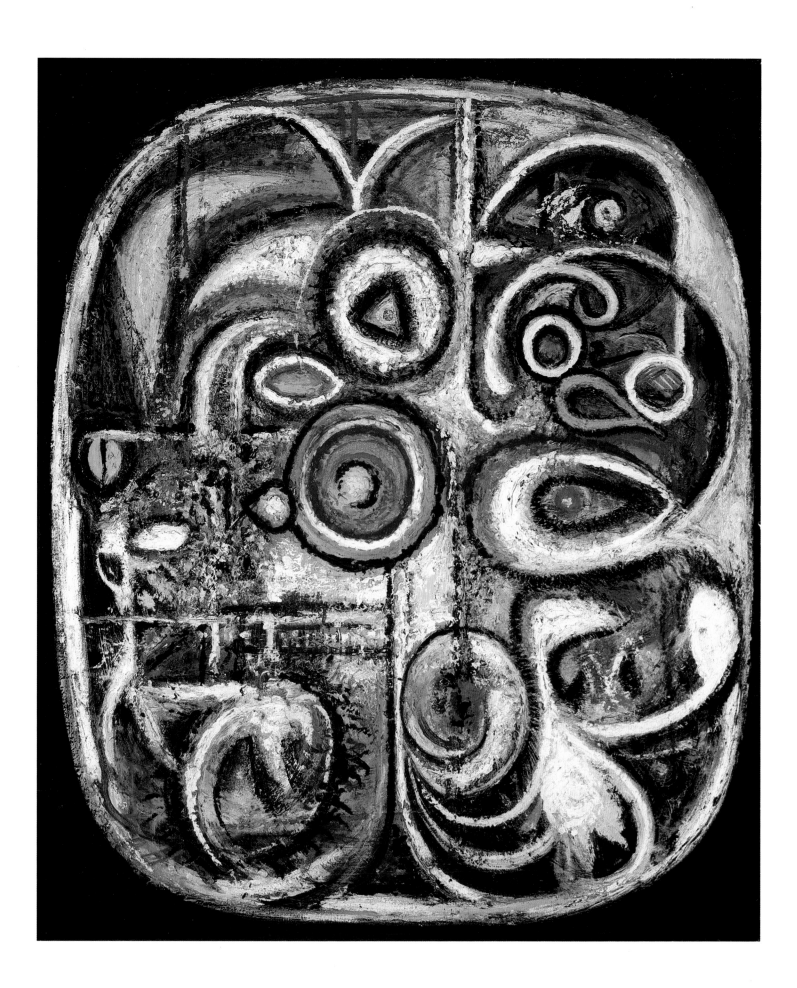

Like many of the Abstract Expressionists, Pousette-Dart was influenced in his early years by the emigré artist and writer John Graham. In 1937, Graham gave Pousette-Dart a copy of his book, *System and Dialectics of Art* inscribed: 'To Richard the sculptor, Graham the painter, XXXVII'. Inside, Pousette-Dart, who was then sculpting more than painting, wrote: 'Too much is made of art in the wrong way. Art has its place in the world as has every other thing, but art is not the world. Art is a beautiful object. Art is a symbol of experience.'

Composition contains many smaller organic shapes within its white-outlined interior shape which in some ways resembles an assymetrical mask. The symbolic significance of masks including secrecy, mystery, metamorphosis, regeneration and social control in primitive societies – the ritual transformation of personality – may have particularly appealed to the artist at this time. Pousette-Dart evolved these shapes from a series of drawings and paintings of heads that he produced during the late 1930s.[2] Influenced in part by his interest in primitive non-Western art, he broke down the planes and curves of the human face into biomorphic component parts, eventually creating an abstract image. The artist also made cut brass sculptures in such shapes that could be either held or worn.

At the time he painted *Composition*, Pousette-Dart, who had been a pacifist since his secondary school days, was a conscientious objector. He had carried on a long battle with his draft board and within himself, writing poems expressing his personal agonies and making many drawings depicting the monstrosities of war. On one of his drawings from this period he noted: 'Spirit is pure form movement – better the more absolute – art is fascinating music – purpose is inner conviction', revealing the link he saw between his artistic endeavour and his spiritual thoughts. His reading has long included such texts as the *Bhagavad-gita*, and writings by Emerson, Krishnamurti, Meister Eckhardt, Richard Maurice Bucke and others.

Pousette-Dart's personal mysticism is behind the mysterious imagery and power of *Composition*. Only occasionally, in works such as *Symphony No. 1, The Transcendental* (1942), *Comprehension of the Atom, Crucifixion* (1944) and *Golden Dawn* (1952) do this artist's titles allude to his rich spiritual beliefs. In *Composition* and in many other works, we can, however, assume that certain abstract forms, such as the circle (as in the transcendental eye or magic circles), which recur with such frequency, derive their significance from his very individual mysticism.

Note
2 For a discussion of these heads and the artist's iconography and early development, see Gail Levin, 'Pousette-Dart's Emergence as an Abstract Expressionist', *Arts Magazine* 54 (March 1980), pp. 125–29

[91] detail

Mark Rothko 1903–1970

92 Green on Maroon

1961, oil on canvas, 259 × 228.6 cm (102 × 90 in)

Provenance
Estate of the artist
Marlborough Gallery, Inc., New York
Thyssen-Bornemisza Collection, 1982

Exhibitions
Zurich, *Mark Rothko*, Kunsthaus, 21 March–9 May 1971, no. 51
New York, *Important Paintings by Jackson Pollock, Clyfford Still, Mark Rothko, Ad Reinhardt, Adolph Gottlieb, and Mark Tobey*, Marlborough Gallery, Inc., 9–27 March 1982
Modern Masters from the Thyssen-Bornemisza Collection, February–August 1986, no. 100
 Madrid, Biblioteca Nacional, Salas Pablo Ruiz Picasso
 Barcelona, Palau de la Virreina

Mark Rothko painted *Green on Maroon* in 1961, the same year he was given his first major museum exhibition by the Museum of Modern Art in New York. This should have put the artist in an ebullient mood, although that is not the feeling one has in viewing this contemplative abstract picture with its subdued tonality. Although it is not known if Rothko painted this canvas before or after his show opened on 18 January, it is said that retrospective exhibitions sometimes cause anxiety beforehand and then result in what can be compared to postpartum depression, a disappointment with all that dissipated excitement. It is probable that *Green on Maroon* was painted after the retrospective had opened and he would have had more free time to paint.

The style of this work is consistent with the simplified rectangular format Rothko developed in the 1950s. Eventually, some of these canvases presented only a rough-edged floating rectangular mass of a second colour contained within the larger form. In 1958, Rothko had been commissioned to make murals for the Four Seasons Restaurant in New York. He had already begun to see his work environmentally and to increase his scale. Then in late 1961, Rothko received a commission to paint murals for a building at Harvard University.

Green on Maroon might be compared with a work like *Painting*, also of 1961, and similar in scale. These are monumental canvases of subtle tonality and sombre mood. They reflect a contemplative artist who experienced depression and worked with a sense of continuity of form that offered little escape. Rothko insisted that his paintings of this period be exhibited in dim lighting, further commenting on their moodiness and lack of brightness. Deeply troubled, his successes brought little relief and he felt rather trapped during the early 1960s.

Clyfford Still 1904–1980

93 Untitled

1965, oil on canvas, 254 × 176.5 cm (100 × 69½ in)
Signed lower right

Provenance
Marlborough Gallery, Inc., New York
Thyssen-Bornemisza Collection, 1982

Exhibitions
New York, *Important Paintings by Jackson Pollock,*
 Clyfford Still, Mark Rothko, Ad Reinhardt, Adolph
 Gottlieb, and Mark Tobey, Marlborough Gallery,
 Inc., 9–27 March 1982

Modern Masters from the Thyssen-Bornemisza
 Collection, May–December 1984
 Tokyo, National Museum of Modern Art
 Kumamoto, Kumamoto Prefectural Museum
 London, Royal Academy of Art, no. 100
 February–August 1986
 Madrid, Biblioteca Nacional, Salas Pablo Ruiz
 Picasso
 Barcelona, Palau de la Virreina

1 Paul Cézanne
The Garden at Les Lauves
c.1906, Phillips Collection
Washington, DC

Clyfford Still painted this canvas in 1965, omitting a title for his abstraction. Most of his works bear only a photograph documentation number (this one is unknown) and the artist went to great lengths to remove the mythic titles of some of his early works, claiming these were invented by others.[1] As an Abstract Expressionist, Still invented his style of painting by the mid-1940s and continued this mode with some spatial and colour variation for the rest of his life. He began to open up his canvas and leave bare space on unprimed canvas as early as 1947.

Still's early admiration for the art of Paul Cézanne, which extended to his writing a MFA thesis on the artist while attending the State College of Washington in Pullman, Washington in 1935, perhaps made him recognise the power of space left blank. One can imagine Still appreciating a work like Cézanne's oil painting *The Garden at Les Lauves* (fig. 1) of c.1906 which he would have seen in The Phillips Collection in Washington, DC. There we find the same airy spaces in great amounts of bare canvas and abstract patterns that Still employed in his own abstract paintings.

Still persisted in trying to prevent a cogent analysis of his work, often changing dates and titles in later years. He denounced: 'academic pretentions, scholastic irrelevancies, or political intimidation', noting 'The paintings *should* speak for themselves'.[2]

Notes
1 *Clyfford Still* (San Francisco, CA: San Francisco Museum of Modern Art, 1976), p.111. The biography of the artist for which Still himself provided information states that for his show in 1946 at the Art of This Century, 'titles were invented and attached by gallery assistants for their own amusement and picture identification'
2 Clyfford Still, 'Introduction', in John P. O'Neill, ed., *Clyfford Still* (New York: Metropolitan Museum of Art, 1979), p.19

Mark Tobey 1890–1976

94 Earth Rhythms

1961, oil on board, 63.5 × 47.5 cm (25 × 18½ in)
Signed lower right: 'Tobey'

Provenance
Albert Turrettini, Geneva
Galerie Beyeler, Basel
Sale, Sotheby's, London, Impressionist and Modern Paintings, Drawings and Sculpture, 4 December 1968, lot 90
Thyssen-Bornemisza Collection, 1968

Literature
Lieberman, p. 74, no. 63

Exhibitions
Mark Tobey, Werke, 1933–1966, March–October 1966
 Amsterdam, Stedelijk Museum
 Hanover, Kestner-Gesellschaft, no. 137
 Düsseldorf, Kunstverein für die Rheinlands und Westfalen, Kunsthalle, no. 107
Bremen, *Moderne Kunst aus der Sammlung Thyssen-Bornemisza*, Kunsthalle, 1975, no. 81
The Origin of the 20th Century in the Collection Thyssen-Bornemisza, 1976, no. 45
 Tokyo, Seibu Museum of Art
 Kobe, Hyogo Prefectural Museum
 Fikuoka, Kitakyushu Municipal Museum
Paris, *La Collection Thyssen-Bornemisza: Tableaux Modernes*, Musée d'Art Moderne de la Ville de Paris,
 21 February–20 May 1978, no. 79
USA tour, 1982–83, no. 63

Mark Tobey painted *Earth Rhythm* in 1961, probably early in the year, before his busy autumn schedule of exhibitions. That autumn, he had a major retrospective in Paris and a one-man show at a New York art gallery. *Earth Rhythm*, which stresses nature, may well have been produced in Seattle where Tobey spent several summer months living in the house of his friends Ambrose and Viola Patterson who were away at that time. By 16 December, he would write from his home in Basel: 'I have not lifted a brush for months and have no inclination to do so.'[1]

Tobey's theme in *Earth Rhythm* reflects his interest in the spiritual and his debt to the Baha'i World Faith which he followed from 1918 until the end of his life. The Baha'i use a nature metaphor to reconcile 'oneness' with all of humanity which is compared to a tree of which the individual is a part and the product of one seed.[2] Tobey's interest in Oriental art also contributed to his interest in the relationship between man and nature.

Tobey's fascination with the rhythm of the Earth suggests his love of music. An amateur pianist and composer, his understanding of rhythm was crucial. Tobey also read botany and biology books.[3] He painted other abstract pictures which also allude to the rhythms of nature: *Jeweled Jungle* (1958), *Tumble Weed* (1960) and *Pacific Drift* (1959–62), for example.

Notes
1 Mark Tobey to Wesley Wehr, letter of 16 December 1961, Archives of American Art, quoted in Eliza E. Rathbone, *Mark Tobey: City Paintings* (Washington, DC: National Gallery of Art, 1984), p. 107
2 William C. Seitz, *Mark Tobey* (New York: Museum of Modern Art, 1962), p. 10
3 *Ibid.*, p. 15

Representation in the 1940s and 1950s

Milton Avery 1885–1965

95 Canadian Cove

1940, oil on canvas, 81.2 × 121.9 cm (32 × 48 in)
Signed lower left: 'Milton Avery'

Provenance
Estate of the artist
Andrew Crispo Gallery, New York
Thyssen-Bornemisza Collection, 1980

Milton Avery's *Canadian Cove* was inspired by his trip to the Gaspe Peninsula in Quebec where he spent two months in 1938. He is not known to have returned there, and yet he continued to represent the memorable seascapes and landscapes in works like *Gaspe – Pink Sky* of 1940. *Canadian Cove* is also related in its subject and general composition to watercolours Avery executed there such as *Gaspe Landscape* of 1938. Characteristic of these works are the small white clapboard buildings, broad expanse of sea and hillsides. Avery painted large areas in each of these works with broken brushstrokes to indicate texture.

Avery's palette in this canvas is very subtle. Most of the soft colours he chose are tints: lavender, mint green, pink, pale blue and grey. The two tiny figures shown seated on the cliff above this Canadian cove may represent his wife Sally and their then eight-year-old daughter, March. Avery loved the seashore and he represented it in many paintings. His drawing with his brush on areas of flat colour probably results from the influence of the work of Henri Matisse.

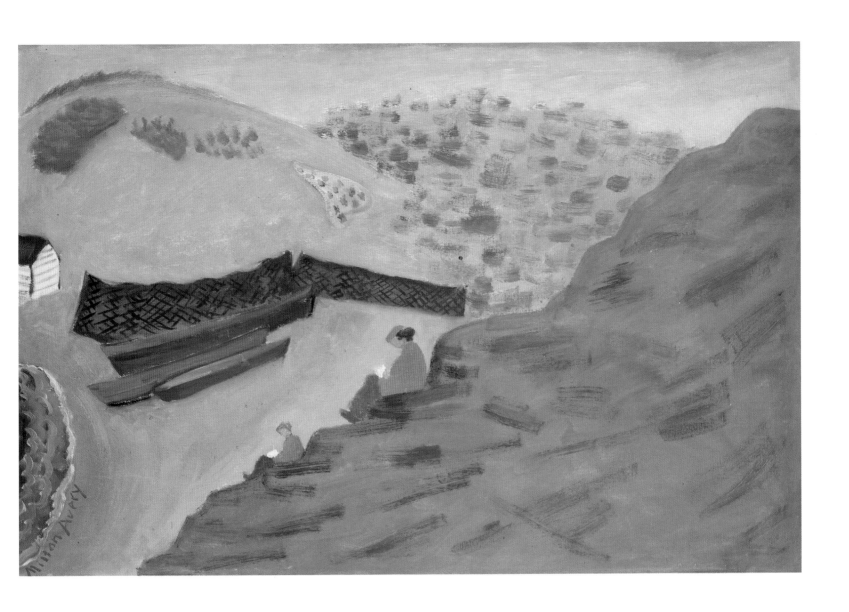

Milton Avery 1885–1965

96 Homework

1946, oil on canvas, 91.4 × 61 cm (36 × 24 in)
Signed and dated lower centre: 'Milton Avery'

Provenance
Estate of the artist
Andrew Crispo Gallery, New York
Thyssen-Bornemisza Collection, 1978

Literature
Zafran, no. 78

Exhibitions
New York, *My Daughter March*, Durand-Ruel Galleries, 1947, no. 11
New York, *20th Century American Painting and Sculpture*, Andrew Crispo Gallery, August 1978, no. 23
Australian tour, 1979–80, no. 78
Vatican, 1983, no. 87; Lugano, 1984, no. 85
USA tour, 1984–86, no. 87

Milton Avery's *Homework* of 1946 represents his daughter March (born 12 October 1932), then about fourteen years old. Avery treasured his family life and was inspired to paint many pictures of his daughter who was his only child. He actually based his exhibition at the Durand-Ruel Galleries in New York in 1947 on this theme. Other depictions of March extend from the baby in *Nursing Mother* (1933) to *March in Red* (1950) (fig. 1).

During the 1940s, Avery produced many figure paintings. The Second World War probably curtailed his ability to travel due to petrol rationing, suggesting one factor which may have caused him to focus on painting the figure. His figures appear as generalised, impersonal, abstracted beings. They sometimes become structures for containing his rich, saturated colour, often in startling combinations.

While Avery often did not bother with facial features, in *Homework* he sketched in March's face, although he made no attempt at modelling. Instead, she is rendered in flat planes with a division line down her centre separating the lighter right side from the left of the picture which seems to be in shadow.

His palette here is particularly intense: her red sweater and blue skirt shown against a bright golden yellow chair. Her knee socks are an acid green while her shoes are a moss green. The background wall is a darker olive green against which is placed the pale blue chest of drawers. She rests her feet on a pink ottoman, upon which rests a turquoise book with the artist's signature. The plank floor boards are black, like a pinstriped suit. The entire floor, together with the olive wall, appears as if it is parallel to the picture plane. Avery achieves this illusion because the lines of the floor boards defy linear perspective.

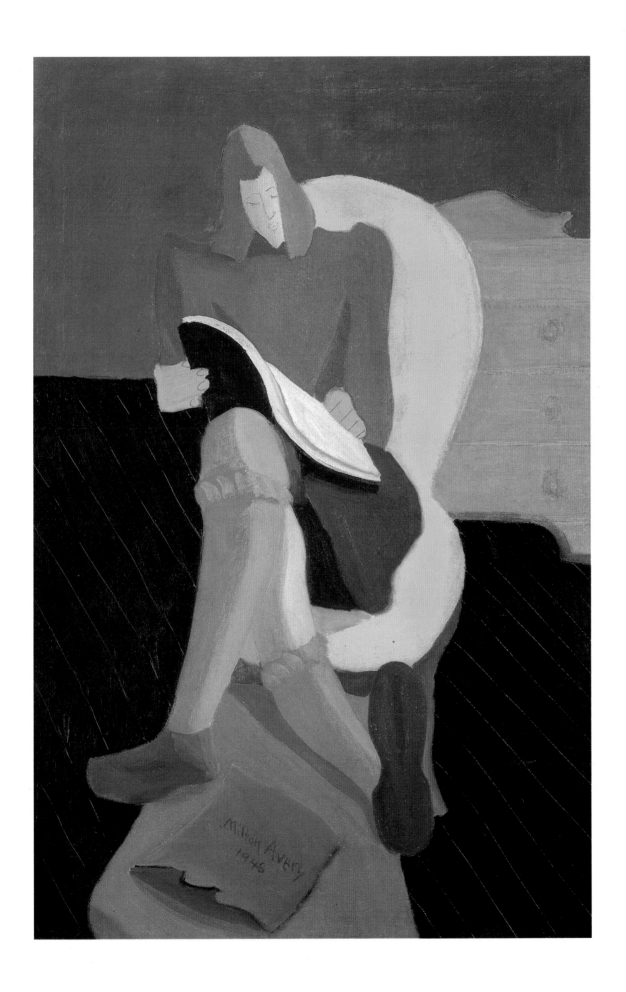

1 Milton Avery, *March in Red*
1950, Sheldon Ross Gallery
Birmingham, MI

While these kinds of striped floors which appear to tilt upwards towards the picture plane appear in numerous Matisse paintings of figures in interiors, the general configuration of the figure in this picture is closest to a work like Matisse's *The Mauve Bolero* of 1941 (fig. 2) which even includes a blue chest of drawers just behind and to the right of the figure as in Avery's *Homework*. Both artists painted a figure holding a book and, like Matisse, Avery has merely drawn in the facial features of his figure. By the time he painted *Homework*, Avery understood Matisse's early idiom of the 1910s and had made something of it for himself, further simplifying by eliminating ornament and reducing detail. Eventually, Avery's colour harmonies dominated compositions with the simplest of shapes.

2 Henri Matisse
The Mauve Bolero, 1941
72×53 cm ($28\frac{1}{4} \times 20\frac{3}{4}$ in)
Galerie Beyeler, Basel

Jack Levine b.1915

97 Reconstruction

1962, oil on canvas, 88.9 × 101.6 cm (35 × 40 in)
Signed lower left: 'Jack Levine'

Provenance
Kennedy Galleries, Inc., New York
Mr and Mrs John Marin, Jr, New York
Kennedy Galleries, Inc., New York
Thyssen-Bornemisza Collection, 1979

Literature
Frank Getlein, *Jack Levine* (New York: Harry
 N. Abrams, Inc., 1966), pl. 158

Exhibitions
Lincoln, MA, *Jack Levine Retrospective*, De Cordova
 Museum, 4 February–24 March 1968, no. 23,
 illus.
New York, *The City as a Source*, Kennedy Galleries,
 Inc., 16 November–23 December 1977, no. 26,
 illus.
Glen Falls, NY, *Jack Levine*, The Hyde Collection, 2
 July–3 September 1978, illus.
Gainsville, FL, *The American Scene*, University Gallery,
 University of Florida, 3 March–15 April 1979,
 no. 16, illus.

1 Hans Holbein, *Portrait of George Gisze*, 1532
oil and tempera on wood, Staatliche Museen
Germäldegalerie, Berlin-Dahlem

Jack Levine's painting *Reconstruction* of 1962 depicts a prototypical German industrialist as a fat, piggish man. Levine, who constantly immerses himself in the art of the old masters, was inspired by the sixteenth-century artist Hans Holbein's penetrating *Portrait of George Gisze* (fig. 1) which he has long admired.

 Levine liked the idea of surrounding the portrait subject with all kinds of personal properties, although the objects he chose are somewhat enigmatic: scales, a bell, a compass, a hypodermic needle and an hour-glass. He suggested that some of these objects have a pharmaceutical association and that he was thinking of someone, perhaps a movie actor.[1] Although he denied that the specific objects have particular meanings, we commonly associate the scales with justice, that is the equivalence and equation of guilt and punishment. The hour-glass suggests the transience of life and the compass commonly alludes to creation or the beginning of all things, particularly because its shape resembles the letter A.

 The title, *Reconstruction*, refers to the rebuilding of Germany after the Second World War. The theme reconstruction is clearly evident in this painting in the form of a large orange steam

Note
1 Author's interview with Jack
 Levine, 9 September 1985,
 New York

shovel visible through the arched window behind the industrialist who seems to be getting more prosperous by this massive rebuilding. Levine has felt that the subject of the Holocaust is too important to trivialise and has in general refrained from more specific works about this immense tragedy. The one exception is his lithograph, *Warsaw Ghetto*, produced in 1969, which depicts Nazi soldiers and is based on an old photograph.

Levine's biting cynicism and lack of sympathy for this subject make this a powerful painting. His wilful distortions of his subject's physiognomy reveal a person of gluttony and greed. His small slit-like eyes show a man no one would want to trust. The artist subtly alludes to the indescribable crimes of past decades.

Jack Levine

b.1915

98 The Patriarch of Moscow on a Visit to Jerusalem

1975, oil on canvas, 213.2 × 237 cm (84 × 96 in)
Signed lower left: 'J. Levine'

Provenance
Kennedy Galleries, Inc., New York
Thyssen-Bornemisza Collection, 1977

Literature
Jack Levine, *Jack Levine/Recent Works* (New York: Kennedy Galleries, Inc., 1975), n.p.
Judith Tannenbaum, 'Jack Levine – Kennedy', *Arts* 50 (February 1976), p.16

Exhibition
New York, *Jack Levine/Recent Works*, Kennedy Galleries, Inc., 8–29 November 1975, no.12

Jack Levine was prompted to paint *The Patriarch of Moscow on a Visit to Jerusalem* by an experience that took place in 1975, during his second trip to Israel. Levine was walking around the old city of Jerusalem with his wife, the late artist Ruth Gikow, when they heard bells ringing and followed the sound. They encountered Pimen, the Metropolitan of Moscow on an official visit to Jerusalem, accompanied by men wearing red fez hats and carrying iron-tipped staves with spiked ends which they banged against the ancient pavement as they walked so that the people would make way.

Levine recalled seeing 'crazy-looking monks, priests, and nuns, flea-ridden, cross-eyed, and blind' and he described the Metropolitan (who was promoted to Patriarch before Levine painted this canvas) as looking 'like Burl Ives or Orson Wells, enormously bulky, very scary' and wearing a white tiara and reflective motorcycle goggles.[1] He reported that he and Ruth looked at one another and exclaimed: 'What the hell was that about!'[2]

About a month or so after returning from this trip, Levine produced this canvas. He was particularly concerned that, while the Soviet Union was accusing Israel of being expansionist, this Soviet-sponsored church official had arrived to claim the properties of the local White Russian community which was slowly dying out. Levine decided that he would include in his painting only the architecture that had been visible during his first visit to Israel, before the six-

Notes
1 Author's interview with Jack Levine, 9 September 1985, New York
2 *Ibid*. This interview is the source for all previously undocumented information below

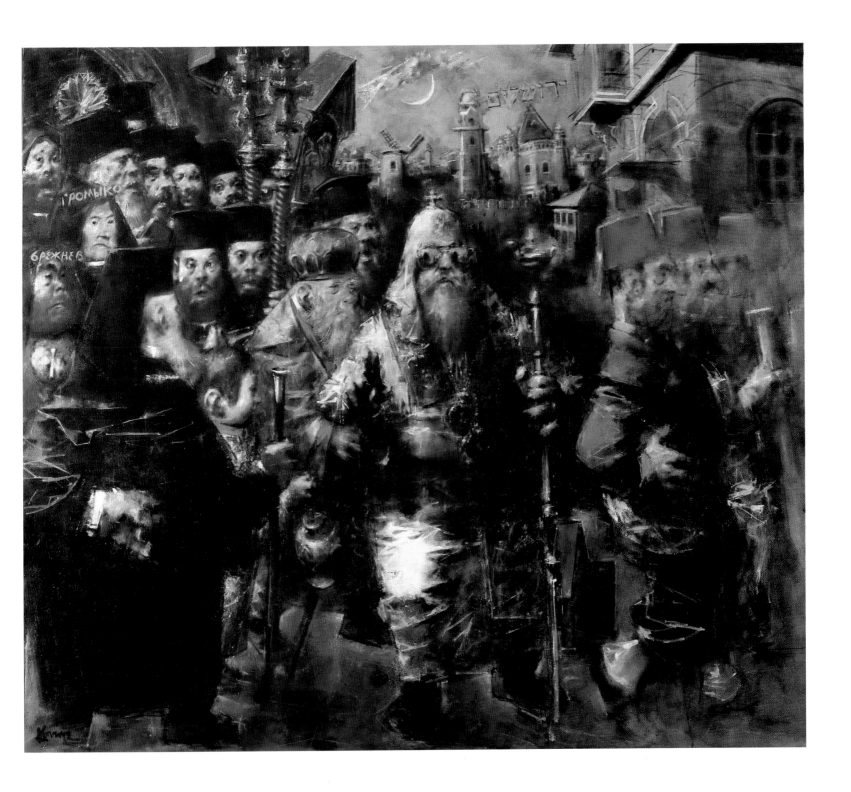

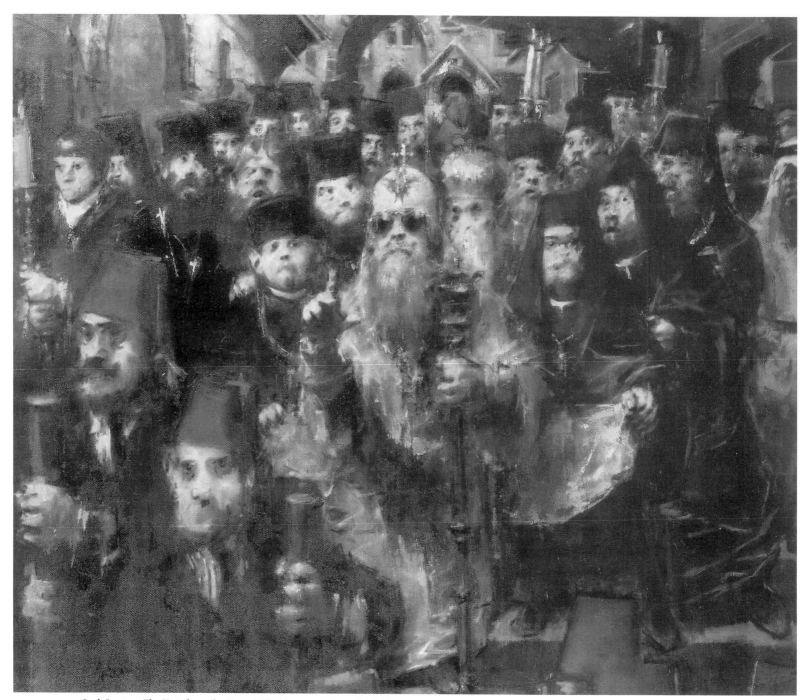

1 Jack Levine, *The Visit from the Second World*, 1974, Kennedy Galleries, Inc., New York

day war in 1967. All that he was able to see of the old city then was the view from the King David Hotel. Levine included in his painting the windmill given to Jewish settlers by Sir Moses Montefiore to encourage their self-sufficiency.

Levine included portraits of Soviet leaders Brezhnev and Gromyko on the left with their portraits labelled in Russian. But in the sky, in Hebrew, is the word 'Jerusalem' written in gold. He described this painting as 'a scene fraught with overtones, Byzantine and enigmatic, and set most strangely and disparately in Jerusalem'.[3]

Note
3 Jack Levine, *Jack Levine/Recent Works* (New York: Kennedy Galleries, Inc., 1975), n.p.

2 Rembrandt, *The Night Watch*, 1642, Rijksmuseum, Amsterdam

Levine produced a number of works related to this canvas including the painting *The Visit from the Second World* (fig. 1) of 1974 and eight drawings, each entitled *Study for Soviet Visitation in Jerusalem* and numbered one through eight. This is a large complex painting which perhaps owes its greatest debt to Levine's knowledge of old master painting, especially Rembrandt's extraordinary group portrait, *The Night Watch* (fig. 2). Levine's light is also enigmatic; the moon is out in the strangely illuminated sky and an intense white light highlights Pimen and members of his boisterous entourage.

Jack Levine b.1915

99 Volpone at San Marco

1977, oil on canvas, 101.6 × 88.9 cm (40 × 35 in)
Signed lower left: 'J. Levine'

Provenance
Kennedy Gallery, Inc., New York
Thyssen-Bornemisza Collection, 1977

Literature
Kenneth W.Prescott, *Jack Levine Retrospective Exhibition: Paintings, Drawings, Graphics* (New York: Jewish Museum, 1978), p.51, illus.

Exhibitions
Jack Levine Retrospective Exhibition: Paintings, Drawings, Graphics, November 1978–January 1979, no.84
 New York, Jewish Museum
 West Palm Beach, FL, Norton Gallery and School of Art
 Memphis, TN, Brooks Memorial Art Gallery
 Montgomery, AL, Montgomery Museum of Fine Arts
 Portland, OR, Portland Art Museum
 St Paul, MN, Minnesota Museum of Art

Volpone at San Marco of 1977 was suggested to Jack Levine as a result of seeing an off-Broadway production of Ben Jonson's play *Volpone* in a treatment by the German writer, Stefan Zweig. Levine liked the play's theme which he saw as greed. This painting depicts three characters out for a walk at Piazza San Marco: Volpone, Lady Would Be and a dwarf. The artist described his dilemma of whether he should paint these figures in Renaissance or modern dress and settled for the latter, suggesting a modern allegory.

Levine had earlier created a pastel of *Lady Would Be*, several ink studies for *Volpone* in 1963, as well as several prints based on this play: *Venetian Lady* (1964), *Volpone II* (1964) and *Volpone III* (1964). Levine has represented the theme of greed through the fat-cheeked Volpone with his enlarged ear and the bare-breasted Lady Would Be, standing just behind him. The contorted face of the dwarf contributes to the viewer's sense of discomfort, as he points to the glittery gold mosaics of San Marco which refer to the splendours of wealth. Once again, Jack Levine points out the disasters of greed.

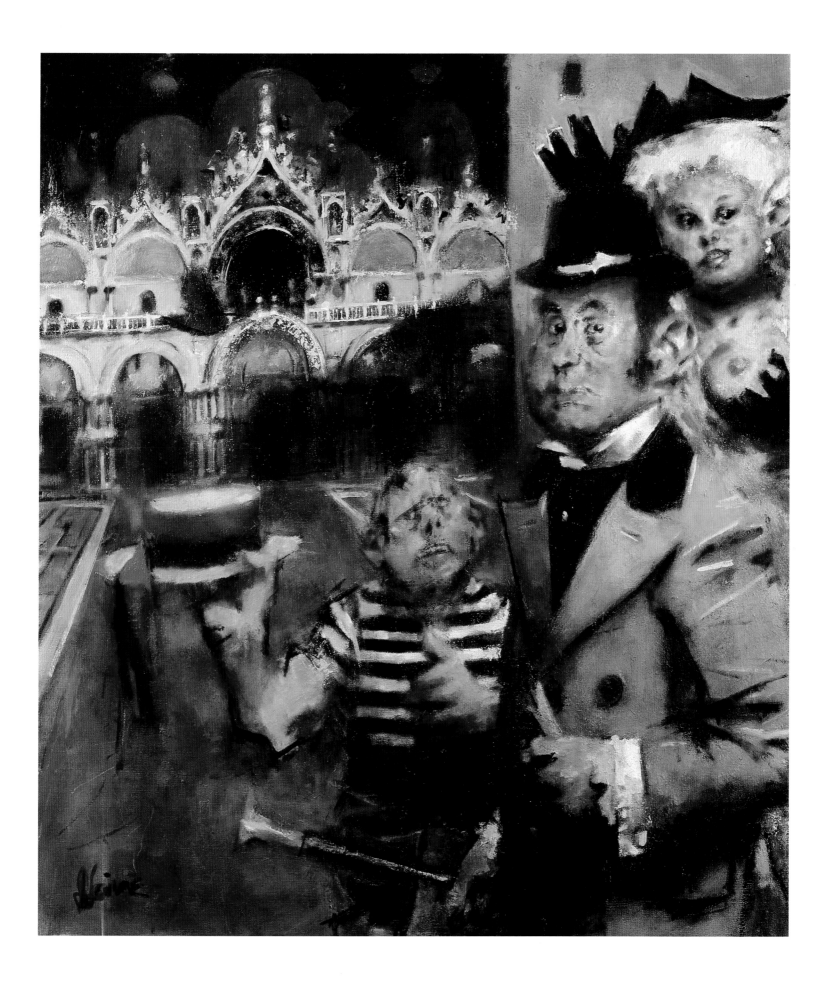

Walter Murch 1907–1967

100 Gear

1950, oil on canvas, 58.5 × 41 cm (23 × 16 in)
Signed lower right: 'Walter Murch'

Provenance
Kennedy Galleries, Inc., New York
Thyssen-Bornemisza Collection, 1977

Literature
Baur, pp. 171, 132, illus., no. 106

Exhibitions
New York, *Twentieth Century Still Life*, Museum of
 Modern Art, 1950
Atlantic City, NJ, *Contemporary Paintings*, Hotel
 Dennis, n.d.
Vatican, 1983, no. 107; Lugano, 1984, no. 105
USA tour, 1984–86, no. 106

Walter Murch's *Gear* of 1950 is characteristic of this artist's work. He repeatedly produced mysterious small-scale still-life paintings of clocks, gears, locks, machines or other common-place objects. He intentionally worked in a limited palette achieving poetic effects through simple means. *Gear* is painted in two predominant colours: orange and the silver grey of metal. *Gear* is closely related to other works in Murch's oeuvre such as his *The Calculator* of 1949, *Clock* of 1950 or *Carburetor* of 1957. Murch causes us to reconsider the mundane which transcend their subject matter through his eccentric paintings.

Murch developed his interest in such objects rather naturally as his father was a successful watchmaker in rural Ontario where he grew up. As a boy, he adored exploring his father's room of tools. Chardin figures importantly among the artists of the past whose work Murch admired and his paintings inspired Murch's silent still-lifes of old, ordinary objects. Murch became friends with the artist Joseph Cornell whose assemblages also convey a sense of poetry and mystery though the use of everyday objects.

Murch's preoccupation with mechanical objects places him in the tradition of artists of the Dada movement including Francis Picabia, Marcel Duchamp and Morton Schamberg who frequently produced such images during the 1910s and 1920s. Murch had studied architec-tural draughting during his schooling in Canada.

After his arrival in New York City in 1927, Murch was more directly influenced by his study of drawing with Arshile Gorky at the Grand Central School of Art. Gorky was then painting still-lifes and other works in the style of Cézanne. Murch continued to study privately with Gorky in that artist's Washington Square studio. Years later, Murch hinted at the influence of Gorky's interest in Cézanne on his own thinking: 'Well, if there is a feeling of geometry in the paintings it may be brought about because of my interest in cylinders and cones and spheres and cubes and I like to think that in arranging those solids or those shapes and simply painting them that a satisfactory result occurs.'[1]

Murch has been singled out as 'one of those rare artists able to bridge the gap between traditional realism and modernism'.[2] Betty Parsons exhibited his work at the Wakefield Gallery in 1941 and again in 1947 at her own gallery where the show was hung by Abstract Expression-ist Barnett Newman, then just beginning his own career as a painter. Murch managed to win the respect of the Abstract Expressionist painters who dominated Parsons' gallery.

Eventually, during the 1960s, his work was admired by Pop artists like Jasper Johns and James Rosenquist who also focused on still-life objects with their own intense individuality. The painterly background of Murch's *Gear* is not unlike the surface found in later works by Johns who also concentrated on the most ordinary of objects.

Notes
1 'Listening to Pictures', transcript of interview with Walter Murch by Arlene Jacobwitz, Brooklyn Museum, Brooklyn, NY, 1966
2 Greta Berman and Jeffrey Wechsler, *Realism and Realities: The Other Side of American Painting, 1940–1960* (New Brunswick, NJ: Rutgers University Art Gallery, 1982), p. 143

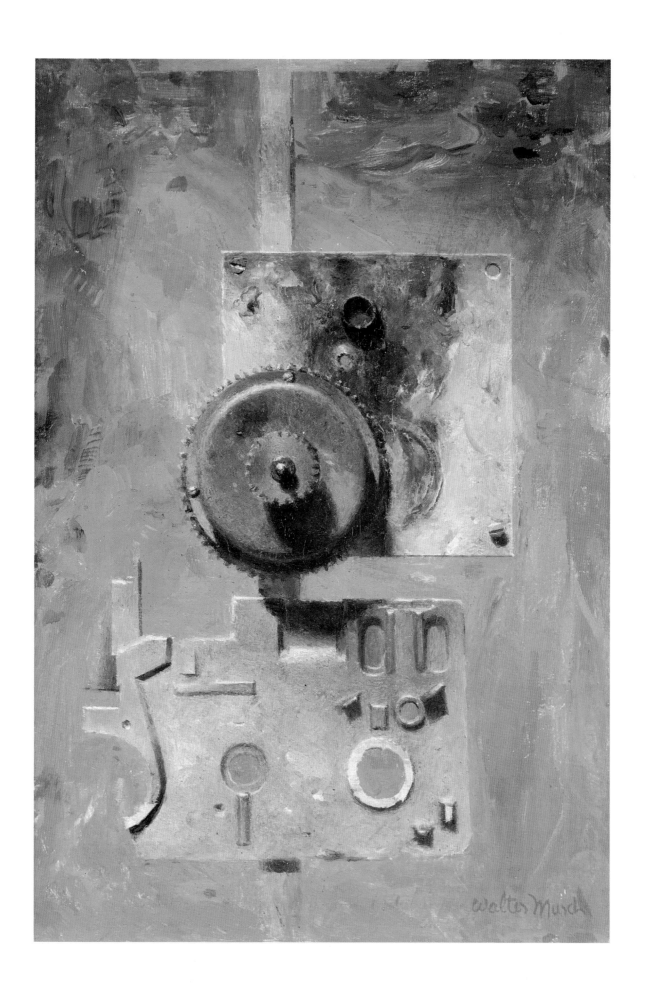

Larry Rivers b. 1923

101 Dutch Masters

1963, oil on collage on masonite, 76.2 × 91.4 cm (30 × 35 in)

Provenance
Marlborough Gallery, Inc., New York
Louis Meisel Gallery, New York
Andrew Crispo Gallery, New York
Thyssen-Bornemisza Collection, 1975

Exhibition
Geneva, *Peinture Americaine en Suisse, 1950–1965*, Musée d'Art et d'Histoire, no. s25

Larry Rivers has produced several versions of the *Dutch Masters* which feature an image distantly adapted from Rembrandt's masterpiece, *Syndics of the Drapers' Guild* of 1662. The artist recalled his actual source of inspiration which was not the Rembrandt, but a billboard advertising cigars:

> One night in the early sixties I passed something on the Long Island Expressway just before the Queens tunnel that I must have seen for years, the billboard advertising cigars, Dutch Masters. I suddenly realized it was sort of perfect. It's weird, isn't it? You're looking at Rembrandt – in neon! advertising cigars. It was too much, it was irresistible![1]

Finding inspiration from popular imagery, in particular commercial advertising, was typical among American artists during the 1960s. This was especially true with Pop artists including Roy Lichtenstein, Tom Wesselmann and Andy Warhol.

The stencilled letters reading 'Dutch Masters' stretch boldly across the top of the canvas recalling the cigar brand. They also suggest the use of such stencilled letters slightly earlier by some of Rivers' contemporaries including Jasper Johns and Jim Dine. The submersion of the figure within the context of Abstract Expressionist brushstroke also reflects the influence of Willem de Kooning on Rivers.

Rivers has utilised paint over masking tape, brown paper, newsprint and other collaged materials. Just above the two figures on the left are two stencils of the letters P and R attached to the picture. At the bottom of the composition, the word 'cigar' is written and cancelled out. This entire picture is in fact the image of a commercial product.

At the same time Rivers created a tribute to an old master that he greatly admires. He has written the name Rembrandt over the head of the man on the far right. Rivers commented on Rembrandt, comparing him to Tiepolo who he felt had been eclipsed after being one of the leading talents of his age: 'He lasted better, and seems to say a lot about the world, but don't we read that into his pictures? When you see Rembrandt's pictures you're overwhelmed by the body of literature explaining what it all means.'[2]

There is a larger version of this image entitled *Dutch Masters and Cigars* as well as several smaller collage versions executed from 1963 to 1968. Rivers recreated this theme in the 1978 work *Golden Oldies: Dutch Masters.* Perhaps he considered this theme a perfect merger between past and present. Its ironic comment is how the same theme takes on different meanings in two vastly separate contexts. Rivers' talent was to merge high art and everyday reality and make us think about both elements of his picture at once.

Notes
1 Quoted in Larry Rivers with Carol Brightman, *Drawings & Digressions* (New York: Clarkson N. Potter, Inc., 1979), p. 190
2 Quoted in Selden Rodman, *Conversations with Artists* (New York: Capricorn Books, 1961), p. 120

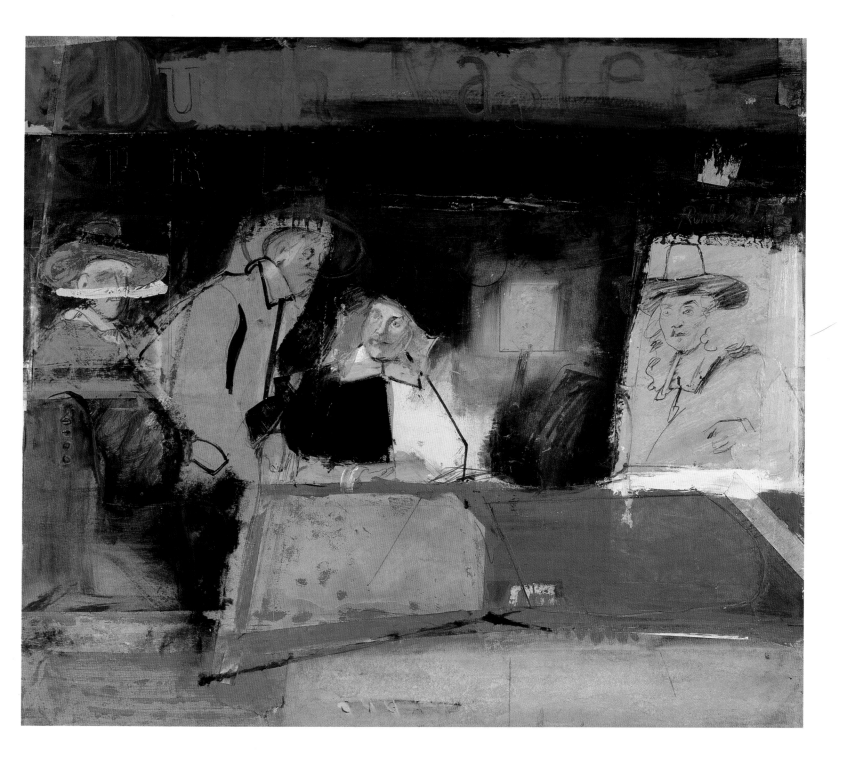

Andrew Wyeth b.1917

102 Afternoon Flight

1970, watercolour on paper, 56.8 × 72.1 cm (22⅜ × 28⅜ in)
Signed lower right

Provenance
Mr and Mrs Joseph E.Levine, Greenwich, CT
Andrew Crispo Gallery, New York
Thyssen-Bornemisza Collection, 1978

Literature
'Amerikanische Malerei aus der Sammlung Thyssen-Bornemisza', *Du* 5 (1984), p. 86, illus.
Zafran, p.169, no.99

Exhibitions
Boston, MA, *Andrew Wyeth*, Museum of Fine Arts, 1970, no.49
New York, *Ten Americans: Masters of Watercolor*, Andrew Crispo Gallery, 16 May–30 June 1974
New York, *Two Worlds of Andrew Wyeth: Kuerners and Olsons*, Metropolitan Museum of Art,
 16 October 1976–6 February 1977, no.122
New York, *Twentieth Century American Masters*, Andrew Crispo Gallery, 23 September–4 November 1978
Boston, MA, *New England Connections*, Federal Reserve Bank, 1978
Australian tour, 1979–80, no.99
Vatican, 1983, no.104; Lugano, 1984, no.102
USA tour, 1984–86, no.104

In *Afternoon Flight* of 1970, Andrew Wyeth depicted a young man sitting on a branch of a tree, pondering something, perhaps just put out of the viewer's range of vision. This use of a figure in the foreground with a vast view beyond is a device frequently used by artists in nineteenth-century painting, such as Frédéric Bazille's *View of the Village* of 1868 (fig. 1), where a young woman sits by a tree in front of a landscape. We are invited to look over each of the subject's shoulders, identifying with their view. Wyeth makes his subject appear unaware that he is being observed, creating a greater sense of mystery.

Wyeth has been repeatedly drawn to such barren trees and sombre winter scenes which he painted in earth-toned palettes, as in *Fungus* of 1959 (fig. 2). He is interested in capturing mood and here he succeeds in expressing a sense of melancholy in this figure's enduring silent contemplation.

Wyeth also concentrates on rendering textures, which he contrasts, as in the bark of the trees, the snow, the man's hair, trousers, and his leather boots and jacket. Focused on attaining a degree of verisimilitude in what he depicts, Wyeth has consistently ignored changing modernist styles. He paints with a precision of detail, using the technique of dry brush to build up surface textures. His choice of subject matter reflects his surroundings and his personal point of view.

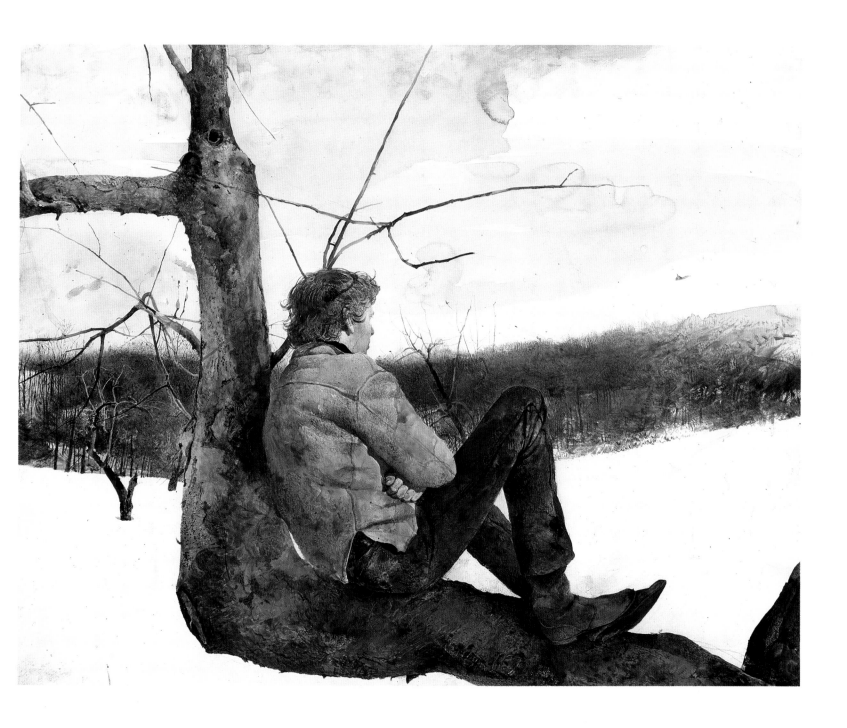

1 Frédéric Bazille
View of the Village, 1868
Musée Fabre, Montpellier

2 Andrew Wyeth
Fungus, 1959, watercolour
Mr and Mrs Bruce Bredin
Wilmington, DE

Andrew Wyeth b.1917

103 My Young Friend

1970, tempera, 81.3 × 63.5 cm (32 × 25 in)

Provenance
Mr and Mrs Joseph E. Levine, Greenwich, CT
Andrew Crispo Gallery, New York
Thyssen-Bornemisza Collection, 1978

Reproduced
Time Magazine (23 February 1970), p.63
'Wyeth's World: Some Coast and a Corner', *Eagle Tribune*, Lawrence, MA (23 July 1970)

Exhibitions
New York, *Two Worlds of Andrew Wyeth: Kuerners and Olsons*, Metropolitan Museum of Art,
 16 October 1976–6 February 1977, no.123
Modern Masters from the Thyssen-Bornemisza Collection, May–December 1984
 Tokyo, National Museum of Modern Art
 Kumamoto, Kumamoto Prefectural Museum
 London, Royal Academy of Arts, no.114
 February–August 1986
 Madrid, Biblioteca Nacional, Salas Pablo Ruiz Picasso
 Barcelona, Palau de la Virreina

1 James McNeill Whistler
The White Girl
(*Symphony in White, No. 1*)
1861–62, National Gallery of Art
Washington, DC

In *My Young Friend*, Wyeth painted a sensitive portrait of a young woman dressed in a beige crew-necked sweater and a fur hat. It is as if the artist had suggested that she dress in such soft earth tones as he prefers to paint. She is shown against a brown wall, making us wonder why she wears such a warm hat indoors. Strands of mousy light brown hair hang out from her hat on either side of her face. Even her eyes and roll neck shirt showing beneath her sweater are brown.

We might call this a tonalist painting, much like Whistler painted a portrait of *The White Girl*, and subtitled *Symphony in White, No. 1* (fig. 1). This is certainly Wyeth's symphony in brown. And like Whistler before him, Wyeth has painted an innocent young girl, whose fixed stare at the viewer or artist belies her actual remoteness. Furthermore, while Whistler had his subject stand on the fur of a bearskin rug, Wyeth has also placed his young subject in fur, probably for both textural and symbolic purposes.

Wyeth was, like Whistler, concerned with the formal aspects of his portrait. Each tone, every nuance, was carefully chosen and precisely rendered. He was aware of every subtety and carefully portrayed his subject's features and colouring in the most gentle setting of muted colour. This, of course, goes well with her thoughtful introspective mood.

Andrew Wyeth b.1917

104 Malamute

1976, watercolour on paper, 79 × 137 cm (31 × 54 in)

Provenance
Mr and Mrs Joseph E. Levine, Greenwich, CT
Kennedy Galleries, Inc., New York
Thyssen-Bornemisza Collection, 1977

Exhibition
London, *Andrew Wyeth*, Royal Academy of Arts, 1980, no. 44

In the rural settings he knows best, Andrew Wyeth is attracted to the vast expanses of open land stretching out as far as the eye can see. The wild and domestic animals in these settings have also fascinated him. *Malamute* of 1975 combines these two aspects to create a composition that is at once threatening and pastoral. The instinctual behaviour of the North American sled dog is somewhat unclear in the painting. We do not know if this pair of dogs will be friendly or not, despite their usual domestication. We are made to wonder if these are wild dogs marauding in the snow looking for food. They appear more as if they are about to raid a chicken coop than about to pull a sled.

1 Winslow Homer, *The Fox Hunt*, 1893, oil on canvas, Pennsylvania Academy of the Fine Arts, Philadelphia, PA

Earlier, in 1959, Wyeth painted *Wild Dog*, as a watercolour study for *Groundhog Day*, a tempera painting of that year, although the image of the dog does not appear in the final picture. Then in 1975, Wyeth, represented dogs in two watercolours, *The Prowler* and *Patrolling*. The setting for *The Prowler*, with a hill tilted downwards towards the right side of the composition, is not unlike that of *Malamute*. Even the titles suggest that Wyeth saw these animals as both potentially friendly and threatening.

Wyeth's *Malamute* is very much in the tradition of the work of Winslow Homer, whose wildlife paintings, like *The Fox Hunt* of 1893 (fig. 1), are full of vitality. Wyeth, no doubt, like many of his critics, has seen himself as following in the realist tradition of Winslow Homer and Edward Hopper. Like them, he has totally identified himself with the landscape of his own surroundings.

Legacy of Dada and Surrealism

Joseph Cornell 1903–1972

105 Blue Soap Bubble

1949–50, construction, 24.1 × 30.5 × 10.2 cm (9½ × 12 × 4 in)

Provenance
Private collection
Andrew Crispo Gallery, New York
Thyssen-Bornemisza Collection, 1978

Joseph Cornell's *Blue Soap Bubble* of 1949–50 is one of a number of constructions which began with his *Soap Bubble Set* of 1936 (fig. 1), exhibited in the Museum of Modern Art's landmark exhibition of that year, 'Fantastic Art, Dada, Surrealism'.[1] Symbols which recur in *Blue Soap Bubble* and elsewhere in Cornell's work have been identified as occurring in *Soap Bubble Set* for the first time: glasses as the cradle of life, four cylinders representing the members of his family, the circular ring suspended as the soap bubble or the moon controlling the tides.[2] Cornell himself wrote about his Soap Bubble Sets in 1948:

> Shadow boxes become poetic theatres or settings wherein are metamorphosed the elements of a childhood pastime. The fragile, shimmering globules become the shimmering but more enduring planets – a connotation of moon and tides – the association of water less subtle, as when driftwood pieces make up a proscenium to set off the dazzling white of sea-foam and billowy cloud crystallized in a pipe of fancy.[3]

Cornell produced many other related works: *Soap Bubble Set* (1939), *Soap Bubble Set* (1942) (fig. 2), *Soap Bubble Set* (1948), *Soap Bubble Set (Lunar Space Object)* (late 1950s) and *Soap Bubble Set* (1953) (fig. 3). The 1942 version has suspended balls and, like *Blue Soap Bubble*, a pair of glasses, while the 1953 version includes four of these glasses and a suspended ring like *Blue Soap Bubble*.

The Soap Bubble Sets derive from Cornell's childhood memories and they reflect his cosmic reveries.[4] The drawer at the base of this construction was often used by this artist and probably suggests the enclosure of memories of the past.[5] It contains two silver balls (probably symbolising planets), a starfish and loose colour sand seen through glass. The glass is crossed by white lines and surrounded by rusticated or torn edges. The dappled blue ground of the drawer suggests both the sea and the night sky, as does the starfish. The back of this box is covered with printed writing, from an unknown Italian text. Cornell has been categorised as an American Surrealist and, indeed, his imagery of the real world is seen through the artist's fantasies. His persistence in pursuing a theme like the Soap Bubble Set constructions reveals an obsessive nature and hints at a private world of the imagination that we can never fully know.

Notes
1 Alfred H. Barr, Jr, ed., *Fantastic Art, Dada, Surrealism* (New York: Museum of Modern Art, 1936), p. 309
2 Diane Waldman, *Joseph Cornell* (New York: George Braziller, 1977), p. 16
3 *Ibid.*
4 Dore Ashton, *A Joseph Cornell Album* (New York: Viking Press, 1974), p. 93
5 *Ibid.*, p. 99

1 Joseph Cornell, *Soap Bubble Set*, 1936, Wadsworth Atheneum, Hartford, CT

2 Joseph Cornell, *Soap Bubble Set*
1942, Solomon Guggenheim
Foundation, Venice

3 Joseph Cornell, *Soap Bubble Set*
1953, Art Institute of Chicago
Chicago, IL

Joseph Cornell 1903–1972

106 Juan Gris Cockatoo No. 4

c. 1953–54, construction with collage, 50 × 30 × 11.5 cm (19½ × 12 × 4½ in)
Signed on back of lower right: 'Joseph Cornell'

Provenance
Estate of the artist
Thyssen-Bornemisza Collection, 1976

Juan Gris Cockatoo No. 4 is one of series of at least fifteen boxes that Cornell made from 1953–54 to the mid-1960s on the theme of Juan Gris, the Cubist painter. In this box and in others in the series, Cornell employed Cubist motifs and techniques himself, particularly in the shadow cast by the bird which is a silhouette cut out from black paper. Evidently Cornell first was inspired by a Juan Gris painting he saw at the Sidney Janis Gallery in New York; the painting depicted a man reading a newspaper at a café table covered by reading materials.

This series of constructions includes a number of elements found in other works by the artist: a cut-out paper print of a bird mounted on wood, collaged newsprint, a circular ring suspended from a metal rod and a light plastic or cork ball which is free to move around.[1] Other works in the series include: *Untitled (Juan Gris)* (fig. 1), *A Parrot for Juan Gris, Untitled (Le Soir)* (fig. 2). The latter work includes the same newspaper logo from the French paper *Le Soir* which Cornell reproduced in a photostatic copy in *Juan Gris Cockatoo No. 4*.

The newspaper that Cornell chose to photocopy was from Monday, August 1878. The drawer in *Juan Gris Cockatoo No. 4* is covered with yellowed French newsprint with white paint. The back of the box is also covered with yellowed newsprint. On the left side, the clipping refers to 'Les Tours de Venus', noting that the planet Venus does not turn like the earth in twenty-four hours. This once again alludes to Cornell's concern with cosmic issues.

Cornell kept a research dossier on Juan Gris and it has been suggested that his attraction to this artist was based on his fascination with the artist's struggles with poverty and ill health. In this dossier, Cornell placed a page cut from *Art News* of January 1950 which printed a letter of 1915 from Gris to his dealer Kahnweiler referring to bouts of 'black melancholy' and describing his difficulties with his work as he struggled against the meticulous side of his own nature.[2] Gris also used images like a pipe, newsprint and flowered papers in his collages, all of which later appear in Cornell's constructions.

Notes
1 Anne d'Harnoncourt, 'The Cubist Cockatoo: A Preliminary Exploration of Joseph Cornell's Homages to Juan Gris', Philadelphia Museum of Art *Bulletin* 74, no. 32 (June 1978), p. 10
2 *Ibid.*, pp. 8–9

1 Joseph Cornell, *Untitled (Juan Gris)*, c. 1953–54
Philadelphia Museum of Art
Philadelphia, PA

2 Joseph Cornell, *Untitled (Le Soir)*
c. 1953–54, Collection of
Daniel Varenne, Paris

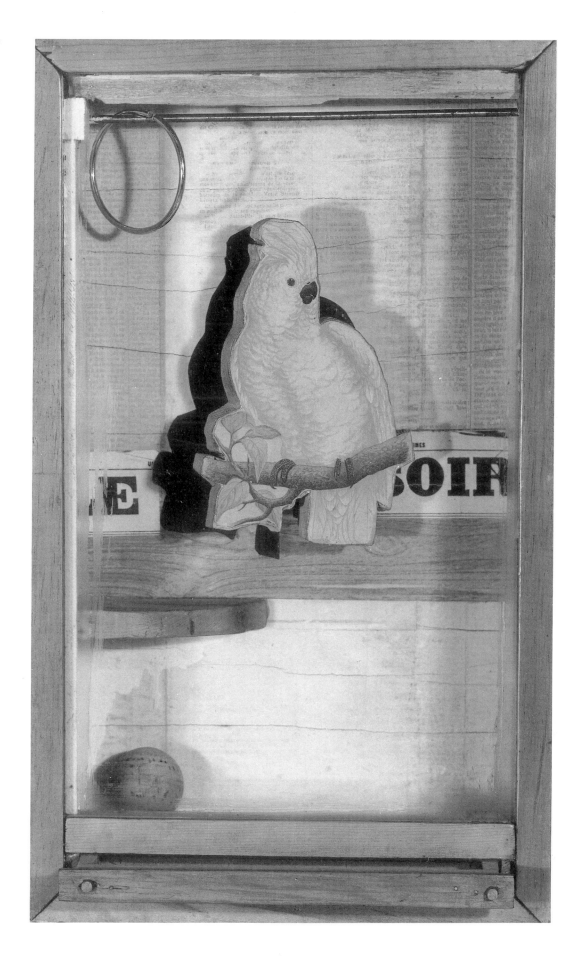

Anne Ryan 1889–1954

107 No. 594

1950, collage, 19 × 17.8 cm (9 × 7⅝ in)

Provenance
Estate of the artist
Andrew Crispo Gallery, New York
Thyssen-Bornemisza Collection, 1978

Literature
Twelve Americans: Masters of Collage (New York: Andrew Crispo Gallery, 1977), no. 171

Exhibition
New York, *Twelve Americans: Masters of Collage*, Andrew Crispo Gallery, 17 November 1977–7 January 1978,
 no. 171

Anne Ryan made her collage *No. 594* in 1950, just two years after she began to make collages in her late fifties. She always numbered rather than titled her work which included paper as well as fabric scraps. Her inspiration came from her discovery of the work of Kurt Schwitters, the German artist from Hanover whose collages grew out of the Dada tradition. She first saw Schwitters' work in an exhibition at the Pinacotheca Gallery in New York in 1948, where she had had her first one-person show in March 1941. Like Schwitters, Ryan was also a poet, having published a volume of her poems entitled *Lost Hills* in 1925.

Ryan's collages reveal her awareness of texture and colour as well as a sensuousness. She emphasised torn edges and unravelled borders of various patterned and textured swatches of cloth, juxtaposed with textured paper. She dressed herself with a similar variety, finding cast-off clothing in thrift shops. Beside her interest in Schwitters, the Cubist organisation of her collages also reflects her friendships with contemporary artists from Hans Hofmann to Barnett Newman.

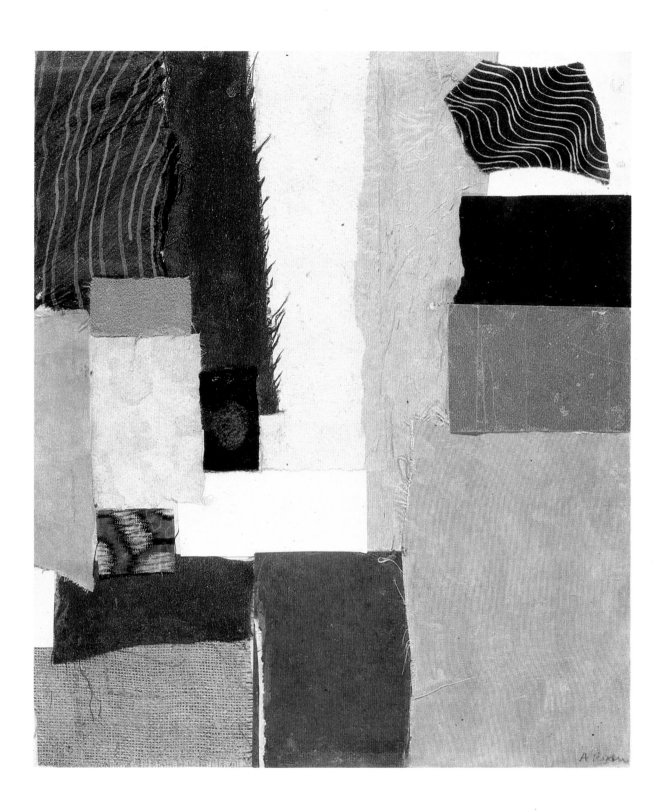

Anne Ryan 1889–1954

108 No. 652

1952, collage, 88.9 × 67.3 cm (35 × 26½ in)
Signed and dated lower right: 'A. Ryan '52'

Provenance
Elizabeth McFadden (daughter of the artist)
Andrew Crispo Gallery, New York
Thyssen-Bornemisza Collection, 1978

Literature
Twelve Americans: Masters of Collage (New York:
 Andrew Crispo Gallery, 1977), no. 177
Zafran, p. 164, no. 64

Exhibitions
New York, *Anne Ryan Collages*, Marlborough Gallery,
 Inc., 16 November–4 December 1974, no. 29, illus.
New York, *Twelve Americans: Masters of Collage*,
 Andrew Crispo Gallery, 17 November 1977–7
 January 1978, no. 177
Australian tour, 1979–80, no. 84

1 Kurt Schwitters, *Mertzpicture 25 A
The Star Picture*, 1920, assemblage
Kunstsammlung Nordrhein-Westfalen
Düsseldorf

Ryan's *No. 652* of 1952 is a collage produced with textured papers and some lightweight fabrics. The entire work is pale in tonality with orange and turquoise highlights, suggesting the effect of stones found in American Indian jewellery. In fact, this unusual colour combination occurs in Schwitters' collages like *Mertzpicture 25 A The Star Picture* of 1920 (fig. 1). In *No. 652*, Ryan has emphasised right angles perhaps thinking not only of the work of Schwitters, but also of the Dutch artist Piet Mondrian or the grid of Manhattan streets and skyscrapers. In her tiny collages, Ryan makes her own subtle poety.

Pop Art

Roy Lichtenstein b.1923

109 Woman in Bath

1963, oil on canvas, 171 × 171 cm (67¼ × 67¼ in)

Provenance
Leo Castelli Gallery, New York
Ilena Sonnabend, Paris
E.J. Power, London
Private collection
Thomas Amman Fine Arts, Zurich
Thyssen-Bornemisza Collection, 1978

Roy Lichtenstein appears to have borrowed the simplified image of *Woman in Bath* from advertising. He commented: 'There are certain things that are useful, forceful, and vital about commercial art.'[1] He has perceptively analysed the effect of commercial art on the viewer:

> The kind of drawing that goes along with commercial art, the kind of education that advertising seems to give the viewer or listener, is very insensitive. . . . I don't know what kind of an effect this oversimplification has brought about, but most of our communications, somehow or other, is governed by advertising, and they're not too careful about how they tend to instruct us. I think that may or may not have a deadening effect on the minds of people.[2]

Desiring to develop a personal style that would reach beyond the overwhelming influence of Abstract Expressionism, Lichtenstein turned to images from commercial art. 'It was hard to get a painting that was despicable enough so that no one would hang it,' he complained, 'everybody was hanging everything. It was almost acceptable to hang a dripping paint rag. . . . The one thing everyone hated was commercial art.'[3]

The technique Lichtenstein employed involved projecting the found commercial imagery onto a canvas through the use of an opaque projector. Occasionally, he recomposed, but he claimed he made only minimal changes when pencilling in the drawing. He then stencilled Ben Day dots onto the canvas and painted the remainder of the canvas, light to dark. He explained: 'I wanted to hide the record of my hand.'[4]

Woman in Bath is related to another of Lichtenstein's canvases of 1963, *Drowning Girl* (fig. 1). Both depict a female submerged in water, emphasising her head and hands. While the woman in the former is glibly cheerful, the latter is highly emotional. In *Drowning Girl*, the artist claimed to have responded to the influence of the Japanese woodcut artist, Hokusai, whose extreme close-ups of heads are often rendered with flatly coloured masses contrasted with patterned areas.[5] This may also have affected the choice of composition and the final disposition of forms in *Woman in Bath*.

Comparing the preparatory drawing for *Woman in Bath* with the canvas itself, the most important change is the cropping of the image, particularly behind the woman's head, lopping off some of her coiffure. Her hair style is more elaborately rendered in the painting. More bubbles were added to the bath water and shadows appear on the tile wall which are not visible in the drawing.

Notes
1 Quoted in G.R. Swenson, 'What is Pop Art?', *Art News* 62 (November 1963), p. 25
2 Quoted in Alan Solomon, 'Conversation with Lichtenstein', reprinted in John Coplans, ed., *Roy Lichtenstein* (New York: Praeger Publishers, Inc., 1972), p. 68
3 Quoted in G.R. Swenson, *op. cit.*, p. 25
4 Quoted in Coplans, ed., *op. cit.*, p. 86
5 Coplans, ed., *op. cit.*, p. 90, quotes the artist: 'In the *Drowning Girl* the water is not only Art Nouveau, but it can also be seen as Hokusai.'

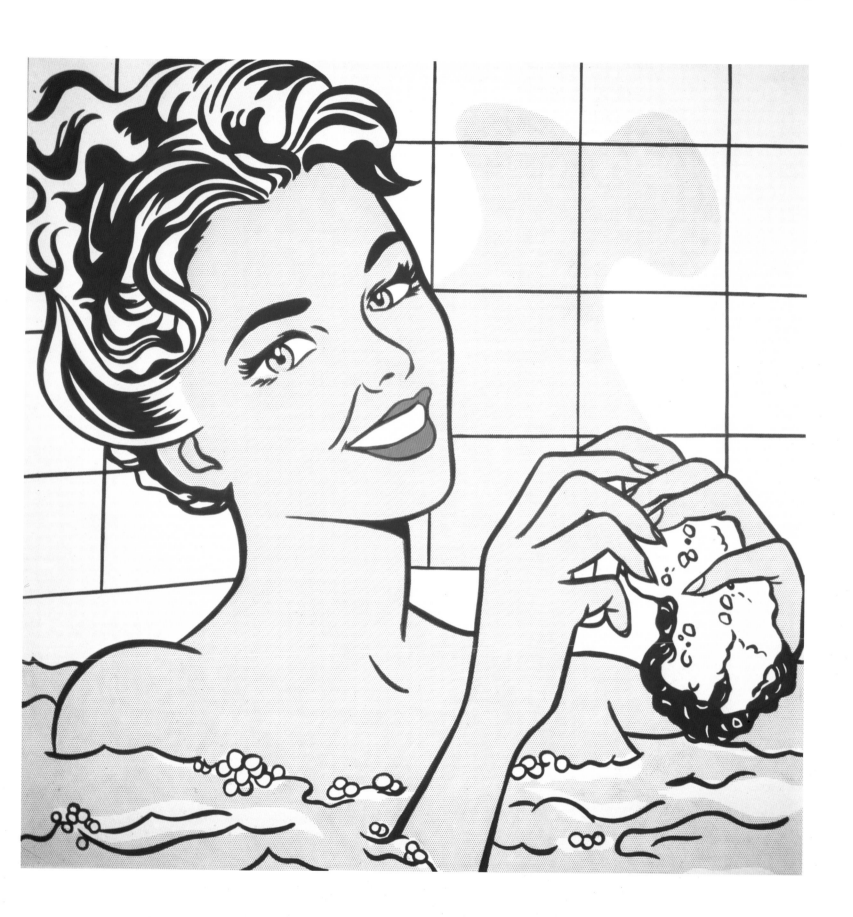

1 Roy Lichtenstein, *Drowning Girl*, 1963, oil on canvas
Museum of Modern Art, New York

2 Tom Wesselmann, *Bathtub Collage No. 3*, 1963, oil on canvas
enamel on wood and assemblage, Museum Ludwig, Cologne

The theme of the woman in a bathtub was a common one among Pop artists during the early 1960s. Tom Wesselmann repeatedly produced such images, for example, *Bathtub Collage No. 3* of 1963 (fig. 2), where a female nude is shown standing in a tub drying herself with a striped towel. Like the woman in Lichtenstein's *Woman in Bath*, the figure is seen against the geometry of a tiled bathroom wall. Yet while Lichtenstein emphasises the woman's smiling face, a generalised gaze lifted from advertisements, Wesselmann's anonymous female is featureless except for her lips. In the same year, sculptor George Segal created *Woman Shaving her Leg* (fig. 3) which also depicts a female nude in a bathtub against a tiled wall, her face cast downwards in concentration.

3 George Segal
Woman Shaving her Leg, 1963
Collection of Mrs Robert B. Mayer
Chicago

4 Edgar Degas, *Woman in her Bath Sponging her Leg*, c.1883, pastel, Musée du Louvre, Paris

This theme of the woman bathing continues a long tradition of male artists who have depicted nude women at such private moments – from Rembrandt's *Bathsheba at her Toilet* of 1643 (fig. 5) to Degas' series of women in and just out of the bath. In a sense, Lichtenstein's *Woman in Bath* is a twentieth-century update of Degas' pastel of about 1883, *Woman in her Bath Sponging her Leg* (fig. 4). But Lichtenstein has also radically altered the mood of Degas' intimate scene where the viewer is voyeur and does not see the bather's face. In *Woman in Bath*, Lichtenstein has the bather not only face the viewer, but make eye contact as well. His is the imagery of advertising and so his lady gives a welcoming greeting, an invitation to try whatever it is she is offering. Eroticism used to sell bubble bath – or whatever! Thus, *Woman in Bath* continues a tradition but recasts it in the mundane language of Pop Art.

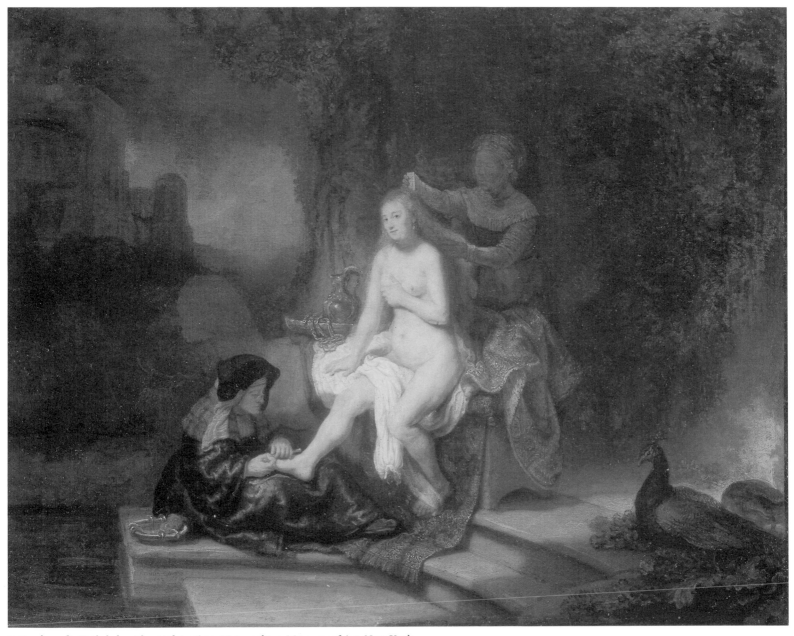

5 Rembrandt, *Bathsheba at her Toilet*, 1643, Metropolitan Museum of Art, New York

Robert Rauschenberg b. 1925

110 Express

1963, oil on canvas with silkscreen, 183 × 305 cm (72 × 102 in)

Provenance
Leo Castelli Gallery, New York
Mr and Mrs Frederick Weisman, Los Angeles, CA
Mr and Mrs Charles B. Benenson, New York
Sale, Sotheby Parke Bernet, New York, Important Post-War and Contemporary Art, 4 May 1974, lot 540
Thyssen-Bornemisza Collection, 1974

Literature
Andrew Forge, *Rauschenberg* (New York: Harry N. Abrams, Inc., 1969)
Andrew Forge, *Rauschenberg* (New York: Harry N. Abrams, Inc., 1978), pl. 41
Zafran, p. 167, no. 92
Lieberman pp. 71–73, illus., no. 62

Exhibitions
Venice, XXXII Biennale Internationale d'Art, 1964, no. 75
Minneapolis, MN, *Robert Rauschenberg Paintings, 1953–64*, Walker Art Center, 3 May–6 June 1965, no. 16
Australian tour, 1979–80, no. 92
USA tour, 1982–83, no. 62
Modern Masters from the Thyssen-Bornemisza Collection, May–December 1984
 Tokyo, National Museum of Modern Art
 Kumamoto, Kumamoto Prefectural Museum
 London, Royal Academy of Arts, no. 103
 February–August 1986
 Madrid, Bibliotheca Nacional, Salas Pablo Ruiz Picasso
 Barcelona, Palau de la Virreina

Robert Rauschenberg's *Express* of 1963 is composed of overlapping photographic images enlarged on sensitised silkscreens and printed onto the canvas. In this sense the composition resembles collage. Some of the images, such as the jumping horse, are repeated and these silkscreen prints are combined with paint. The enlarged silkscreened images become grainy and even somewhat transparent. Rauschenberg collected his photographs from newspapers and other sources of popular imagery.

In choosing the title *Express*, Rauschenberg plays on the various meanings of this word, including travelling at high speed without delay, something which is exact or precise, to delineate or depict, or to give expression to the artistic or creative impulses. There are many obvious references to speed and movement in this picture: the jockey and the horse jumping the fence, dancers in motion, a mountain climber hoisting himself up by a rope, and a nude descending a staircase. The latter image is clearly a reference to Marcel Duchamp's infamous painting *Nude Descending a Staircase* which captured popular attention and its place in history at the New York Armory Show of 1913. Rauschenberg admires Duchamp about whom he commented: 'I find his life and work a constant inspiration. I don't think Duchamp meant any of his things to be just gestures. . . .'[1]

Note
1 Quoted in Calvin Tomkins, *The Bride and the Bachelors* (New York: Viking Press, Inc., 1965), p. 236

The photograph in the lower right corner is a very famous nineteenth-century image of Generals Grant and Lee at the latter's surrender at Appomattox, Virginia during the American Civil War. This may have had particular meaning to Rauschenberg, as a Southerner living in New York, for he was a native of Port Arthur, Texas, near the Louisiana border. Two gears are shown to the left of this solemn military image.

At the opposite corner, on the left, is a photograph of a barge passing under a bridge in Chicago. At the top of the canvas, opposite the gears is the image of a male dancer who is probably Rauschenberg's friend Merce Cunningham, whom he had first met at Black Mountain College in Beria, North Carolina in the summer of 1952. At the time he produced *Express*, a decade had passed since 1953, when Rauschenberg designed costumes for *Septet* – his first work for Cunningham's new dance company. Rauschenberg has made other pictures which refer to this friendship, including his combine painting, *Trophy I (for Merce Cunningham)* of 1959 (fig. 1). Filled with complex meaning, *Express* is not about to be quickly deciphered.

1 Robert Rauschenberg
Trophy I (for Merce Cunningham)
1959, combine painting
Kunsthaus, Zurich

James Rosenquist b.1933

111 Smoked Glass

1962, oil on canvas, 61 × 81.5 cm (24 × 32 in)
Signed, titled and dated on verso

Provenance
Green Gallery, New York
Galerie Rudolf Zwirner, Cologne
Helmut Klinker, Bochum
Sale, Christie's, London, Contemporary Art, 3 December 1974, lot 174
The Mayor Gallery, London
Thyssen-Bornemisza Collection, 1977

Literature
R. Budde, 'James Rosenquist: Catalogue Raisonné' in *James Rosenquist: Gemälde-Räume-Graphik*
 (Cologne: Wallraf-Richartz Museum, 1972), no. 26, p. 144
Marcia Tucker, *James Rosenquist* (New York: Whitney Museum of American Art, 1972), p. 12, illus., p. 45
Zafran, pp. 167, 166, illus., no. 90
Lieberman, p. 62, no. 53
Judith Goldman, *James Rosenquist* (New York: Viking Press, 1985), illus., p. 105

Reproduced
Advertisement for Christie's sale on 3 December 1974, *Apollo* c (November 1974), p. 33

Exhibitions
Cologne, *James Rosenquist: Gemälde-Räume-Graphik*, Wallraf-Richartz Museum, Kunsthalle, 29 January–11 March
 1972
New York, *James Rosenquist*, Whitney Museum of American Art, 12 April–29 May 1972, no. 45
Australian tour, 1979–80, no. 90
USA tour, 1982–83, no. 53

Smoked Glass of 1962 reflects James Rosenquist's experience painting commercial billboards in the 1950s. His unusual sense of scale relates to his fascination with seeing things close-up, larger than life, apart from nature. When he worked on billboards from photographs, Rosenquist responded by feeling 'like I hadn't done it, that it had been done by a machine. . . . I reproduced it as photographically and as stark as I could.'[1] He continued to work in a similar manner in his own paintings.

Rosenquist used grisaille, or shades of grey, for most of this painting, and he juxtaposed this monochromatic palette with a square of bright red on the lower left, which in turn emphasises the grey. This combination is evocative of illustration in magazine advertising. Two years after completing *Smoked Glass*, Rosenquist commented on his preference for 'anonymous' images in his attempt to avoid irrelevant reactions from the spectator such as anger or nostalgia: 'In 1960 and 1961 I painted the front of a 1950 Ford. . . . I use images from old magazines – when I say old, I mean 1945 to 1955 – a time we haven't started to ferret out as history yet. . . . These images are like no-images. There is a freedom there. If it were abstract, people might make it into something.'[2]

The imagery of *Smoked Glass* is related to Rosenquist's painting *I Love You with My Ford* of 1961, finished just one year earlier. On the right of *Smoked Glass* is a headlight and a small fragment of the chrome grill from the 1950 Ford, the entire front grill of which is visible in *I Love You with My Ford*. Both paintings feature portions of a female face painted in grisaille. In

Notes
1 Quoted in G. R. Swenson, 'What is Pop Art?', *Art News* 62 (November 1963), p. 63
2 Quoted in *ibid.*, p. 41

Smoked Glass, Rosenquist depicted only a female's nostrils and her open mouth, shown exhaling the smoke of a cigarette, the lit tip of which is held up against the red squares on the lower left of the canvas. In the lower right corner appear strands of hair, with its sensual associations apparently continuing the effect of that visible against the curve of the woman's cheek.

It seems clear that Rosenquist's imagery in both of these paintings is about eroticism, perhaps alluding to an encounter in an automobile recalled from the artist's youth. In *Smoked Glass*, the woman's open mouth with lipstick-covered lips is clearly inviting. We are reminded of advertising images which are sexual allusion to sell products, a particularly obvious tactic in the promotion of cigarettes. Setting the cigarette against red emphasises it and its hot, sexual association. Rosenquist appears to titilate and tease without overtly revealing the specific meaning of the images he utilised.

George Segal

<div align="right">

b. 1924

</div>

112 Red Girl in Blanket

1975, plaster, 99 × 124 × 33 cm (39½ × 49 × 13 in)

Provenance
Sidney Janis Gallery, New York
Thyssen-Bornemisza Collection, 1977

Literature
Sam Hunter and Don Hawthorne, *George Segal* (New York: Rizzoli, 1984), illus. in colour, p. 66, no. 69;
 p. 373, listed no. 241

Exhibition
New York, *Exhibition of Recent Sculpture by George Segal*, Sidney Janis Gallery, 26 January–26 February 1977, no. 9

George Segal is best known for his complete figures cast from real people, often the artist's patient relatives and friends. These figures are placed within authentic settings, usually created out of authentic objects as props. Marcel Duchamp appreciated Segal's intentionality: 'With Segal it's not a matter of the found object, it's the chosen object.'[1] Segal has selected characteristic poses and environments for each of the figures he sculpts. In his sculptures, Segal is concerned with purely formal issues as well as the meaning of his figures.

Red Girl in Blanket of 1975 is one of a group of reliefs of partial figures that Segal has produced since 1969. Eight years had passed since Segal sculpted *Man Sitting at Table*, his first plaster figure based on his wrapped bandage and plaster technique. His studio contained a variety of unassembled moulds and rejected parts which he began to turn into independent works of art which he referred to as 'independent thoughts or sensations'.[2]

Segal explained these more fragmentary works as deriving from 'some kind of erotic or sensual impulse, to define bits of lips, fingers, breasts, folds of flesh, intricate lines'.[3] He has also related these works to his interest in 'questioning the nature of twentieth-century collage,' elaborating: 'I discovered that the thing I liked about collage is not the way it's scattered so musically over the surface, but the fact that each piece of collage seems to me a glimpse, a rapid glimpse out of the corner of my eye.'[4]

Red Girl in Blanket relates to Segal's *Girl on Blanket, Hand on Leg* of 1973 (fig. 1) which also shows a fragmentary view of a female nude, her head buried beneath a blanket which serves as the background to the figure. In the latter work, Segal emphasised the buttocks and depicted a fuller figure, with folds of flesh along the torso and larger, drooping breasts. Although the work hangs on the wall the effect is to make one visualise a woman lying on a bed, partially covered by a blanket and partially revealed. The sense of catching a glimpse of this female figure, partially hidden beneath the bed clothes, adds to the sensuality of this work. Its rich monochrome red surface further contributes to this sensation, calling upon our association of the colour red with sensuality, as in 'red-hot lover'.

The eroticism of this work is certainly intentional. Several years earlier, in 1970, Segal created *Lovers II*, a fragmentary sculpture of a man and woman embracing in bed. In *Red Girl in Blanket*, Segal created a celebration of this sensuous female form, emphasising her curves and the softness of her body, echoed by the soft folds of the blanket with which she is entwined.

Notes
1 Marcel Duchamp, Autograph note in *New Sculpture by George Segal* (New York: Sidney Janis Gallery, 1965)
2 Quoted in Phyllis Tuchman, *George Segal* (New York: Abbeville Press, 1983), p. 71
3 *Ibid.*
4 *Ibid.*

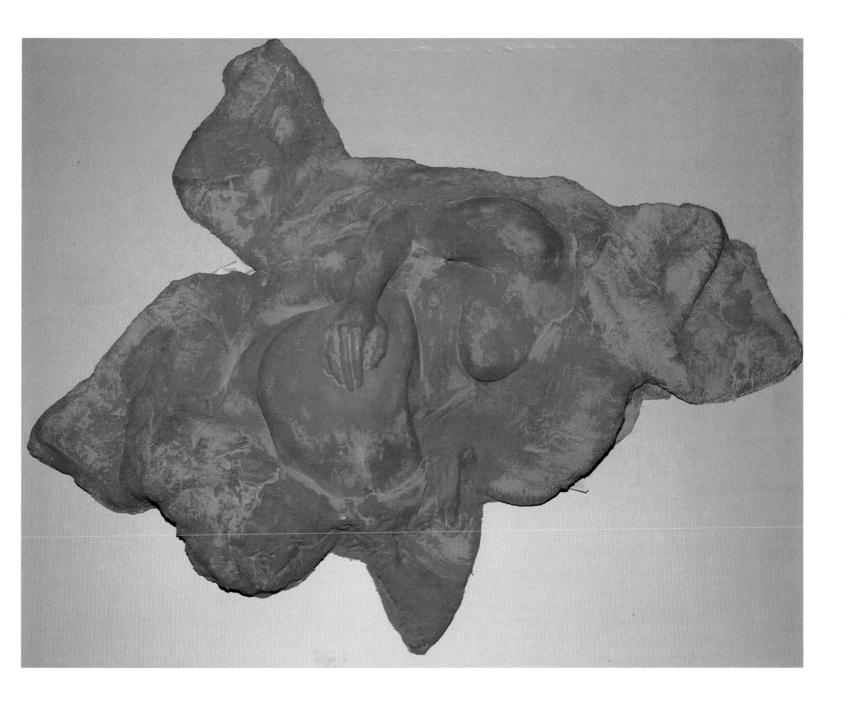

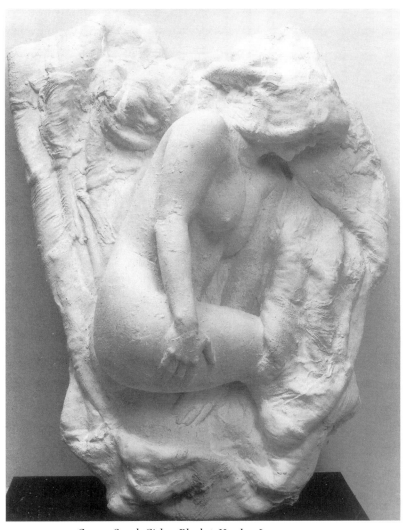

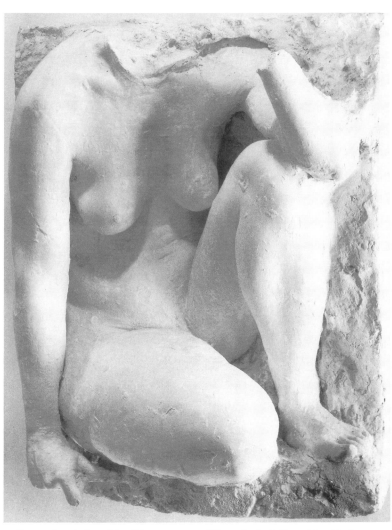

1 George Segal, *Girl on Blanket, Hand on Leg*, 1973
Sidney Janis Gallery, New York

2 George Segal, *Crouching Woman*, 1975, Sidney Janis Gallery, New York

Segal's series of pastels from the mid-1960s offer a clue to his involvement with the form of the female nude viewed in fragments. These pastels are also executed in bright colours, suggesting their role in the eventual development of fragmentary nude reliefs like *Red Girl in Blanket*. In omitting any depiction of the nude's head or face, Segal, in both the pastels and the reliefs, creates not a specific woman but the essence of the female. This is echoed in many of his other reliefs of this period: his series of *Girl in Robe* from 1974 and his *Crouching Woman* of 1975 (fig. 2).

At the time *Red Girl in Blanket* was exhibited in 1977, critics responded enthusiastically to the injection of bright colour and to the sensuality enthusiastically of the forms. Leo Rubinfien commented: 'Segal's bright color works to overwhelming effect. Bright blues and oranges subsume and add to all the themes of the reliefs irony and sentiment. They suggest at once the tendency of memory to distort – to change the emotional coloration of an event – and the vivid, feverish, sensuality of the sexual moment which the colors glorify.'[5] Donald Kuspit noted: 'Color is used to penetrate the figure's paralysis at the turning point of awareness, and to make

Note
5 Leo Rubinfien, 'On George Segal's Reliefs', *Artforum* 15 (May 1977), p. 45

Notes

6 Donald Kuspit, 'On the Verge of Tragic Vision', *Art in America* 65 (May 1977), p. 84

7 Albert Elsen, 'Mind bending with George Segal', *Art News* 76 (February 1977), p. 37

its presence stronger, more momentous than even its isolation does. The bas reliefs work the same way. Figures are frozen in intense, erotic positions, accentuating and making more abstract their already abstract presence, truncated and compressed by the frame.'[6] Albert Elsen praised the poetry of Segal's fragments: 'The often partial concealment of a head, limb or torso within the surrounding matrix proposes an equivocal poetic focus: that of the body as a distillation of the artist's consciousness, as that of the model whose self-image is narrowed by sexual awareness.'[7]

Segal's creation of fragmentary figures as wall reliefs also evolved out of the large oil paintings of nudes he produced during the late 1950s, such as *The Blow* (1958) or *Red Courbet* (1959) (fig. 3), in which figures are often abruptly cropped by the edges of the painting in the manner of Degas. The sculptor to whom Segal has the closest affinity here is probably Rodin, but Segal's reliefs like *Red Girl in Blanket* manage to cast the partial figure in a new twentieth-century light, expressing at once the erotic and the mysterious.

3 George Segal, *Red Courbet*, 1959, Collection of the artist, Sidney Janis Gallery, New York

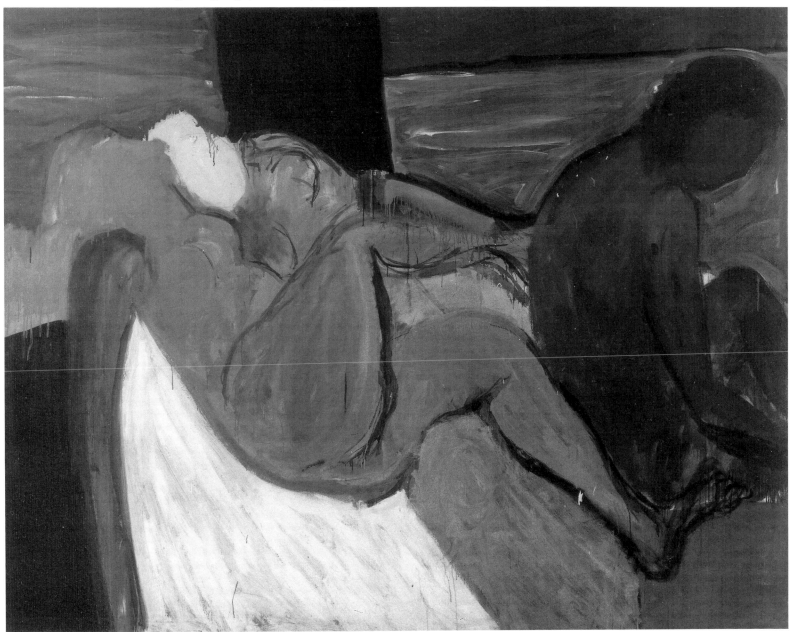

Tom Wesselmann b.1931

113 Nude No.1

1970, oil on canvas, 63.5 × 114.5 cm (25 × 45 in)
Signed on frame

Provenance
Sidney Janis Gallery, New York
Private collection, New York
Andrew Crispo Gallery, New York
Thyssen-Bornemisza Collection, 1974

Literature
Zafran, p.169, illus., no.98
Lieberman, p.63, illus., no.54

Exhibitions
New York, *Tom Wesselmann: Recent Paintings*, Sidney Janis Gallery, 1970
New York, *Twentieth-Century American Masters*, Andrew Crispo Gallery, 1974, no.87
Australian tour, 1979–80, no.98
USA tour, 1982–83, no.54

The elements composing Tom Wesselmann's *Nude No.1* of 1970 are related to the paintings of his Bedroom series of close-up views in large scale, particularly *Bedroom Painting No.15* of 1968–70 (fig.1). In both pictures the same images appear: an orange, a fully-opened red rose or roses, a nude female in partial view, a framed self-portrait of the artist, and a round throw pillow which is yellow in the latter painting and green in the former. While *Bedroom Painting No.15* contains only a foot with painted toe nails, *Nude No.1* is the quintessential Wesselmann image, containing a female figure cropped at one end at the thighs and at the forehead on the other end, one of his 'Great American Nudes' accompanied by still-life elements.

Although Wesselmann is generally considered part of the stylistic phenomenon known as Pop Art, he has protested at such a catagorisation: 'I dislike labels in general and Pop in particular, especially because it over-emphasizes the material used. There does seem to be a tendency to use similar materials and images, but the different ways they are used denies any kind of group intention.'[1] Nonetheless, in the early 1960s, Wesselmann came to be known along with other Pop artists, like Lichtenstein, Rosenquist and Warhol, who used commercial imagery in their work. At the time, however, these other artists painted these images while Wesselmann made collages directly out of the commercial raw material. He only switched to pure painting as he increased his scale and collage materials became more difficult to find.

During the early 1960s, Wesselmann's nudes developed out of his series of small collages which he called 'Great American Nudes'. At first he began to change his scale by making enlarged copies of these collages. He subsequently referred to these original small collages as 'Little Great American Nudes'. The artist recalled this progression:

> I can only describe it as a tightening of the elements, a kind of process of depersonalization. Colors became flatter, cleaner, brighter; edges became harder, clearer; and there was more use of real objects – prints, bottles, advertisements, etc. The sound of the paintings became sharper. I felt the need to lock up my paintings so tightly that nothing could move. That way, by becoming static and somewhat anonymous, they also became more charged with energy.[2]

Notes
1 Quoted in G.R.Swenson, 'What is Pop Art?', *Art News* 62 (November 1963), p.41
2 Quoted in John Rublowsky, *Pop Art* (New York: Basic Books, Inc., 1965), p.137

The eroticism of *Nude No. 1* is obvious. The figure's face is featureless except for her large sensuous lips. This is not a portrait of an individual, but a symbol of woman as a sexual being. The contours of her body are emphasised, the slopes and curves acting like a metaphor for landscape. This female also represents an earth mother, a symbol of fertility, with her large pink nipple dramatically shown against the blue vase containing roses of the same pink tonality. Both the fully opened roses and the ripe orange suggest her fecundity and refer back to the roundness of her breast and the colour of her nipple. The association between female anatomy and fruit had been evoked in literature since ancient times.[3] Meyer Schapiro pointed out in his discussion of Cézanne's apples: 'Through its attractive body, beautiful in color, texture and form, by its appeal to all the senses and promise of physical pleasure, the fruit is a natural analogue of ripe human beauty.'[4] The Venetian blinds are down, mostly closed, signifying the privacy of this intimate moment.

Peering out from within the confines of a frame is the face of the artist himself, the ultimate voyeur, playfully taking part in the erotic tableau he has created. This image of Wesselmann, painted from life, is meant to be read as a self-portrait, whereas in certain other works, such as *Bedroom Painting No. 12*, the artist worked from a photograph of himself to create an image which he utilised 'as a more or less anonymous personage'.[5] It is fitting that Wesselmann has included his own image with one of his nudes, the Pop Art icon with which he is most closely associated.

Notes

3 For a discussion of such erotic metaphors in the nineteenth and twentieth centuries, see Linda Nochlin, 'Eroticism and Female Imagery in Nineteenth-Century Art' in *Woman as Sex Object: Studies in Erotic Art, 1730–1970*, ed. by Thomas B. Hess and Linda Nochlin, *Art News Annual* XXXVIII (1972), pp. 8–15

4 Meyer Schapiro, 'The Apples of Cézanne: An Essay on the Meaning of Still-life' in *The Avant-garde*, ed. by Thomas B. Hess and John Ashberry, *Art News Annual* XXXIV (1968), p. 37

5 Slim Stealingworth, *Tom Wesselmann* (New York: Abbeville Press, 1980), p. 66

1 Tom Wesselmann, *Bedroom Painting No. 15*, 1968–70, oil on canvas, Chrysler Museum, Norfolk, VA

Tom Wesselmann b. 1931

114 Open End Nude Drawing

1971, stencil with pencil and watercolour, 10.2 × 23 cm (4 × 9 in)
Signed and dated lower left: ' # 70 Wesselmann 74'

Provenance
Sidney Janis Gallery, New York
Thyssen-Bornemisza Collection, 1976

Literature
Slim Stealingworth, *Tom Wesselmann* (New York: Abbeville Press, 1980), illus. p. 284

This drawing is number seventy in an edition of a potentially unlimited number, all of which are hand coloured by the artist. *Open End Nude Drawing* is related to the artist's Great American Nude series as described in [113]. Wesselmann was obviously quite taken with his model's suntan, rendering the lines of her bikini against her nude body. This same preoccupation with suntan lines is evident in his paintings such as *Great American Nude No. 76* of 1965 or *Great American Nude No. 91* of 1967.

Tom Wesselmann b.1931

115 Bedroom Collage

1974, pencil, liquitex and collage on board, 12×21.5 cm ($4\frac{3}{4} \times 8\frac{1}{2}$ in)
Signed upper left: 'Wesselmann 12/20'

Provenance
Gift of the artist to the Thyssen-Bornemisza Collection, 1977

Literature
Slim Stealingworth, *Tom Wesselmann* (New York: Abbeville Press, 1980), illus. p. 285

Bedroom Collage is one of an edition of twenty. Wesselmann's first collage edition was produced in 1970 by his wife Claire based on the artist's prototype. *Bedroom Collage* is closely related in its theme and composition to the much larger oil on canvas of 1968, *Bedroom Painting No. 6*. Instead of the drawn Venetian blinds of the painting, the collage uses a postcard view of the New York skyline as seen through the window, defined by a bold orange band on two sides. The scale is that which would be seen by an observer in close proximity to the woman's breast which looms large in front of the cityscape. Rather than the roses of the painting, the collage features spring daffodils whose elongated trumpets perhaps call attention to the projecting nipple.

Wesselmann alludes to sensuality by including a bit of actual leopard fur in the lower left of the collage next to the breast. In the painting, he duplicated this leopard pattern in paint adjacent to the breast. And once again, as in *Nude No. 1* [113], he plays on the association of fruit to fecundity and to the female body by juxtaposing a shiny bright orange.

Wesselmann returns here to collage which he began in the early 1960s. He commented: 'One thing I like about collage is that you can use anything, which gives you that kind of variety; it sets up reverberations in a picture from one kind of reality to another. I don't attach any kind of value to brushstrokes, I just use them as another thing from the world of existence.'[1]

Note
1 Quoted in G.R.Swenson, 'What is Pop Art?', *Art News* 62 (November 1963), p.41

Tom Wesselmann b.1931

116 Drawing for Banner Nude

1975, pencil and liquitex on Bristol Board, 22 × 39 cm (8½ × 15 in)
Signed along lower left side: 'Wesselmann ca 68'

Provenance
F.Rapetti
Thyssen-Bornemisza Collection, 1976

This drawing is typical of Wesselmann's Great American Nude imagery. Shown with her blonde hair flowing sensuously, she wears only stockings and the outline of her suntan. Featureless except for brightly coloured lips, her mouth open and inviting, she is not a particular woman but the artist's symbol of all women. This drawing is related to the artist's *Great American Nude No. 82* of 1966 where a reclining woman, nude except for stockings, was created in painted moulded plexiglass.

Minimal and Reductivist Art

Josef Albers 1888–1976

117 Casablanca B

1947–54, oil on board, 41.3 × 60.7 cm (16¼ × 23⅞ in)

Provenance
Sidney Janis Gallery, New York
Arnold H. Maremont
Andrew Crispo Gallery, New York
Thyssen-Bornemisza Collection, 1977

Literature
Jean Charlot, 'Nature and the Art of Josef Albers', *College Art Journal* 15, no. 3 (Fall 1956), p. 191, illus.
Leif Siöberg, 'Fragen au Josef Albers', *Kunstwerk* 14 (April 1961), p. 57, illus.

Exhibitions
Chicago, IL, *The Maremont Collection at the Institute of Design*, Institute of Technology, 1964, no. 4
Washington, DC, *Treasures of 20th Century Art from The Maremont Collection*, Washington Gallery of Modern Art,
 1964

Josef Albers painted *Casablanca B* as a part of one of his continuing series on exploring colour principles. It is one of his works with two centres which resulted from previous experiments, including those with 'Equal and Unequal' in 1939, and his *Treble clefs* in 1932–35. He did not work in the two-centre works as frequently as his famous Homage to the Square series.

Casablanca B is painted entirely in shades of grey in the centre and red around the exterior of the picture. Of his own work and that of artists who do not regard colour as 'a concomitant of form', Albers has written: 'color is the chief medium of the pictorial language. Here color attains autonomy.'[1] He explained: 'I am particularly interested in the psychic effect, an esthetic experience that is evoked by the interaction of juxtaposed colors.'[2]

Albers created these colour experiments in part to demonstrate that our perceptions of colour are illusory. We perceive colours according to their surroundings. He was very interested in the relationship of geometric parts as affected by colour. He was able to carefully calculate and measure such effects by employing the same shapes repeatedly and by changing only the colour combinations. Thus, he even preferred colours as they were manufactured, straight from the tubes.

Albers was one of the most insistent artists who worked in series; he had true perseverance. He explored colour recollection, the relativity of colour, after-images, harmonies and space illusions. Albers was a great teacher and the influence of his work in colour has been very far-reaching, extending beyond painting into many other areas.

Notes
1 Quoted in Eugene Gromringer, *Josef Albers* (New York: George Wittenborn, Inc., 1968), p. 104
2 *Ibid.*

Josef Albers 1888–1976

118 Structural Constellation – Alpha

1954, incised vinyl, 49 × 65.5 cm (19 × 25½ in)

Provenance
Sidney Janis Gallery, New York
Thyssen-Bornemisza Collection, 1977

Literature
Herbert Read, *A Concise History of Modern Painting* (New York: Frederick Praeger, 1968), p. 213

Exhibitions
Icon Idea, Smithsonian Institution travelling exhibition, 1971
New York, *Less is More*, Sidney Janis Gallery, 1977

Josef Albers began his Structural Constellation series about 1950, concentrating on this series particularly in the years 1954–58. He continues to explore a given idea over and over again with slight variations on his theme. Albers had a systematic mind and enjoyed these repetitions and subtle changes, demonstrating great patience and enduring curiosity. In the case of the Structural Constellations, he even eliminated colour to concentrate on form and worked in black and white.

The Structural Constellations began as drawings in Albers' sketchbook and were subsequently transferred onto graph paper and then vinyl. Albers desired an impersonal look without any brushstrokes visible to suggest the human hand. Earlier, at the Bauhaus, Albers had produced glass paintings which achieved this machine-made look. His oil paintings are less successful in this aspect of his own aim.

In *Structural Constellation – Alpha*, Albers investigated right angles and slanting parallel lines. In this series, he explored the diagonal line and many variations on the use of all these possible combinations. The result is the illusion of a structure somewhat like that of a Japanese origami design in folded paper. Albers questioned our perception of space and three-dimensionality. He played with possibilities of perspective variations. He made us look more intensely.

Al Held b.1928

119 Solar Wind VI

1974, acrylic on canvas, 182.9 × 152.4 cm (72 × 60 in)

Provenance
Andre Emmerich Gallery, New York
Arthur Smith, New York
Andrew Crispo Gallery, New York
Thyssen-Bornemisza Collection, 1977

Literature
Marcia Tucker, *Al Held* (New York: Whitney Museum of American Art, 1974), p.19, illus., p.100

Al Held painted a series of Solar Wind pictures of which *Solar Wind VI* of 1974 is one example. This series resulted in part from Held's fascination with radio astronomy because it was 'non-perceptual, that is physical objects can only be seen by being heard'.[1] Held produced diagrammatic notations which suggest auditory experience, actual events in a real world continuum of space and time.

Held's space here is conceptual and intellectual, at once abstract and almost mystical. He makes transformations through geometry. In this work, the influence of Josef Albers seems apparent. Held knew Albers and his work while teaching at Yale University beginning in 1962, the year Albers was awarded an Honorary Doctor of Fine Arts degree there. Held seems to have absorbed much from the German emigré's geometric work in white on black, concentrating on the same colour combination in the early 1970s. An example of such work by Albers is his *Structural Constellation– Alpha* of 1954 [118].

This Solar Wind series is composed on subtle variations on a theme based on a transparent cube which contains other floating geometric shapes. Held reminds us that he plays with illusionistic space on a flat canvas surface. The shapes continue beyond the edges of the canvas, visually inviting the spectator to participate in the space defined by the artist. Held's painting is about issues of perception and exploring their complexities.

Note
1 Quoted in Marcia Tucker, *Al Held* (New York: Whitney Museum of American Art, 1974), p.19

Morris Louis 1912–1962

120 Pillars of Hercules

1960, acrylic on canvas, 231.1 × 367.3 cm (7 ft 7 in × 8 ft 9¼ in)

Provenance
Estate of the artist
Andre Emmerich Gallery, New York
Andrew Crispo Gallery, New York
Thyssen-Bornemisza Collection, 1983

Literature
Robert Ayers, 'Color and Motion', *Artscribe* 33 (February 1982), illus., p. 45

Exhibitions
London, *Morris Louis*, Arts Council of Great Britain, Hayward Gallery, 27 June–1 September 1974, no. 20, illus.,
 p. 45
Morris Louis Gemälde 1958 bis 1962, September 1974–April 1975, no. 20, illus., p. 45
 Düsseldorf, Städtische Kunsthalle
 Humlebaek, Denmark, Louisiana Museum of Modern Art
 Brussels, Palais des Beaux-Arts
Purchase, NY, *Hidden Desires*, The Neuberger Museum, 1980, illus.
Modern Masters from the Thyssen-Bornemisza Collection, February–August 1986, no. 101
 Madrid, Biblioteca Nacional, Salas Pablo Ruiz Picasso
 Barcelona, Palau de le Virreina

Morris Louis painted *Pillars of Hercules* in 1960, only one year before his death. This canvas is an example of the artist's work known as the Column series, painted during the summer of 1960, just before he began the series known as the 'Unfurleds', which he evidently considered his greatest achievement.[1] This is an unusual series in that the centre of the composition is left completely empty, forcing the viewer to focus on the outer edges of the canvas. There bands of brightly coloured paint have been allowed to stain the canvas. The application of paint and colour is completely asymmetrical.

In the actual 'Unfurleds', cascading rivulets of colour begin just beneath the upper corners and flow downwards and inwards, leaving the bare unprimed canvas visible in the centre. Like those pictures, *Pillars of Hercules* conveys an airy, open quality. These paintings are among the most interesting ones which are characteristic of the lyrical abstractions produced during the 1960s.

The evolution of this style actually began with Jackson Pollock's paintings of black enamel on raw cotton duck canvas during 1951. Helen Frankenthaler, visiting Pollock in the company of her friend, the art critic, Clement Greenberg, saw the possibility of adapting this staining technique to paintings emphasising colour. Louis was very impressed when he saw Frankenthaler's painting, *Mountains and Sea*, on a visit to New York in April 1953, in the company of Kenneth Noland, a younger painter who also lived in Washington.

Note
1 Kenworth Moffett, *Morris Louis in the Museum of Fine Arts, Boston* (Boston, MA: Museum of Fine Arts, n.d.)

Note
2 For more information on this
formula, see Michael Fried,
Morris Louis, 1912–1962
(Boston, MA: Museum of
Fine Arts, 1967), Appendix I,
pp. 79–80

Louis produced *Pillars of Hercules* with Magna made by Bocour Artist Colors, Inc., a synthetic medium. When the formula of this paint in tubes was changed in early 1960 and could no longer be thinned down to allow for staining, Bocour produced a special Magna for this purpose which was sold to Louis and others in gallon cans. This new paint had the consistency of maple syrup.[2]

Louis' title refers to the strength of Hercules, the most famous of the Greek heroes, who was celebrated for his courage and fortitude. Perhaps Louis, as a pioneer of post-painterly abstraction, identified with this heroic figure. In *Pillars of Hercules*, he incorporates the action of the paint flow and the vibrancy of the colour bolts against the pristine canvas.

Frank Stella b.1936

121 Untitled

1966, alkyd on canvas, 91.4 × 91.4 cm (36 × 36 in)

Provenance
M.Knoedler & Co., Inc., New York
Thyssen-Bornemisza Collection, 1983

Frank Stella painted this square canvas in 1966 during a period of constant experimentation with Minimalist styles. He used Benjamin Moore alkyd paint that was very matte and static in its surface. Stella had previously experimented with his so-called Black paintings with their pinstripes left bare. He then proceeded to paint canvases with notches cut out of the corners or the sides and sometimes with a space cut from the centre. He used metallic paints produced commercially. Continually, Stella explored pictorial structure and its relationship to the framing edge. He was influenced by artists ranging from Matisse to Barnett Newman.

Stella experimented with colours and with values in a methodical spirit. This painting utilises, instead of hues, a steplike succession of grey values. He chose six equidistant values from black to white on the grey scale. Working in shades of grey recalls old master paintings and even illustrations painted in grisaille. In these pictures Stella also played around with the notion of illusions of recessional space. He was interested in formalised, programmatic issues of design.

Stella could begin each new formal departure as a set of visual problems to be solved. His method was intellectual and calculated. Stella worked on these explorations with an unrelenting energy and zest. He commented: 'My pictures were definitely involved in a specific attitude towards painting – and certain attendant formal and technical problems. They were also involved with the problem of establishing a painterly identity – what it is to be a painter and make paintings. . . .'[1]

Note
1 Quoted in William S. Rubin, *Frank Stella* (New York: Museum of Modern Art, 1970), p. 89

Recent representation

Romare Bearden
<div style="text-align:right">b. 1914</div>

122 Sunday After Sermon

1969, collage on board, 101.6 × 127 cm (40 × 50 in)
Signed lower left: 'Romare Bearden'

Provenance
Cordier and Ekstrom Inc., New York
Mr and Mrs Hoyt, New York
Andrew Crispo Gallery, New York
Thyssen-Bornemisza Collection, 1978

Literature
M. Bunch Washington, *Romare Bearden: The Prevalence of Ritual* (New York: Harry N. Abrams, Inc., 1974), p. 163, illus.
Baur, pp. 167, 114, illus., no. 88

Exhibitions
New York, *Twelve Americans: Master of Collage*, Andrew Crispo Gallery, 17 November 1977–7 January 1978, illus. no. 8
Vatican, 1983, no. 88; Lugano, 1984, no. 86
USA tour, 1984–86, no. 88

Romare Bearden's collage *Sunday After Sermon* of 1969 combines newsprint, photographs from magazines, coloured paper, and patterned paper. He explained his intention in the collages of this period: 'I am trying to explore, in terms of the particulars of the life I know best, those things common to all cultures.'[1] As a young man, Bearden was outspoken about the need for originality among black artists in America, who he wanted to evolve something 'original or native like the spiritual or jazz music'.[2]

Bearden's *Sunday After Sermon* reflects his own perceptions of daily life for blacks in America. He brings to these insights not only his personal experience, but also his observations made during his work in the late 1930s and early 1950s, as a case worker for the New York City Department of Social Services. Bearden has a feeling for small incidents, subtle expressions and postures, all of which communicate a sense of immediacy.

Collages did not appear in Bearden's work until 1963, when he was a member of the Spiral group which was founded just before the civil rights March on Washington. He had been painting almost exclusively non-objective or fully abstract work during the late 1950s, and had just returned to more figurative work in 1961. Discussing a collaborative project for the Spiral group, Bearden suggested a collage on Negro themes. Although the group effort never took place, Bearden began making his own collages, on which he has worked almost exclusively since 1964.

Bearden's collage style, while highly original, reflects his own sophisticated knowledge of earlier twentieth-century art. In 1950, he travelled to Paris on the GI Bill to study at the Sorbonne and met a number of important avant-garde artists including Georges Braque, Jean Hélion and Constantin Brancusi. He also became acquainted with author James Baldwin and other ex-patriate Americans.

Notes
1 Quoted in Carroll Greene, Jr, *Romare Bearden: The Prevalence of Ritual* (New York: Museum of Modern Art, 1971), p. 3
2 Romare Bearden, 'The Negro Artist and Modern Art', *Journal of Negro Life* (December 1934), pp. 371–72

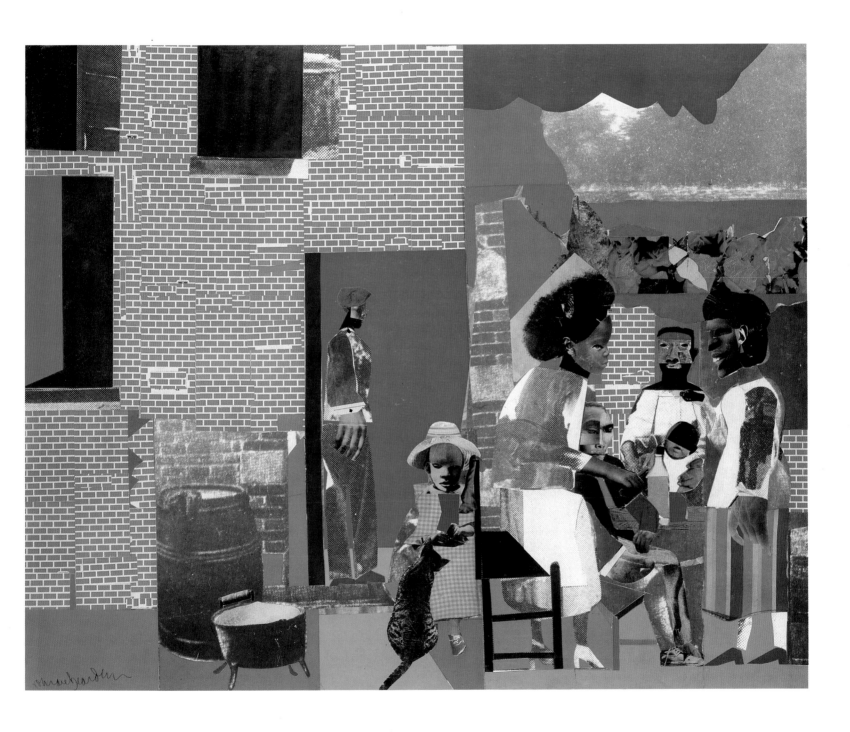

1 Jean Hélion
Journalier au Gisant
1950, oil on canvas
Galerie Karl Flinker, Paris

2 Romare Bearden, *Before the Dark*, 1971, collage on board, Munson-Williams-Procter Institute, Utica, NY

Bearden combines the cubist collage technique with a reportorial sensibility, evoking scenes of everyday life through a sophisticated sense of design. *Sunday After Sermon* is a street scene utilising a flattened brick façade, parallel to the picture plane, with several slightly abstracted figures standing before it. This recalls Hélion's street scenes of journalists of the late 1940s and early 1950s that Bearden would have seen in Paris (fig. 1).

In his collages, Bearden has found his own voice and style, expressing personally meaningful subject matter through a modernist vehicle. Subsequent to *Sunday After Sermon*, he continued to create such urban street scenes, sometimes more closely focused like *Before the Dark* (1971) (fig. 2) and sometimes encompassing a larger area, as in *The Block* (1971). All of these scenes reveal Bearden as the sensitive observer of life around him.

Richard Estes b. 1936

123 Telephone Booths

1967, acrylic on masonite, 122.2 × 174.3 cm (48⅛ × 68⅝ in)
Signed lower right: 'Richard Estes'

Provenance
Allan Stone Gallery, New York
Mr and Mrs Haigh Cudney, NJ
Andrew Crispo Gallery, New York
Thyssen-Bornemisza Collection, 1977

Literature
Phil Patton, 'The Brush is Quicker than the Eye', *Horizon* (June 1978), pp. 66–69, p. 67, illus.
A.O. Dean, 'Estes' New York', *AIA Journal* 68 (April 1979), illus., p. 70
Louis Meisel, *Photorealism* (New York: Harry N. Abrams, Inc., 1981), p. 220, illus., no. 452
Lieberman, pp. 76–77, illus., no. 65

Reproduced
New York Magazine (16 December 1968), cover illus.
Arts Magazine 46 (September 1972), p. 34
Artweek 14 (16 July 1983), p. 6

Exhibitions
New York, *Richard Estes*, Allan Stone Gallery, 1969
Kassel, West Germany, *Documenta 5*, Neue Galerie Schöne Aussicht, Museum Fredericianum, 1972, catalogue 15
Worcester, MA, *Three Realists: Close, Estes, Raffael*, Worcester Art Museum, 1974, illus.
New York, *20th Century American Painting and Sculpture*, Andrew Crispo Gallery, 1977, no. 19
Richard Estes: The Urban Landscape, May 1978–April 1979, no. 5
 Boston, MA, Museum of Fine Arts
 Toledo, OH, Toledo Museum of Art
 Kansas City, KS, Nelson-Atkins Museum of Art
 Washington, DC, Hirshhorn Museum and Sculpture Garden
Australian tour, 1979–80, no. 94
USA tour, 1982–83, no. 65

Richard Estes painted *Telephone Booths* in 1967 after he had observed and photographed this site in New York City where Broadway, Sixth Avenue, and 34th Street come together near Macy's Department Store. Known as a Photo-Realist, Estes selectively combines the information from many photographs to create the scene he wishes to paint. He does not rely on projecting a slide of the photograph on the canvas or on using a grid to transfer the image from the photograph. The effects of light seem realistic, but they may not be exactly as he observed this place at any one moment.

Estes admits to admiring the work of the realist painter Edward Hopper, and, in a sense, Estes uses his photographs the way Hopper used the monochromatic sketches that he made on location to paint canvases in the studio. That is both artists synthesise from their observations of reality and both eliminate the unnecessary detail from the final composition. Estes commented: 'I think with painting it's a problem of selection and imagination, but it's never a problem of creation. It's wrong to think that anyone ever creates. At best one selects new imagery. I can select what to do or not to do from what's in the photograph. I can add or subtract from it.'[1]

Note
1 Quoted in an interview with John Arthur in *Richard Estes: The Urban Landscape* (Boston, MA: Museum of Fine Arts, 1978), p. 27

In the glass windows and in the metal panels of these phone booths which are no longer extant, Estes painted a simultaneous view of the interiors of the booths and the neighbouring buildings reflected in them. We see a woman in a blue dress, a man in a hat and trench coat, a woman in a light coat, and the reflection of F. W. Woolworth's across the street. In the background, we see Macy's, an iron railing, a yellow taxi and pedestrians in the busy city streets. The reflection creates a sense of movement, making this seem like the kind of view we might see just in passing by.

Richard Estes

b.1936

124 People's Flowers

1971, oil on canvas, 162.5 × 92.7 cm (64 × 36½ in)

Provenance
Allan Stone Gallery, New York
Private collection
Andrew Crispo Gallery, New York
Thyssen-Bornemisza Collection, 1975

Literature
Louis Meisel, *Photorealism* (New York:
 Harry N. Abrams, Inc., 1981), p. 220, illus., no. 448

Reproduced
Advertisement for Allan Stone Gallery, New York, *Art
 Journal* 30, no. 3 (Spring 1971), p. 237

1 Edward Hopper, *Nighthawks*, 1942, Art Institute of Chicago, Chicago, IL

Exhibitions
New York, *Richard Estes*, Allan Stone Gallery, 1971
Kassel, West Germany, *Documenta 5*, Neue Galerie Schöne Aussicht, Museum Fredericianum, 1972, catalogue 15
Worcester, MA, *Three Realists: Close, Estes, Raffael*, Worcester Art Museum, 1974, illus.
New York, *20th Century American Painting*, Andrew Crispo Gallery, 1974
Richard Estes: The Urban Landscape, May 1978–April 1979, no. 5
 Boston, MA, Museum of Fine Arts
 Toledo, OH, Toledo Museum of Art
 Kansas City, KS, Nelson-Atkins Museum of Art
 Washington, DC, Hirshhorn Museum and Sculpture Garden
New York, *Summer Loans*, Metropolitan Museum of Art, August–September 1979

In 1971, Richard Estes painted *People's Flowers* depicting a shop located at the corner of Sixth Avenue and 27th Street in Manhattan's wholesale plant and flower district. This building has since been destroyed by fire, although the business still exists elsewhere on that block. Estes focused on the corner seen through the glass store window along with reflections of other nearby buildings and the traffic in the street.

Although this is an urban landscape in a very busy area of a crowded city, there are no figures visible. Estes explained his concern that figures might spoil his intentions: 'When you add figures, then people start relating to the figures and it's an emotional relationship. The painting becomes too literal, whereas without the figures it's more purely a visual experience. I don't want any kind of emotion to intrude.'[1] Thus, the artist makes a pun of sorts, painting *People's Flowers* without any people visible.

The idea of depicting a corner shop with a view through the window to the buildings across the street had been a theme which Edward Hopper had painted on several occasions. Estes would have been extremely familiar with Hopper's 1942 masterpiece, *Nighthawks* (fig. 1), in the Art Institute of Chicago, both from his time as an art student there and from the three years he lived in Chicago in the late 1950s. Like Hopper, whom Estes admired,[2] Estes never depicts crowds in the city, is preoccupied with the effects of light, and has a background in commercial illustration which perhaps makes him more receptive to seemingly ordinary subject matter.

Notes
1 Quoted in A.O. Dean, 'Estes' New York', *AIA Journal* 68 (April 1979), p. 73
2 Estes mentions admiring three artists, Hopper, Degas and Eakins, in an interview with John Arthur, in *Richard Estes: The Urban Landscape* (Boston, MA: Museum of Fine Arts, 1978), p. 18

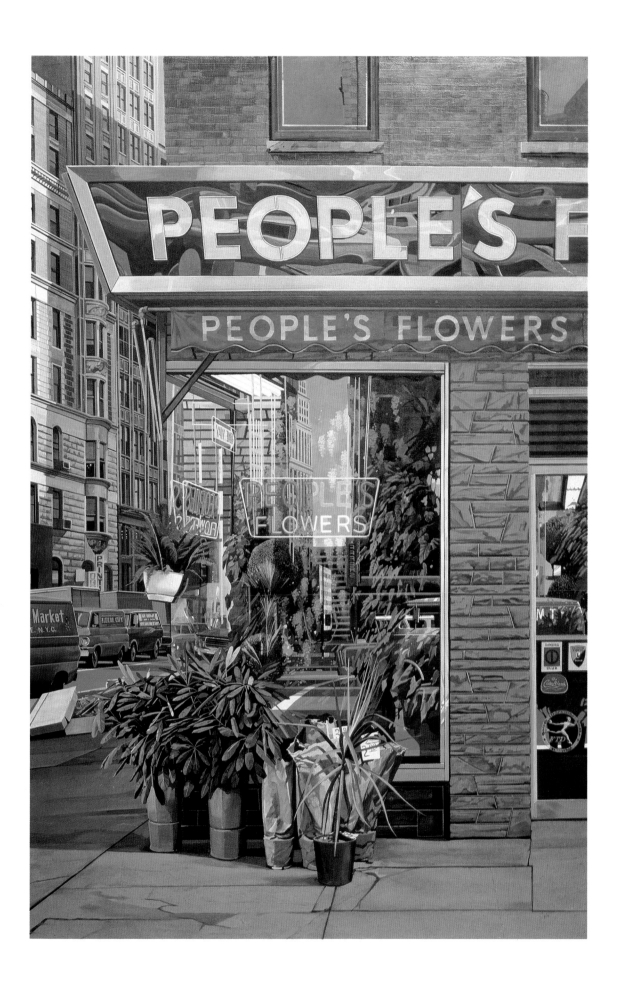

Richard Estes

125 Hotel Lucerne

1976, oil on canvas, 122 × 153 cm (48 × 60 in)
Signed on right next to Pub sign on blue sign

Provenance
Sidney Janis Gallery, New York
Andrew Crispo Gallery, New York
Thyssen-Bornemisza Collection, 1982

Literature
Louis Meisel, *Photorealism* (New York: Harry N. Abrams, Inc., 1981), p. 229, illus., no. 482

Exhibitions
New York, *Richard Estes*, Sidney Janis Gallery, 1976
Richard Estes: The Urban Landscape, May 1978–April 1979, no. 20
 Boston, MA, Museum of Fine Arts
 Toledo, OH, Toledo Museum of Art
 Kansas City, KS, Nelson-Atkins Museum of Art
 Washington, DC, Hirshhorn Museum and Sculpture Garden
Vatican, 1983, no. 114; Lugano, 1984, no. 112
USA tour, 1984–86, no. 113

When Estes showed *Hotel Lucerne* at the Sidney Janis Gallery it was known as *Phone-Phone*. This painting demonstrates this artist's keen ability to depict reflection convincingly. We see the street scene on the right reflected in the window on the left, so that we view this image twice. Clearly reflected are the firebox on the street corner, the yellow estate car and other cars, and the building behind them. Thus, the double phone booths, which occupy the middle ground in the centre of this painting, become a visual pun on the repetition of forms in this picture.

Hotel Lucerne depicts the corner of West 79th Street and Amsterdam Avenue on Manhattan's upper West Side. Estes recorded this urban street scene in a neighbourhood undergoing extensive gentrification. While the hotel remains, the Hardware Housewares store is no longer located on the corner and much new building is going on in this area. Perhaps reluctantly, Estes has allowed a few figures to intrude in his cityscape. They are painted in a generalised manner with few details. This artist is more concerned with the general ambiance and the effect of light than in specific mood or other emotional dimensions.

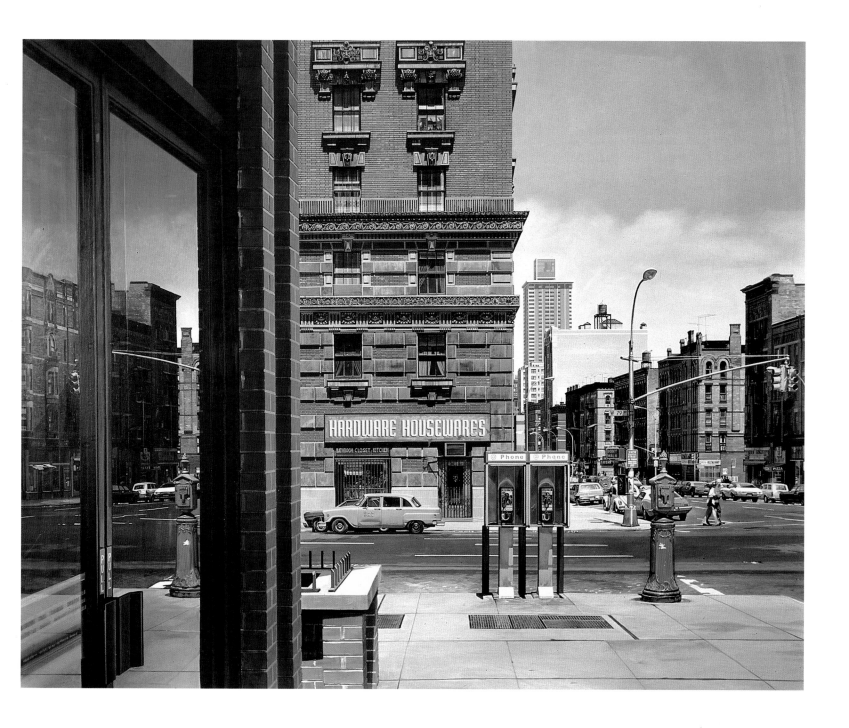

Richard Lindner 1901–1978

126 Moon over Alabama

1963, oil on canvas, 200 × 102 cm (80 × 40 in)
Signed and dated lower right: 'Lindner 63'

Provenance
Cordier and Ekstrom Inc., New York
Mr and Mrs Charles B. Benenson, New York
Sale, Sotheby Parke Bernet, New York, Important Post-War and Contemporary Art, 3 May 1974, lot 545
Thyssen-Bornemisza Collection, 1974

Literature
Dore Ashton, 'Richard Lindner: the secret of the inner voice', *Studio International* 167 (January 1964), pp. 12–17
'Les expositions à New York', *Aujourd'hui* 8 (January 1964), p. 96
Dore Ashton, *Richard Lindner* (New York: Harry N. Abrams, Inc., 1969), no. 124
Rofl-Gunter Dienst, *Lindner* (New York: Harry N. Abrams, Inc., 1970), no. 29

Reproduced
Advertisement for Cordier and Ekstrom, Inc., New York, *Art in America* 52 (February 1964), p. 12
Advertisement for Sotheby's sale of 3 May 1974, *Arts Magazine* 48 (April 1974), p. 5
David Shirey, 'Art Market', *Arts Magazine* 48 (May 1974)

Exhibitions
New York, *Richard Lindner*, Cordier and Ekstrom, Inc., 25 February–21 March 1964
New York, *Annual Exhibition of Contemporary American Painting*, Whitney Museum of American Art, 1963–64
Vatican, 1983, no. 113; Lugano, 1984, no. 111
USA tour, 1984–86, no. 112

In *Moon over Alabama* of 1963, Richard Lindner depicted a woman and a man passing each other impersonally in the street, striding by one another, headed in opposite directions. They are shown against a colourful background of abstract shapes. Her dress continues this kind of abstract pattern. She also wears a blue mask and magenta red stockings and carries a two-toned blue and yellow handbag. The size of her lips and bustline are exaggerated in order to seem suggestive.

In contrast, this man wears a grey conservative suit, but he does sport a pink shirt and a green tie. His lips too are brilliant red. Lindner emphasised costumes and masks, suggesting a certain exhibitionism and a sense of aggressive exuberance. His exaggerations and bright colours place his art closer to German Expressionism than to American Pop artists with whom he often exhibited. There is nothing cool and detached like the commercial imagery of so much of Pop Art, but rather Lindner's work exudes a feverish sensuality.

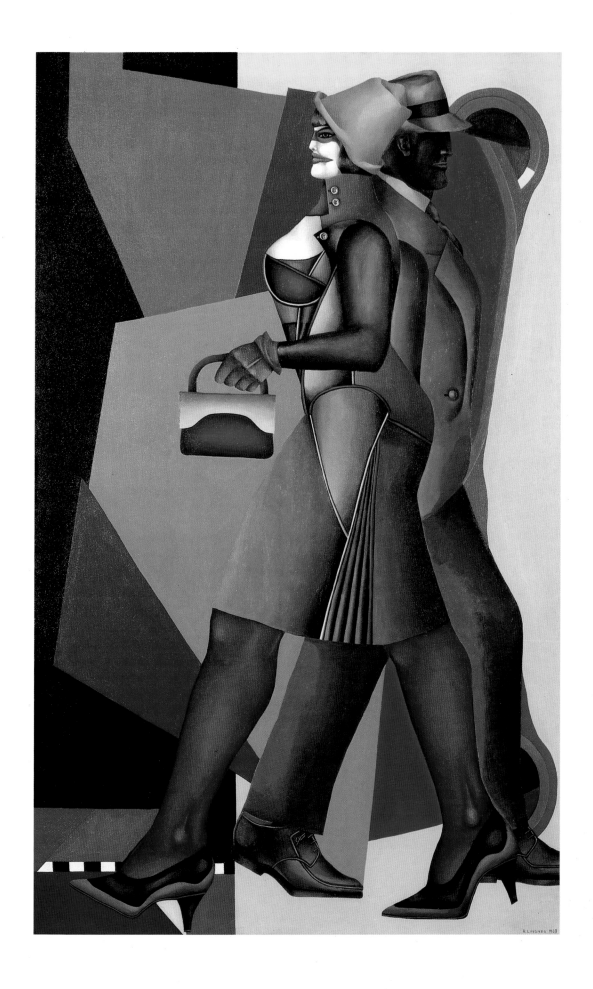

Richard Lindner 1901–1978

127 Out of Towners

1968, watercolour on paper, 60 × 50 cm (23⅞ × 19⅞ in)
Signed lower right: 'R.Lindner 1968'

Provenance
Galerie Bernard, Paris
Thyssen-Bornemisza Collection, 1973

Literature
Hilton Kramer, *Richard Lindner* (Boston, MA: New York Graphic Society, 1975), p.67, illus.

Exhibition
New York, *Richard Lindner: Fun City*, Spencer A.Samuels Gallery, 12 October–24 November 1971, no.6

Richard Lindner's *Out of Towners* of 1968 is one of a series of watercolours the artist made for the portfolio 'Fun City', based on his view of New York. As an immigrant and refugee, Lindner was capable of a distance and special point of view. He utilised a vibrant palette, doll-like figures who often wear masks, and a variety of theatrical exaggerations. The mannequin-like quality of his figures may have been influenced by his admiration of the work of Oscar Schlemmer.

Lindner satirically depicted an unappealing couple visiting New York. Flanked by dual images of the Statue of Liberty, one in yellow and one in black, this man and woman are probably not only out of towners but also foreigners. He smokes an enormous cigar and his eyes are only tiny slits. They are overdressed in a plethora of colourful accessories: hats, his orange tie and pink button, her corsage, necklace and two-toned glasses. Her hair is purple and her lips brilliantly red. Lindner commented: 'what I admire about women: when they are eighty, they still put things on to be women. A woman of eighty still wears jewelry and make-up. I think this has to do with just trying to be a woman as long as possible.'[1]

Note
1 Quoted in Dean Swanson, *Richard Lindner* (Berkeley, CA: University Art Museum, University of California, 1969), p.10

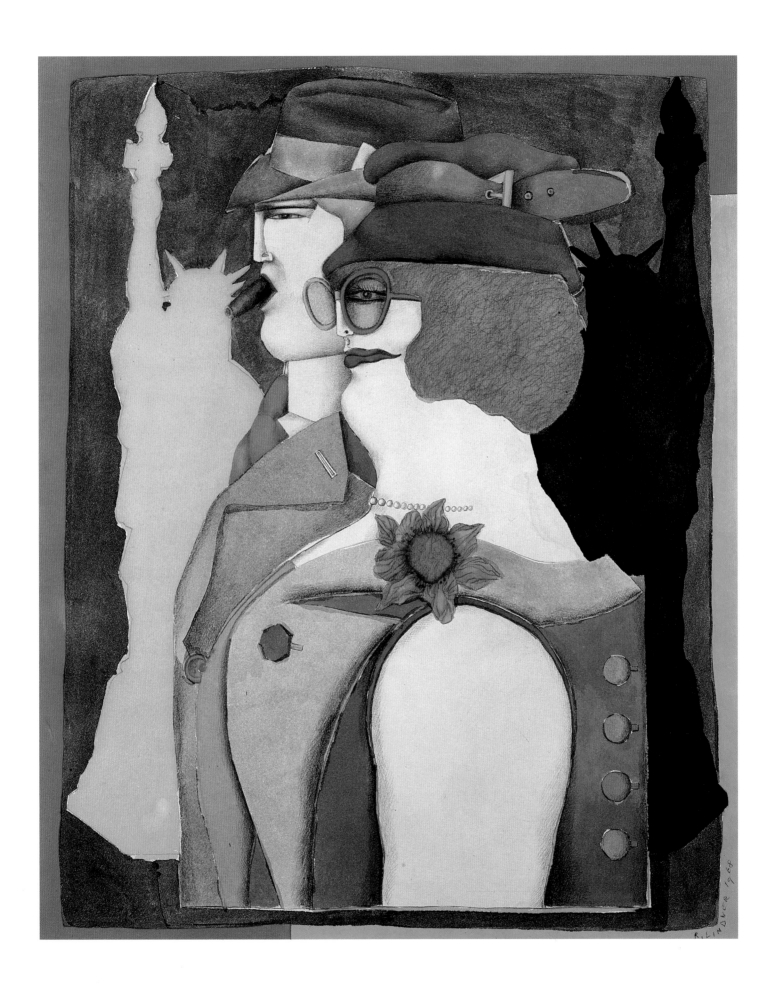

Saul Steinberg

128 Ingresso Air Mail

1970, watercolour, crayon and collage on paper, 49.5 × 64.5 cm (19½ × 25 in)
Signed and dated lower right: 'Steinberg 1970'

Provenance
Galerie Maeght, Paris
Thyssen-Bornemisza Collection, 1980

Literature
Derrière le Mirroir 241 (October 1980)

Exhibition
Paris, *Saul Steinberg, Richard Lindner*, Galerie Maeght, 1980, no. 20

Saul Steinberg made his reputation as an illustrator and subsequently has gained a following in fine arts circles as well. His drawings are full of exaggerations, fantasies and wilful distortions. Steinberg takes the most ordinary of objects or situations and transforms our vision of them to create something unique and fanciful.

Ingresso Air Mail of 1970 is one of a series of such drawings on the theme of airmail envelopes with their marvellous identifying stripes in various attention-getting colours, usually red and blue on a white ground. This artist has taken the commonplace sight of an airmail envelope on a table and, with his imagination and the legacy of Cubism and other modernist styles, has transformed the envelope into a kind of mechanical abstraction that seems like it could fly on its own.

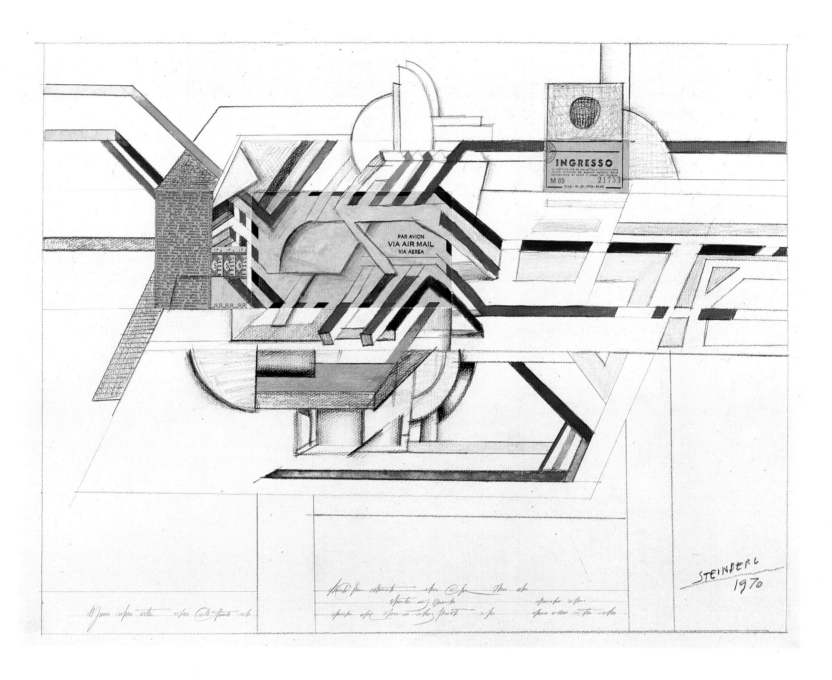

1 Saul Steinberg, *Air Mail Table*, 1971, Collection of the artist, Pace Gallery, New York

Steinberg has used various collaged elements including a newspaper article, an airmail envelope, and an entrance stub with the word INGRESSO of the title. The stub and the newspaper cutting are in Italian, a language with which Rumanian-born Steinberg is quite comfortable after taking his architectural degree in Milan in 1940. The yellowed newspaper cutting is from the social column of an Italian newspaper reporting on what various socialites were wearing.

Ingresso Air Mail plays on the humour of transforming such ordinary objects into a mechanical fantasy. It is related to other Steinberg works of this period including: *Via Aerea* (1969), *Steinberg Still Life* (1969), *Cubisterie* (1969), *Air Mail Still Life* (1971), *Belgian Air Mail* (1971), *Air Mail Table* (1971) (fig. 1) and *Air Mail Tokyo* (1972). Decades after its invention, Steinberg poked fun at the Cubists and their collages, playfully inventing his own modernist version.

[128] detail

Photograph acknowledgements

AMSTERDAM
Rijksmuseum, [98] fig. 2
Stedelijk Museum, Intro. fig. 9

ATLANTA, GA
High Museum of Art, Intro. fig. 5, [6] fig. 2

AUSTIN, TX
James and Mari Michener Collection, Archer M. Huntington Art
Gallery, University of Texas, [47] fig. 2

BALTIMORE, MD
The Baltimore Museum of Art, [17] fig. 2

BASEL
Galerie Beyeler, [96] fig. 2

BERLIN-DAHLEM
Staatliche Museen, Gemäldegalerie, [97] fig. 1

BIRMINGHAM, MI
Sheldon Ross Gallery, [96] fig. 1

BOSTON, MA
Museum of Fine Arts, [6] fig. 3

BUFFALO, NY
Albright-Knox Art Gallery, Intro. fig. 3, [21] fig. 4

CHICAGO, IL
Art Institute of Chicago, [105] fig. 3, [124] fig. 1
Collection of Mrs Robert B. Mayer, [109] fig. 4

COLOGNE
Museum Ludwig, [109] fig. 3

COLUMBUS, OH
Columbus Museum of Art, [7] fig. 1, [8] fig. 1

COPENHAGEN
The Royal Museum of Fine Arts, [29] fig. 1

DETROIT, MI
Detroit Institute of Arts, [48] fig. 2

DÜSSELDORF
Kunstsammlung Nordrhein-Westfalen, [108] fig. 1

EVANSTON, IL
Terra Museum of American Art, [35] fig. 1

FORT WORTH, TX
Fort Worth Art Center, [45] fig. 1
Fort Worth Art Museum, [72] fig. 1

HARTFORD, CT
Wadsworth Atheneum, [18] fig. 1, [32] fig. 1, [105] fig. 1

HOUSTON, TX
De Menil Foundation Inc., [83] fig. 1

LINCOLN, NE
Sheldon Memorial Art Gallery, University of Nebraska,
[21] fig. 3

LONDON
The British Museum, [61] fig. 1
Lisson Gallery, Intro. fig. 10

LUDWIGSHAFEN
Wilhelm-Hack-Museum, [28] fig. 1

MILWAUKEE, WI
Collection of Mr Sidney Kohl, [78] fig. 1

MONTPELLIER
Musée Fabre, [102] fig. 1

NEWTON CENTRE, MA
Stephen and Sybil Stone Foundation, [47] fig. 1

NEW YORK, NY
H. V. Allison Galleries & Co., [11] fig. 1
Sidney Janis Gallery, [112] figs 1, 2, 3
Kennedy Galleries, Inc., [98] fig. 1
The Metropolitan Museum of Art, [4] fig. 1, [5] fig. 1, [21] fig. 2,
[25] fig. 1, [26] fig. 1, [30] fig. 1, [33] fig. 2, [78] fig. 2, [109]
fig. 5
The Museum of Modern Art, [17] fig. 1, [33] fig. 1, [59] fig. 1,
[71] **fig. 1**, [81] fig. 1, [84] fig. 1, [85] fig. 1, [109] fig. 1
Pace Gallery, [128] fig. 1
Salander-O'Reilly Gallery, [50] fig. 1
The Whitney Museum of American Art, [62] fig. 1

NORFOLK, VA
Chrysler Museum, [113] fig. 1

OMAHA, NE
Joslyn Art Museum, [87] fig. 2

PARIS
Galerie Karl Flinker, [122] fig. 1
Musée du Louvre, [109] fig. 6
Collection of Daniel Varenne, [106] fig. 2

PHILADELPHIA, PA
Pennsylvania Academy of the Fine Arts, [104] fig. 1
Philadelphia Museum of Art, [43] fig. 1, [48] fig. 3, [83] fig. 2,
[106] fig. 1

PRAGUE
National Gallery, [28] fig. 2

REIMS
Musée de Saint Denis, [50] fig. 2

ROCHESTER, NY
Memorial Art Gallery, University of Rochester, [16] fig. 2

SAN FRANCISCO, CA
M. H. de Young Memorial Museum, [4] fig. 2

SARASOTA, FL
John and Mable Ringling Museum of Art, Intro. fig. 11

ST LOUIS, MO
St Louis Art Museum, Intro. fig. 12

UTICA, NY
Munson-Williams-Proctor Institute, [44] fig. 2, [122] fig. 2

VENICE
Solomon Guggenheim Foundation, [88] fig. 1, [105] fig. 2

WASHINGTON, DC
Hirshhorn Museum and Sculpture Garden, Smithsonian
Institution, Intro. fig. 8, [87] fig. 1
National Gallery of Art, [30] fig. 2, [48] fig. 1, [89] fig. 1,
[103] fig. 1
National Portrait Gallery, Smithsonian Institution, [60] fig. 1
The Phillips Collection, [6] fig. 1, [93] fig. 1

WICHITA, KS
Wichita Art Museum, [44] fig. 1

WILMINGTON, DE
Collection of Mr and Mrs Bruce Bredin, [102] fig. 2

ZURICH
Kunsthaus, [110] fig. 1

Biographies

Compiled by Susan Edwards

Josef Albers (1888–1976)

Josef Albers was born in Bottrop, Germany, on 19 March 1888. Albers earned a teaching certificate from the Teachers College in Buren in 1908. In 1913, he enrolled at the Royal Art School of Berlin where he received a Qualified Art Teacher's certificate in 1915. He attended the Kunstgewerbschule in Essen from 1916 to 1919 while teaching during the day. From 1919 to 1920, he studied with Franz von Stück at the Academy of Fine Arts in Munich. In 1920, he entered the Bauhaus in Weimar under Johannes Itten. Albers eliminated figuration and began exploring the principles of visual illusion. In 1923, Albers joined the teaching staff at the Bauhaus where his colleagues were Klee, Kandinsky and Maholy-Nagy, among others. In 1925, he married Anni Fleischmann. The Bauhaus moved to Dessau in 1925, and to Berlin in 1932. Albers remained with the Bauhaus until 1933, when he and his wife emigrated to the United States. Between 1933 and 1949, Albers taught at Black Mountain College in North Carolina, disseminating the modernist principles of the Bauhaus. Albers lectured on modern art and design at Harvard University from 1936 to 1941. Before leaving Black Mountain, he was working on his spacial illusion paintings. He began his most famous series, *Homage to the Square*, in 1949. In 1950, he was appointed Head of the Yale University Department of Design. For the next twenty-five years, he explored colour illusion and depth perception. His book, *Interaction of Color*, was published in 1963. In 1970, Albers moved to Orange, CT. He died in New Haven, CT, on 25 March 1976.

Ivan Albright (1897–1983)

Ivan LeLorraine Albright and his twin brother, Malvin, were born in North Harvey, IL, on 20 February 1897. Albright was reared in the suburban Chicago area. He studied architecture from 1915 to 1916 at Northwestern University and 1916 to 1917 at the University of Illinois. During the First World War, Albright was a medical illustrator stationed in Nantes, France. He was fascinated by necrosis and x-rays. After the war, he studied at the Ecole des Beaux-Arts in Nantes. He returned to Illinois and entered the School of the Art Institute of Chicago in 1920. He graduated in 1923 with honours in Life and Portrait Painting. In the winter of 1923–24, he studied at the Pennsylvania Academy of the Fine Arts and the National Academy of Design in New York. In the late 1920s, Albright lived and painted in Southern California. Albright received honourable mention when he first exhibited at the Art Institute of Chicago in 1930. He worked for the Works Progress Administration from 1933 to 1934. In the summer of 1938, Albright taught figure painting at the School of the Art Institute of Chicago. The acidic colour and exaggerated realism of Albright's style became well known after he and his brother, Malvin, painted a series of portraits for the film, *The Picture of Dorian Gray*, in 1943. In 1946, Albright married Josephine Medill Patterson Reeve and adopted her two children by a former marriage. Together they had a son Adam Medill Albright born in 1947 and a daughter Blandina Van Etten Albright born in 1949. Albright received numerous awards and honours. Retrospective exhibitions of his work were held at the Art Institute of Chicago in 1964 and at the Whitney Museum of American Art in 1965. Ivan Albright died on 18 November 1983.

Milton Avery (1885–1965)

Milton Clark Avery was born on 7 March 1885, in Sand Bank (later Altmar), NY. In 1898, his family moved to Wilson Station, CT. Around 1905, Avery enrolled in a lettering class at the Connecticut League of Art Students. When this class was cancelled, he transferred to a life-drawing class with Charles Noel Flagg. Avery's first public exhibition was the Fifth Annual Exhibition of Oil Paintings and Sculpture in the Annex Gallery at the Wadsworth Atheneum in Hartford in 1915. By 1917, Avery was working nights and painting days. In 1918, he transferred to the School of Art Society of Hartford, where he won top honours in portrait and life-drawing classes. Avery became a member of the Connecticut Academy of Fine Arts in 1924. The following year he moved to New York City. He studied at the Art Students League and, in 1926, married Sally Michel. Sally worked as a freelance illustrator to allow Milton to paint full time. Avery exhibited in New York for the first time with the 1927 exhibition of the Society of Independent Artists. The Avery's only daughter, March, was born in 1932. Avery had his first one-man show at the Valentine Gallery in 1935. In 1938, he worked in the Easel Division of the Works Progress Administration/Federal Art Project. Avery's first one-man museum show was held at the Phillips Memorial Gallery, Washington, DC in 1944; and his first retrospective, 'My Daughter March', opened in New York at the Durand-Ruel Galleries in 1945. In 1951, he joined the Grace Borgenicht Gallery. By then he was exhibiting regularly in group shows at both galleries and museums. In 1960, he had a retrospective at the Whitney Museum of American Art. He executed his last painting in 1964 and died on 3 January 1965.

Romare Bearden (b. 1914)

Romare Bearden was born on 2 September 1914, in Charlotte, NC. He attended primary school in New York and graduated from Peabody High School in Pittsburgh, PA. Bearden earned a BS from New York University in 1935. Although he studied mathematics, he served as art editor and drew political cartoons for the campus humour magazine, *NYU Medley*. Bearden studied for a year, from 1936 to 1937, at the Art Students League under George Grosz. That year he joined the Harlem Artists' Guild and became associated with the 306 Group, another group of Harlem artists. In 1938, Bearden worked for the Department of Social Services. Bearden became friendly with William Attaway, Charles Alston, Add Bates and the composer, Frank Fields. In 1940, he began painting a series of paintings on Southern themes. Through Add Bates, Bearden met Stuart Davis. After serving in the US Army during the Second World War, Bearden had his first major one-man show at the Kootz Gallery in 1945. Though he began to exhibit regularly in group shows, he returned to work for the Department of Social Services. In 1950, Bearden went to Paris to study philosophy at the Sorbonne, where he met Brancusi, Hélion, Braque, and expatriate American artists and intellectuals including James Baldwin. He returned to New York in 1954 and married Nanette Rohan. He worked briefly as a songwriter before resuming his painting career. In the early 1960s, Bearden began working in collage. He helped form the Spiral group and was the Director of the Harlem Cultural Council in 1964. Bearden taught at Williams College, MA, in 1970 and co-authored *Six Black*

Masters of American Art with Harry Henderson in 1972. He has been honoured with major retrospective exhibitions and now lives in New York.

George Bellows (1882–1925)

George Wesley Bellows was born on 12 August 1882, in Columbus, OH. He made drawings for his school and university publications. He was an excellent athlete and on the baseball team at Ohio State University. In 1904, at the beginning of his final year, Bellows left college to study painting with Robert Henri at the New York School of Art. In 1907, one of Bellows' paintings was accepted for the Spring Exhibition at the National Academy of Design. He taught life-drawing classes at the Art Students League from 1909 to 1911. In 1909, he married Emma Louise Story with whom he had two daughters: Anne, born in 1911, and Jean, born in 1915. His first one-man show was held in 1911 at Madison Gallery in New York. He was on the organising committee of and exhibited in the Armory Show of 1913. Also in that year, Bellows began drawing cartoons for John Sloan at the journal, *The Masses*. In 1916, he was making lithographs with George C. Miller as his printer. Bellows spent the summer of 1917 in Carmel, CA, at an artist colony. In 1918 he enlisted in the US Army Tank Corps. Bellows taught the 1919 summer session at the Art Institute of Chicago. He moved his studio to Woodstock, NY, in 1921. At that time, Bolton Brown printed his lithographs. Bellows drew illustrations for published serials of Donn Byrne's *The Wind Blower* and H. G. Wells' *Men Like Gods*. He found absorbing subjects to paint at the beach, the circus, in sports arenas and in domestic settings. Bellows died on 8 January 1925 in New York.

Thomas Hart Benton (1889–1975)

Thomas Hart Benton was born on 15 April 1889, in Neosho, MO. Between 1896 and 1904, Benton studied at the Corcoran Gallery of Art, Washington, DC, while his father was serving in the House of Representatives. Benton studied at the Art Institute of Chicago for two years before moving to Paris in 1908. In Paris, he studied at the Académies Julian and Colarossi. During the three years he was there, he met Leo Stein, Stanton Macdonald-Wright, John Thompson, George Carlock and Morgan Russell. In 1912 Benton settled in New York. He was included in 'The Forum Exhibition of Modern American Painters' at the Anderson Galleries in 1916. In 1917, Benton exhibited at the Daniel Gallery and became associated with John Weichsel's People's Art Guild. After being discharged from the US Navy in 1919, Benton began making epic historical murals. In 1922, he married Rita Piacenza. After 1926, Benton taught at Bryn Mawr College, Dartmouth College, and at the Art Students League, where his most famous student was Jackson Pollock. Benton painted murals at the New School for Social Research entitled 'America Today' in 1930. Two years later he painted the murals 'The Arts of Life in America' for the library at the Whitney Museum of American Art. Benton travelled extensively during the late 1920s and early 1930s in the southern and western portions of the United States. He published his impressions in *An Artist in America* in 1937. His daughter, Jessie P. Benton, was born in 1939. One of America's most celebrated 'Regionalists', Benton continued to receive commissions throught the country including in his home state of Missouri. He painted murals at the Missouri State Capital in Jefferson City and the Truman Library in Independence. Benton died in Kansas City, MO, on 19 January 1975.

Oscar Bluemner (1867–1938)

Oscar Bluemner was born on 21 June 1867, in Prenzlau, Germany. He attended technical high schools in Hanover and Berlin before emigrating to the United States in 1892. Bluemner worked in a New York architect's office and then moved to Chicago to design prefabricated units for the World's Columbian Exposition in 1893. The following year Bluemner returned to New York and practised architecture until the financial crash of 1894, after which he moved back to Chicago. In 1897, he married Lina Schumn with whom he had two children: Robert, born 1898, and Vera, born 1903. Bluemner received an architect's licence and became a US citizen while in Chicago. In 1900, he moved to New York and in 1910, he started his first oil paintings. In 1912, Bluemner travelled to Germany, Paris (where he met Juan Gris), Italy, Holland and England. Five of his paintings were exhibited in the New York Armory Show in 1913. His first one-man show was at '291' in 1915. Bluemner was included in 'The Forum Exhibition of Modern American Painters' at the Anderson Galleries in New York in 1916. That year, the Bluemners moved to New Jersey. Bluemner exhibited annually at the Bourgeois Galleries in New York from 1918 to 1923. He lectured at the New School of Social Research in New York in 1920. Bluemner's wife, Lina, died in 1926. He and his two children moved to South Braintree, MA. In 1933, Bluemner was employed by the Public Works of Art Project. On 12 January 1938, he committed suicide.

Guy Pène du Bois (1884–1958)

Guy Pène du Bois was born in Brooklyn, NY, on 4 January 1884. He studied at the New York School of Art beginning in 1899 and was still a student there when Robert Henri joined the staff in 1902. In 1905, du Bois went to Paris with his father where he studied at the Académie Colarossi under Steinlen. When du Bois returned to New York in 1906, he worked as a reporter for the *New York American*. He was promoted to the position of art critic in 1909, a post he held until 1912. In 1911, du Bois married Florence Sherman Duncan, and their daughter Yvonne was born in 1913. Du Bois served on the publicity committee for the 1913 Armory Show, and that year began to assist Royal Cortissoz on the *New York Tribune*. Du Bois' career as an art critic was paralleled by his painting career, and in 1913 he joined the Kraushaar Gallery. The du Bois family lived in Nutley, NJ, between 1914 and 1917. A son, William, was born in 1916, the year du Bois joined the *New York Post*. In 1917, du Bois exhibited at the Whitney Studio Show, and the following year he had his first one-man show there. Du Bois began teaching in 1920, first at the Art Students League and later in his studio. The du Bois family moved to Connecticut in 1920 and then to France in 1924. In 1930, they returned, and du Bois went back to teaching. He taught for a year at the Art Students League again and in 1932 opened the Guy Pène du Bois School. In the late 1930s, he taught at the Amagansett Art School, Long Island, and at Cooper Union School of Art. Du Bois received numerous awards and honours during the 1940s. In 1951, he worked with Raphael Soyer on *Reality: A Journal of Artists' Opinions*. He visited Paris with his daughter, Yvonne, for the last time in 1953, and died in Boston, MA, on 18 July 1958.

Patrick Henry Bruce (1881–1936)

Patrick Henry Bruce was born on 25 March 1881, in Halifax or Campbell County, VA. He studied under Edward Valentine at the Art Club of Richmond in 1898, and at the Virginia Mechanics Institute, where he learned mechanical drawing and draughting. In 1901, he moved to New York to study with William Merritt Chase. He later studied with Robert Henri and Kenneth Hayes Miller at the New York School of Art. There Bruce became friends with Edward Hopper, Guy Pène du Bois and George Bellows. In 1904, he settled in Paris, returning only

briefly in 1905, to marry Helen Frances Kibbey. In Paris, Bruce studied with Matisse and met Gertrude and Leo Stein, Arthur B. Frost, Jr, Guillaume Apollinaire, and Sonia and Robert Delaunay. His son, Roy Bruce was born in 1907. Bruce was included in a group formed by Steichen in 1908 known as 'The New Society of American Artists in Paris'. Bruce developed an interest in African Art and was influenced by Cézanne. He exhibited frequently with the Salon des Indépendants, the Salon d'Automne, and at the 1913 First German Autumn Salon of Der Sturm in Berlin. In New York, he exhibited in the 1913 Armory Show, at the Montross Gallery in 1916, and at the Modern Gallery in 1917. In 1919, the Bruces moved to New York where Helen opened an antique shop. Bruce sent antiques to her and she sent money to him in Paris until the end of his life. Bruce exhibited at the Galleries of the Société Anonyme in New York in 1920. In 1925, he exhibited with the Surrealists in 'L'art d'aujourd 'hui'. Bruce continued to paint while becoming increasingly depressed. In 1923, Bruce destroyed the paintings in his studio. He offered his friend, Henri-Pierre Roché twenty-one paintings that had been stored elsewhere. Bruce worked until 1936, when he went to New York. On 12 November 1936, he committed suicide.

Charles Burchfield (1893–1967)

Charles Burchfield was born on 9 April 1893, in Ashtabula, OH. Burchfield attended state schools in Salem, OH, and was valedictorian of his school class in 1911. After leaving, he worked as an accountant for the Mullins Company in Salem. In 1912, he attended the Cleveland School of Art and studied with Henry G. Keller, Frank N. Wilcox and William J. Eastman. In 1916, he was awarded a scholarship to study at the National Academy of Design, but he left classes there after only one day and returned to Salem. He was stationed at Camp Jackson, SC, during the First World War. Between 1921 and 1929, Burchfield worked in the design department of a Buffalo, NY, wallpaper company, M. H. Birge and Sons. In 1922, he married Bertha L. Kenreich, with whom he had five children: Mary Alice, born 1923; Martha Elizabeth, born 1924; Sarah Ruth, born 1925; Catherine Esther, born 1926 and Charles Arthur, born 1929. During the early 1930s Burchfield was the subject of exhibitions held at the Museum of Modern Art, New York, the Rochester Memorial Art Gallery, Rochester, NY, and the Phillips Memorial Gallery in Washington, DC. In 1936, Burchfield worked for *Fortune* magazine, painting railroad yards in Pennsylvania and sulfur and coal mines in Texas and West Virginia. Burchfield's paintings were exhibited frequently at major museums during the 1940s. Between 1949 and 1952, he taught at the University of Minnesota, Art Institute of Buffalo, Ohio University and Buffalo Fine Arts Academy. In 1963, he was appointed art consultant for the State University of New York in Buffalo. On 10 January 1967, Charles Burchfield died in Buffalo, NY.

Joseph Cornell (1903–72)

Joseph Cornell was born on 24 December 1903, in Nyack, NY. Even though the family's prosperous circumstances were reduced after the death of Cornell's father in 1917, Cornell attended Phillips Academy in Andover, MA, for four years, where he studied science. In 1921, Cornell rejoined his family then living in Bayside, Long Island. For ten years he worked as a salesman in the textile industry. Cornell spent his spare time frequenting small shops looking for books, records, prints, photographs and exotica. Cornell attended opera, theatre, ballet and films with his sisters. During the 1920s, he started going to painting and photography exhibitions. Cornell sought help from a Christian Science practitioner for nightmares and stomach disorders, and in 1924, he embraced the faith himself.

In 1929, his family moved to Flushing, NY. In 1931, Cornell watched the Surrealist exhibition being unpacked at the Julien Levy Gallery. He subsequently brought Levy several 'montages'. In 1932, Cornell exhibited a collage and an object in the exhibition, 'Surrealism', at Julian Levy Galleries. Cornell admired the Surrealists, but did not share their subconscious or dream theories. He also experimented with film montage. He met Duchamp, Stieglitz and Walter Murch. He made only a marginal living as an artist. During the 1940s, Cornell experienced erratic moods but worked steadily and expanded his circle of friends to include Matta, Motherwell, Peggy Guggenheim, Max Ernst and the ballerina, Tamara Toumanova. He exhibited at Art of This Century in 1942. In 1961, the Museum of Modern Art exhibited his work in 'The Art of Assemblage'. Cornell died on 29 December 1972, in New York.

Ralston Crawford (1906–78)

Ralston Crawford was born on 5 September 1906, in St Catherines, Ontario, Canada. Four years later his family moved to Buffalo, NY. When he was twenty years old, Crawford worked on a tramp steamer. He studied at the Otis Art Institute in Los Angeles, 1926–27 and worked briefly at the Walt Disney studio before going to the Pennsylvania Academy of the Fine Arts in 1927. Studying at the Barnes Foundations, he was introduced to Matisse and Picasso. In 1930, Crawford moved to New York. He married Margaret Stone in 1932; later that year, in Paris, he studied at the Académies Colarossi and Scandinave. His first one-man show was at the Maryland Institute of Art in Baltimore in 1933. He studied briefly at Columbia University and for several years in Chadds Ford and Exton, PA. In 1937, Crawford was awarded a Bok Fellowship to study at the Research Studio in Florida. Like many Precisionist painters, Crawford became interested in photography and, on a trip to New Orleans, he photographed black jazz musicians. In New York, in 1942, he married Peggy Frank; and, that year, was awarded the Metropolitan Museum of Art Purchase Prize for colour lithography. He was stationed in the China–Burma–India theatre during the Second World War, and, in 1946, *Fortune* commissioned Crawford to paint the A-bomb tests in the Marshall Islands. Between 1947 and 1961, Crawford taught at Honolulu Academy of Arts, the Brooklyn Museum Art School, Louisiana State University and the New York School for Social Research. Retrospectives of his work were held at the Milwaukee Art Center in 1958, Creighton University, NE, in 1968 and at the Century Association in New York in 1969. Crawford died in Houston, TX, on 1 May 1978.

Stuart Davis (1894–1964)

Stuart Davis was born in Philadelphia, PA, on 7 December 1894. His family moved to East Orange, NJ, in 1901. Davis left school in 1909 to study painting with Robert Henri in New York, where he became friends with John Sloan, George Luks, Glenn O. Coleman and H. C. Glintenkamp. He worked for Sloan doing covers and illustrations at *The Masses*. He also drew cartoons for *Harper's Weekly*. Five of his watercolours were exhibited in the Armory Show in 1913. Davis exhibited with the Society of Independent Artists in 1917 and, later that year, had his first one-man show at the Sheridan Square Gallery. During the First World War, Davis was a map-maker for Army Intelligence. His second one-man show was in 1918 at the Ardsley Gallery in Brooklyn. In 1927, Davis began his Eggbeater series, important in his development of abstraction, and had the first of eleven one-man shows at the Downtown Gallery. He spent the following year in Paris. Between 1931 and 1932, Davis taught at the Art Students League in New York. In 1932, Davis painted a mural at Radio City Music Hall. From 1933 to 1938, he worked for the Works Progress Administration. In

1938, he married Roselle Springer. From 1940 to 1950, he taught at the New School for Social Research, and in 1951, was Visiting Instructor of Art at Yale University. During the 1940s and 1950s, Davis was honoured with retrospective exhibitions, awards and prizes. His only child, George Earl, was born in 1952. Davis exhibited in the XXVII Venice Biennale in 1956 and received the Solomon R. Guggenheim Museum International Awards in 1958 and 1960. During the 1960s, Davis exhibited annually at the Downtown Gallery. In 1964, he was honoured with medals presented by the Pennsylvania Academy of the Fine Arts and The Art Institute of Chicago. He died on 24 June 1964 in New York.

Charles Demuth (1883–1935)

Charles Demuth was born in Lancaster, PA, on 8 November 1883. He studied at Drexel Institute of Art in Philadelphia and at the Pennsylvania Academy of the Fine Arts with Thomas Anshutz, William Merritt Chase, Hugh Breckenridge and Henry McCarter. During his student years, he twice travelled to Europe. Following his first exhibition at the Pennsylvania Academy's Annual Watercolor Show in 1912, Demuth made a third trip abroad. On this trip he studied at the Académies Julian, Moderne and Colarossi, met Gertrude and Leo Stein, encountered the paintings of the Fauves, Picasso, Matisse and Gris, and went with Marsden Hartley to Berlin where they saw the works of Die Brucke and Der Blaue Reiter. In 1914 the Charles Daniel Gallery in New York gave Demuth the first of eight one-man shows. Demuth met Eugene O'Neill that summer in Provincetown, MA. Thereafter Demuth spent summers in Provincetown and divided the other seasons between his Washington Square studio in New York and his mother's home in Lancaster, PA. After a trip to Bermuda in 1916 with Marsden Hartley, Albert Gleizes and Louis Bouché, Demuth began the Bermuda landscape series and the window motif florals. Demuth was influenced by Cubism, as well as the architectural landscapes of Pennsylvania and New England. His close association with Alfred Stieglitz began in 1924. Though weakened by diabetes (diagnosed in 1921), Demuth continued to work and exhibit. He painted the last of the 'pornographic' watercolours in 1930. He spent the summer of 1934 in Provincetown painting beach scenes. He died in New York on 23 October 1935.

Arthur G. Dove (1880–1946)

Arthur Garfield Dove was born on 2 August 1880, in Canandaigua, NY. His family moved to Geneva, NY, in 1882, where Dove attended Hobart College for two years before transferring to Cornell University in Ithaca, NY. Dove graduated from Cornell in 1903. In 1904, he married Florence Dorsey and moved to New York, where he began working as a freelance illustrator, publishing his work in *Colliers*, *McCalls*, *The Saturday Evening Post* and *Life* magazines. In 1907–1909 he lived in Europe, where he visited Italy but stayed mostly in the south of France, spending part of the time in Cagnes with Alfred Maurer. He exhibited at the Salon d'Automne in 1909. He was then working in an impressionistic style. Dove resettled in New York in 1909, and that year first exhibited at '291', Little Galleries of the Photo-Secession, with Hartley, Marin, Maurer, Weber, Steichen, Brinkly and Carles. After his son, William, was born in 1910, Dove bought a farm in Westport, CT. He began painting abstractions, and in 1912 Stieglitz gave Dove his first one-man show. Dove exhibited at the 1916 'Forum Exhibition of Modern American Painters' at the Anderson Galleries. In 1924, Dove started making assemblages. In 1929, his wife, Florence, from whom he had been separated for nine years, died; and the following year Dove married Helen Torr Weed. He exhibited frequently at 'An American Place Gallery' after 1930. In 1933,

Dove moved back to Geneva, NY, and in 1938, he moved to Centerport, Long Island. He died on 22 November 1946, in Huntington, Long Island.

Richard Estes (b. 1936)

Richard Estes was born in Kewanee, IL, in 1936. Later he moved with his family to Evanston, IL. At the age of sixteen, Estes entered the Art Institute of Chicago where he studied academic figure painting and charcoal drawing from the model. His drawing instructor, Isobel Mackinnon, a pupil of Hans Hofmann, presented Hofmann's 'push-pull' spacial concepts. Estes took advantage of the proximity of the museum. He especially liked Degas, Eakins and Hopper. After graduating in 1956, Estes went to New York for six months. He returned to Chicago for three years, before moving back to New York. Though Estes did not take etching, lettering, lithography, or commercial illustration at the Art Institute, he worked in publishing and advertising doing cover overlays, paste-ups, mechanicals, lettering and some illustration. In 1962, Estes lived and worked in Spain. Estes managed to save enough money by 1966 so that he could leave his job and paint the 'urban landscape' full time. Estes' first one-man show was at the Allan Stone Gallery in 1968. In 1971, he was awarded a fellowship by the National Endowment for the Arts. In 1972, he was the visiting artist at the Skowhegan School in Maine. Estes exhibits regularly in groups shows and now lives and works in New York and Maine.

Arshile Gorky (1905–48)

Arshile Gorky was born Vosdanig Manoog Adoian on 25 October 1905, at Khorkom Vari in Turkish Armenia. He studied at the Polytechnic Institute in Tblisi before leaving with his sister for the United States in 1920. Gorky settled in Providence, RI, and enrolled at the Rhode Island School of Design. He moved to Boston in 1923 and studied at the New School of Design and became the instructor of the life-drawing classes within a year. In 1925, Gorky went to New York where he studied at the National Academy of Design and the Grand Central School of Art. He was on the teaching staff at the Grand Central School of Art from 1926 to 1931. Gorky exhibited in a group show at the Museum of Modern Art in 1930. His first one-man show was in 1934 at the Mellon Galleries in Philadelphia. In 1935, Gorky joined the Works Progress Administration and was married briefly to Marney George. His first New York one-man show was at the Boyer Gallery in 1938. Gorky was commissioned to paint the murals for the Aviation Building at the 1939 New York World's Fair. In 1941, Gorky married Agnes Magruder. During the 1940s, Gorky was influenced by Kandinsky and de Kooning; and after moving to Connecticut in 1942, he adopted a new style. In 1943, his daughter, Maro, was born. His second daughter, Natasha, was born in 1948. He met André Breton and other Surrealist painters in the mid-1940s. From 1945 to 1948, Gorky exhibited annually at the Julien Levy Gallery in New York. A fire in his Connecticut studio destroyed many of Gorky's paintings in 1946. He committed suicide on 21 July 1948, in Sherman, CT.

Marsden Hartley (1877–1943)

Marsden Hartley was born Edmund Hartley on 4 January 1877, in Lewiston, ME. He lived in Auburn, ME, until 1893 when he went to live with his father and step-mother in Cleveland, OH. Hartley first studied art with Cleveland artists and then in 1898 began study at the Cleveland School of Art. Hartley went to New York in 1899 to the Chase School. From 1900 to 1904, he studied at the National Academy of Design. In 1900, Hartley began to spend summers in Maine. He worked with a theatre group from 1904 to 1906, when he adopted his step-mother's

maiden name, Marsden. In 1909, Hartley went to New York and met members of The Eight and Alfred Stieglitz, who gave Hartley his first one-man show in New York at '291' in 1909 and subsequent shows in 1912 and 1914. Hartley travelled back and forth between Maine and New York for the next two years. In 1912, he took the first of many trips to Europe where he became familiar with the almanac *Der Blaue Reiter* and the writings of Kandinsky and frequented Gertrude Stein's salon in Paris. In 1913, Harley took two trips to Germany meeting Kandinsky, Gabriele Münter and Franz Marc, and exhibiting at the First German Autumn Salon in Berlin organised by Der Sturm. Hartley returned to the United States in November 1913, but in spring 1914, he moved back to Germany. Soon after his friend, Lieutenant Karl von Freyburg, was killed in action in 1914, Hartley began his emblematic German military paintings. Hartley returned to New York in December of 1915. In 1916 he visited Bermuda and exhibited at the Forum Exhibition in New York. In 1918 he moved to Sante Fe, NM, for a year. Hartley served as the Secretary of the Société Anonyme in 1920. During the 1920s, Hartley lived in France spending holidays in Italy and Germany. He moved to New York in 1930. He was awarded a Guggenheim grant in 1931 and went to live in Mexico in 1932, leaving for Germany in April 1933. He worked for the Public Works of Art Project in 1934 and the Works Progress Administration in 1936. Hartley divided his time between New York and Maine in the late 1930s. He died on 2 September 1943, in Ellsworth, ME.

Al Held (b. 1928)

Al Held was born on 12 October 1928, in Brooklyn, NY. He served in the US Navy during the Second World War. In 1947, he joined 'Folksay', a group of politically active writers and musicians. Held began to study art in 1948 at the Art Students League under Harry Sternberg. After seeing Jackson Pollock's paintings in 1949, Held changed his own style. Held continued to study at the Académie de la Grande Chaumière in Paris with Ossip Zadkine. In 1950, he took a studio in Montparnasse, and in 1952 Held had his first show at the Galerie Huit in Paris. He returned to the United States and in 1953 married the sculptor, Sylvia Stone. Almost all of Held's paintings were tragically destroyed by fire in 1953. Held lived in San Francisco for a year taking odd jobs before resettling in New York and opening a small business. His daughter, Mara, was born in 1954. Held was included in a group show at Tanager Gallery in 1955 and had his first one-man show at the Poindexter Gallery in 1955. In 1962, Held was appointed Associate Professor at Yale University, New Haven, CT. He was awarded the Logan Medal by the Art Institute of Chicago in 1964 and received a Guggenheim Fellowship in 1966. Also in 1966, Held was given a show at the Stedelijk Museum in Amsterdam. In the late 1960s and 1970s, Held made several transitions in his work abandoning colour, stressing line and an analytical approach to unified composition. Held lives and paints in New York.

Robert Henri (1865–1929)

Robert Henry Cozad was born in Cincinnati, OH, in 1865. His family moved to Nebraska, but because of a scandal, assumed the surname Henri before going to New Jersey in 1883. From 1886 to 1888, Henri studied at the Pennsylvania Academy of the Fine Arts under Thomas Anshutz, James B. Kelley and Thomas Hovenden. He studied with Bourgereau at the Académie Julien, Paris. In 1892, Henri was teaching at the Women's School of Design in Philadelphia and studying with Robert Vonnon at the Pennsylvania Academy of the Fine Arts where he met John Sloan in 1892. Within a year, Henri's studio was a gathering place for young artists, and in 1884, he shared a studio with William Glackens. In 1898, Henri married

Linda Craige, who died eight years later. Henri joined the Macbeth Gallery in 1902. Henri withdrew his entry from the National Academy of Design 1907 spring exhibition because of the rejection of the work of Glackens, Luks, Shinn, Rockwell Kent and Carl Sprinchorn. Soon he began to make plans for the first exhibition of The Eight to be held the following year at the Macbeth Gallery. In 1908 Henri married the artist, Marjorie Organ. He opened the Henri School of Art in 1909, and taught Hopper, Kent, Sprinchorn, Glen Coleman, Bellows, Bruce, Kuniyoshi, Morgan Russell and Stuart Davis. In 1912, Henri went to Paris with Walter Pach and had his first encounter with Cubism. Henri had five paintings in the 1913 Armory Show. He taught at the Art Students League from 1916 to 1928. Henri travelled extensively in the United States and abroad before his death on 12 July 1929 in New York.

Hans Hofmann (1880–1966)

Hans Hofmann was born in Weissenburg, Germany, on 21 March 1880. The family moved to Munich in 1886, where Hofmann began to study art in 1898. From 1903 to 1914, Hofmann lived in Paris, where he attended classes at the Académie de la Grande Chaumière, and met Matisse, Delaunay, Picasso and Braque. Upon returning to Munich, Hofmann opened the Hans Hofmann School of Fine Arts. In 1923, Hofmann married Maria (Miz) Wolfegg. Hofmann was a guest teacher at the University of California at Berkeley in the summer of 1930, and in 1932 he emigrated to the United States. He taught at the Art Students League and the Thurn School of Art in Gloucester, MA, before opening the Hans Hofmann School of Fine Arts in New York in 1934. In 1935, Hofmann established a summer school at Provincetown, MA. After a long period of working only on drawings, Hofmann began to paint again. In 1941 Hofmann became a US citizen, and in 1944 Peggy Guggenheim gave him his first exhibition in New York and at Art of This Century. Hofmann exhibited regularly in the United States throughout the 1940s. In 1949, he returned to Paris to visit the studios of Braque, Brancusi and Picasso. In 1957, the Whitney Museum of American Art organised a travelling retrospective exhibition. Hofmann, along with Philip Guston, Franz Kline and Theodore Roszak, represented the United States in the XXX Venice Biennale of 1960. By the 1960s, Hofmann was exhibiting internationally and the spatial theories he had taught decades earlier were now being passed to another generation. In 1963 his wife, Miz, died. Hofmann married Renate Schmitz in 1965 and died on 17 February 1966, in New York.

Edward Hopper (1882–1967)

Edward Hopper was born on 22 July 1882, in Nyack, NY. He attended the New York School of Art between 1900 and 1906, where he studied painting with Robert Henri, William Merritt Chase and Kenneth Hayes Miller. Hopper worked briefly as an illustrator before taking the first of three trips to Europe, visiting Paris, London, Amsterdam and Brussels in 1906–1907. In 1909 he went to Paris, and in 1910 he returned to Paris and visited Madrid. Hopper supported himself as a commercial artist but also exhibited his paintings in group shows, notably the 'Exhibition of Independent Artists', 1910, and, annually at the MacDowell Club, New York, from 1912 to 1916. Hopper's painting, *Sailing*, was included in the New York Armory Show of 1913. From the 1910s, Hopper spent summers in rural New England. His first one-man show was at the Whitney Studio Club in 1920, however it was not until his highly successful exhibition at Frank K. M. Rehn Gallery in 1924, that he was to give up commercial art work. That year he married Josephine Verstille Nivison, also a painter and a former actress. In 1933 the Museum of Modern Art held the first retrospective exhibition

of Hopper's work which travelled to the Arts Club of Chicago the following year. In 1934 the Hoppers built their summer home in South Truro, MA. They travelled to Mexico in 1943, 1946, 1951, 1952 and 1955. In 1950 the Whitney Museum of American Art organised a retrospective exhibition which travelled to Boston and Detroit. In 1953 Hopper served on the editorial committee for *Reality: A Journal of Artists' Opinions*, a magazine published by representational artists. Retrospective exhibitions were held at the Arizona Art Gallery in 1963, and in 1964 another major retrospective, organised by the Whitney Museum of American Art, was exhibited in New York, Chicago and Detroit. On 15 May 1967, Edward Hopper died in New York.

Rockwell Kent (1882–1971)

Rockwell Kent was born in Tarrytown, NY, on 21 June 1882. From 1900 to 1903, Kent attended William Merritt Chase's art classes at Shinnecock Hills near Southampton, Long Island. He studied at the New York School of Art under Robert Henri and Kenneth Hayes Miller, and also worked in the studio of Abbott H. Thayer in 1904. Kent studied architecture at Columbia University before joining the firm of Ewing and Chappell as a draughtsman. He did odd jobs in Monhegan Island, ME, in New Hampshire and in the Berkshires until 1909 when he and Julius Golz established the Monhegan summer art classes. Kent exhibited with Hartley, Maurer, Prendergast, Luks, du Bois and others at the Society of Independent Artists in 1917. In 1918, Kent, who had already lived in Newfoundland, incorporated as 'Artist Kent', sold shares in himself and moved to Alaska. Three years later he bought back all the shares, disincorporating himself and moved to Vermont. Kent's Alaskan paintings were exhibited at Knoedler's in New York in 1920. His first book *Wilderness* was published in 1920. Subsequently Kent wrote *Voyaging* (1924); *North by East* (1930); *Rockwellkentiana* with Carl Zigrosser (1933); *This is My Own* (1940); *It's Me O Lord* (1955) and *Greenland Journal* (1963). Kent illustrated the works of Shakespeare, Voltaire, Melville, Chaucer and Whitman. Kent painted and exhibited his adventures from his 1922 voyage through the Straits of Magellan to his trips to Greenland in the 1930s. He was frequently the subject of congressional investigations during the 1940s and 1950s for his participation in organisations deemed Communist or fronts for Communist organisations. Kent lived the latter years of his life in Au Sable Forks, NY, and died in Plattsburgh, NY, on 13 March 1971.

Willem de Kooning (b. 1904)

Willem de Kooning was born in Rotterdam, Holland, on 24 April 1904. He was apprenticed to a commercial art and decorating firm at the age of twelve, and in 1920, he worked for Bernard Romein, a designer in late Art Nouveau style. De Kooning studied at the Rotterdam Academy of Fine Arts and Techniques. While still in Holland, de Kooning became familiar with Mondrian, the de Stijl group, French and Belgian art, and the work of the American architect, Frank Lloyd Wright. In 1926, de Kooning emigrated to the United States, settling first in New Jersey, and a year later, in New York. He met John Graham, Arshile Gorky, Stuart Davis and other artists about 1929. Until he enrolled in the Federal Arts Project, the Works Progress Administration, in 1935, de Kooning had supported himself doing odd jobs including house painting, sign painting, lettering, shop displays, furniture design and carpentry. De Kooning first exhibited at the Museum of Modern Art in a group exhibition, 'New Horizons in American Art' in 1936. He soon began to receive regular commissions. In 1940, he designed sets and costumes for the ballet, *Les Nuages*. In 1943, he married Elaine Fried. He taught at Black Mountain College, NC, in the summer of 1948. De Kooning was among the organisers of the

Eighth Street Artists Club, 1949. In 1950, de Kooning taught one term at the Yale Art School. He exhibited his renown figurative studies of women in his third one-man show at the Sidney Janis Gallery in 1953. *The Women*, though initially controversial, would become among the most celebrated series of paintings produced in America. Joan Ward gave birth to de Kooning's daughter, Lisa, in 1956. In 1964 de Kooning was awarded the Presidential Medal of Freedom. He has lived in the Springs, East Hampton, NY, since 1962.

Lee Krasner (1908–84)

Lee Krasner was born Lenore Krassner on 27 October 1908, in Brooklyn, NY. She studied at the Women's Art School of Cooper Union, from 1926 to 1929; the Art Students League under George Bridgman in 1928; the National Academy of Design, from 1929 to 1932; City College and at the Greenwich House in 1933. After working for the Public Works of Art Project and for the Works Progress Administration's Federal Art Project, Krasner studied with Hans Hofmann for three years from 1937 to 1940. Krasner was selected by John Graham to participate in 'American and French Paintings', at the McMillan Gallery, New York, in 1942. Jackson Pollock, whom Krasner married in October 1945, was also in that exhibition. They moved to the Springs, Easthampton, NY, and from 1946 to 1949 Krasner created 'Little Image' paintings. Krasner had her first one-person exhibition show at Betty Parsons Gallery, New York, in 1951. In 1953, she began working in collage, using fragments of destroyed paintings. Krasner went to Europe for the first time in 1956, but returned immediately upon notice of the death of her husband. In 1959, she created two murals in mosaic for Uris Brothers in New York. The Whitechapel Art Gallery in London held a retrospective of Krasner's work in 1965. Her work was exhibited frequently in galleries and museums through the 1960s and 1970s, and she was awarded for 'Outstanding Achievement in the Visual Arts' by the Women's Caucus for Art in 1980. Krasner died on 19 June 1984, in New York.

Walt Kuhn (1877–1949)

Walt Kuhn was born William Kuhn on 27 October 1877, in Brooklyn, NY. He went to Brooklyn Polytechnic Institute before opening a bicycle shop in Brooklyn in 1897. Kuhn moved to San Francisco in 1899 where he drew cartoons. He studied at the Académie Colarossi in Paris in 1901 and with Heinrich von Zugel at the Royal Academy in Munich the following year. From 1905 to 1914, Kuhn was a cartoonist for *Life, Puck, Judge* and the *New York Sunday Sun, New York World*. In the winter of 1908, Kuhn taught at the New York School of Art. He married Vera Spier in 1909, and their daughter, Brenda, was born in 1911. In the winter of 1910–11, Kuhn was given his first one-man show at the Madison Gallery in New York. Kuhn served as the Executive Secretary for the 1913 Armory Show. He exhibited at the Montross Gallery in 1914 and again in 1922, 1924 and 1925. During the 1920s, Kuhn designed and directed theatrical revues in New York and Chicago. Kuhn lived and worked in New York and spent summers in Maine, however the summer of 1925 and the springs of 1931 and 1933 he lived in Europe. Kuhn was the Consulting Architect for the Union Pacific Railroad from 1936 to 1941. During this period, Kuhn designed club cars for the streamliners. He died on 13 July 1949, in White Plains, NY.

Ernest Lawson (1873–1939)

Ernest Lawson was born on 22 March 1873, in Halifax, Nova Scotia. He had his first art lessons at the age of fifteen in Kansas City, MO. His family then moved to Mexico City where he worked as a draughtsman. Lawson moved to New York in 1891 and enrolled at the Art Students League; soon transferring to the

Art School run by John H. Twachtman and J. Alden Weir in Cos Cob, CT. In 1893, he left for Paris to study at the Académie Julian. While in Paris, Lawson had some contact with Sisley. Lawson exhibited at the 1894 Salon des Artistes français, and in the same year returned to the United States to marry Ella Holman. Together they went back to Paris for a year. Their first child, Margaret, was born there; and in 1897, while Lawson was teaching in Columbus, GA, Dorothy, a second daughter was born. The Lawsons returned to New York in 1898. Lawson exhibited at the 1904 Universal Exposition in St Louis and was awarded a silver medal. In 1904, Lawson met William Glackens and through him Robert Henri's protegés, John Sloan, Everett Shinn and George Luks. With Arthur B. Davies and Maurice Prendergast the group became known as The Eight. After the first exhibition of The Eight at the Macbeth Gallery in 1908, Lawson exhibited regularly in the United States and Canada. He was included in the 1913 Armory Show in New York. From 1926 to 1930, Lawson taught intermittently at the Broadmoor Academy, Colorado Springs, and at the Kansas City Art Institute. In 1936, Lawson moved to Florida to be with friends, Mr and Mrs Royce Powell. On 18 December 1939, he died at Coral Gables, FL.

Jack Levine (b. 1915)

Jack Levine was born on 3 January 1915, in Boston, MA. Levine took his first art lessons at the Jewish Welfare Center in Roxbury, MA, and later studied at the Boston Museum school. He was drawing in the manner of Leonardo da Vinci, Mantegna, and other Renaissance masters when he came to the attention of Denman Ross, a professor at Harvard University. Ross helped arrange financial assistance for Levine to study with him from 1929 until 1931. In 1935, Levine joined the Works Progress Administration. Important influences at this time were George Grosz, Rouault, Soutine and Kokoschka. Levine painted the urban poor and satirised the privileged. His socially oriented art would have its greatest following during the 1930s and 1940s. In 1939, Levine had his first one-man show at the Downtown Gallery. Levine served in the US Army from 1942 to 1945. In 1945 he received a Guggenheim Fellowship. After painting the controversial Welcome Home in 1946, Levine was labelled 'subversive' and was investigated by the House Committee on un-American Activities. Despite disfavour, Levine remained a social and political realist. He was awarded a Fulbright Fellowship in 1950. He studied in Rome absorbing all that he could from the old masters especially Rubens, the Italian Mannerists and the Baroque artists, El Greco, Tintoretto and Rembrandt. In the 1950s Levine became less controversial, painting Old Testament themes and parodies of classical paintings. The 1960s proved politically fertile for Levine's brand of satire. Levine lives in New York. He was married to the painter, Ruth Gikow until her recent death; he has one daughter, Susanna, who is also an artist.

Roy Lichtenstein (b. 1923)

Roy Lichtenstein was born on 27 October 1923, in New York. He studied with Reginald Marsh at the Art Students League in 1939 and 1940. After graduating from Benjamin Franklin High School in 1940, Lichtenstein entered Ohio State University in Columbus, OH, where Marsh was then teaching. Lichtenstein served in the US Army during the Second World War. He returned to Ohio State University obtaining a BFA in 1946 and an MFA in 1949. In 1949, Lichtenstein married Isabel Wilson with whom he had two children. He was an Assistant Professor at Ohio State University, 1949–51, and subsequently spent six years working as a commercial artist and doing various odd jobs before returning to academia. He taught at the State College of New York in Oswego from 1957 to 1960, and at Douglass

College in New Brunswick, NJ, in 1960. Lichtenstein was then painting in an Abstract Expressionist style. Through his friend, Allan Kaprow, Lichtenstein met Rauschenberg, Johns and Oldenberg. In 1960, the Lichtensteins divorced. In 1961, Lichtenstein painted Look Mickey, I've Hooked a Big One, an image of Donald Duck in the flat, mechanical style of commercial art in simple colours with Ben Day dot background. He showed his new work to Ivan Karp then at the Leo Castelli Gallery where he had a one-man show in 1962. Lichtenstein was influenced by Picasso, Cézanne, Matisse, Leger and Mondrian as well as comic strips. He lives and works in Southampton, NY.

Richard Lindner (1901–78)

Richard Lindner was born in Hamburg, Germany, on 1 November 1901. He spent his childhood in Nuremberg. He studied music in Nuremberg and later in Munich. In Munich at the Akademie der Bildenden Kunste, he also studied art, from 1924 to 1927. After a year in Berlin, Lindner returned to Munich to serve as art director for Knorr & Hirth, a distinguished publishing house. When the Nazis came to power in 1933, Lindner escaped to Paris. He tried to enter the French and British armies before emigrating to the United States in 1941. In New York, Lindner met other refugees including Saul Steinberg, who would be a life-long friend, Hedda Sterne and Evelyn Hofet. He worked as an illustrator for books and magazines, notably, Vogue, Fortune and Harper's Bazaar. It was not until 1950 that Lindner began to paint full time. In 1952, he joined the staff of Pratt Institute in Brooklyn, teaching 'Creative Expression'. He had his first one-man show at Betty Parsons Gallery in 1954. In 1957, he lectured at Yale University School of Art and Architecture and received the William and Norma Copley Foundation Award. During the 1960s, Lindner gained recognition because he was wrongly categorised as a Pop artist. Though he did not want his aesthetics misunderstood, he welcomed the opportunity to participate in group shows at museums and galleries. In 1965, he was guest lecturer at Hochschule für Bildende Kunst in Hamburg. By 1968, Lindner was exhibiting regularly in museums and galleries in the United States, as well as, in Hanover, Baden-Baden and West Berlin. He married Denise Kopelman in 1968 and lived in Paris and New York until his death on 16 April 1978.

Morris Louis (1912–62)

Morris Louis was born on 28 November 1912, in Baltimore, MD, the son of Louis and Cecelia Bernstein. He attended state schools and won a state-wide scholarship competition for higher education at Maryland Institute of Fine and Applied Arts, where he studied from 1929 to 1933. During the early years of the Depression, Louis did various odd jobs in Baltimore. Between 1936 and 1940, he lived in New York and shared a workshop with Siqueiros and others. Among his artist friends were Arshile Gorky and Jack Tworkov. He changed his surname from Bernstein to Louis before leaving New York. In 1940, Louis returned to Baltimore to teach privately. In July 1947, he married Marcella Siegel and moved to Silver Spring, MD. Louis moved to Washington, DC, in 1952 and began teaching at the Washington Workshop Center where he met Kenneth Noland. Through Noland, Louis met David Smith and Clement Greenberg. In 1953, Louis had his first one-man show at the Workshop Center Art Gallery in Washington. It was in 1953 that Louis and Noland visited the studio of Helen Frankenthaler for the first time. The following year Louis was selected by Greenberg for the group show at the Kootz Gallery, 'Emerging Talent'. In 1957, Louis exhibited at the Castelli Gallery and had a one-man show at the Martha Jackson Gallery. He taught a painting seminar in Baltimore in 1959. By 1960,

his works were exhibited in both London and Paris. Louis died on 7 September 1962.

John Marin (1870–1953)

John Marin was born in Rutherford, NJ, on 23 December 1870. After the death of his mother, Marin lived with his maternal grandparents. He attended Hoboken Academy, Stevens Preparatory and Stevens Institute. Marin worked as a freelance architect in 1893. In 1901, he studied with Thomas Anshutz at the Pennsylvania Academy of the Fine Arts where he befriended Arthur B. Carles. Marin studied briefly at the Art Students League in 1905 before leaving for Paris in September of that year. While abroad, Marin took trips to Holland, Belgium, Italy, England and Luxembourg. Marin exhibited at '291' in 1909 and returned to the United States in 1910. Stieglitz helped Marin financially until paintings were sold. In 1912, Marin married Marie Jane Hughes, and in 1914, he took his first trip to Maine where he spent most summers. In November of 1914, Marin's only child, John C. Marin, III, was born. The Daniel Gallery, New York, held a retrospective of Marin's work in 1920, and a large exhibition at the Montross Gallery in 1922 brought Marin significant recognition. Marin spent the summers of 1929 and 1930 in Taos, NM. He was given a major retrospective by the Museum of Modern Art in 1936. Marin's wife died in 1945, and in 1946 he suffered a heart attack. He died at Cape Split, ME, on 2 October 1953.

Reginald Marsh (1898–1954)

Reginald Marsh was born in Paris, on 14 March 1898. In 1900, his parents, American artists, moved to Nutley, NJ, and subsequently to New Rochelle, NY. At Yale University, Marsh studied art and drew illustrations for *The Yale Record.* After graduation in 1920, he worked as a freelance illustrator in New York. Between 1922 and 1925, Marsh drew city subjects and theatrical sketches for the *Daily News.* and designed theatre curtains and sets in New York and Provincetown, MA. He married the sculptor, Betty Burroughs in 1923. Marsh's first one-man show was at the Whitney Studio Club in 1924. In 1925, Marsh worked for the *New Yorker*, did freelance work for *Esquire, Fortune* and *Life* Magazines, and took the first of six European trips. In 1927, he enrolled at the Art Students League to study with Kenneth Hayes Miller, George Bridgeman, George Luks, Macque Maroger, Stanley William Hayter and Mahonri Young. Marsh studied anatomy at the College of Physicians and Surgeons in New York and later wrote *Anatomy for Artists.* Marsh's first marriage ended in divorce, and in 1934 he married the painter, Felicia Meyer. In the mid-1930s, Marsh received commissions for murals in the Washington, DC Post Office Building and the New York Custom House. Though painting and exhibiting regularly, Marsh assumed a full-time teaching position at the Art Students League in 1942. In 1943, he was the artist correspondent for *Life* magazine in Brazil, Cuba and Trinidad. Marsh was a summer guest instructor at Mills College, Oakland, CA in 1946, and in 1949, was appointed head of the Department of Painting at the Moore Institute of Art, Science and Industry in Philadelphia. Marsh died in Dorset, VT, on 3 July 1954.

Walter Murch (1907–67)

Walter Tandy Murch was born in Toronto, Ontario, Canada, on 17 August 1907. He studied at the Ontario College of Art under Arthur Lismer. He took evening classes at the Art Students League in New York under Von Schlegall in 1927. Later he studied under Kenneth Hayes Miller. Murch enrolled at the Grand Central School of Art. He was taught there by Arshile Gorky and continued private instruction with Gorky for the next two years. Murch found freelance work illustrating Stuart

Chase's *Men and Machines* and Sir James Jeans' *Stars in Their Courses.* In 1930, Murch married Katherine Scott. In 1931, Murch worked for Lord & Taylor's department store making posters and designing shops. He met the art dealer, Betty Parsons, while working there. In the 1930s, Murch frequented galleries, and at Julian Levy's he met Joseph Cornell. The artists exchanged ephemera and became friends. Murch's freelance jobs expanded in scale. He was painting murals for other department stores such as McCreery's and Best & Co. His illustrations were used in advertising for Shaeffer Beer, Goodyear Tire Company and AT&T. In 1941, Murch had his first one-man show at the Wakefield Gallery. He began showing at the Betty Parsons Gallery in 1947, and through the gallery he met Stamos, Rothko and Pollock. Though his work remained intimate, Murch felt painting murals yielded an understanding of large scale abstraction. Parsons continued to exhibit Murch's work during the 1950s and 1960s. From 1952 to 1961, Murch taught at Pratt Institute in Brooklyn. He taught one year at New York University and briefly at Boston University. He was on the Columbia University teaching staff from 1961 until he died on 11 December 1967.

Georgia O'Keeffe (1887–1986)

Georgia O'Keeffe was born near Sun Prairie, WI, on 15 November 1887. She was given private drawing lessons at the ages of eleven and twelve in addition to instruction at school. O'Keeffe studied at the Art Institute of Chicago with John Vanderpoel from 1905 to 1906, and at the Art Students League under William Merritt Chase, F. Luis Mora and Kenyon Cox from 1907 to 1908. She visited an art class at the University of Virginia taught by Alon Bement upon whose suggestion she went to New York in 1914, to study with Arthur Dow at Teachers College, Columbia University. In the autumn of 1915 while teaching in South Carolina, O'Keeffe sent some drawings to a friend in New York who showed them to Alfred Stieglitz. Stieglitz exhibited the drawings the following spring. Learning that her drawings were being shown without her permission, O'Keeffe went to Stieglitz requesting they be taken down. The drawings remained in place. Stieglitz gave O'Keeffe a one-person show at '291' in May of 1917. He also exhibited her paintings at the Anderson Galleries in 1923 and 1924, and they were married in 1924. O'Keeffe had annual exhibitions at Stieglitz's Intimate Gallery from 1926 to 1929 and at 'An American Place Gallery' from 1930 to 1946. O'Keeffe held teaching positions at the University of Virginia Art Department, 1913–16 (summers only); Columbia College, Columbia, SC, 1915 and West Texas State Normal School, Canyon, TX, 1916–18. She painted her first big flower paintings in 1924, the first New York City paintings in 1926, and after an extended visit to New Mexico in 1929, she painted the first of the bone paintings in 1931. After Stieglitz's death in 1946, O'Keeffe settled permanently in Abiquiu, NM. She was honoured repeatedly with major retrospective exhibitions. She died on 6 March 1986.

Alfonso Ossorio (b. 1916)

Alfonso Angel Ossorio was born in Manila, the Philippines, on 2 August 1916. He was educated in England and the United States. After graduating from Harvard University in 1938, Ossorio entered the Rhode Island School of Design. He became a naturalised citizen of the United States in 1939 and from 1940 was briefly married to Bridget Hubrecht. He lived in Taos, NM for two years before joining the US Army in 1943. His first one-man show was at the Wakefield Gallery in 1943. In 1949, Ossorio met Lee Krasner and Jackson Pollock. In the fall of that year he went to Paris to meet Dubuffet. Ossorio spent most of 1950 in the Philippines doing murals for a chapel built by his father and brother. Ossorio returned to Paris in 1951. His

friend, Dubuffet, introduced him to Michel Tapie who organised a one-man show of Ossorio's paintings at the Studio Paul Facchetti in Paris. In 1952, Ossorio met Clyfford Still who, like the Pollocks and Dubuffets, would become a good friend. Ossorio joined the Betty Parsons Gallery in 1953 and would exhibit there throughout the 1950s. He was a co-founder of the Signa Gallery in East Hampton, NY. In the early 1960s, Ossorio exhibited at the Galerie Stadler in Paris, at the Cordier & Warren Gallery in New York and at the Galerie Cordier-Stadler in Frankfurt, Germany. Ossorio lives at 'The Creeks' in East Hampton, NY.

Maxfield Parrish (1870–1966)

Maxfield Parrish was born Frederick Parrish on 25 July 1870, in Philadelphia, PA. He first studied art while in Paris with his parents from 1884 to 1886. Parrish graduated from Haverford College in 1892 and for the next two years studied at the Pennsylvania Academy of the Fine Arts under Robert Vonnoh and Thomas Anschutz. He also attended classes taught by Howard Pyle at the Drexel Institute in Philadelphia. In 1894, his watercolour study, *Old King Cole*, was exhibited at the Pennsylvania Academy of the Fine Arts. Parrish's first cover design was for *Harper's Bazar* (later *Bazaar*) in 1895. That same year Parrish took his new bride, Lydia Austin, to France, Belgium and England. Afterwards, they settled in Philadelphia. Parrish's first commission for book illustration was in 1897 for *Mother Goose in Prose* by L. Frank Baum. Parrish and his wife moved to Cornish, NH, in 1898. In 1900, Parrish was awarded honourable mention at the Paris Exposition. He spent the years 1900 to 1902 convalescing from tuberculosis in New York and Arizona. In 1903, he toured Italy making preparatory sketches for *Italian Villas and Their Gardens* by Edith Wharton (1910). Parrish exhibited at the 1904 St Louis Exposition. In 1904, his first son, John Dillwyn, was born. Subsequently he had two more sons: Maxfield Parrish, Jr, born in 1906 and Stephen, born 1909, and a daughter, Jean, born 1911. In 1925, Parrish had an exhibition at Scott and Fowles Gallery in New York. Among the paintings shown were many of the illustrations for *The Knave of Hearts* by Louise Saunders (1925). In 1953, Parrish's wife, Lydia, died. The George Walter Vincent Smith Art Museum in Springfield, MA, held a Maxfield Parrish retrospective in 1966. Maxfield Parrish died on 30 March 1966 in Cornish, NH.

Jackson Pollock (1912–56)

Paul Jackson Pollock was born on 28 January 1912, in Cody, WY, to Scots-Irish parents. (His father had taken the surname of his adoptive parents.) During Pollock's early years, the family moved back and forth from California to Arizona. After Pollock left school, he entered the Manual Arts School in Los Angeles. An instructor named Schwankovsky introduced him to Theosophy and Krishnamurti. In 1930, Pollock moved to New York and studied with Thomas Hart Benton and John Sloan at the Art Students League. Pollock made several cross country trips in the early 1930s. In 1935, he worked for the Works Progress Administration and had an exhibition at The Brooklyn Museum. In 1937, he began psychological treatment for alcoholism and in 1939, he began Jungian therapy. His friend, John Graham, organised a group exhibition in 1941 at the McMillan Gallery. Lee Krasner was in the group. In 1943, Pollock signed a contract with Peggy Guggenheim which guaranteed security and freedom to paint full time. In October of 1945 he and Krasner were married and moved to the Springs, NY. In 1947, Betty Parsons took over Pollock's contract from Peggy Guggenheim. Alfonso Ossorio, Pollock and Krasner's close friend, organised an exhibition for Pollock at Studio Paul Facchetti in Paris in 1952. By 1954, Pollock was inactive. On

11 August 1956, Pollock was killed in a car accident in the Springs, NY.

Richard Pousette-Dart (b. 1916)

Richard Pousette-Dart was born in St Paul, MN, on 8 June 1916. The family moved to Valhalla, NY, in 1918. Pousette-Dart graduated from Scarborough School in Scarborough-on-Hudson, NY, in 1935 and attended Bard College in Annandale-on-Hudson in 1936. He moved to New York in 1936 and had his first one-man show at Artists Gallery in 1941. He married Evelyn Gracey in 1946. Their first child, Joanna, was born in 1947 and their son, Jonathan, was born in 1952. The family settled in Suffern, NY, in 1958. Pousette-Dart first exhibited at Betty Parsons Gallery in 1948. The Whitney Museum of American Art had a major retrospective exhibition of his work in 1963 and another one-man show of his paintings in 1974. Pousette-Dart taught at the New School for Social Research, NY, 1959–61; the School of Visual Arts, NY, 1964; was guest critic at Columbia University, 1968–69; taught at Sarah Lawrence College, Bronxville, NY, 1970–74 and began teaching at the Art Students League in 1980. He received a Guggenheim Fellowship in 1951, a Ford Foundation Grant in 1959, a National Endowment for the Arts Award for Individual Artists in 1967 and was made Milton Avery Distinguished Professor of the Arts at Bard College in 1983. Pousette-Dart lives in Suffern, NY.

Maurice Prendergast (1859–1924)

Maurice Brazil Prendergast and his twin sister, Lucy Catherine, were born on 10 October 1859, in St John's, Newfoundland, Canada. The family moved to Boston in 1861, where Maurice attended school until he was fourteen. He was then apprenticed to a commercial art firm. In May of 1891, Prendergast sailed for Paris to study at the Académie Colarossi with Gustave Coutois and at the Académie Julian with Jean-Paul Laurens, Joseph Blanc and Benjamin Constant. Prendergast returned to Boston in 1895 to exhibit his paintings at the Boston Art Club. In 1897, his paintings were exhibited at the New York Watercolor Society Eighth Annual Exhibition. In 1898, Prendergast returned to Europe for eighteen months. During this visit, he painted in St Malo, Paris, Siena, Florence, Rome, Capri and Venice. Prendergast moved to New York in 1904, the year he exhibited at the National Arts Club with Robert Henri, John Sloan, Arthur B. Davies, William Glackens and George Luks. In May of 1907, Prendergast went back to France, living first in Paris and then in St Malo. He returned to the United States in October of 1907 and exhibited with The Eight at the Macbeth Gallery in 1908. Prendergast exhibited with Marin, Hartley and others in an Independent Exhibition held at the Gallery of the Society of Beaux Arts Architects in New York in 1911. That year he travelled to Paris, Brittany and Venice and then lived in Boston in 1912. Prendergast was on the organising committee of and exhibited seven paintings in the 1913 Armory Show. In 1914 Prendergast again visited France. From 1914 to 1922, he kept a studio in New York. Maurice Prendergast died on 1 February 1924.

Robert Rauschenberg (b. 1925)

Robert Rauschenberg was born Milton Rauschenberg on 22 October 1925, in Port Arthur, TX. After serving in the US Navy during the Second World War, Rauschenberg studied art for one year at Kansas City Art Institute. In 1948, Rauschenberg sailed for Paris to study at the Académie Julian. He returned to study briefly with Josef Albers at Black Mountain College, North Carolina. There he met Merce Cunningham, John Cage, David Tudor and Lou Harrison. Rauschenberg moved to New York and attended the Art Students League until 1952,

studying there with Morris Kantor and Vaclav Vytlacil. Rauschenberg's brief marriage to Susan Weil in 1950 produced one son, Christopher, in 1951. Rauschenberg's first one-man show was held the same year at Betty Parsons Gallery. In 1952, Rauschenberg returned to Black Mountain College and in the autumn went to Italy, France and Spain with Cy Twombly, later proceeding alone to North Africa. Rauschenberg returned to New York and in 1954 began designing sets and costumes for the Merce Cunningham and the Paul Taylor Dance Companies. In 1955, he lived in the same building with and befriended the artist, Jasper Johns. In 1958, Rauschenberg joined the Leo Castelli Gallery. Rauschenberg, who collaborated with composers, poets and performed for choreographers, in 1963 choreographed and designed the first of his own dance productions, *Pelican*. Major retrospectives of his work have been held at the Whitechapel Gallery, London, 1964, Walker Art Center, Minneapolis, 1965 and at the National Collection of Fine Arts, Washington, DC, 1977, travelling to New York, San Francisco, Buffalo and Chicago. In 1970 Rauschenberg founded Change, Inc, an assistance foundation for artists. Rauschenberg lives in New York.

Man Ray (1890–1976)

Man Ray was born Emmanuel Rudnitsky on 27 August 1890, in Philadelphia, PA. Man Ray, who was primarily self-taught, finished school and attended some drawing classes at the Ferrer Center in New York in 1912. In 1913, he married Adon Lacroix. They lived in Ridgefield, NJ, until 1915 when they moved to New York. The Daniel Gallery in New York gave Man Ray his first one-man show in 1915, the same year he met Marcel Duchamp and took up photography. Man Ray was a founder member of the Society of Independent Artists. He, along with Katherine Dreir and Marcel Duchamp, helped found the Société Anonyme in 1920. After publishing an issue of *New York Dada* with Marcel Duchamp in 1921, Man Ray left for Paris. He befriended the Parisian Dadaists, was given a one-man show at Libraire 6 in 1921, and exhibited at the first international Dada show at Galerie Montaigne in 1922. Man Ray was simultaneously publishing his photographs, making film and even appeared in Rene Clair's 1924 film, *Entr'acte*. In 1925, Man Ray exhibited in the first Surrealist Exhibition at Galerie Pierre in Paris. Through the late 1920s and 1930s, he continued making film, producing photographs and rayographs and exhibiting internationally with Dadaists and Surrealists. In 1940, Man Ray left Paris and returned to New York by way of Lisbon. He moved to Hollywood that year and in 1946 married Juliet Browner in Beverly Hills. During the 1940s, Man Ray exhibited his paintings, drawings, photographs and rayographs in California museums and galleries. In 1951, he returned to Paris. For the next two decades Man Ray enjoyed widespread appreciation for his early work. He died on 18 November 1976, in Paris.

Larry Rivers (b. 1923)

Larry Rivers was born on 17 August 1923, in the Bronx, NY, to Samuel and Sonya Grossberg. He began a career in music as a jazz saxophonist in 1940. After serving in the US Army Air Corps from 1940 to 1942, Rivers returned to study at the Juilliard School of Music in 1944. In 1945, Rivers started painting and married Augusta Burger, from whom he was separated a year later. He met Nell Blaine, and from 1947 to 1948, he studied with Hans Hofmann in New York and Provincetown, MA. Rivers entered New York University in 1948 to study with William Baziotes and graduated in 1951. During the late 1940s and early 1950s, Rivers met de Kooning, Kline, Guston, Pollock, Frankenthaler, Alfred Leslie and the poets, Frank O'Hara, John Ashbery and Kenneth Koch. Rivers'

first trip to Europe was in 1950, and the following year he was given his first one-man show by the Tibor de Nagy Gallery in New York. Rivers began collaborating with poets, notably, Frank O'Hara and Kenneth Koch. He returned to Paris in 1958, and in 1961, married Clarice Price. Rivers was given a studio at the Slade School of Fine Arts, University of London, in 1964. A retrospective was organised by the Rose Art Museum of Brandeis University in 1965. In addition to working on painting-constructions in the 1960s, Rivers collaborated on television films for which he took two trips to Africa, one life threatening, before returning to New York. Rivers has four children: Joseph, Steven, Gwynne and Emma.

James Rosenquist (b. 1933)

James Rosenquist was born on 29 November 1933, in Grand Forks, ND. His family moved frequently during his childhood. They were living in Minneapolis, MN, when Rosenquist won a scholarship to Saturday art classes at the Minneapolis School of Art. From 1952 to 1954, Rosenquist studied at the University of Minnesota under Cameron Booth. In 1955, Rosenquist went to New York on another scholarship, to study at the Art Students League. In the mid-1950s, Rosenquist met Edwin Dickinson, George Grosz, Robert Indiana, Robert Rauschenberg, Jasper Johns and Jack Youngerman, and shared a studio with Alice Forman, Joan Warner and Peggy Smith. Between 1957 and 1960, Rosenquist worked for Artcraft Strauss Company painting billboards. He took drawing classes organised by Youngerman and Indiana. Claes Oldenburg and Henry Pearson were also in those classes in the late 1950s. While painting billboards outside of an office building, Rosenquist met a textile designer named Mary Lou Adams whom he married in 1960. By 1960, Rosenquist's work was attracting the attention of the influential such as Ileana Sonnabend, Ivan Karp, Richard Bellamy, Henry Geldzahler and Leo Castelli. In 1961, Rosenquist joined the Green Gallery and had his first one-man show there in 1962. Rosenquist was commissioned by Philip Johnson to paint a mural for the New York World's Fair in 1963. That year he was included in group shows at the Museum of Modern Art and the Solomon R. Guggenheim Museum. He joined the Leo Castelli Gallery in 1963 and had his first exhibition in Paris in 1964. Before his marriage ended, his son, John, was born in 1964. Rosenquist moved his studio to East Hampton, NY, in 1967, but now lives in New York.

Mark Rothko (1903–70)

Mark Rothko was born Marcus Rothkowitz in Dyinsk, Russia, on 25 September 1903. He emigrated to Portland, OR, in 1913. Rothko attended Yale University from 1921 to 1923. He moved to New York and enrolled at the Art Students League in 1924. There he took an anatomy course with George Bridgman and studied painting with Max Weber. Rothko taught art at the Brooklyn Jewish Center from 1929 to 1952. In 1932, Rothko married Edith Sachar. The Portland Museum of Art had a one-man show of Rothko's work in 1933. Rothko co-founded the art group, The Ten, in 1935, and exhibited with them for the next five years. In 1936 Rothko worked for the Works Progress Administration. He became a naturalised citizen in 1938. His first marriage having ended in divorce, Rothko married Mary Alice (Mell) Beistel in 1945. Their daughter, Kathy Lynn (Kate) was born in 1950 and their son, Christopher Hall, was born in 1963. Rothko exhibited at Art of This Century in 1945 and at Betty Parsons annually from 1947 to 1952. Rothko taught summer sessions at the California School of Fine Arts, San Francisco, in 1947 and 1949. He was visiting artist at Tulane University, New Orleans, in 1957. In the spring of 1964, John and Dominique de Menil commissioned Rothko to paint murals for a chapel in Houston, TX. Rothko took his family to Europe in

1966, and taught at the University of California, Berkeley, summer 1967. On 25 February 1970, Rothko committed suicide in New York.

Anne Ryan (1889–1954)

Anne Ryan was born in Hoboken, NJ, on 20 July 1889. She received a convent education and in 1911 had completed a second year at St Elizabeth's College when she married a law student, William McFadden, and moved to Newark. Before separating in 1923, they had three children: twins, William J. Jr and Elizabeth, born in 1912, and Thomas Soren, born in 1919. During the twenties, Ryan cultivated the literati and artistic milieu in Hoboken and New York. Her first book of poetry, *Lost Hills*, was published in 1925. In 1931, Ryan went to Majorca to concentrate on her writing. She spent the summer of 1932 in Paris and in 1933 returned to live in New York. Encouraged by her new friends, Tony Smith and Hans Hofmann, Ryan, at the age of forty-nine, began to paint. In 1941, she joined Atelier XVII and had her first New York one-person show at The Pinacotheca. The turning point in Ryan's career came in 1948 when she saw the Kurt Schwitters exhibition at the Rose Fried Gallery. Subsequently Ryan began making collages that were exhibited at the Marquie Gallery within the year. The following year the Kharouba Gallery in Portland, OR, held a major exhibition of her collages, and in 1950, Ryan joined the Betty Parsons Gallery. During the early 1950s, Ryan continued working in the medium of collage refining her choice of materials and developing stylistic subtleties. While her collages were being exhibited and critically accepted, she was still writing and publishing stories. On 18 April 1954, Anne Ryan died in Morristown, NJ.

George Segal (b. 1924)

George Segal was born on 26 November 1924, in New York. The family lived in the Bronx until 1940 when they moved to South Brunswick, NJ. Segal attended Cooper Union from 1941 to 1942 and Rutgers University, NJ, part-time from 1942 to 1946. In April of 1946, Segal married Helen Steinberg with whom he had two children, Jeffrey and Rena. Segal studied at Pratt Institute, Brooklyn, 1947–48, and in 1949 received a BS in Art Education from New York University where he studied with William Baziotes and Tony Smith. During this period, he frequented the Eighth Street Artists Club. By 1953, he became friends with Allan Kaprow. Segal went to the artists' community in Provincetown, MA, for three consecutive summers beginning in 1956, where he met Hans Hofmann. In 1956, Segal had his first one-man show at the Hansa Gallery, but his paintings did not sell well. He was resigned to teaching school and operating the family chicken farm in New Jersey, where in 1958, Segal started working in sculpture. A year later he exhibited his plaster figures at Hansa Gallery, and, then, in 1960, he exhibited plaster figures in tableaux at the Green Gallery in New York. Segal received an MFA from Rutgers University in 1963, where his thesis project was his own sculpture. He first travelled to Europe in 1963, visiting Paris and Düsseldorf. Exhibiting at the Sidney Janis Gallery frequently between 1965 and 1982, Segal created his first bas-reliefs in 1966 and his first fragments in 1969. He lectured at Princeton University in New Jersey during 1968–69. He was given retrospective exhibitions at the Walker Art Center, Minneapolis in 1978, which travelled to the San Francisco Museum of Modern Art and the Whitney Museum of American Art, and at the Israel Museum, Jerusalem, in 1983. Segal lives in South Brunswick, NJ.

Ben Shahn (1898–1969)

Ben Shahn was born in Kovno, Lithuania, on 12 September 1898. In 1906, he emigrated with his family to Brooklyn, NY.

From 1913 to 1917, he was apprenticed to Hessenberg's Lithography Shop in Manhattan, and in 1916, he enrolled at the Art Students League for a month. Between 1919 and 1922, he studied at New York University, City College of New York, and the National Academy of Design. In 1922, Shahn married Matilda Goldstein, with whom he had two children, Judith and Ezra. In 1924–25, Shahn travelled in North Africa, Spain, Italy and France to study at the Académie de la Grande Chaumière. Shahn met Walker Evans in 1929, and in 1930, he had his first one-man show at the Downtown Galleries. He began the Sacco-Vanzetti series in 1931. Shahn enrolled with the Public Works of Art Project in 1934. Shahn's first marriage ended in divorce; and in 1935, he married Bernarda Bryson with whom he had three more children, Susanna, Jonathan and Abigail. He was employed by the Farm Security Administration from 1935 to 1938, and in 1938, Shahn and his wife were commissioned to paint the Bronx Central Annex Post Office Murals. The Shahns moved to Jersey Homesteads (later Roosevelt), NJ, in 1939. In 1942, Shahn worked as Graphics Director of the Office of War Information and in 1945 worked in the Graphics Arts Division of the Congress of Industrial Organisations, a labour group. Shahn was a prolific writer and published regularly as he continued to exhibit his paintings and prints. He taught at the Boston Museum of Fine Arts, in 1947, and at the University of Colorado and at the Brooklyn Museum Art School in the early 1950s. Shahn exhibited at the 1954 XXVII Venice Bienniale, and was the Charles Eliot Norton Professor at Harvard University in 1956–57. Ben Shahn died on 14 March 1969.

Charles Sheeler (1883–1965)

Charles R. Sheeler Jr, was born 16 on July 1883, in Philadelphia, PA. He studied applied design at the School of Industrial Art from 1900 to 1903. Between 1903 and 1906, Sheeler studied with William Merritt Chase at the Pennsylvania Academy of the Fine Arts, including Chase's summer tours of England and Holland in 1904 and Spain in 1906. In 1907, Sheeler exhibited in group shows at the National Academy of Design, the Pennsylvania Academy of the Fine Arts and at the Macbeth Gallery in New York. Sheeler left for Europe in 1908, and travelled in Italy and France for the next year. He returned to Philadelphia and in 1912 took up commercial photography recording architectural projects. Six of Sheeler's paintings were exhibited in the 1913 Armory Show in New York, and he exhibited at the Anderson Galleries' 'The Forum Exhibition of Modern American Painters' of 1916. In 1919, Sheeler moved to New York. The following year he collaborated with Paul Strand on the film, *Manhatta* and had his first one-man show in New York at the De Zayas Gallery. Sheeler married Katharine Shaffer in 1923, and in 1927 they moved to South Salem, NY. Sheeler's series of thirty-two photographs of the Ford Motor Company in River Rouge, MI, taken in 1928, provided industrial themes for future paintings. Sheeler visited Paris and Germany in 1929. He joined the Downtown Gallery and had his first one-man show there in 1931. In 1932, Sheeler and his wife, Katharine, moved to Ridgefield, CT. She died the following year. In 1939, the Museum of Modern Art held a retrospective of Sheeler's paintings. In 1942, Sheeler married Musya Sokolova and moved to Irvington-on-Hudson, NY. Sheeler served as artist-in-residence at Philips Academy in Andover, MA, in 1946. A stroke in 1959 left Sheeler unable to paint or take photographs. He died on 7 May 1965, in Dobbs Ferry, NY.

John Sloan (1871–1951)

John Sloan was born on 2 August 1871, in Lock Haven, PA. His family moved to Philadelphia in 1876. Sloan attended Central High School from 1884 to 1888. Among his classmates were

future artist, William Glackens, and future collector, Albert C.Barnes. Sloan taught himself to etch. He studied drawing at night at the Spring Garden Institute in Philadelphia in 1890. In 1892, he began classes with Thomas Anshutz at the Pennsylvania Academy of the Fine Arts and joined the art department of the Philadelphia *Inquirer*. From 1895 to 1898, Sloan worked for the Philadelphia *Press*. He was also art editor of *Moods: a Journal Intime*, doing magazine illustrations and painting portraits. He illustrated Stephen Crane's *Great Battles of the World* in 1900. In 1901, Sloan married Anna (Dolly) M.Wall. They moved to New York in 1904, and Sloan exhibited with the Henri group at the National Arts Club. As a member of The Eight, Sloan exhibited at the Macbeth Gallery in 1908. He was the Socialist party candidate for the New York State Assembly in 1910 and 1915. He was art editor for *The Masses* from 1912 to 1916. Sloan exhibited two paintings and five etchings in the New York Armory Show of 1913. He taught at the Art Students League from 1914 to 1930, and again from 1932 to 1938. In 1918, Sloan accepted a life-time position as president of the Society of Independent Artists. He published his book *Gist of Art* in 1939. After the death of his first wife in 1943, Sloan married Helen Farr in 1944, spending increasingly more time in Santa Fe, NM. He died on 7 September 1951, in Hanover, NH.

Raphael Soyer (b.1899)

Raphael Soyer and his twin brother, Moses, were born in Borisoglebsk, Russia, on 25 December 1899. The family emigrated to Philadelphia, PA, in 1912 and moved to the Bronx, NY, the following year. Soyer took night classes at Cooper Union from 1914 to 1919. He studied at the National Academy of Design from 1919 to 1923 and at the Art Students League from 1920 to about 1922 under Guy Pène du Bois. Soyer participated in group shows at the Salons of America in 1926, and the Whitney Studio Club, 1927–28. The Daniel Gallery gave him his first one-man show in 1929. Soyer taught at the John Reed Club, New York, in 1930, and at the Art Students League from 1933 to 1934 and again from 1935 to 1942. In 1931, Soyer married Rebecca Letz; they have one daughter, Mary. He spent three months in Europe in 1935. During the 1940s, Soyer exhibited regularly at and received honours from the Art Institute of Chicago, 1940; the Corcoran Gallery of Art, Washington, DC, 1943 and the Pennsylvania Academy of the Fine Arts, 1946. During the early 1950s, Raphael Soyer organised informal discussion sessions among New York Realist artists. The group published a magazine called *Reality: A Journal of Artists' Opinions*, but soon disbanded and the publication folded. From 1957 to 1962, Soyer taught at the New School for Social Research, and between 1965 and 1967, he taught at the National Academy of Design. The Whitney Museum of American Art organised a Raphael Soyer retrospective in 1967 which travelled to Chapel Hill, NC; Atlanta, GA; San Francisco, CA; Columbus, OH; Minneapolis, MN and Des Moines, IA. The Hirshhorn Museum and Sculpture Garden, Washington, DC, celebrated Soyer's eightieth birthday with a one-man show in 1980. Raphael Soyer lives in New York.

Saul Steinberg (b.1914)

Saul Steinberg was born in Ramnicul-Sarat, Romania, on 15 June 1914. Within six months, his family moved to Bucharest. Steinberg graduated from school in 1932 and studied Philosophy and Letters at the University of Bucharest. He enrolled in the Politecnico Facolta di Architettura, Milan, in 1933. In 1936, he began publishing cartoons for a biweekly, *Bertoldo*, and by 1940, when he graduated as Dottore in Architettura, his drawings were being published in *Life* and

Harper's Bazaar. Steinberg practised architecture in Milan from 1939 to 1941. He left Italy in 1941 for the Dominican Republic, and then emigrated to the United States in 1942. He enlisted in the US Navy in 1942 and became a naturalised citizen in 1943. Betty Parsons gave Steinberg his first one-man show in 1943, and in October of that year Steinberg married the artist, Hedda Sterne. Steinberg's military service required extensive travel in the Asian, European and African theatres, and in 1945 he published a book of drawings of his wartime experiences as an enlisted man. After the war, Steinberg lived in Paris while covering the Nuremberg trials for the *New Yorker*. During the 1940s, Steinberg exhibited at the Museum of Modern Art, the Metropolitan Museum of Art, New York; the Detroit Institute of Arts and the Victoria and Albert Museum in London. In the early 1950s, Steinberg lived in California, Italy and South America. In the late 1950s and early 1960s, he travelled extensively in Russia, Europe, Africa, the Near East and the Far East. He was the artist-in-residence at the Smithsonian Institution, Washington, DC, in 1967. He lives and works in New York and East Hampton.

Frank Stella (b.1936)

Frank Philip Stella was born in Malden, MA, on 12 May 1936. At Phillips Academy in Andover, MA, he studied with the abstract painter, Patrick Morgan. In 1954 he went to Princeton University, where he studied painting with Stephen Greene, designed covers for the college literary magazine, *Nassau Lit*, and began to visit New York museums and galleries. Stella graduated with an AB in history in 1958 but was already influenced by Johns, Rothko and Gottlieb. He moved to New York where he did odd jobs and painting. In 1959, Stella was in a group show at the Allen Memorial Art Museum, Oberlin College, OH. Through the art historian Robert Rosenblum, who had been at Princeton with Stella, Stella met Johns and Rauschenberg. In 1959, he joined the Castelli Gallery. In 1960, Stella lectured at Pratt Institute in Brooklyn. He travelled extensively in 1961, stopping first in Lakeland, FL, to see the buildings by Frank Lloyd Wright at Florida Southern College and then to England, France, Spain and Morocco. That year, Stella married Barbara Rose in London and exhibited at the Galerie Lawrence in Paris. He returned to New York and was in a 1962 production by Merce Cunningham and a 1966 performance piece by Rauschenberg. His daughter, Rachel, was born in 1962, and his son, Michael, was born in 1966. Stella was the artist-in-residence at Dartmouth College, New Hampshire in 1963; visiting critic at the Department of Art of Cornell University in 1965 and artist-in-residence at the University of California, Irvine, in 1967. He was included in the XXXII Biennale in Venice in 1964. After his 1970 retrospective at the Museum of Modern Art, Stella turned to imaginative spatial relief and colour abstraction. He lives and works in New York.

Clyfford Still (1904–80)

Clyfford Still was born on 30 November 1904, in Grandin, ND. His family moved to Spokane, WA, in 1905. During Still's early years, his family moved back and forth from Spokane to South Alberta, Canada. Still studied literature, music and poetry as a youth and took his first trip to New York in 1926. He enrolled in the Art Students League, stayed less than an hour and returned to Spokane. He went to Spokane University for a year, and then moved to Canada until 1931. Still re-entered Spokane University with a teaching fellowship and graduated in 1933. From 1933 to 1941, Still taught at Washington State College in Pullman, WA. He also taught at Richmond Professional Institute in Virginia from 1943 to 1945. In 1945, Still moved to New York and through Mark Rothko, met Peggy Guggenheim

who gave him a one-man show at Art of This Century in 1946. Still went back to teaching in 1946, first at California School of Fine Arts, San Francisco, 1946 to 1950; and then at Hunter College, New York, 1951 and Brooklyn College, 1952–53. He was visiting artist at the University of Colorado, Boulder, in 1960. Still interrupted his teaching to try to organise 'The Subjects of the Artist', with Rothko. They hoped to teach young artists in the milieu of New York. By 1948, the project demanded his full attention, so Still left California to join William Baziotes, David Hare, Robert Motherwell and Mark Rothko in New York; however, the informal art school project was abandoned and Still returned to teaching. He moved to Maryland in 1961 and died in Baltimore on 23 June 1980.

Mark Tobey (1890–1976)

Mark Tobey was born on 11 December 1890, in Centerville, WI. He attended Saturday classes at the Art Institute of Chicago after his family moved to Hammond, IA, in 1906. Tobey, who admired Charles Dana Gibson, worked as a fashion artist in Chicago and New York between 1911 and 1917. Though reared a Congregationalist, Tobey joined the Baha'i World Faith about 1918. Tobey had an unsuccessful marriage in the early 1920s. He taught at the Cornish School of Allied Arts in Seattle, WA, 1922 to 1923, where a student, Teng Kuei, introduced him to Chinese brushwork. Tobey travelled in Europe and the Near East from 1925 to 1927. In the late 1920s, Tobey divided his time among Seattle, Chicago and New York. In 1931, he went to Mexico where he met Martha Graham, Marsden Hartley and René d'Harnoncourt. Tobey was a resident artist at Dartington Hall, Devon, England from 1931 to 1938, where he met Pearl S. Buck, Arthur Waley, Aldous Huxley, Rabindranath Tagore and Rudi Shankar. While at Dartington Hall, Tobey visited Europe and the Orient, living briefly in a Zen monastery. Tobey worked for the Works Progress Administration in 1938. Through the 1940s and 1950s, Tobey lived in Seattle, WA, but his paintings continued to be exhibited in New York and internationally, including the Venice Biennales of 1948, 1956 and 1958. Tobey met the painter, Pehr Hallsten, in 1954 while visiting Sweden. In 1960, Tobey moved to Basel, Switzerland, with Pehr Hallsten and Mark Ritter. He was given retrospective exhibitions by the Musée des Arts Decoratifs, Paris in 1961 and the Museum of Modern Art, New York in 1962–63. Tobey was also a poet and an accomplished pianist. He died in Basel on 24 April 1976.

Max Weber (1881–1961)

Max Weber was born in Bialystock, Russia, on 18 April 1881. His family emigrated to Brooklyn, NY, in 1886. After graduating from Boy's High School, he attended Pratt Institute studying under Arthur Wesley Dow. He taught drawing at the University of Virginia, 1901–1903 and at the State Normal School, Duluth, MN, 1903–1905. In 1905, Weber went to Paris and began studies at the Académie Julian under Jean-Paul Laurens. Later he studied at the Académies Colarossi and Grand Chaumière and organised art classes under Henri Matisse. Before returning to New York in 1909, Weber met Rousseau, Picasso, Robert Delaunay, Apollinaire and Maurice Denis, exhibited at the Salon d'Automne and travelled in Spain and Italy. In 1909 he had his first one-man show at the Haas Gallery in New York, and exhibited in a group show at '291'. In 1911 he had his first one-man show at '291'. Weber was selected by Roger Fry to participate in the 1913 Grafton Group exhibition in London. Weber's first book of poems was published in 1913. His *Essays on Art* was published three years later, and his second book of poems, *Primitives*, was published in 1926. In 1916, Weber married Frances Abrams with whom he had two children: a son, Maynard Jay, born 1923 and a daughter, Joy Sarah, born 1927. Weber taught at the White School of Photography in New York, 1914–18, at the Art Students League, 1920–21 and 1925–27, and was a guest teacher at Minnesota State University in 1931. In 1929, the Webers moved to Great Neck, Long Island, NY. Retrospectives of his work were held at the Museum of Modern Art in 1930 and at the Whitney Museum of American Art in 1949. His paintings have been shown extensively in exhibitions in the United States and internationally. He received numerous honours and awards during his lifetime. Max Weber died on 4 October 1961.

Tom Wesselmann (b. 1931)

Tom Wesselmann was born in Cincinnati, OH, on 23 February 1931. His early aspirations did not include becoming an artist. While serving in the US Army during the Korean War (1952–54), Wesselmann began drawing gag cartoons. At Fort Riley, KS, he studied aerial photograph interpretation, and later at Fort Bragg, NC, he taught the subject. Upon discharge, Wesselmann returned to the University of Cincinnati where he began selling his cartoons while completing a degree in psychology. After graduating in 1956, Wesselmann moved to New York to study at Cooper Union under Alex Katz and Nicholas Marsicano. In 1959, Wesselmann graduated from Cooper Union. Though despondent over the break-up of his marriage, he kept working and began a series of collages. Wesselmann was impressed with the work of Motherwell, de Kooning, Matisse and the composer, John Cage. He was very fond of the writings of Jack Kerouac, Samuel Beckett, Ionesco and Henry Miller. By 1961, he was exhibiting regularly and had begun the Great American Nudes. Subsequently he painted series of *Still-Lifes*, *Bathtub Collages* and *Foot Paintings*. In 1966, he joined the Sidney Janis Gallery. In 1973, he began work on the book *Tom Wesselmann* under the pseudonym, Slim Stealingworth. The project lasted ten years. During that time, Wesselmann continued painting and expanded to sculpture. He has participated in numerous one-man, group and museum exhibitions. He now lives with his wife, Claire in New York. They have three children, Jenny, Kate and Lane.

Andrew Wyeth (b. 1917)

Andrew Newell Wyeth, the son of N.C. Wyeth, was born on 12 July 1917, in Chadds Ford, PA. Wyeth attended a Montessori School but received most of his education through tutors who came to the home. At the age of fifteen Andrew began taking art lessons from his father who stressed the use of models over imagination. In the late 1930s, Peter Hurd, Wyeth's brother-in-law, introduced Wyeth to the medium of tempera. In 1937, Wyeth exhibited at the Macbeth Gallery in New York. Wyeth was influenced by Winslow Homer, his father, and the prints of Albrecht Dürer. In 1940, Wyeth married Betsy Merle James who took him to meet her childhood friend, Christina Olsen. Wyeth painted many pictures of the Olsen family and their home in Cushing, ME. From the 1940s, the Olsens joined the Kuerners, the Wyeth's neighbours in Pennsylvania, as Wyeth's most absorbing subjects. Wyeth's son, Nicholas, was born in 1943, and his second son, James Browning, who would also become an artist, was born in 1946. Wyeth's meticulous imagery has made him one of America's most popular artists. He has received numerous awards and honours. Major retrospective exhibitions of his work have toured the United States, England and Japan. Wyeth, often categorised as a Magic Realist, never abandoned the world and tradition to which he was born. He lives in Chadds Ford, PA and Cushing, ME.

N.C. Wyeth (1882–1945)

Newell Convers Wyeth was born in Needham, MA, on 22 October 1882. After graduating from Mechanic Arts School in 1899, he studied at the Massachusetts Normal Art School and Eric and Pape's Art School in Boston under George L. Nayes and Charles W. Reed. Wyeth went to Wilmington, DE, in 1902, to study with the illustrator, Howard Pyle. In 1904, Wyeth worked on a ranch in Colorado and as a mailrider in New Mexico. While in the southwest, he collected costumes and other items he would use as props in later paintings. In 1906, Wyeth married Carolyn B. Bockius and moved to Chadds Ford, PA. Together they had five children: Henriette, born 1907; Carolyn, born 1909; Nathaniel Convers, born 1911; Ann, born 1915 and Andrew Newell III, born 1917. Wyeth illustrated Robert Louis Stevenson's *Treasure Island, Kidnapped, The Black Arrow* and *The Adventures of Robin Hood*. He received commissions to paint large panels in the Missouri State Capitol of Civil War Battles, panels in the Federal Reserve Bank, murals in the New First National Bank of Boston and three panel murals in the dining room of the Hotel Roosevelt in New York. In later years Wyeth lamented his concentrated focus on illustration. Though he felt he had earned a very good living, he wished he had done more easel painting. Wyeth's strong but nurturing manner encouraged spontaneous creativity especially in his own children. The Wyeths lived in Chadds Ford except for summers in Maine and during the period 1921 to 1923 spent in Needham, MA. Wyeth painted over 2,000 illustrations for articles, posters, advertisements and books. N.C. Wyeth and his grandson, Newell C. Wyeth II, were killed in a car accident on 19 October 1945.

Selected bibliography

GENERAL BOOKS

Baigell, Matthew, *American Scene: American Painting of the 1930s* (New York: Praeger Publishers, Inc., 1974)

Barr, Alfred H. Jr, ed., *Fantastic Art, Dada, Surrealism* (New York: Museum of Modern Art, 1936)

Battcock, Gregory, ed., *Minimal Art: A Critical Anthology* (New York: E. P. Dutton, 1968)

— ed., *Superrealism* (New York: Dutton, 1975)

Berman, Greta and Wechsler, Jeffrey, *Realism and Realities: The Other Side of American Painting, 1940–1960* (New Brunswick, NJ: Rutgers University Art Gallery, 1982)

Brown, Milton W., *American Painting: From the Armory Show to the Depression* (Princeton, NJ: Princeton University Press, 1955)

— *The Story of the Armory Show* (New York: Joseph H. Hirshhorn Foundation, 1963)

Friedman, Martin, *The Precisionist View in American Art* (Minneapolis, MN: Walker Art Center, 1960)

Hobbs, Robert C. and Levin, Gail, *Abstract Expressionism: The Formative Years* (Ithaca, NY: Cornell University Press, 1979)

Homer, William I., *Alfred Stieglitz and the American Avant-Garde* (Boston, MA: New York Graphic Society, 1977)

— ed., *Avant-Garde Painting and Sculpture in America, 1910–1925* (Wilmington, DE: Delaware Art Museum, 1975)

Lane, John R. and Larson, Susan C., *Abstract Painting and Sculpture in America 1927–1944* (New York: Harry N. Abrams, Inc., 1983)

Levin, Gail, 'American Art', in *Primitivism in 20th Century Art: Affinity of the Tribal and the Modern*, ed. William Rubin (New York: Museum of Modern Art, 1984)

— 'Surrealisten in New York und Ihr Einfluss auf Die Americanische Kunst', in *Europa/Americka: Die Geschichte einer Kunstlerischen Faszination seit 1940* (Cologne, West Germany: Museum Ludwig, 1986)

— *Synchromism and American Color Abstraction* (New York: George Braziller, 1978)

Levin, Sandra Gail, 'Wassily Kandinsky and the American Avant-garde, 1912–1950' (New Brunswick, NJ: Ph.D. dissertation, Rutgers University, 1976)

Pincus-Witten, Robert, *Postminimalism* (New York: Out of London Press, Inc., 1977)

Robins, Corinne, *The Pluralist Era: American Art, 1968–1981* (New York: Harper & Row, Publishers, 1984)

Sandler, Irving, *The New York School: The Painters & Sculptors of the Fifties* (New York: Harper & Row, Publishers, 1978)

— *The Triumph of American Painting: A History of Abstract Expressionism* (New York: Praeger Publishers, Inc., 1970)

Seitz, William C., *Abstract Expressionist Painting in America* (Cambridge, MA: Harvard University Press, 1983)

Tsujimoto, Karen, *Images of America: Precisionist Painting and Modern Photography* (Seattle, WA: University of Washington Press, 1982)

Weschsler, Jeffrey, *Surrealism and American Art, 1931–1947* (New Brunswick, NJ: Rutgers University Art Gallery, 1977)

INDIVIDUAL ARTISTS

Joseph Albers
Gromringer, Eugene, *Joseph Albers* (New York: George Wittenborn, Inc., 1968)

Ivan Albright
Croydon, Michael, *Ivan Albright* (New York: Abbeville Press, 1978)

Milton Avery
Grad, Bonnie L., *Milton Avery* (New York: Strathcona, 1981)
Kramer, Hilton, *Milton Avery: Paintings 1930–1960* (New York: Yoseloff, 1962)

Romare Bearden
Greene, Carroll, Jr, *Romare Bearden: The Prevalence of Ritual* (New York: Museum of Modern Art, 1971)

George Bellows
Bellows, Emma, *The Paintings of George Bellows* (New York: Alfred A. Knopf, 1929)
Morgan, Charles H., *George Bellows: Painter of America* (New York: Reynal & Company, 1965)
Young, Mahonri Sharp, *The Paintings of George Bellows* (New York: Watson-Guptill Publications, 1973)

Thomas Hart Benton
Baigell, Matthew, ed., *A Thomas Hart Benton Miscellany* (Lawrence, KS: University Press of Kansas, 1971)
— *Thomas Hart Benton* (New York: Harry N. Abrams, Inc., 1974)
Benton, Thomas Hart, *An American in Art. A Professional and Technical Autobiography* (Lawrence, KS: University Press of Kansas, 1969)
Burroughs, Polly, *Thomas Hart Benton: A Portrait* (Garden City, NY: Doubleday & Company, Inc., 1981)
Levin, Gail, 'Thomas Hart Benton, Synchromism, and Abstract Art', *Arts Magazine* 56 (December 1981), pp. 144–48

Oscar Bluemner
Oscar Bluemner: Paintings, Drawings (New York: New York Cultural Center, 1969)
Zilczer, Judith, *Oscar Bluemner: The Hirshhorn Museum and Sculpture Garden Collection* (Washington, DC: Smithsonian Institution Press, 1979)

Guy Pène du Bois
Guy Pene du Bois: Artist about Town (Washington, DC: Corcoran Gallery of Art, 1980)

Patrick Henry Bruce
Agee, William C. and Rose, Barbara, *Patrick Henry Bruce, American Modernist: A Catalogue Raisonné* (New York: Museum of Modern Art, 1979)
Levin, Gail, 'Patrick Henry Bruce and Arthur Burdett Frost, Jr.: From the Henri Class to the Avant-Garde', *Arts Magazine* 53 (April 1979), pp. 102–106

Charles Burchfield
Barr, Alfred H., Jr, *Charles Burchfield: Early Watercolors* (New York: Museum of Modern Art, 1930)
Baur, John I. H., *Charles Burchfield* (New York: Whitney Museum of American Art, 1956)
— *The Inlander: The Life and Work of Charles Burchfield, 1893–1967* (Newark, DE: University of Delaware Press, 1982)
Travato, Joseph S., *Charles Burchfield, Catalogue of Paintings in Public and Private Collections* (Utica, NY: Munson-Williams-Proctor Institute, 1970)

Joseph Cornell
Ashton, Dore, *A Joseph Cornell Album* (New York: Viking Press, 1974)
McShine, Kynaston, ed., *Joseph Cornell* (New York: Museum of Modern Art, 1980)
Waldman, Diane, *Joseph Cornell* (New York: George Braziller, 1977)

Ralston Crawford
Agee, William C., *Ralston Crawford* (New York: Twelve Trees Press, 1983)

Stuart Davis
Blesh, Rudi, *Stuart Davis* (New York: Grove Press, Inc., 1960)
Goosen, E. C., *Stuart Davis* (New York: George Braziller, 1959)
Kelder, Diane, ed., *Stuart Davis* (New York: Praeger Publishers, Inc., 1971)
Lane, John R., *Stuart Davis: Art and Theory* (Brooklyn, NY: Brooklyn Museum, 1978)

Willem de Kooning
Gaugh, Harry F., *Willem de Kooning* (New York: Abbeville Press, 1983)
Hess, Thomas B., *Willem de Kooning*. The Great American Artist Series (New York: George Braziller, 1959)
Rosenberg, Harold, *Willem de Kooning* (New York: Harry N. Abrams, Inc., 1974)

Charles Demuth
Eiseman, Alvord L., *Charles Demuth* (New York: Watson-Guptill Publications, 1982)
Ritchie, Andrew Carnduff, *Charles Demuth* (New York: Museum of Modern Art, 1950)

Arthur G. Dove
Morgan, Ann Lee, *Arthur Dove: Life and Work, With a Catalogue Raisonné* (Newark, DE: University of Delaware Press, 1984)
Wight, Frederick S., *Arthur G. Dove* (Berkeley, CA: University of California Press, 1958)

Richard Estes
Richard Estes: The Urban Landscape (Boston, MA: Museum of Fine Arts, 1978)

Arshile Gorky
Jordan, Jim M. and Goldwater, Robert, *The Paintings of Arshile Gorky: A Critical Catalogue* (New York: New York University Press, 1982)
Levy, Julien, *Arshile Gorky* (New York: Harry N. Abrams, Inc., 1966)
Rand, Harry, *Arshile Gorky: The Implications of Symbols* (Montclair, NJ: Allanheld & Schram, 1980)

Marsden Hartley
Haskell, Barbara, *Marsden Hartley* (New York: New York University Press, 1980)
Levin, Gail, 'Marsden Hartley and the European Avant-Garde', *Arts Magazine* 54 (September 1979), pp. 158–63
— 'Marsden Hartley, Kandinsky, and Der Blaue Reiter', *Arts Magazine* 52 (November 1977) pp. 156–60
— 'Marsden Hartley and Mysticism', *Arts Magazine* 60 (November 1985), pp. 16–21
McCausland, Elizabeth, *Marsden Hartley* (Minneapolis, MN: University of Minnesota Press, 1952)

Al Held
 Sandler, Irving, *Al Held* (New York: Hudson Hills Press, 1984)
 Tucker, Marcia, *Al Held* (New York: Whitney Museum of American Art, 1974)

Robert Henri
 Homer, William Innes, *Robert Henri and His Circle* (Ithaca, NY: Cornell University Press, 1969)
 Perlman, Bennard B., *Robert Henri Painter* (Wilmington, DE: Delaware Art Museum, 1984)

Hans Hofmann
 Goodman, Cynthia., *Hans Hofmann* (New York: Abbeville Press, 1986)
 Seitz, William C., *Hans Hofmann* (New York: Museum of Modern Art, 1963)

Edward Hopper
 Goodrich, Lloyd, *Edward Hopper* (New York: Harry N. Abrams, Inc., 1971)
 Levin, Gail, *Edward Hopper* (New York: Crown Publishers, Inc., 1984)
 — *Edward Hopper: The Art and the Artist* (New York: W. W. Norton & Co., 1980)
 — *Edward Hopper: The Complete Prints* (New York: W. W. Norton & Co., 1979)
 — *Edward Hopper: Gli anni della formazione* (Milan, Italy: Electra Editrice, 1981)
 — *Edward Hopper as Illustrator* (New York: W. W. Norton & Co., 1979)
 — *Hopper's Places* (New York: Alfred A. Knopf, 1985)

Rockwell Kent
 Johnson, Fridolf, ed., *Rockwell Kent: An Anthology of His Works* (New York: Alfred A. Knopf, 1982)
 Traxel, David, *An American Saga: The Life and Times of Rockwell Kent* (New York: Harper & Row, Publishers, 1980)

Lee Krasner
 Rose, Barbara, *Lee Krasner: A Retrospective* (New York: Museum of Modern Art, 1983)

Walt Kuhn
 Adams, Phillip Rhys, *Walt Kuhn, Painter His Life and Work* (Columbus, OH: Ohio State University Press, 1978)

Ernest Lawson
 Ernest Lawson (New York: ACA Heritage Gallery, Inc., 1967)
 Bois, Guy Pène du, *Ernest Lawson* (New York: Whitney Museum of American Art, 1932)
 Karpiscak, Adeline Lee, *Ernest Lawson 1873–1939* (Tucson, AZ: University of Tucson Museum of Art, 1979)

Jack Levine
 Getlein, Frank, *Jack Levine* (New York: Harry N. Abrams, Inc., 1966)
 Levine, Jack, *Jack Levine Recent Work* (New York: Kennedy Galleries, Inc., 1975)
 Wight, Frederick S. and Goodrich, Lloyd, *Jack Levine* (New York: Whitney Museum of American Art, 1955)

Roy Lichtenstein
 Alloway, Lawrence, *Roy Lichtenstein* (New York: Abbeville Press, 1983)
 Coplans, John, ed., *Roy Lichtenstein* (New York: Praeger Publishers, Inc., 1972)
 Waldman, Diane, *Roy Lichtenstein* (London: Thames and Hudson, 1971)

Richard Lindner
 Kramer, Hilton, *Richard Lindner* (Boston, MA: New York Graphic Society, 1975)
 Swanson, Dean, *Richard Lindner* (Berkeley, CA: University Art Museum, University of California, 1969)

Morris Louis
 Elderfield, John, *Morris Louis* (New York: Museum of Modern Art, 1986)
 Fried, Michael, *Morris Louis, 1912–1962* (Boston, MA: Museum of Fine Arts, 1967)
 — *Morris Louis* (New York: Harry N. Abrams, Inc., 1970)

John Marin
 Norman, Dorothy, *The Selected Writings of John Marin* (New York: Pellegrini & Cudahy, 1949)
 Reich, Sheldon, *John Marin: A Stylistic Analysis and Catalogue Raisonné* (Tucson, AZ: University of Arizona Press, 1970)

Reginald Marsh
 Cohen, Marilyn, *Reginald Marsh's New York: Paintings, Drawings, Prints and Photographs* (New York: Dover Publications, Inc., 1983)
 Goodrich, Lloyd, *Reginald Marsh* (New York: Harry N. Abrams, Inc., 1972)
 Laning, Edward, *The Sketchbooks of Reginald Marsh* (Greenwich, CT: New York Graphic Society, Ltd, 1973)

Walter Murch
 Walter Murch: A Retrospective Exhibition (Providence, RI: Museum of Art, Rhode Island School of Design, 1966)

Georgia O'Keeffe
 Goodrich, Lloyd, *Georgia O'Keeffe* (New York: Whitney Museum of American Art, 1970)
 Lisle, Laurie, *Portrait of an Artist* (New York: Washington Square Press, 1980)
 O'Keeffe, Georgia, *Georgia O'Keeffe* (New York: Viking Press, 1976)

Alfonso Ossorio
 Friedman, Bernard Harper, *Alfonso Ossorio* (New York: Harry N. Abrams, Inc., 1973)
 Alfonso Ossorio (East Hampton, NY: Guild Hall Museum, 1980)

Maxfield Parrish
 Ludwig, Coy, *Maxfield Parrish* (New York: Watson-Guptill Publications, 1973)
 Saunders, Louise, *The Knave of Hearts* (New York: Charles Scribner's Sons, 1925)
 Wharton, Edith, *Italian Villas and Their Gardens* (New York: The Century Company, 1910)

Jackson Pollock
 O'Connor, Francis V., *Jackson Pollock* (New York: Museum of Modern Art, 1967)
 O'Connor, Francis Valentine and Thaw, Eugene, eds, *Jackson Pollock: A Catalogue Raisonné of Paintings, Drawings, and Other Works* (New Haven, CT: Yale University Press, 1978).

Richard Pousette-Dart
 Levin, Gail, 'Pousette-Dart's Emergence as an Abstract Expressionist', *Arts Magazine* 54 (March 1980), pp. 125–29

Maurice Prendergast
 Green Eleanor, *Maurice Prendergast: Art of Impulse and Color* (College Park, MD: University of Maryland, 1976)

Robert Rauschenberg
 Alloway, Lawrence, *Robert Rauschenberg* (Washington, DC: National Collection of Fine Arts, Smithsonian Institution, 1976)
 Tomkins, Calvin, *Robert Rauschenberg and the Art World of Our Time* (Garden City, NY: Doubleday, 1980)

Man Ray
 Penrose, Roland, *Man Ray* (Boston, MA: New York Graphic Society, 1975)

Larry Rivers

Harrison, Helen A., *Larry Rivers* (New York: Harper & Row, Publishers, 1984)

Rivers, Larry and Brightman, Carol, *Drawings & Digressions* (New York: Clarkson N. Potter, Inc., 1979)

James Rosenquist

Goldman, Judith, *James Rosenquist* (New York: Viking Penguin, Inc., 1985)

Tucker, Marcia and Solomon, Elke M., *James Rosenquist* (New York: Whitney Museum of American Art, 1972)

Mark Rothko

Clearwater, Bonnie, *Mark Rothko: Works on Paper* (New York: Hudson Hills Press, 1984)

Waldman, Diane, *Mark Rothko, 1903–1970: A Retrospective* (New York: Harry N. Abrams, Inc., 1978)

Anne Ryan

Faunce, Sarah, *Anne Ryan, Collages* (Brooklyn, NY: Brooklyn Museum, 1974)

George Segal

Hawthorne, Don, and Hunter, Sam, *George Segal* (New York: Rizzoli International Publications, Inc., 1984)

Tuchman, Phyllis, *George Segal* (New York: Abbeville Press, 1983)

Ben Shahn

Morse, John D. ed., *Ben Shahn* (New York: Praeger Publishers Inc., 1972)

Prescott, Kenneth W., *Prints and Posters of Ben Shahn* (New York: Dover Publications, Inc., 1981)

Soby, James Thrall, *Ben Shahn Paintings* (New York: George Braziller, 1963)

Charles Sheeler

Dochterman, Lillian, *The Quest of Charles Sheeler* (Iowa City, IA: University of Iowa Press, 1963)

Friedman, Martin L., *Charles Sheeler* (New York: Watson-Guptill Publications, 1975)

Rourke, Constance, *Charles Sheeler: Artists in the American Tradition* (New York: Harcourt, Brace, 1938)

John Sloan

St John, Bruce, *John Sloan* (New York: Praeger Publishers, Inc., 1971)

— ed., *John Sloan's New York Scene: from the diaries, notes and correspondence, 1906–1913* (New York: Harper & Row, Publishers, 1965)

Sloan, John, *Gist of Art* (New York: American Artists Group, Inc., 1939)

Raphael Soyer

Goodrich, Lloyd, *Raphael Soyer* (New York: Whitney Museum of American Art, 1967)

— *Raphael Soyer* (New York: Harry N. Abrams, Inc., 1972)

Lerner, Abram, *Soyer Since 1960* (Washington, DC: Smithsonian Institution Press, 1982)

Saul Steinberg

Rosenberg, Harold, *Saul Steinberg* (New York: Alfred A. Knopf, 1978)

Frank Stella

Rubin, William S., *Frank Stella* (New York: Museum of Modern Art, 1970)

Clyfford Still

O'Neill, John P., ed., *Clyfford Still* (New York: Metropolitan Museum of Art, 1979)

Clyfford Still (San Francisco, CA: San Francisco Museum of Modern Art, 1976)

Mark Tobey

Rathbone, Eliza E., *Mark Tobey City Paintings* (Washington, DC: National Gallery of Art, 1984)

Seitz, William C., *Mark Tobey* (New York: Museum of Modern Art, 1962)

Max Weber

North, Percy, *Max Weber: American Modern* (New York: Jewish Museum, 1982)

Werner, Alfred, *Max Weber* (New York: Harry N. Abrams, Inc., 1975)

Tom Wesselmann

Stealingworth, Slim, *Tom Wesselmann* (New York: Abbeville Press, Inc., 1980)

Andrew Wyeth

Corn, Wanda M., *The Art of Andrew Wyeth* (Boston, MA: New York Graphic Society, 1973)

Meryman, Richard, *Andrew Wyeth* (Boston, MA: Houghton, Mifflin Co., 1968)

N. C. Wyeth

Allen, Douglas and Allen, Douglas Jr, . *C. Wyeth: The Collected Paintings* (New York: Crown Publishers Inc. 1972)

Index

Numbers in bold type refer to illustrations